HIDE
SEEK

DIFFERENCE AND DESIRE IN AMERICAN PORTRAITURE

HIDE/SEEK

DIFFERENCE AND DESIRE IN AMERICAN PORTRAITURE

Jonathan D. Katz and David C. Ward

Jennifer Sichel, Research Assistant

IN ASSOCIATION WITH THE NATIONAL PORTRAIT GALLERY

SMITHSONIAN BOOKS, WASHINGTON, DC

Hide/Seek: Difference and Desire in American Portraiture is
the companion volume to the exhibition of the same name
opening at the National Portrait Gallery, Smithsonian
Institution, October 2010.

Unless otherwise indicated, dimensions given for paintings
are the stretcher dimensions; for photographs, the image
sizes; and for other works on paper, the sheet sizes.

Printed and Bound in Hong Kong by Toppan,
not at government expense
15 14 13 12 11 10 5 4 3 2 1

Smithsonian Books titles may be purchased for educational,
business, or sales promotional use. For information, please
write: Special Markets Department, Smithsonian Books,
P.O. Box 37012, MRC 513, Washington, DC 20013.

SMITHSONIAN BOOKS
Director: Carolyn Gleason
Project Editor: Christina Wiginton
Editorial Assistant: Michelle Lecuyer

Editorial and Production Management:
Dru Dowdy, National Portrait Gallery
Book Design: Studio A, Alexandria, VA

Additional research assistance from
Patrick Mansfield

Library of Congress
Cataloging-in-Publication Data

Katz, Jonathan D.
Hide/Seek : difference and desire in American portraiture/
Jonathan D. Katz and David C. Ward, Jennifer Sichel; in
association with the National Portrait Gallery/Smithsonian
Books, Washington, DC.
p. cm.
Companion volume to the exhibition of the same name
opening at the National Portrait Gallery, Smithsonian
Institution, October 2010.
Includes bibliographical references and index.

ISBN 978-1-58834-299-7 (hardcover)

1. Portraits, American—Exhibitions. 2. Sex customs in
art—Exhibitions. 3. Sex symbolism—Exhibitions. I. Ward,
David C. II. Sichel, Jennifer. III. National Portrait Gallery
(Smithsonian Institution) IV. Smithsonian Books (Pub-
lisher) V. Title. VI. Title: Difference and desire in American
portraiture.
N7593.K38 2010
704.9'420973074753—dc22

2010020082

The National Portrait Gallery is enormously grateful to its many donors who made this groundbreaking project possible.

The exhibition, catalogue, and additional programs for *Hide/Seek: Difference and Desire in American Portraiture* are made possible by the generous support of The Calamus Foundation.

Leadership support has been provided by Donald A. Capoccia and Tommie Pegues and The Andy Warhol Foundation for the Visual Arts.

The Wyeth Foundation for American Art has provided essential support for the catalogue.

Additional support is provided by The John Burton Harter Charitable Foundation, Ella Foshay, Vornado/Charles E. Smith, and Catherine V. Dawson.

Also supported by The Robert Mapplethorpe Foundation, Inc., and The Durst Organization, Ashton Hawkins and Johnnie Moore, The David Schwartz Foundation, Frank Sciame, and Jonathan Sheffer and Christopher Barley.

Contents

Foreword
Martin E. Sullivan

Pierre L'Enfant's plan for the District of Columbia, drawn up in 1791, envisaged a "pantheon" of American heroes yet to come. L'Enfant's preferred location for such a pantheon became, in fact, the site of the U.S. Patent Office building in the 1830s, a structure soon known as America's "Temple of Invention." But his original vision was realized only in 1968, when the Smithsonian's National Portrait Gallery and National Collection of Fine Art (now the American Art Museum) opened their doors in that same neoclassical building.

For more than forty years, the National Portrait Gallery has been a living repository of American memory by portraying the lives of men and women who helped to shape the nation's struggles and triumphs. It has given special attention to how the ideals set forth in America's founding documents, especially the Declaration of Independence and the Constitution, have prompted the expansion of civil and societal rights.

Recently, a long-term exhibition called "The Struggle for Justice" has showcased the efforts of remarkable leaders and advocates for a wide array of human and civil rights. It is with pride, therefore, that the Portrait Gallery now presents *Hide/Seek: Difference and Desire in American Portraiture*. This book accompanies the first major museum exhibition to chart the influence of gay and lesbian artists on modern American portraiture. Not just a chronicle of a prominent subculture, *Hide/Seek* reconsiders neglected dimensions of American art. From Thomas Eakins to the present day, it charts the heretofore unexamined impact of gay and lesbian artists on the portrayal of personal identity. Through this approach, *Hide/Seek* offers a new lens with which to view the panorama of American life.

In addition to its commentary on cultural history, *Hide/Seek* offers a sumptuous survey of more than a century of American portraiture, with masterworks by Thomas Eakins, Romaine Brooks, Marsden Hartley, Jasper Johns, Andy Warhol, and many more. The exhibition and its attendant public programming also feature video art, movies, music, and dramatic performances.

Hide/Seek is quite unlike more traditional representations of portraiture. It has necessitated asking new questions and risking new interpretations, some of which may challenge accepted canons of art history. The National Portrait Gallery is enormously grateful to the many individual donors and foundations that provided support in making this project a reality. Co-curators David Ward and Jonathan Katz orchestrated this ambitious effort to a successful conclusion, ably assisted by staff colleagues and wonderful volunteers at every step of the way.

Martin E. Sullivan
Director
National Portrait Gallery,
Smithsonian Institution

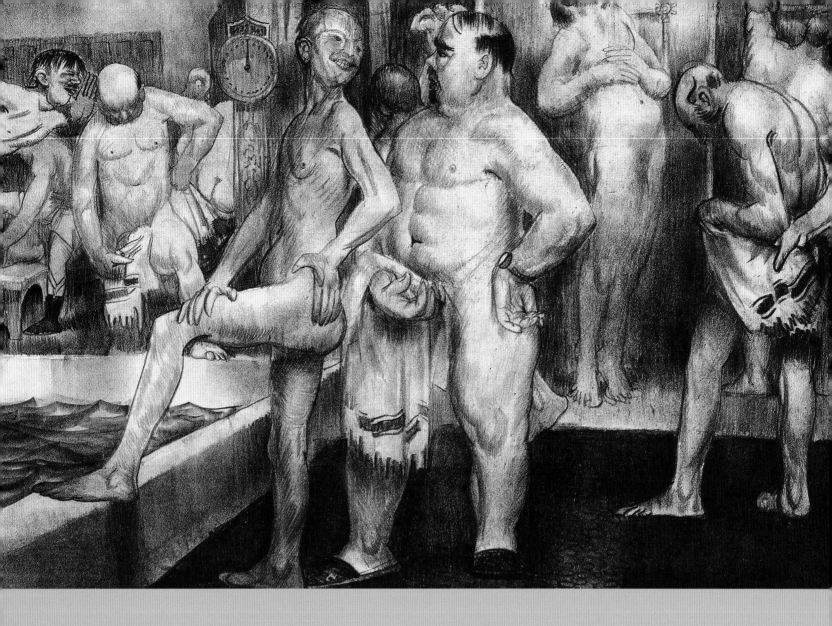

The Shower-Bath (detail) by George Bellows
Reproduced in full as Plate 8.

Hide/Seek: Difference and Desire in American Portraiture

Jonathan Katz

There they are front and center: a thin, effeminate man looking seductively over his shoulder at another man, classically masculine, beefy of build, standing behind him and returning his stare. This erotically charged contact between two naked men in a bath house—at best, an unaccustomed subject in any artwork—is made more curious still as we parse the telling details. Alone, these two men pantomime an erotic exchange. They are the only ones who violate the social code, policed only in its breach, which prohibits nude men from looking at other nude men. With a salacious leer, the thin man thrusts his posterior in the direction of the beefy man, whose towel betrays his sexual excitement, but whose face is a studied, stony mask. They are made a pair, yet in build, attitude, expression, position, equally made opposites in nearly every way—and they are the focal point of this image. All around them, the other men are unaware of this interaction. Careful not to look around, self-contained, and lost in thought, these other men behave in public as they would in private. Only one other figure in the image, the man at the lower left of the pool, is aware that this scene of public nudity is indeed public: he looks at us as we look at him. And through his intercession, we catch ourselves, made aware that in peeping into a men's shower bath, we, too, have violated the social code that dictates downcast eyes. Like the odd couple in the center, we, too have peeked.

The Shower-Bath (pl. 8) as this image is known, is a print from 1917 by George Bellows. And its forward homoeroticism, strange in any American artwork before the last two decades or so, is stranger still in a print, for unlike paintings—which need only one sympathetic buyer—as multiples, prints must appeal to a large populace. This particular print, unusually, went through three editions, in three slightly variant states—testimony to its wide popularity. A print with a homosexual erotic theme would not earn a place on the walls of most American homes or museums even today, and this print is almost a century old. How can we account for its existence, much less its critical and commercial success?

One approach, following the contemporary scholarship on Bellows, would be to simply ignore the homoeroticism at the center of this image and assume contemporary audiences did likewise. (Strikingly, in the voluminous literature on Bellows, this print has never before been addressed in terms of its same-sex dynamics.) Alternatively we could attempt a biographical argument and claim that Bellows was probably gay, choosing an image of interest to himself and perhaps others like him. But there is no evidence of Bellows's

intimacy with men, and much evidence of his devotion to his wife and children, whom he repeatedly drew and painted. Moreover, this print stands as one of but a handful of Bellows's works with homoerotic elements. Alternatively, we could read the image as a marketing gambit in which a non-homosexual artist seeks to feed a homosexual audience hungry for representations of same-sex desire. But if that were the case, we would presumably encounter evidence of the existence of such an art market in the period, stocked by similarly homoerotic images by other artists—and we don't.

While the theme of *The Shower-Bath* confounds our expectations of early-twentieth-century American art in almost every regard, there is one framework that makes sense. Instead of approaching this homosexual encounter from the perspective of our contemporary expectations and assumptions, if we reconstruct the social world of same-sex desire in the early twentieth century, we will find that, paradoxically, this is not a scene of queer subculture at all.[1] An investigation into homosexuality in the U.S. Navy roughly contemporaneous with *The Shower Bath*, among other sources, allows us a glimpse into the social organization of same-sex desire.[2] In an attempt to police homosexuality within its ranks, the navy solicited good-looking young men to volunteer to have sex with other men and report back on their partners. Under the then-prevailing cultural standards, only men who were passive erotically, contravening the gendered behavioral norms of their sex, were in fact queer. The volunteers—"trade" in the parlance of the times—and the navy brass who solicited their assistance, thus had no qualms about assigning teenagers to such duty, because no matter what happened between them and the targets of their investigation, as long as they were in the active role, their traditional masculinity was in no way compromised. Sexual identity, in short, was premised not on the gender of one's sexual partner, but rather one's own gendered role in the sex act. Thus, it was entirely possible for a man to maintain erotic relationships with his own sex and not be thought, or think himself, queer, provided he assumed the normatively masculine role.

As a result of this very different definition of queerness, there was vastly greater social visibility—and tolerance—of same-sex eroticism than would be the case in midcentury, before the rise of the modern lesbian and gay rights movement. Whereas a man would never dare make a pass at another man in today's navy unless he felt assured that the target of his affections would reciprocate his desire—and for many navy

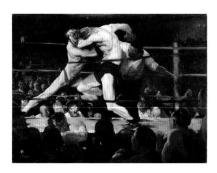

Fig. 1 / *Stag at Sharkey's* by George Bellows (1882–1925), oil on canvas, 1909. The Cleveland Museum of Art, Ohio; Hinman B. Hurlbut Collection (1133.1922)

men, not even then—in 1917, to offer oneself "as a woman" to another man entailed no prejudgment that the man would be interested in men per se. If anything, such an offer would be taken as a tribute to his self-evident, utterly "normal" masculinity. Thus, by then predominant definitions, there is only one queer figure in Bellows's print, and the widespread acknowledgment of his presence was hardly as socially disruptive or marked as it would be today. In contrast, under our contemporary sexual system, wherein we assume both partners in a same-sex coupling are homosexual, for one man to solicit another man is to suggest that he perceives the other man to be queer, too. In a culture that equates same-sex sexuality with unmanliness, that is an assumption too often met with violence.

This now distinctly foreign understanding of queer desire has profound ramifications for reading *The Shower-Bath*. Within the sexual economy of Bellows's print, queer men required straight men for erotic fulfillment, and straight men valued queer men for sexual release. As result, there was a symbiotic relationship and a form of communion—sexual as well as social—between queer and non-queer men. In public, putting down queers was still de rigueur, but in private, other forms of relationship could be obtained. On the other side, queer men relied on other queers for friendship, but for sex, by definition, only a non-queer man or trade would do. Two queers simply would not have had the capacity to erotically fulfill one another, for two passive, female-gendered bedmates were not sexually compatible. As a result, queers had little incentive to segregate into gay ghettos for either safety or companionship; segregation instead meant the absence of that very erotic possibility that made living as a queer worth the risks. (Conversely, today's LGBTQ[3] life is often organized within dense communities of other LGBTQ people as protection from risk and because, as an identity visited upon both partners, whatever their gendered role, to be LGBTQ today is defined by social and sexual fulfillment with others of one's own kind.) Absent segregated communities, there was also, of course, little call for queer political organizing and activism around social and political liberation. Rather, queer and straight found themselves interdependent in an era that frowned on premarital heterosexual relations and offered comparatively few disincentives for lonely men to bed other men as long as they could retain their masculinity in the process.

In short, circa 1917, a work such as *The Shower-Bath* would have illustrated a familiar, rather unremarkable scene in a public bath. The locale

is important, for bathhouses, before the routine availability of warm-water indoor plumbing, served significant hygienic, social, and sexual purposes. Within their walls, queer and straight men would routinely meet.[4] Since accepting sexual contact had little social significance for the active partner, there was less social pressure to forcibly reinforce one's masculinity over and against its degraded, feminized obverse, the queer. In *The Shower-Bath*, the thin man's hand-on-hip effeminacy, leering glance, and proffered buttocks make him a stereotype to be sure, but one not so dangerous as to be excised from representation entirely. Similarly, the masculine character of the trade, or top man, is a careful study in social dynamics. His erection betrays sexual excitement, but his face is a studied mask of blasé indifference. While it was socially acceptable to penetrate a queer, masculinity demanded that he appear neither too eager nor too emotionally involved. Queers, after all, were tolerable stand-ins for women, but not objects of desire in and of themselves.

For a painter like Bellows, a member of what was then called the Ashcan School, a cohort of painters committed to the pictorial dissection of the society of their times—not least at its margins—painting a queer was no more remarkable than painting the poor or immigrants. Indeed, Bellows would similarly stereotype, and ridicule, the *Shower-Bath*'s masculine obverse—two men slugging it out in a boxing match—in some of his most famous images. In works such as *Stag at Sharkey's* (fig. 1), the fight audience's intense identification with the boxers' overwrought masculinity is every bit as much a caricature as his queer's perceived absence of the same. Like *Shower-Bath*, *Stag at Sharkey's* is a kind of social document written through satire, as the painting's highly gendered title, contorted faces, and air of sweat and savagery makes abundantly clear. Queers and boxers could be made equally marginal to dominant masculinity, albeit from opposite sides: they were both associated with forms of excess—too much or too little masculinity—and thus fell prey to the vice, unbridled passion, and libertinism thought to be the inheritance of all who lived outside the moderate, marital norm.

Bellows's *River Front No. 1* (pl. 7), completed two years before *Shower-Bath*, is its equal as a social dissection of the richly available prospects for a specifically urban eroticism. At first glance it is an idyllic scene of boyhood innocence, complete with attentive working-class mothers picking up and dropping off their kids at one of the city's swimming beaches, but the scene is

haunted by a figure who clearly does not seem to belong. Dressed as a dandy in black and graced with a top hat and cravat, he is the sole figure who is neither tending to the children nor interested in swimming. In fact, he seems to only be watching a veritable sea of naked boys who seem all too keen to bend down, lie on their backs, and otherwise offer full view of their buttocks. As such, *River Front No. 1* is not dissimilar from Bellows's earlier *Forty-Two Kids* (1907), which also presents an innocent gambol at a swimming hole populated by naked boys. But while *Forty-Two Kids* conjures fantasies of a then fast-disappearing rural life more Huck Finn than Henry Roth, the distinctly urban *River Front No. 1* is knowing, its innocence interrupted by a fuller and more complex account of the multiple trajectories of those who could find pleasure in swimming holes.

Romaine Brooks's roughly contemporaneous *Self-Portrait* (1923) (pl. 12) similarly trades in gender nonconformity as a marker for sexual nonconformity, but any easy parallel to male sociosexual relations is compromised by the very different social trajectories open to women at the time. Whereas gender nonconformity in a man moved him down the social hierarchy, the same nonconformity in a woman could mark her ascent. Mannish women like Brooks, Gertrude Stein (pl. 20), and Janet Flanner (pl. 17) were celebrated because of their exceptional gifts, of course, but also because their gender nonconformity was taken as an outward sign of their atypical femaleness. In an era that marked a woman's path as essentially moving from her father's house to her husband's—with all the financial and social dependence this implies—masculine attire and appearance telegraphed a more autonomous and independent spirit.

Of course, for the "New Woman" of the 1920s, who finally secured the right to vote in August 1920, independence was a general value, and gender nonconformity—short hair, smoking, etc.— signaled allegiance to this newly progressive social norm. But Brooks, in her many portraits of women of this era, amplifies this into a full-scale gender reversal. Her women can look and dress like men, as in her portrait of *Una, Lady Troubridge* (pl. 13), the partner of Radclyffe Hall, who penned one of the earliest explicitly lesbian novels with *The Well of Loneliness*. Troubridge, who had left her husband, an admiral, in favor of Hall, wears a severe, highly masculinized, and dandified outfit, not dissimilar from that worn by Stephen Gordon, chief protagonist of *Well of Loneliness*.

Aided and abetted by great wealth—Brooks was a millionaire many times over when a million was a good deal more money than it is today— the masculine appearance of women like Brooks and Gertrude Stein was indexed to their assumption of a masculine social role, which is to say, assuming a public, not a domestic profile. As wealthy women, artists like Brooks and Stein could live, travel, and work autonomously, never worrying about conforming to a husband's expectations. Brooks's paintings and Stein's erotic love poetry are among the most openly lesbian of any artist of the period precisely because their wealth insulated them from the demands of the marketplace. Often adapting a distinct paternalism with reference to their female partners, both Stein and Brooks played with the language of masculine dominion. Brooks, for example, painted her young lover, the dancer Ida Rubinstein, in *White Azaleas* as a nude, captivatingly erotic odalisque—precisely the kind of reclining, sexually passive, and expectant female that male artists had portrayed. Tellingly, after subsequently becoming involved with her social equal, the heiress Alice Pike Barney, Brooks adopted a very different tack. She paints Barney, clothed in a lavish fur stole, as a notably proper woman.

In the same vein, Gertrude Stein can also seem traditionally male in her relationship to her partner, Alice B. Toklas. Toklas was in charge of the domestic sphere, typing Stein's handwritten manuscripts, planning the parties, and leading the wives to tea at the salons the couple hosted, while Stein enjoyed the company of the men. Stein even ventriloquizes her partner's voice in *The Autobiography of Alice B. Toklas*. Despite the title, Stein not only authored the book but is its chief protagonist.

Money, talent, social power, and access meant that figures such as Brooks and Stein could compete successfully in a man's world on its own terms. While "passing" women (women who lived their lives as men, often taking wives) were far more common than is generally acknowledged prior to the twentieth century, the lesbian model of butch/femme instead presumes the butch is not trying to be or pass as a man, but rather to claim privilege as a masculinized woman within our gendered social system. Such a claim, unlike that of "passing" women, poses a real threat to traditional masculinity in arguing for a definition of masculinity irrespective of biological sex. While butch/femme relationships would come to prominence in the mid-twentieth century—eventually even coming to represent lesbian identity— these expatriate upper-class women were among the first to both embody and artistically represent butch/femme relationships. That they could do so was in no small measure because their claim

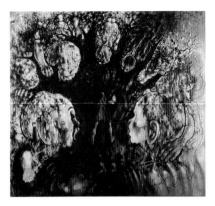

Fig. 2 / *Hide-and-Seek* by Pavel Tchelitchew (1898–1957), oil on canvas, 1940–42. The Museum of Modern Art, New York City; Mrs. Simon Guggenheim Fund (344.1942)

to masculine privilege was not only stylistic, but backed by the kind of capital—cultural as well as monetary—that remains a staple of masculinity today.

While Americans wealthy enough to live abroad could take full advantage of France and Germany's far more relaxed social norms regarding sex/gender conformity, those living in the United States were less lucky. The Napoleonic penal code had decriminalized same-sex eroticism in France as early as 1791, but in the States, the first decades of the twentieth century instead witnessed a substantial increase in promotion of "social hygiene." Despite its euphemistic name, this was a conservative social movement—with a distinctly unsavory eugenicist edge—to police sexual behavior. During its heyday in the United States anti-venereal disease campaigns were hardly the movement's sole purpose, and its episodic public morality crusades occasionally made life difficult for those who contravened gender norms. Moreover, "public hygiene" operations tended to involve the police, while spurring outbreaks of religious, juridical, and medical zealotry, and a general, low level of harassment.

Even outside these occasional crusades, life for American queers wasn't easy. Among men, as the pictorial evidence underscores, sexual encounters were routinely available, but sustaining emotional bonds much less so.[5] Among women, it could be difficult to locate like-minded women, and social strictures greater than homophobia restricted women's freedom of movement and autonomy. In short, to be queer in the United States in the early decades of the twentieth century was to be socially and legally vulnerable and faintly abnormal. But—and this is the key difference from contemporary definitions—since sexual difference had yet to coalesce as an identity stricture and thus forge a collective politics, it was subject to far less intense social sanction. As a result, there was less incentive to write queerness out of the sphere of public representation, or perhaps, better said, to paint it out.

The social universe of sexual desire, in painting, as in life, is so often of necessity communicated through the most subtle gestures, glances, and codes. When the desire in question is literally illegal, it is all the more fugitive, such that images of queer historical import, such as *Shower Bath*, have passed under our contemporary perception utterly undetected. Hence this book's title: *Hide/Seek: Difference and Desire in American Portraiture*, which of course invokes the children's game

of Hide and Seek. But it also acknowledges an eponymous painting by Pavel Tchelitchew (fig. 2), owned by the Museum of Modern Art. In 1948, *Hide-and-Seek* was voted the most popular work in the museum's collection, the museum itself being the chief repository of modernist art in America. Thus it's no exaggeration to claim that, at least for a while, *Hide-and-Seek* was the most popular work of contemporary art in the country. The painting depicts a large, surrealist tree, along with a few figures and parts of figures hiding within its trunk and branches. *Hide-and-Seek* has always been viewer-friendly, offering recognizable imagery as a reward for close looking. Neither commenting on the tradition of previous painting nor invoking any particular ideology save a loose Freudianism, the painting did not call for any specialist forms of knowledge. The more the viewer studied the painting, the more details it revealed, and before long, the image was teeming with hidden worlds.

The painting's artist, the openly gay Russian émigré Tchelitchew, was the partner of poet and novelist Charles Henri Ford and a friend of the American ballet impresario Lincoln Kirstein (pl. 19), whose ballets he helped design. *Hide-and-Seek* presents a dynamic familiar to a subculture long used to employing protective camouflage, while at the same time searching for tiny signs, clues, or signals that might reveal the presence of other queer people. From a glance held a little too long, to the cut of hair or dress, to manners and tastes undetectable to the uninitiated, queer people have long used a superficial conformity to camouflage instrumental differences legible only to those who know where and how to look. And there is often no better form of social camouflage than the refusal of camouflage. Amid *Hide-and-Seek*'s many feints and busy distractions, its tangential social worlds and loving evocations of childhood, at the very center of the canvas is something that generally escapes notice until someone points it out: an erect penis configured through the whirling bark of a tree trunk. It's only there if you know where and how to look. Although clues abound in the painting, from the title on, that *Hide-and-Seek* is an image larded with secrets, it is equally true that seeing and noticing are two very different acts. This book seeks to turn such seeing into noticing.

A portrait of Tchelitchew's partner Charles Henri Ford (pl. 27) by the great French photographer Henri Cartier-Bresson can serve as a pendant to *Hide-and-Seek*. Like the painting, it too is larded with codes, although these codes are sufficiently obvious as to beg interpretation. A remarkably forward and witty pictorial

wink, it places the young Ford just leaving a French *pissoir*, public urinals that had a notable reputation as places where men inclined toward other men would meet. He's buttoning up his trousers, a self-satisfied look on his face, positioned such that a Krema advertisement featuring a large tongue is juxtaposed with his crotch. The photograph thus revels in its overdetermined queer coding, practically daring the viewer *to fail* to interpret its many indices of gay identity. As such, it also constitutes a pictorial revelation of its subject's proclivities, a collaboration between subject and artist that enables an art of the surface, of the superficial, to bear a deeper charge. But again, these meanings, like all meanings, are necessarily viewer-dependent, and the photograph is structured so that the viewer can either enjoy the code, not understand the code, choose not to understand the code, or pretend to not understand the code that animates it. Meaning, in short, is never simply a product of the artist's intentions, and perhaps nothing underscores that more powerfully than an art that engages sexual difference.

Thus this book cannot be a segregated history of sexual minorities in American portraiture, for as we've seen, such segregation was by no means true of sexuality at the level of either artist or audience, especially in the early decades of the twentieth century. As a consequence, *Hide/Seek* features straight artists representing gay figures, gay artists representing straight figures, gay artists representing gay figures, and even straight artists representing straight figures (when of interest to gay people/culture). Moreover, for many of the paintings and painters under consideration, this entire gay/straight dichotomy was either outside the historical boundaries of their consciousness or rejected as too simplistic a formulation for something as complex as desire. Thus the story of *Hide/Seek* is by and large the story of American art itself, one in which the cliché of the art world as peculiarly hospitable to sexual minorities is more than amply realized. But then again, the art world wasn't nearly as exceptional in its widespread tolerance of sexual difference as it may appear from our contemporary vantage point. Once upon a time, same-sex desire both implied and necessitated close contact with the straight world, contact that the straight world in turn penalized, acknowledged, policed, enjoyed, negotiated—in short, reciprocated.

That almost no name in this book will be unfamiliar is itself a sign of how firmly canonical our choice of artists has been. Our goal is not to challenge the register of great American artists, but rather to underscore how sexuality informed

their practice in the ways we routinely accept for straight artists. By no means intended as encyclopedic, this work by necessity omits a large number of artists, either because of their comparatively low profile or because they or their estates objected to their inclusion. It is no surprise to note that even in 2010, the public articulation of an artist's sexuality remains fraught, in part because, as publicly traded commodities, the value of an artwork depends on a critical consensus. Some claim, we think mistakenly, that the public declaration of an artist's sexuality will damage that artist's market. But although we have tried to show sensitivity to such concerns, wherever possible we have also tried to work around them, for such censorship can only still the advance of art-historical knowledge. Sexuality, as we understand it here, is not a private matter, but a question governing the means of representation. Were an artist's private sexual behavior the only indication of their sexuality, they would not be in this book. Rather, we have used sexuality as a lens to examine some key works in American art precisely because it was visible. While sexuality has long been deployed in this manner by art historians, it has generally done so in ways that conformed to dominant social codes. As a case in point, the import of Picasso's mistresses to his artistic development has long been the stuff of uncontroversial art-historical investigation, a fit subject for exhibitions in major museums from New York to Sydney. Yet this book accompanies the very first exhibition in a major museum in this country to attempt a similar investigation for artists inclined toward their own sex.

While we have tried to represent a diverse group of artists, our emphasis on canonical figures has worked against our desire for inclusivity. Even today, the art world is too often closed to women and ethnic and racial minorities; in the past, that tendency was amplified. While we could have chosen to focus on a more diverse group of artists, our goal has been to address the role of sexual difference within the American mainstream, both as a means of underscoring the hypocrisy of the current post-Mapplethorpe anxiety about referencing same-sex desire in the museum world and toward scrutinizing the widely held but utterly unsupportable assumption that same-sex desire is at best tangential to the history of American art.

We have also chosen to understand portraiture in the most expansive sense, as anything from the portrait of an individual to the portrait of a community. The pervasive silencing of same-sex desire in accounts of American portrait painting is all the more notable because the genre is

perhaps the most extensive—yet still untapped—sexuality archive in existence. How, in the United States of the nineteenth and twentieth centuries, did sexual behavior evolve into sexual identity, from what you did to what you were, and how, as the twentieth century shaded into the twenty-first, has sexual identity increasingly morphed back into sexual behavior? Early archival evidence of same-sex desire in the United States—most of it from police logs and jury trials—is notably weak in both writing style and descriptive detail, preferring to let terms like "sex crime," "deviance," or "perversion" do most of the expressive work. But because visual art did not have to name, judge, and categorize, it could make use of the simple fact that images at once addressed multiple audiences with multiple skills, experiences, and competencies. And as long as the representation of the unrepresentable existed in the shadows, it could bank on the fact that the failure to notice queerness was always socially acceptable, while correct identification carried the taint of an always-suspect private erudition, if not actual experience. As a result, while detailed literary sources about queer life prior to the mid-twentieth century are scarce, we have literally thousands of images—paintings, sculptures, watercolors, prints, films, and photographs—that eloquently attest to forms of sexual desire and association long before the advent of our modern lesbian and gay identity and its often policed, and occasionally violent, segregation of gay from straight.

Of all of these artworks, the most eloquent are the portraits, as portraiture is dedicated to searching revelation, sometimes even against the sitter's will. At the same time, a portrait is never merely documentary, but a social performance—it exists, after all, to be publicly seen. But how an artist wants to be seen and how a sitter wants to be seen are not always the same thing, and a portrait is often the product of a tense negotiation between the two. At historical moments when same-sex desire was literally a crime and the ramifications of revealing sexual difference could be great, it is striking that we can offer no coherent trajectory in the representation of sexuality from oppression and enforced silence to openness and celebration. Indeed, one of the most conspicuous aspects of this book is its refusal to frame queer history as moving in one direction only, toward ever-growing tolerance and social acceptance. In portraiture, it's not at all unusual to find strikingly frank early depictions of sexual difference followed by works that invent ever more baroque means to tiptoe around what could no longer be comfortably represented. Portraiture plays a key role toward understanding

sexual differences in a world not yet divided between homosexuals and heterosexuals, a world where the concept of "having " a sexuality did not yet exist. It helps us answer not only the question of what same-sex desire signified socially and how it was marked but also, by implication, how critical an aspect of character it was deemed to be in the accurate portrayal of a sitter.

Historical background

When, fed up with years of police harassment, a group of lesbians, drag queens, kids of color, and other social marginals with little to lose, finally rioted at New York's Stonewall Inn for three days in June 1969, they pushed into prominence the notion of modern gay and lesbian community as separated, even segregated, from the norm and loosely defined around a set of common differences from the straight world. (Although the art world contained such coherent communities long before Stonewall, these arts-oriented gay and lesbian communities were conjoined more properly by another difference-in-common—i.e., art—than by what we would understand as their sexuality.) What the Stonewall riots did, then, was act as a catalyst for a widespread understanding of sexuality according to a model of minority-group politics, with all the mappings of subculture—codes of dress, speech, behavior, consumerism, even neighborhood—that subculture implies. These newly articulated "minority" differences weren't new; they merely grew in prominence alongside a liberationist discourse with roots in the civil rights and antiwar movements, which sought to ground sexual freedom in the constitutionally protected category of difference.

In contrast, before Stonewall, sexual difference was widely understood according to pathological models, and people defined as sick rarely seek to band together and march under a label advertising their sickness. But following the civil rights movement's brilliant orchestration of minority identity as part and parcel of the American promise, a similar model of identity was gaining ascendancy within queer culture. This new model was promoted in print by the pseudonymous Donald Webster Cory (his real name was Edward Sagarin) in his 1951 landmark *The Homosexual in America*. The early lesbian and gay liberationist journal *One* quickly promoted this minority model, and by the time of the Stonewall riots it had become widely accepted within progressive and youth circles. Thus a minority model of lesbian, gay, and subsequently bisexual and transgendered people was quickly and successfully mobilized, winning civil rights

at an unprecedented speed. But there was a hidden cost. The more LGBTQ identity structures ratified and promoted difference in concert with this minority model, the more a century of homo- and heterosexual coexistence and erotic cross-play disappeared. By the early 1980s, the promotion of a gay and lesbian population made distinct from the social majority was in full flower, and what was once a complexly shared erotic history was remade into two distinct histories.

Two intertwined and defining events underscored the dangers of this now-divided history. The first was the advent of AIDS. The peculiar origins of the virus, initially far more widespread in the gay community, gave the illusion of a biological basis for an essential LGBTQ difference. So resonant was this construction of a "natural" distinction between gay and straight that the conservative evangelical activist Gary Bauer, President Ronald Reagan's chief adviser on domestic policy, said on the television show *Face the Nation* in 1987 that the president had not even uttered the word "AIDS" publicly until late in 1985 because "it hadn't spread into the general population yet."[6] This after almost 10,000 Americans had died.

As AIDS made seemingly very real the existence of two Americas—one in the midst of horrific plague and another seemingly more concerned with its potential than those already presumed infected—right wing and conservative Christian strategists began to use the disease to advance an ever more profound barrier between gay and straight. A once-useful minority model promoted by LGBTQ people had become a tool successfully employed by their political enemies. North Carolina senator Jesse Helms repeatedly and aggressively sought to pair homosexuality with AIDS in the context of artistic representation. In 1988, Helms first forced through an amendment to a huge AIDS research and education bill to "prohibit the use of funds provided under this Act to the Centers for Disease Control from being used to provide AIDS education information, or prevention materials and activities that promote, encourage or condone homosexual activities or the intravenous use of illegal drugs."[7] Even though the amendment thus explicitly prohibited addressing risk reduction for the two populations most affected, it passed 94–2 with only Senators Lowell Weicker of Connecticut and Daniel Patrick Moynihan of New York voting against it. In securing that lopsided victory, Helms pioneered the politics of the "homovisual": now the mere specter of witnessing same-sex desire was sufficient to secure its repression, ostensibly as a means of battling AIDS.

A year later, the active, hot phase of what is now widely referred to as "the culture wars" began, the second event that illustrated the dangers of the now-increasingly-profound segregation of gay and straight. Again and again Helms hammered away at the essential equivalency of art, homosexuality, and AIDS, reanimating the recently deceased photographer Robert Mapplethorpe to bear his message. "It is an issue of soaking the taxpayer to fund the homosexual pornography of Robert Mapplethorpe, who died of AIDS while spending the last years of his life promoting homosexuality."[8] No wonder then that Christina Orr-Cahall, then director of the Corcoran Gallery of Art in Washington, D.C., cancelled the presentation of Mapplethorpe's now ironically entitled retrospective, "The Perfect Moment." Exemplifying the pervasiveness and influence of Helms's rhetoric, in 1990 the president of the Massachusetts chapter of Morality in Media observed upon the opening of "The Perfect Moment" in Boston, "[p]eople looking at these kinds of pictures become addicts and spread AIDS."[9] Here, succinctly realized, was the crux of the issue, a stunning series of elisions now yielding the horrifying equation art=gay=AIDS. With this final triumph of Helms's homovisual, a decades-long blacklist on the representation of same-sex desire in American museums had begun.

Before Representation

The work of Thomas Eakins acutely poses the question of the implication of same-sex desire prior to the advent of "homosexuality" as an available category. Resistant to the reigning hypocrisies of his day, and as a result quite controversial, Eakins has long fed a debate about the explicit homoeroticism of his art, and the obvious connection, so easy to draw, between that homoerotism and our understanding of his own sexuality. But how can we discuss Eakins's sexuality in advance of the very words that convey it? A number of paintings, such as his famous *Swimming Hole*, beg the question. But as one Eakins scholar notes, such critical precision carries a substantial danger:

In other words, the risk in arguing that it is an anachronism to say Eakins was gay is that we will support desexualizing and degaying his work in every context. Eakins's work, however, in every sense of the word, is infused with the sexual. . . . It is entirely possible to place Eakins and The Swimming Hole, *for instance, near the beginning of a homoerotic (and even homosexual) visual tradition in American art.*[10]

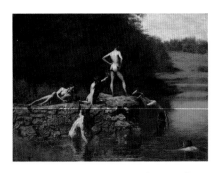

Fig. 3 / *Swimming* by Thomas Eakins (1844–1916), oil on canvas, 1885. Amon Carter Museum, Fort Worth, Texas; purchased by the Friends of Art, Fort Worth Art Association, 1925

The fact that the literature on Eakins has long had to dance around the "problem" of sexuality in the treatment of this dean of American painters is itself quite revealing. There has been much about Eakins that his biographers and critics have had to work hard to disavow, long before they were disavowing the sexuality of other artists, long before sexuality itself was generally framed as an operative "problem." In both his life and his art, Eakins has had a certain "taint" that writers once felt forced to confront, if only to dismiss its implications. Lloyd Goodrich, a dominant Eakins scholar of the twentieth century, was emblematic in this regard. Writing in 1982 for the National Gallery of Art, he confronts the question of Eakins's sexuality, only to quash it:

The companionship of Eakins and [his colleague Samuel] Murray meant much to both of them. The suggestion has been made that the relation was a homosexual one. There is no need to get involved in moral issues about this; it is an interesting question that deserves consideration. There is of course no factual evidence. None of Eakins' friends, pupils, and sitters with whom I talked in the 1930s, several of whom were entirely frank about sexual matters, mentioned homosexuality; on the contrary, the more critical accused him of too much sexuality with regard to women. His intense interest in the female nude and his persistent habit of asking women to pose nude for him have been detailed. As to his art, he painted many portraits of women, almost as many as of men, and they are among his most sympathetic portraits. . . .

Without being so rash as to try to define homosexuality in art, it does seem to me that in modern times (not Greece or the Renaissance) the art of homosexuals tends to show certain qualities that are conspicuously absent in Eakins': sophistication, wit, elegance, fantasy, satire, decorative values. And specifically, an attraction toward the male more than the female, and a tendency to idealize the male face and figure. I do not perceive any of these characteristics in Eakins' work.[11]

There is no need to underline the crude stereotyping in this formulation, merely noting its energetic, if to our ears rather tinny, attempt to distance Eakins from what apparently certainly looks like, sounds like, and acts like homosexuality. Otherwise, why bring it up? Of real interest is Goodrich's claim of Eakins's excessive heterosexuality, the widely held perception that "the more critical accused him of too much sexuality with regard to women." As we'll see, there is a surprising parallel between Eakins's putative excess with women and his manifest interest in the male nude.

Lately, as the scholarship on Eakins and sexuality has grown in scale, critical sophistication, and insistence, instances of active disavowal like Goodrich's have given way to a now-blanketing silence. As a result, large-scale scholarly exhibitions like the massive 2001 Eakins exhibition at the Metropolitan Museum of Art and Philadelphia Museum of Art utterly ignored what is now more than twenty years of bibliography on Eakins and sexuality, a willful, critical blindness that would be nearly impossible with regard to any other pressing scholarly debate. But telling though the transition from anxious disavowal to utter silence, Eakins's sexuality keeps looming. In his review of the 2001 Eakins retrospective, *New Yorker* art critic Peter Schjeldahl evocatively writes that despite the fact that the "catalogue essays are quaintly reticent about Eakins's sexuality . . . pansexual heat glowed in dim rooms that smelled of dust and varnish."[12]

"Pansexual heat" is a lovely attempt to evade the problem of having to label Eakins's sexuality, but it does lack something in terms of historical specificity, which a new generation of Eakins scholars are working hard to rectify.[13] In general these scholars, and the work of Jennifer Doyle is exemplary in this regard, characterize Eakins as a committed sexual dissident. Mobilizing both famous biographical incidents like his firing from the Pennsylvania Academy in 1886 for removing the loincloth of a live male model in an all-female life-drawing class, as well as close readings of his paintings, these scholars point up Eakins's continuous refusal of appropriate social behavior, especially with regard to the relation between the genders—and the scandals this caused—as emblematic of his larger resistance to the social norms governing our bodies.

A Philadelphia businessman and patron of the arts, Edward Hornor Coates, commissioned *Swimming* from Eakins in 1884 (fig. 3). (The painting also goes by the popular title *The Swimming Hole*.) A member of the board and eventual president of the Pennsylvania Academy of the Fine Arts, Coates was in a delicate position when Eakins showed him the completed painting, which hung in the academy as of October 1885 with Coates listed as the owner. Eakins was without a doubt a star at the academy, but already stormclouds were gathering over his reputation. A month later, in a four-page letter that was an elaborately kind attempt to soften the blow, Coates rejected *Swimming* and selected another painting from Eakins, claiming that "the present canvas is to me admirable in many ways but I am inclined to believe that some of the pictures you have are even more representative. . . .

You must not suppose from this that I depreciate the present work—such is not the case."[14] When the loincloth incident occurred a month after the letter was sent, Eakins's dismissal from the Pennsylvania Academy was all but sealed.

It is tempting to contravene Coates and note how "representative" *Swimming* actually is. After all, the painting, like the loincloth incident, directly implicates Eakins in what is at best a troubled relationship to notions of sexual propriety. A photographic study for the painting, *Eakins's Students at "The Swimming Hole"* retains the power to disturb, not only as an image of a teacher photographing his students in the nude, but more broadly for the blurring of the distinction between model and artist, representation and representer. As Doyle pointedly asks, "How many of us, though, would really be comfortable hanging in our office a painting like *The Swimming Hole*, executed by a colleague who appeared in the painting along with a number of his and our own students, all naked, of the same sex, and suggestively posed?"[15] Of course, images like the *Swimming Hole* photogragh were hardly unprecedented, and we can see from artist Thomas Anshutz's roughly contemporaneous images a similar interest in swimming, water holes, and the male nudity that this environment both justifies and naturalizes (fig. 4). But Anshutz, in keeping with the norms governing the relation between the clothed and the naked, maintains a comforting distinction in photographing these other men, youths, and boys. They are his subjects, distanced from the photographer, and unlike Eakins, Anshutz doesn't trouble that social hierarchy by including himself among them.[16]

But in *Swimming*, Eakins paints himself as the figure in the water on the right, underscoring, even more than in his photographic studies of the composition, his fraught role as a participant observer. Many have noted the profound affinities between this painting and Walt Whitman's eleventh poem in *Leaves of Grass*. That poem, familiarly called "The Twenty-Eight Young Men," was first published in 1855. Some forty years later Eakins would have certainly known it, for he knew the poet and his work quite well. Indeed, Eakins painted and photographed Whitman several times (pl. 1) and was ultimately chosen for the honor of being a pallbearer at his funeral.

The most striking affinity between *Swimming* and "The Twenty-Eight Young Men" is not their shared setting, nor the implicit homoerotic nature of the scene, but the way in which both painting and poem confuse watching and doing, witnessing and participating, unsettling any clear distinction between the observer and the observed. In the poem, Whitman alternates between being the omniscient narrator and assuming the voice of a lonely young woman who peers out the windows of her house and sees twenty-eight young men frolicking naked in the water. But this woman's thoughts, voiced by Whitman, equally voice the poet's own desires, for the woman imagines herself caressing the young men, and eventually, in the lines "who puffs and declines with pendant and bending arch," she fellates them to orgasm.[17]

Like that twenty-ninth bather and like Whitman's own authorial voice, Eakins, too, intrudes on his own depiction, his body obscured in the water, but his eyes registering, like Whitman's woman in the house, the nude young men who are his subject. In a 1996 article, Elizabeth Johns specifically names Eakins as Whitman's twenty-ninth bather, but in so doing, she also worries over the propensity "to use pictures to gratify contemporary hunger to know—or a least to speculate on—the precise sexual orientation of our predecessors. Such gratification can satisfy our desires to find kinship across the decades or centuries, but it can also 'appropriate' a figure." Ultimately, Johns decides that *Swimming* is not, in her words, "preference-specific (that is, as not explicitly homosexual)."[18] If that's the case, it's also, as Whitney Davis succinctly put it, "not not homosexual" either, for if Eakins is indeed the twenty-ninth bather, what are we to do with Whitman's evident attempt to specify that figure's active sexual involvement with the young men—"They do not think whom they souse with spray?"

In a nutshell, the problem with all these attempts to adjudicate Eakins's sexuality is that they employ a homo/hetero binary to address an artist working at precisely the moment when these categories were only first emerging. But if we cannot use our own terms like homosexual, and we refuse to ignore or devalue the evident same-sexual nonconformity that animated both Eakins and his work, what vocabulary can we use? As Doyle and others have persuasively argued, period-specific constructions of sexual nonconformity would most centrally turn on the potential for an untroubled indulgence in the kind of nonreproductive, pleasure-inducing sexuality summarized under the term "lust." Eakins famously recounted stripping naked in front of a female student in his office to show her how his pelvis worked; he expected male and female students to pose naked for one another, and for him; he groped his models, arguing that he learned as much from touching their nude bodies as from seeing and photographing them. Not surprisingly,

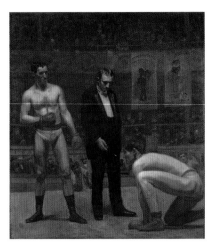

Fig. 5 / *Taking the Count* by Thomas Eakins (1844–1916), oil on canvas, 1898. Yale University Art Gallery, New Haven, Connecticut; Whitney Collection of Sporting Art, given in memory of Harry Payne Whitney, B.A. 1894, and Payne Whitney, B.A. 1898, by Francis P. Garvan, B.A. 1897, M.A. (Hon.) 1922

his claim to have only the highest of intentions fell on deaf ears.

It was the charge of lust that haunted and occasionally derailed Eakins's career. At the close of the nineteenth century, sexuality that was neither marital nor reproductive was deemed a violation of the proper purposes of our sexual being, and as we've seen, Eakins was as controversial for his intense relationships with women, as with men. In the nineteenth-century attitudes toward sexual pleasures, there would be but a small leap from sexual pleasure with females with whom one was not married to homosexuality, for neither was marital and procreative.[19] Both acts would both have been framed as lustful, and thereby had more in common with each other than they had with marital relations.

Since Eakins's pedagogy made him look, as he knew well himself, both predatory and perverse, why did he do it? While it's still tempting to assign Eakins a motive in keeping with the scandalmongers of his day, from another perspective, his loud protests that realist art demanded a scientific relationship to the body can be viewed as an attempt to rescue the studio—and his art in general—from the very prurience he was accused of indulging.[20] It was no secret that live models were generally not of the sort students would want to invite home, hired as they so often were from brothels. By posing nude in front of his students and having them pose before each other, Eakins cultivated a realist commune where dedication to the body in its naked form knew no other motives. Here, his active participation in the communal posing was actually evidence that his relationship to nudity was precisely *not* voyeuristic. But paradoxically, this very denial of erotic interest spawned intense speculations about his eroticism, speculation that parallels the way we now seek to know Eakins's "real" sexuality.

In contrast to other painters of his day, Eakins's involvement with loaded subject matter always seemed to come back to him, referencing his life, his perspective, and his personal relationships in one sense or another. As such, his work is made autobiographical, even when the subject is seemingly far removed from the artist himself. For example, we know a lot about Eakins's relationship to the boxer he depicted in *Salutat* (pl. 2). Billy Smith, twenty-two years old when he first posed for Eakins, fought as a featherweight under the name Turkey Point Billy Smith.[21] The two men became lifelong friends, and according to Gordon Hendricks, Smith regularly visited and massaged the ailing, elderly artist, earning the gratitude of Eakins's wife and friends.[22] Yet the lightly built Smith was an unlikely star of

a boxing picture that itself was the obverse of what a boxing picture normally would be. Less than 120 pounds, more a boy than a man, Smith is not an obvious representative of the pugilistic tradition. He is also notably not boxing. Painted from the rear in scanty boxing trunks, Smith was transposed by Eakins from an emblem of masculine aggression to the passive object of display, in some sense the polar obverse of George Bellows's strategy in *Stag at Sharkey's*. In the all-male environs of a boxing match—women were not allowed entrance—men were always on display for other men, but the brutality of the sport banished any untoward resonances to that fact (fig. 5). Here, absent the competition, which normally permits the visual consumption of the lithe bodies of well-built young men, boxing succumbs transparently to the homosocial gaze. In *Salutat*, men of all sorts stare at Billy, and we stare at them, and at him, and at them staring at him. More curious still, this ephebic youth faces away from us, a portrait from the rear, the white orbs of his naked buttocks transformed into the still center of a remarkably coherent spiral of sight lines.

But it is in *The Gross Clinic*, perhaps more than any other work, in which Eakins invents a homosocial iconography in advance of the advent of the homosexual. A portrait of the eminent eponymous surgeon, *The Gross Clinic* is notable as well for the undefined gender of its ostensible subject, a seventeen-year-old youth arrayed on his side, with his buttocks facing the viewer. This curious posture, along with the youth's androgyny, has been interpreted as amplifying the authoritative power of the surgeon, doubtless already the profound focus of this enormous painting. But the particulars of the incision in the boy's leg offer still another prospect; the boy bears a long red slit along his thigh, a labial opening pulled apart by retractors. (Ever the realist, Eakins based the painting on an actual operation he had witnessed, in which a segment of diseased bone was removed from a youth's upper leg.) In classical mythology, a subject Eakins knew intimately, such a thigh wound is also the site of male nativity, as in Zeus' birthing of Dionysius. Dr. Gross, who himself helped birth the then-new field of surgery, was just such a male generative figure, and thus this wound does double duty as the symbolic site of a classically conceived act of male birthing as well, the gender play of such an act amplified by the "available" buttocks of the youth.

As with *Swimming* and *The Gross Clinic*, in *Salutat* Eakins also found a subject that made the visual contemplation of the young male body socially acceptable. Like Whitman's paean to

a particular vision of America, a democracy of desire that respected neither limits nor boundaries, Eakins's work is neither an evocation of a singular erotic perspective nor a missive to the like-minded. How could it be when the parameters of that identity had yet to even emerge? Rather, like Whitman, Eakins generalizes desire, implicating the viewer as he implicated himself in a dissident eroticism that recognizes beauty in the male body as the female, and more dangerously still, recognizes the capacity for that body to incite desire without regard to gender. Here, men are not just desiring, but themselves desirable, the object of the gaze and not just its generator. And this still proves sufficiently shocking, sufficiently disturbing, that today, more than 120 years after these images were created, we continue to try to contain and recuperate their threat to our notion of masculinity by marking them off as "gay."

In contrast to Eakins, J. C. Leyendecker passed easily and undetected through the highest levels of business and social life, although the homosocial universe of his work seems strikingly obvious today. Partnered with the man who was also his chief model, Leyendecker grew famous for his invention of that early advertising icon, the Arrow shirt man. A commercial illustrator, perhaps the leading such figure of his day, Leyendecker had an audience that was exponentially vaster than Eakins's. Yet in his *Saturday Evening Post* covers and his numerous advertisements for Arrow shirts, Leyendecker never seems to prod an anxious masculinity, instead reifying that comfortable homosociality—like the Yale Club of old—premised on the exclusion of women. In part, his work evaded the controversies that haunted Eakins because, through its focus on homosociality ahead of homoeroticism, it seems far removed from the older painter's dissident and dangerously seductive eroticism (pl. 6).

F. Holland Day, too, was far less controversial in his time than Eakins, despite the fact that as a photographer, his images of nude male youths were necessarily far more sexually explicit. In part, this is because Day, like his then-great rival Alfred Stieglitz, was a pictorialist, interested in lending his medium the gauzy, expressive distortions more common to painting than photography. Using double exposures, out-of-focus lenses, darkroom manipulation, and other manual means, Day's photographs make their subjects over into types and generalities, often in the process expressly quoting key themes from Western art—most famously in a series of crucifixions figuring the photographer as (an occasionally nude) Jesus.

Independently wealthy, Day was not dependent on the art market, though in his time he was a significant critical and commercial success. He founded and directed a publishing house, Copeland and Day, which offered some of the most controversial European fare for the American market, including printing Oscar Wilde's *Salome*. He photographed one of the earliest campaigners for what we would call gay rights, the English writer Edward Carpenter, as well as numerous youths, many of them black or Arab, often naked, including a series of photographs starting at age thirteen of a talented and handsome Lebanese youth, Kahlil Gibran. But what enabled Day's images to escape controversy was not simply their gauzy pictorialism, but the fact that they traded self-consciously in the then-familiar trope of Orientalism.

Orientalism was a nineteenth-century style that displaced sensuality and erotic promise onto a Western construction of the East. Especially prominent in French painting of the latter half of the nineteenth century, the numerous harem, market, and slave scenes generally offered the fantasy of unlimited erotic fulfillment, enabled by the doubled social and cultural marginality of its erotic object, women of the East. This Romantic Orientalism had begun to wane by the1890s in favor of a more ethnographic Orientalism, for Romantic myths were harder to maintain in the face of increasing firsthand contact. Yet Day's Orientalism was of the earlier, Romantic strain. Along with an entire generation of male photographers of the male nude, Day, seeking models to represent same-sex desire, found Romantic Orientalism's constructions exactly to his liking.

Day's Orientalism is an admixture of the traditional eastern prototype of harem-like availability intermingled with numerous classicizing elements. In making use of togas, Greek mythology, and other elements of the classical past, he and other photographers were self-consciously importing the widespread perception of the classical world's sanction of same-sex desire into the standard (and almost always heterosexual) Orientalist vocabulary. In merging the classical and the oriental, photographers like Day were literally inventing a language of same-sex eroticism suitable for a fine-art context. The very historicist and fantastic quality of these pictorial romances, as in Day's *Orpheus* series, enabled an expressly homoerotic content to pass under the radar, for it was deemed appropriate—historically and thematically—to its subject matter.

Winslow Homer and John Singer Sargent, too, let racial differences whitewash homoerotic desire. Indeed, for a segment of the American art world of the late nineteenth and early twentieth century, the representation of black subjects

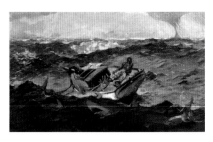

Fig. 6 / *The Gulf Stream* by Winslow Homer (1836–1910), oil on canvas, 1899. The Metropolitan Museum of Art New York City; Catharine Lorillard Wolfe Collection, Wolfe Fund, 1906 (06.1234)

Fig. 6 / Detail

by white artists constitutes a kind of American Orientalism, not least because these images of blacks are often notably distinct from their images of whites—far more sensuous and loosely handled, with the subjects often partially or completely unclothed. Homer, the buttoned-up painter of the northern New England coast, never shows skin unless it's black. In comparison with such prim and protestant paintings as *Undertow*, his black figure in *Gulf Stream* is practically licentious. In *Undertow*, two powerfully built men frame the two rescued women who seem more interested in holding on to each other than their rescuers. The men, in turn, avoid looking at and touching the women, emblematic of Homer's repeated segregation of the sexes in his work. Homer paints men and he paints women, but they are almost never in contact or conversation, even when both sexes occupy one painting, as here. Tellingly, when *Undertow* was first exhibited, a critic who had previously seen the unfinished work in Homer's studio described the woman to the left as a male youth. It's a logical mistake, given her muscular arms and the way gendered characteristics like breasts and hair are seemingly so casually, yet carefully obscured.

By contrast, in *Gulf Stream*, a black, shirtless male odalisque—the reclining figure traditional to representations of eroticized women—anchors the composition, the still center of a swirling gamut of lethal dangers (fig. 6). Indeed, this handsome youth seems to have not a care in the world, though his boat's mast is broken, sea spouts are rising, and the turbulent waves are roiling with sharks. A rescue ship is clearly visible to us in the left background, but he doesn't look for it, nor does it see it, and in no way does he seem invested in attracting attention to himself. Amidst all these lethally overdetermined dangers, his fate is sealed. If indeed this lackadaisical youth is the object of erotic desire, has Homer placed numerous obstacles in his own way, surrounding desire with danger? Of course, we can't know the validity of any such psychoanalytic frame, but we do know that Homer can be said to have replicated this self-isolating dynamic in his own life. The Boston-born Homer, who never married, similarly secluded himself in the coastal wilds of Prouts Neck, Maine, far from the erotic possibilities of the big cities like New York, where he once lived.[23]

In a similar vein, it would be hard to imagine that the bald eroticism of John Singer Sargent's *Nude Study of Thomas E. McKeller* (Museum of Fine Arts, Boston) would have been acceptable had the model been white. McKeller, who posed

for Sargent during his work on the murals for the Museum of Fine Arts in Boston, was an elevator operator whom Sargent noticed one day at the newly opened Copley Plaza Hotel.[24] Not intended for public showing, the study was made for Sargent's own pleasure and sequestered in his studio. Apparently painted there as well, the spread-eagled, frontal nudity is most unusual for the time, with no overlay of myth or narrative to justify the provocative pose. Sargent's *Nude Male Standing* (pl. 3) is a more chaste version of the same young man.

In contrast, an upper-class white young man posing for Sargent, W. Graham Robertson, penned an account of what it was like sitting for the artist and in his telling, Sargent is a model of repression and decorum (fig. 7). The man in question was twenty-eight years of age when he was asked to sit, having met the artist when he accompanied his mother during her own sittings. Robertson was himself a painter and a gifted raconteur, and in his narrative of the making of portrait, published almost forty years later, in 1931, he does his best to drop as many hints as he possibly can about Sargent's sexuality without ever having to name it.[25]

Robertson arrives at the studio at the duly appointed hour, and Sargent decided to pose him dressed in a heavy winter coat in the midst of summer. With a mock ingeniousness, Robertson wonders, "Why a very thin boy (I then looked no more) in a very tight coat should have struck him as a subject worthy of treatment I never discovered." Robertson then goes on narrate how he came to faint in the midst of posing, and his tale is so littered with raised eyebrows and broad allusions to homosexuality as to make it comic:

I had been standing for over an hour and saw no reason why I should not go on for another hour, when I became aware of what seemed a cold wind blowing in my face accompanied by a curious "going" at the knees.

I tried to ask for a rest, but found that my lips were frozen stiff and refused to move. Hundreds of years passed—I suppose about twenty seconds.

Sargent glanced at me. "What a horrid light there is just now," he remarked. "A sort of green—" He looked more steadily. "Why, it's you!" he cried, and seizing me by the collar, rushed me into the street, where he propped me up against the door-post. It was a pity that Oscar Wilde opposite was not looking out of the window: the wonderful possibilities of Tite Street were yet unexhausted.[26]

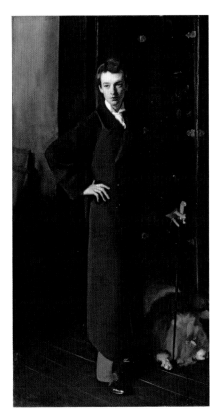

Fig. 7 / *Portrait of W. Graham Robertson* by John Singer Sargent (1856–1925), oil on canvas, 1894. Tate Gallery, London, England

The older artist holding the thin blond boy by the collar against the doorpost is made to immediately reference Oscar Wilde, who lived across the street. Even in 1931, this was an entirely legible use of code.

The photographer Berenice Abbott, born a generation after Day, offered no overlays of history, myth, or romance to justify her early work's attention to the often strikingly visible (at least compared to the United States at the time) lesbian culture of Paris, itself heavily peopled by her fellow expatriates. In fact, Abbott's Paris works, such as her arresting portrait of the American-born writer and journalist Janet Flanner, are notable for their early striving toward the creation of a public iconography of queerness, politicized where Day was pictorialized, overt where Day was encoded. Paradoxically, any overt manifestation of lesbian desire had to avoid sexual explicitness if it was to remain exclusively keyed to women, as in Cecil Beaton's sensitive portrait of Getrude Stein and Alice B. Toklas (pl. 20), which paradoxically separates the lovers to establish their intimacy. Images of women touching or otherwise in contact run two polar risks: in a culture all too willing to avoid seeing lesbian desire, women who touch each other can be taken as merely family or friends, and yet at the same time they can also be taken as feeding the heterosexual male erotic gaze. Beaton's careful use of distance here acknowledges the prospect of the image's multiple misreadings. A gay man, Beaton was sensitive to the manifold misfires in the representation of female intimacy. But he is also separating Stein and Toklas according to hierarchical ranking. Stein is the focus of interest, and Toklas her support, a status evident to this day on their shared tombstone, which is graced with Stein's name on the front and Toklas's on the back.

In Abbott's portrait of Janet Flanner (pl. 17), she, too, tenders an explicit resistance to colonization by the heterosexual male gaze at a historical moment when that gaze was unaccustomed to challenge. Abbott's *Flanner* is a woman who has no interest in the usual accoutrements of femininity and publicly declares her refusal to either hide or apologize for that fact. She stares out at us implacably, her handsome head offset by two fingers cocked at her ear, as if anticipating a rejoinder to her candid self-presentation. She's dressed quite mannishly, with necktie, cufflinks, and top hat, while the traditional signs of her gender—hair, breasts, and figure—are carefully, deliberately obscured. On her top hat, she wears a visual riddle: two masks, one black, one white, neither doing what masks are supposed to do, namely obscuring her identity. On the contrary, it's the masks that make her memorable. With her steady gaze and dark eyes, Flanner challenges and provokes, returning our stare—the obverse of the stereotypical coy, bashful female portrait. A portrait with masks has become an unmasking.

This portrait joined a veritable pantheon of lesbian artists and writers—figures Abbott seems to have deliberately sought to chronicle—in then-bustling expatriate Paris. Her glamorous *Djuna Barnes* (pl. 16) is similarly charged, but inhabits a more traditional New Woman iconography, combining lipstick and mannish tailoring in an image of glamorous femininity. Barnes was the author of, among other works, *Ladies Almanack* and the novel *Nightwood*. The former was a thinly veiled satire of expatriate lesbian Paris, counting Janet Flanner and Natalie Barney among a host of other recognizable caricatures. *Nightwood*, widely considered her master work, is a poetic novel of misconnections in love—homosexual and heterosexual. In this portrait, Barnes appears very much the femme, in contrast to Abbott's very butch portrait of Flanner. Taken together, the photographs underscore Abbott's commitment to the pictorial chronicling of the dominant butch/femme social organization of Paris, several years before Brassaï's well-known book *Paris by Night* (1933), which included numerous celebrated photos of Paris's lesbian club Le Monocle.

But over the course of a long and celebrated career, there came to be two Abbotts, and they don't meet. After Paris, Abbott would become famous for her studies of New York in light and shadow, her photographs of an iconic city of skyscrapers and immigrant Jews on the Lower East Side. Her earlier photographic provocations taken in Paris were not to be repeated. In comparison to the aggressive refuting of social norms within the Paris portraits, the New York work can seem formal, even diffident. After Paris, she would never again use sexual dissidence as a theme. Long after the lesbian and gay liberation movement had won some impressive victories, Abbott angrily denounced any attempt to read her work according to lesbian tropes, telling the artist Kaucyila Brooke, "I am a photographer, not a lesbian."[27] Abbott, who lived intimately with women her entire life, can thus seem, at least in the present circumstance, to be a conflicted figure, despite her early work. Of course, Abbott's refusal of the term "lesbian" was perhaps also

Fig. 8 / On "That" Street by Charles Demuth (1883–1935), watercolor over graphite on cream laid paper, laid down on ivory board, 1932. The Art Institute of Chicago, Illinois; gift of Georgia O'Keeffe for the Alfred Stieglitz Collection (1949.528)

Fig. 9 / Distinguished Air by Charles Demuth (1883–1935), watercolor and graphite on paper, 1930. Whitney Museum of American Art, New York City; purchase, with funds from the Friends of the Whitney Museum of American Art and Charles Simon 68.16

animated by the fear that her work would assume significance only as a subcultural document, or, to paraphrase a weary metaphor, that she would become merely a great lesbian photographer. But one of the threads of this book is the repeated discovery that an artist's earliest work is often freer in the figuration of same-sex desire: after the artist tastes fame and the market takes an interest, frank homoeroticism often recedes. Agnes Martin, Andy Warhol, and even Robert Rauschenberg much more explicitly frame their sexuality at the beginning of their careers.

Berenice Abbott's pictorial evocation of an open lesbian subculture in Paris of the 1920s finds a parallel in Charles Demuth's New York of a decade earlier. His c. 1918 watercolor Cabaret Interior with Carl Van Vechten (pl. 9), highlights a teeming urban subculture a mere two decades after the first coinage of the word "homosexual" in English. Like many of Demuth's watercolors drawn from the city's queer subculture, the portrait would have been meaningful only among a cohort of friends who would have understood and enjoyed its many internal references. The eponymous protagonist Carl Van Vechten, who would subsequently achieve fame and notoriety as a photographer and chronicler of the Harlem Renaissance, is here mildly caricatured as a camp poseur gossiping as sailors dance together. The figure in brown with his back to us is Demuth himself, his presence a repeated motif in these images. Even the red bird in the cage behind Van Vechten could be symbolic, though that prospect is hardly definitive. We do know that the so-called Bird Circuit, a clutch of gay bars titled with bird's names, was found in Midtown Manhattan around Third Avenue starting in the 1940s—bars like the Blue Parrot, the Golden Pheasant, and the Swan. It's likely that the "bird" code began even earlier, with a possible derivation from such slang as "he's a queer bird." But more than anything else, Cabaret Interior with Carl Van Vechten draws its impact from the figuration of a subculture; it is in every sense of the word an interior scene, a place segregated from the larger world with its own, very different social codes.

Unlike that circumscribed interior scene, Demuth's subsequent On "That" Street (fig. 8) opens a rare window onto the elaborate choreography of public gay male sexual culture. Again, Demuth represents himself as the brown-coated figure with his back to us. (A childhood injury made one leg slightly shorter than the other, and he generally gives himself a walking stick and contrapposto posture.) The title reference would have been immediately identifiable as a certain street near the Brooklyn Navy Yards where sailors

on shore leave would congregate to meet the men who might take them in, feed them, and perhaps pay them for their company. But Demuth here offers a small-scale dissection of the conventions of this sexual culture, further evidence of the way pictures can encode historical content that simply does not survive in the written record. The sailor on the right is "trade," a masculine figure who, like the beefy man in Bellows's Shower Bath, would have been understood as a top, erotically in sync with his gender. The other sailor, with his hands-on-hip swishy stance, is clearly queer, and Demuth (whose hands-on-hip stance mirrors the queer sailor's) freely implicates himself in this scene of sexual adventure, looking askance at his fellow queer as both compete for the attention of the trade. This is not the way it's supposed to work, the watercolor seems to suggest, as an annoyed Demuth peers down his nose at the younger queen insistently interrupting his sexual conquest with an offer of his own that presumably can include neither money nor housing.

In fact, the competition for sexual favors is a leitmotif of Demuth's self-representation, and he often represents himself as sadly outgunned by the competition. But sexual disappointment would pale in importance to the frustrating search for love. The highly instrumental queer/trade dynamic essentially enabled the relatively easy procurement of sex with a range of men, but militated against the prospect of emotional engagement, much less love. Demuth even wrote an unpublished short story called "Some Unknown Thing" about these frustrations and the attendant loneliness that a lack of emotional support engendered. In the story, he has his protagonist, after witnessing couples kissing in the moonlight on the deck of a ship, fulminate against this "unknown thing" that keeps him from experiencing the emotional sustenance and deep human connection others merely assume.[28] His watercolors such as Distinguished Air (fig. 9) are more than tallies of libidinal frustration; they also caricature the absence of a deep connection, even among those already coupled. Distinguished Air is a sharp satire of the frustrations of modern art, both conceptual and sexual. A veritable circuit of displacements and dissatisfactions, Distinguished Air pictures the brown-suited, becaned Demuth stand-in, who may be partnered with a woman, but whose gaze nonetheless wanders to the sailor's groin. The sailor in turn stands arm-in-arm with a man, but his gaze takes in the lone woman to the right, whose open fan, in turn, at once articulates and forecloses her genitalia as she stares warily at the Brancusi-like phallic sculpture that inspired this scene of

sexual hunger and its inarticulate frustration on the shores of social propriety and economic need. Inspired by an eponymous group of three short stories by the gay writer Robert McAlmon about Weimar Berlin, and featuring an openly gay expatriate artist among the characters, *Distinguished Air*—both in its narrative and pictorial form—tellingly conflates modernity and homosexuality.[29]

So pervasive was the sense that Demuth's art drew its impact, for better and for worse, from his sexuality, that his critics worked hard to frame his pictorial style in terms of the negative consequences of same-sex desire—one of the very first instances of the imposition of a homophobic critical frame over an artist, in what would be a continuing saga throughout the twentieth century. As early as 1917, Willard Huntington Wright chose his words carefully to imply a parallel between a widespread perceptions of homosexual effeminacy and Demuth's thinly painted, delicate images, arguing that his "water-colours possess a delicacy of colour, a nervousness, a lightness, and occasionally a sensitivity of line. . . . It reveals in the artist a contentment with his tricks and mannerisms and a lack of striving for more solid and masculine attributes."[30] Even Demuth's friend Marsden Hartley was not above such tactics, and in his memorial text to the painter he joined the chorus lamenting his "delicacy." This "delicacy" is surprising given the highly material, even base, stuff of his art. From factory buildings to still-lifes to sex scenes on the beach, Demuth was interested in the material world—so much so that his eventual dealer, Alfred Stieglitz, was not a particularly strong partisan of Demuth in large measure because his work seemed so uninterested in the spiritual or transcendental impulses that animated the work of the dealer's favorites, such as Hartley and Georgia O'Keeffe.[31]

In one celebrated group of works, the so-called Poster Portraits, Demuth replicated the conditions of delimited circulation and legibility that structured his more private watercolors, albeit in larger scale, with very public finished paintings. The Poster Portraits are widely considered not only Demuth's greatest works, but among the greatest American paintings of the period. Yet for all their grand formal mastery, when the executor of his will, his friend Georgia O'Keeffe, decided to donate his work to major institutions, she gave the Poster Portraits to a library, along with Alfred Stieglitz's correspondence, and not to an art museum per se, precisely because she deemed them to be the pictorial equivalent of letters. Like the watercolors, the Poster Portraits were written in a kind of pictorial code legible only to Demuth's intimates. The

sketch for a never-completed Poster Portrait of his colleague Marsden Hartley (pl. 11), for example, features Hartley's signature lapel flower, a gardenia, as well as a rude jab at Hartley's tendency to work into a conversation some reference to the prodigious size of his penis, here made evident through the representation of an anthurium blossom with an exaggeratedly long and baroque stamen.

It is hard to overstress how insular and interconnected the modern art world in America was at the time. Stieglitz and his galleries served as the organizational headquarters, and Demuth befriended the key figures of American modernism, including not only artists like O'Keeffe and Hartley, but Marcel Duchamp, with whom he used to visit New York's nightlife; poet William Carlos Williams; critic Henry McBride; Carl Van Vechten; Gertrude Stein; and the Stettheimer sisters, whose New York salon rivaled Stein's in Paris. This circle of friends, all boldfaced names in American culture, would not be equaled in subsequent prominence and influence until the development of a similar circle in Coentes Slip in the 1950s. Both circles were notably same-sex inclined and both tended, with the clear exception of Demuth, to avoid explicit self-identification as queer—even Van Vechten was in a marriage of convenience. But Demuth was as "out" as the early twentieth century enabled, and as we've seen, since queerness was associated with gender cross-identification, he was framed as effeminate and delicate. It remains for further study to understand why so often such affiliated groups embrace one figure who comes to embody the disparaged queer identity—Warhol served a similar function for the postwar avant-garde—thus allowing the other same-sex-inclined figures to assume a variant on social normativity.

Demuth's friend and rival Marsden Hartley often portrayed the men in his life through a symbolic language as well, though, as with many of the other facets of his life, he would publicly deny it. Of the repeated deployment of a language of symbols in his paintings, Hartley once wrote, "The forms are only those which I have observed casually from day to day. There is no hidden symbolism whatsoever in them; there is no slight intention of that anywhere. Things under observation, just pictures of any day, any hour. I have expressed only what I have seen."[32] Despite his recitation of a realist creed, Hartley was powered by a metaphysical disposition that seems an unlikely merger between American transcendentalism in an Emersonian vein and a deep Catholic faith. Hartley worked hard in his art to transmute suffering into salvation, and he

Fig. 10 / *Portrait of a German Officer* by Marsden Hartley (1877–1943), oil on canvas, 1914. The Metropolitan Museum of Art, New York City; Alfred Stieglitz Collection, 1949 (49.70.42)

Fig. 11 / *Christ Held by Half-Naked Men* by Marsden Hartley (1877–1943), oil on fiberboard, 1940–41. Hirshhorn Museum and Sculpture Garden, Smithsonian Institution, Washington, D.C.

sought to achieve in paint a transcendent peace repeatedly denied him on earth. Indeed, death was often the trigger for Hartley's development of unprecedented modes of portraiture as he sought to transform the loss of a loved one into a renewed pictorial presence.

Among the earliest abstractions in American art, Hartley's so-called German Officer Paintings were initially understood in exclusively formal terms (fig. 10). Hartley had gone to Berlin for many of the same reasons that lesbian artists had gone to Paris—the much less repressive social culture. In 1897, a prominent group of citizens, including the physician and sexuality researcher Magnus Hirschfeld, banded together to form the Scientific Humanitarian Committee, which set out to decriminalize homosexuality by making sexual freedom a *cause célèbre*. A year later, Berlin would become the seat of the world's first modern gay-rights movement, and although the measure failed in the Reichstag that year, it would be routinely brought for a vote until the dawn of the Nazi era, each time garnering more support. This heady, newly assertive gay movement would change the face of German society— and make it a worldwide magnet for disaffected men like Hartley.[33]

But as World War I made an ally into an enemy, Hartley's life in Berlin grew increasingly difficult. The devastating death early on of Lieutenant Karl von Freyburg, who may have been his lover, proved a powerful incentive toward the development of Hartley's new pictorial language. Because the object of his affection was a man and an enemy combatant, Hartley was not free to express his mourning. *Painting No. 47, Berlin* (pl. 5) thus constitutes a landmark instance of what would become a leitmotif in the development of queer American portraiture: the self-conscious creation of a bifurcated pictorial language, at once public and private, similar to Demuth's in the Poster Portraits but even more abstracted and symbolic. To the public, a work like *Painting No. 47* was simply an abstraction (and because of its clearly Germanic military flavor, not initially well received in the United States), but to Hartley and probably to his closest friends, the painting was redolent of von Freyburg's life and death, featuring his initials, his regiment number, his age at death, the iron cross he was awarded, the spurs of his cavalry boots, and various regimental flags and insignia. These symbols assume the rough shape of a human figure, topped by a German cavalry helmet. Above the helmet is a wagon-wheel–like form, Hartley's symbol of the heavens, and a saintly halo, as if to convince himself of, or console himself with, von Freyburg's ascension.

Again and again, Hartley paints portraits of key figures in his life only after their death. *Eight Bells Folly: Memorial to Hart Crane* (pl. 31) notes not only the temporal measure of Crane's then-recent shipboard suicide (in nautical time, eight bells is noon), but the poet's death at age of thirty-three (like a secular Christ) and, yet again, the fervent hope for his Christlike ascension amid the heavenly stars. But the most compelling aspect of the painting is its numerology: eight eyes in the water join the numeral 8 and the eight bells in the title to form a meditation on that number. Eight means many things to Hartley: as the visual representation of infinity, it bespeaks transcendence; Hartley reports that eight-pointed stars were everywhere under the German Kaiser; and under Catholic dogma, Christ enters Jerusalem on the eighth day (fig. 11). But it is the eight eyes in the water that are most haunting. They bespeak other watery suicides, an oblique commentary on the senseless death of a great poet, who was about to be forced into a marriage he did not want. While Hartley was notably mute on the symbols of the German Officer Paintings— presumably because they directly referenced his relationship to von Freyburg—he wrote a letter detailing the symbolic code of *Eight Bells Folly* even before the painting was finished.[34]

Both Hartley and Demuth were friendly with the pioneering Dada artist Marcel Duchamp. Theorist, trickster, celebrity, and inventor, the handsome and dandyish French-born artist was an unambitious leader of the American avant-garde. Notably unhomophobic, Duchamp was an early habitué of New York's drag clubs and would in time stalwartly defend the vitality of gay artists in the face of homophobic slurs by Frank Lloyd Wright at the Western Roundtable of Modern Art in 1949.[35] Though romantically involved exclusively with women, in 1920 Duchamp donned female clothing and, working to uncouple the presumptive and automatic identification of an artist with his or her work, invented a female alter ego, Rrose Sélavy—a name that stands as a rough approximation of the French for "Eros is life." Man Ray famously photographed Rrose Sélavy, and it would be hard to overstate the import of this completely open gender subversion by one of the most celebrated artists in the United States at the time. Of course, this gender play was but one aspect of a larger goal, namely to subvert the overwhelming graphic emphasis of so much recent abstraction in favor of a more cognitive art that took seriously the philosophical problems that tried to undo any clear boundary between reality and representation. (Abstract art was new in America at the time,

Fig. 12 / *Portrait of Marcel Duchamp* by Florine Stettheimer (1871–1944), oil on canvas, 1923. William Kelly Simpson

in no small measure through the good offices of Duchamp himself.) But the spirit of this investigation was playful, experimental, and even joyous. It was always alive to the erotic, not simply as a sequestered bodily pleasure, but as a conceptual goal, a frame of mind in approaching life. It is no wonder he subsequently became the patron saint of a number of gay artists, for he authorized a recognition that a dissident and innovative art was not incidental to a dissident identity.

Indeed, it was just this kind of progressive, questioning, playful spirit that endeared Duchamp to a number of the artists who frequented a salon hosted by the Stettheimer sisters—especially its two dominant voices, Florine and Ettie Stettheimer—daughters of a wealthy and highly cultured German-Jewish New York family. Florine Stettheimer was a painter of great originality whose sophisticated canvases wear an air of naiveté lightly, making more palatable their highly knowing and often implicitly eroticized who's who of the American avant-garde before World War II. Portraiture was her chief, though not exclusive, métier, and Stettheimer's portraits often effeminize her male sitters and masculinize her women. Indeed, herself something of an erotic cipher, she seems to have cultivated a deliberate gender ambiguity in her work.

This refusal to declare herself as either a lesbian or not was no stratagem of the closet; on the contrary, it made her sexual dissidence unusually visible and textured. No surprise then, that she similarly obfuscates her pictorial subjects. Her work and her life remind us that the obverse of heterosexual need not be homosexual, and that the most visible resistance to gender norms can be a universal androgyny, where male and female meet somewhere in the middle.

Stettheimer's fey subjects, such as Carl Van Vechten, seem only too happy to be portrayed as if gender and sexual dissidence are but aspects of a larger aesthetic refinement, as if to be avant-garde was not merely a pictorial style, but a personal one as well. It therefore comes as no surprise to discover that Stettheimer made multiple portraits of that artist who had earlier, and very publicly, adopted a female alter ego, Marcel Duchamp. In one of these portraits (fig. 12), Duchamp is seated opposite Rrose Sélavy, who wears a pink jumpsuit. As he sits in an armchair imprinted with his initials, he controls a turning rod that seems to govern how far Rrose—already seated on a spring-loaded stool higher than Marcel—may ultimately rise. In another remarkable portrait, Duchamp is pictured as a severed, disembodied head, radiant in the light, with ruby-

red lips and a delicate bone structure (pl. 15). Absent that irrefutable guarantor of gender—a body—Duchamp seems pure immanence.

Pansies and bull daggers—effeminate men and masculine women—were only the most visible segment of a population that was growing increasingly articulate and assertive throughout the 1920s and into the 1930s. This increase in queer visibility was of a piece with the new prominence of women and African Americans following the dislocations of World War I. The wartime necessity of replacing millions of working men fighting in Europe changed the face of American industry and fostered new and greater social mobility that led to the rise of women's suffrage and the New Woman and, with the great migration of blacks northward, a new cultural assertiveness on the part of African Americans.[36] Out of this more optimistic historical moment, suffused with what seemed to be the first glimmers of that long-hoped-for racial, gender, and sexual equality, arose what came to be called the Harlem Renaissance—or, as it was also known at the time, the New Negro movement. Within this movement, three newly assertive populations—African Americans, women, and queers—hardly operated discretely. For example A'Lelia Walker, the millionaire heiress of a hair-straightener fortune, and by all accounts the defining host (and occasional patron) of Harlem culture, was all three. Alain Locke, a senior scholar and the editor of the *New Negro Anthology* was homosexual as well. Locke in turn encouraged and published many of the other key figures of the New Negro movement, most of whom were also gay or bisexual, including Langston Hughes, Wallace Thurman, Countee Cullen, Claude McKay, and Richard Bruce Nugent. The latter was the author of what was probably the first openly gay text written by an African American, the short story "Sadhji," published in Locke's anthology, as well as the better known, and far more assertively gay, veiled self-portrait "Smoke, Lilies and Jade," published a year later. Nugent's remarkable illustrations for these and other writings were also widely published.

But this literary culture varied widely in its degree of sexual openness, and figures like Langston Hughes were almost completely closeted. The same was not true of the more popular arts, music chief among them. When blues great Ma Rainey, for example, was arrested in 1925 after hosting a lesbian orgy, she subsequently released a record entitled "Prove It on Me Blues," which took her arrest as its selling point

(pl. 22). Deliberately seeking to court controversy over her sexuality, advertisements for the record were illustrated with images of a stout, mannishly dressed middle-aged woman—clearly Rainey— talking to two younger, svelte, and stylishly dressed women while a policeman looked on. The ad copy read, "What's all this? Scandal?" and the song began, "Went out last night with a crowd of my friends. They must have been women, 'cause I don't like no men. It's true I wear a collar and a tie. . . . They say I do it, ain't nobody caught me, Y'all got to prove it on me."[37] Rainey was hardly the only blues great to address her sexuality in song. George Hannah, possessed of a high-pitched voice, sang titles like Sissy Man Blues and Freakish Man Blues. Bessie Jackson sang the overt "B.D. Woman's Blues," in which B.D. stood for Bull Dagger. Hannah even recorded a song about lesbian cunnilingus under the thinly veiled allusive title, "Boy in the Boat."

Yet for all this cultural ferment, in some sense the term Harlem Renaissance is a misnomer, for it seems to suggest that Harlem was culturally dead and then came back to life. In fact, what really changed was that dominant white America finally started to attend to black culture. Two in-terrelated factors helped spur widespread recognition of what was going on in Harlem. One was Prohibition (1920–33), which succeeded in closing bars and dance clubs in white areas, but in a familiar pattern, permitted them to flourish— often by paying protection to the police—in black neighborhoods like Harlem. Many white citizens first came to Harlem during Prohibition, crossing a profound racial divide that made Harlem essentially a black city in the midst of a white one. There, they first encountered Harlem's person-alities, social mores, and ar-tistic culture.

The second, interrelated factor was that the culture these white tourists found in Harlem was notably more tolerant of sexual difference, giving many whites their first taste of an unashamed, well-integrated queer culture. Ruby Smith, blues great Bessie Smith's niece, recounts her experiences of the buffet flats at the time. Buffet flats were essentially bawdy houses with live sex shows. They were called buffet flats because every thing was on offer, and, like a buffet, you could sample according to your tastes with no implicit judgment on what you did or didn't try. It was possible to encounter a male same-sex couple, a heterosexual couple, and female same-sex couple all performing next door to one another in no relation of priority. For white tourists, who were accustomed to finding the same-sex possibility sequestered from dominant culture—

on "that" street, as it were—such an attitude was revelatory. In venues like the Cotton Club, openly queer performers regularly entertained, and as the evening's entertainment was already in violation of the law under Prohibition, it encouraged a sexual openness unavailable in other parts of the city.[38]

Harlem therefore became the center of many white homosexuals' existence. Carl Van Vechten, who was first a music and dance critic, then a novelist, and finally a photographer, was perhaps the most notable white popularizer of Harlem. His first novel, *Peter Whiffle: His Life and Works*, published in 1922, was a remarkably gay and quite campy narrative of an aimless, dissolute young man.[39] Four years later, in 1926, Van Vechten wrote a novel that alienated some of the most prominent figures in Harlem by virtue of its title, *Nigger Heaven*, and its depiction of Harlem as a sexual playground. Yet for Van Vechten and many other white queers, Harlem *was* a sexual playground, and its poverty, un- and under-employment, and racial tensions were less germane to their experience of the place than its erotic possibilities. Still, Van Vechten was unarguably a progressive. He was not only a generous patron to a number of black artists and writers, but he encouraged wealthy whites to support cultural work in Harlem. But when, in 1936, Romaine Brooks, no leftist herself, sought to pay tribute to Van Vechten in a portrait, she dressed him in an all-white suit like a colonial governor and posed him against a black background that slowly reveals itself to be a constellation of young men's faces, literally fading to black (pl. 24). For Van Vechten, who was often seen in the company of handsome young black men, this was doubtless intended as flattery.

Despite the controversy *Nigger Heaven* created— W.E.B. Du Bois railed against the book—Van Vechten's third and arguably greatest career was as court photographer of the Harlem Renaissance. Langston Hughes, Bessie Smith (pl. 25), and Bill (Bojangles) Robinson all sat for him, as did many other cultural gentry, within Harlem and without, especially gay and lesbian figures. Included in that group are the then very young writers James Baldwin, Truman Capote, and Gore Vidal, and the British ballet dancer Hugh Laing and his life partner, the choreographer and co-founder of the London Ballet, Antony Tudor, not so covertly holding hands (pl. 26). Still, some of the photographs play with many of the same racial stereotypes that sparked protest against *Nigger Heaven*. Like all forms of irony, they tend to cite precisely the social and cultural codes they

Fig. 13 / *Georgia O'Keeffe* by Alfred Stieglitz (1864–1946), palladium print, 1919. The Metropolitan Museum of Art, New York City; gift of Mrs. Alma Wertheim, 1928 (28.130.1)

then hope to undercut. In the image of Langston Hughes (pl. 23), for example, the great poet is posed next to a drawing that manages to make his race, not his poetry, its chief subject.

———

Georgia O'Keeffe's work has lent itself to discrete periodization: the early biomorphic abstractions, the great triumph of the famous flower paintings suffused with an erotic sensibility, and the highly formal compositions based on New York skyscrapers. These are followed by a move to New Mexico and O'Keeffe's iconic skull pictures, and finally succeeded by a range of desert landscapes. All these subjects are self-evidently O'Keeffe's in the seeming animation of the inanimate, but there the similarity, it is generally thought, ends. Yet this division of her oeuvre is deeply flawed by its inattention to a profound continuity that runs throughout almost all of her art, despite its differences in subject matter. Understanding that which unites and unifies her disparate periods allows us to approach the enduring fascination she continues to inspire as America's most celebrated female artist.

That modifier, "female," is neither an unselfconscious sexist holdover nor an irrelevance but in fact remains as central to our understanding of O'Keeffe's work today as it has been since her first showings at Alfred Stieglitz's 291 gallery. Photographer, gallerist, and tireless promoter of modern art in America, Stieglitz was in a position to advance O'Keeffe's career. And he aggressively promoted O'Keeffe as the emblematically female artist, having, it was reported, once said of her, "Finally, a woman on paper. A woman gives herself. The miracle has happened."[40] Despite the fact that very little of O'Keeffe's oeuvre was traditional portraiture, almost all of her work was thus made over into a self-portrait. Notably, Stieglitz's vision of womanhood was said to involve a woman offering herself, and that O'Keeffe would do in multiple ways: in pictorial terms, as well as by marrying Stieglitz and becoming his favorite photographic model. He was twenty-three years her senior, and they were lovers for six years before they married. Their relationship, however turbulent, was rooted in deep affection. Still, his writings and famous photographs of her nude body and its part-by-part relations, from hands to breast to thighs, have served to cement an image of O'Keeffe that is profoundly gendered (fig. 13). But that gendered vision would not have the defining impact it did were it not always abetted by O'Keeffe's own work, which similarly framed her artistic voice and vision in highly femi-

nized terms, recoverable not only as a gendered female, but a sexed female as well.

From the beginning, Stieglitz framed O'Keeffe's work as not simply as coterminous with her gender, but specifically with her anatomy.[41] As early as 1919, in his essay "Woman in Art," he wrote, "Woman feels the world differently than Man feels it. . . . The Woman receives the World through her Womb. That is the seat of her deepest feeling. Mind comes second."[42] In Stieglitz's circle, and American modernism generally, the rapid promotion of Freudian frames of reference contributed to this categorizing of intellect according to sexed characteristics. O'Keeffe was notable for abandoning a historically male pictorial vocabulary in favor of one that was deemed elementally female. With depressing regularity, O'Keeffe's biological sex was made to do the work that for men was instead clearly a function of intellect.[43] Initially, she seems to have acquiesced in this construction of her as elementally female and motivated by instinct: after all, she was celebrated and selling. But in time, she grew first weary and then actively offended by the construction of her art that her own husband was promoting. Her first rebellion was to paint the polar obverse of the abstractions and flowers that made her famous, New York's skyscrapers. No less biological, female, and womb-like subject could be found, and predictably, Stieglitz was opposed to this shift in her art.

The key problem, O'Keeffe came to feel, was with her flower paintings. Even someone she knew fairly well, her colleague Marsden Hartley, framed them "as living and shameless private documents as exist. . . . By shameless, I mean unqualified nakedness of statement."[44] There it was again, her flowers standing in for her sex—at once "naked" and "shameless." The flower paintings had been made autographic, instinctive, automatic, and utterly naturalized, as if she were a mere vessel through which "the female" signified—the example par excellence of Stieglitz's, "The Woman receives the World through her Womb. . . . Mind comes second." So O'Keeffe moved West, away from her husband and the fecund naturalism of her flower paintings and into the deserts of New Mexico, where, we are told, her work made a radical break and moved toward her now well-known imagery of the desert, of skulls and bones.

To be sure, the skull paintings have a very different purchase on the notion of nature and were indeed wholly new in O'Keeffe's oeuvre, but in no way do they represent a radical break in her work. On the contrary, with the advent of the desert imagery, O'Keeffe succeeded in finding a pictorial language for the female body that was

Fig. 14 / *Summer Days* by Georgia O'Keeffe (1887–1986), oil on canvas, 1936. Whitney Museum of American Art, New York City; gift of Calvin Klein (94.171)

illegible to what she referred to as "the men"— the critics and curators who had, until that point, framed her career.[45] The skull paintings were as resonant *to her* as were the flowers, and in the classic skull paintings, works like *Summer Days* (1936) (fig. 14), O'Keeffe hangs the skull vertically to reference the female sex, but in a way illegible to men. *Summer Days* can—like the flowers—be said to describe a woman's body, with the horns marking out her waist and hips and the skull itself a vagina, but now a vagina made dentate. O'Keeffe even painted flowers at the skull's opening, as if to draw a line between this new imagery and her earlier work. The over- all form of these skulls as she paints them floating vertically in the desert landscape is still broadly vaginal, but it has successfully escaped critical notice precisely because in being dead and dry, these skulls evade the generative and alluring qualities associated with female sexu- ality. And that is exactly as she intended it. An embodied femaleness identical to the flower paintings can be said to suffuse these desert works, but in being impenetrable, dry, dead, etc., they no longer worked to seduce a heterosexual male erotic, and thus no longer constructed O'Keeffe according to that erotic's logic. In these works, O'Keeffe finally found a way to represent the female body on her own terms. In other early skull paintings such as *Cow's Skull: Red, White and Blue* or *Mule Skull with Pink Poinset- tias,* the backgrounds morph into labial folds surround-ing the skull, centered on its opening. In a famous 1939 statement accompanying her exhibition at Stieglitz's An American Place and entitled "About Myself," O'Keeffe under- scores how self-conscious this turn to the desert was, and how gendered:

A flower is relatively small. Everyone has many associations with a flower—the idea of flowers. . . . Still—in a way—nobody sees a flower—really—it is so small—we haven't time. . . . So I said to myself— I'll paint what I see—what the flower is to me but I'll paint it big and they will be surprised into taking time to look at it. . . . Well—I made you take time to look at what I saw and when you took time to really notice my flower you hung all your associa- tions with flowers on my flower and you write about my flower as if I think and see what you think and see of the flower—and I don't.

Then addressing her move to the Southwest, she describes her response to the bones she found there:

To me they are as beautiful as anything I know. . . . To me they are strangely more living than the animals walking around. . . . The bones seem to cut sharply to the center of something that is keenly alive on the desert even tho' it is vast and empty and untouchable—and knows no kindness with all its beauty.[46]

These "living" bones thus become the means of a continuing exploration now keyed as much to evasion of one frame of reference (male) as it is to incitement of another—hers. And that's why, despite her long-term relationship with Stieglitz and several other men, there has been contin- uous debate about whether O'Keeffe also had female lovers. Scholars have made the identi- fication of her sexuality and the precise character of her relationship with Marie Chabot or Mable Dodge Luhan the subject of much historical contestation. These debates have left the picto- rial evidence largely unexplored, however. Whether or not O'Keeffe had sex with women, it is manifestly clear that she sought to develop a means of representing female bodies and female sexuality untouched by men—a vision, that is broadly lesbian, whether or not her sense of self followed suit.[47]

It is with O'Keeffe's great *Goat's Horn with Red* (pl. 35) that we see how powerfully dissident these desert pictures were, for here she takes the emblematically phallic icon, the ram's horn, and paints it as if seen up the middle of the spiral, converting its phallic protrusion into a volume marked with a menstrual red. When a large sculp- ture was commissioned, O'Keeffe chose *Goat's Horn with Red* and then blew it up gigantically. In a photograph taken during the sculpture's instal- lation at the San Francisco Museum of Modern Art, she had herself photographed at the age of eighty-three, standing proudly in the ram-horn's central void—a living symbol of a feminist contes- tation of phallic supremacy, originating decades before the word "feminism" even achieved cur- rency. No wonder, whatever her actual sexuality, she is at some level always made lesbian: like so many queer artists, O'Keeffe self-consciously developed a private language that allowed her to articulate things she did not want understood under the very nose of dominant culture. To organize a symbolic practice around voids, holes, and concavities in and of themselves, and not as receptacles for men, was to queer the world she had inherited.

In one of the most moving examples of the circulation of particular forms of knowledge within an inner circle of other gay artists, the photographer George Platt Lynes set up a portrait of Marsden Hartley (pl. 32) that would prove to be among the very last ones taken before his death. A weary looking Hartley slumps in his chair; his looming shadow merges with that of a young man behind him. That young man is Jonathan Tichenor, brother of George Tichenor, Lynes's studio assistant and possible lover. But George was killed in World War II, and in a highly emotional act of identification with the elder artist, Lynes photographs him so as to acknowledge—if only pictorially—their shared, if unspoken and highly private, loss of the men they loved across two world wars. Long before the art world realized the significance of the German Officer portraits, the queer world knew, as this photograph underscores.

Precocious, charming, and handsome, Lynes met Gertrude Stein in Paris before he turned eighteen. Entranced by her experimental writing, he decided to pursue a literary career. Upon returning to the United States at age twenty, he opened a progressive bookstore. Given a camera soon thereafter, he began taking portraits of friends and exhibiting them in the store. Soon he turned to photography full time, traveling to Europe with his new lovers, Glenway Wescott and Monroe Wheeler—themselves a couple—and through their good offices meeting a number of avant-garde European and expatriate artists along the way. After returning to the United States the second time, Lynes opened a photography studio in New York and was soon taking photos for *Vogue*, among other magazines, where he rose quickly to prominence. But still in his early thirties, he began to grow bored with fashion photography and increasingly devoted himself to "private" photographs, often male nudes, which are among the most revelatory images we have of gay male subjectivity in the years around World War II.

Above all, Lynes was a master of lighting and sightlines, and his photographs are often dense essays in the social and political ramifications of seeing and being seen. Even a simple self-portrait, taken in a mirror (as if one eye has been replaced by the camera's lens) is transformed into a complicated meditation on the construction of selfhood. In place of the traditional American notion of what the eminent sociologist David Riesman termed inner-directedness, Lynes realizes a vision of identity as always fully relational. Notably, he gives pictorial form to this realization more than a decade before scholars like Riesman and William Whyte (whose 1956 *The Orga-*

nization Man is the apotheosis of this literature) chronicle their "discovery" of a new American type. No longer consisting of the frontiersman-like "inner-directed" American characters of old, this new type was an "outer-directed" or "other-directed" individual, seemingly capable of achieving meaning only within the web of the social.[48] In photograph after photograph, Lynes realizes a vision that we become who we are through the act of being read or interpellated by others. As a homosexual, the way one was read by society, individually and collectively, often did not conform to one's sense of self. To be gay was to risk being continuously called out—at great personal danger—and thus it was immediately evident how little control one had over how one was read. In his self-portrait, we expect to find a composed image of the artist as he wishes to be seen but instead encounter him looking at us as—half camera, half man—materializing this relation of mutual recognition as the basis for identity. Of course, Lynes took the photograph by shooting himself in a mirror, and not surprisingly, mirrors become one of his favorite metaphors for this interpellative process, which we even refer to as "mirroring" in ordinary language.

Lynes's 1953 photograph of Ralph McWilliams (pl. 38) takes this mirroring yet further. Through the device of a damaged mirror, he begins to specify the distortions inherent in the process of recognition—and self-recognition—through the eyes of others in a homophobic society. In the photograph, we can't really see McWilliams directly, but are forced to see him as he sees himself, reflected in a mirror. But that mirror is scratched and worn, offering us a flawed, partial view of him. This evocation of a deeply damaged and distorted reflection easily slips into a metaphor for the terms under which the homosexual was perceived in a homophobic culture. No wonder then that Lynes was a favorite of sexological researcher Alfred Kinsey, who aggressively sought to acquire Lynes's photographs, albeit more as documentary than fine art. This happened at a historical moment when merely mailing such photographs would have been a federal crime punishable by a prison term, and may help explain why Lynes, who died of lung cancer at forty-eight, decided to destroy his own archive prior to his death. Thus much of what survives of his work is courtesy of friends, family, and the Kinsey Institute. Arguably the greatest gay photographer of midcentury America, Lynes never saw his sexuality-themed work—the bulk of his output during the last fifteen years of his life—publicly shown.[49]

Paul Cadmus is the subject of several of Lynes's best photographs, as Lynes would himself be portrayed—along with Wescott and Wheeler—in one of Cadmus's paintings. Cadmus and Lynes had a close rapport, in part premised on their intersecting social universe, shared models, and common involvement in romantic triads: Lynes, of course, with Wescott and Wheeler; and Cadmus's own long-term partner, Jared French, subsequently married a woman, Margaret Hoening. In one photograph, Cadmus is shown in the act of drawing alongside his partner French and their friend George Tooker, while in the Cadmus painting *Conversation Piece* (1940), Lynes, Wescott, and Wheeler are depicted on the lawn of Wescott's family home. The handsome, irrepressible Cadmus was controversial from the start, and an early canvas, *Fleet's In*, was removed from public display in 1934, ostensibly because of its unsavory representation of sailors on shore leave, but doubtless as well because of its inclusion of a homosexual pick-up scene in the background. Cadmus's early works uninhibitedly pictured the integrated urban eroticism of pre-Stonewall gay life, where all manner of sexual possibility, gay and straight, could be found jumbled together.

The Shower from 1943 offers a clue to the complex living arrangements of Cadmus, partner Jared French, and French's wife Margaret. Together, they would rent a beach house on Fire Island, where they would paint and take photographs. The photographs proved so close in style, despite their different hands, that the three came to sign their photography collectively as PaJaMa, after the first two letters of each name (pl. 28). Yet in *The Shower* we get a glimpse of some of the psychological complexity that lurked within this unusual arrangement, as Margaret stares at the showering Jared, who, as the visual pivot of the painting poised between his wife and his lover, in turn only looks down at his own body, literally walled off from each—while his shower runoff flows inexorably towards the posterior of a nude and seemingly estranged Cadmus.

In 1943, amid the Second World War, Cadmus began a long-term correspondence with the great British novelist E. M. Forster, author of among other novels, *A Passage to India* and the posthumously published *Maurice*, his sole work with an explicit same-sex theme. They were deeply sympathetic to one another and out of their correspondence, Cadmus developed a painting in tribute to Forster called *What I Believe*. It takes its name from a commissioned essay on that topic originally published by *The Nation* in 1938 and reissued in book form as *Two Cheers for Democracy*. At a moment when war was clearly not far off in Europe, in "a world," as he put it, "which is rent by religious and racial persecution," Forster's essay was paean to the power of the individual, or groups of individuals, against the state. After attacking the twinned abstractions of religious and political faith, the creeds that lead people to attack other people in contradistinction to what they claim to hold dear, Forster then rhetorically asks what he does in fact believe, and answers, "I certainly can proclaim that I believe in personal relationships."[50]

But this faith in personal relationships—and in democracy—as the sole creed that offers the individual liberty, does not entail a presumption that all beings are inherently equal. On the contrary, Forster comes out strongly in favor of what he calls an "aristocracy," but this term is subject to sufficient qualification that its allegorical meaning becomes clear. Celebrating an "aristocracy of the sensitive," for whom there is a "secret understanding between them when they meet," and who maintain their aristocracy only if they don't "thwart their bodies," Forster telegraphs credence in a homosexual elite—and Cadmus clearly echoes this belief in his painting. Forster attempts to communicate this belief in the kind of code that works to warmly embrace and emotionally sustain one audience, the homosexual, to the exclusion of another, the dominant.[51]

Similarly, Cadmus's *What I Believe* (1947–48; pl. 29) is written in a kind of code, made available to one audience—mostly those with whom the artists had personal relationships—to the exclusion of others. The painting is divided in halves, and the left half is peopled by Cadmus's friends in a Forster-like "aristocracy of the sensitive," sensitive serving as a code for homosexual at the time. Presiding over the entire company is Forster, with his golden garland, alongside Margaret French. Together they extend a benediction over Jared French and Paul Cadmus, who draws the scene before him. Two nude young men returned from war, one of whom is reading Forster's "What I Believe," occupy the foreground, while another nude male couple embrace behind Margaret French and Forster. One of these two figures, the balding man depicted in rear profile, appears to be Lincoln Kirstein, the bisexual impresario of the American Ballet Theater and husband of Cadmus's sister, Fidelma. Kirstein appears yet again, immediately behind the male couple, now playing the flute, and his lap supports the heads of Fidelma and a black woman. Three nude young men build a rough shelter. Thus, the left side of the painting, dedicated to the arts—reading, painting, literature, and architecture—stands in peace, a cooperative hymn to classicism, artistic

creation, and the prosperity it brings. The right side of the painting, however, separated from the left by a body of water illuminated by the phallic lighthouse of Alexandria, is in every respect the left's obverse. Different-sex couples predominate here, and the world they inhabit is one of death and destruction. Even the ground, so lush on the left side of the painting, is bare and singed on the right. At the top of the image, perched on a crumbling parapet/concentration camp, stand the dictators Hitler, Stalin, and Mussolini, raining missiles on the assembled multitudes below. That multitude, headed by a representative of each of the races (Jews apparently here constituting a race) lead to images of miscegenation, racist caricature, drunkenness, and finally the irony of a grim reaper who can but hide his eyes at the horror of it all. It's a stunningly racist vision, and a reminder that in less than two decades after the Harlem Renaissance, homosexuality could again be made white. A single, white, elect, heterosexual couple evades the mayhem only by turning their glance toward the gay side of the painting. Thus Forster's "aristocracy of the sensitive" is locked down in Cadmus's painting to a crude division between gay and straight, left and right, the gay occupying elysian fields where the classical past lives on in fecund creativity and Western civilization continues to flower. But the straight world has no art, just rampant reproduction, vice, racial impurity, mayhem, and death. The straight world engenders the decline and death of Western civilization, not its flowering.[52]

In the ten years between its first appearance as Forster's essay and its subsequent Cadmus incarnation, *What I Believe* tracks a profound shift away from the integrative sociosexual ethic of the prewar years, which is evident in Cadmus's early works like *Greenwich Village Cafeteria* (1934). Only a decade later, we can witness the emergence of gay and straight as two armed camps where a once largely peaceful coexistence held sway. This mobilizing of gay and straight as essentially two distinct species is an aspect of the postwar world's increasingly virulent homophobia, and *What I Believe* (1947–48) is among its earliest signs. As Alan Bérubé delineates in his book *Coming Out Under Fire*, with the massive uptick in inductions following the attack on Pearl Harbor, the military mobilized psychiatric screening examinations to identify homosexuals—female and male—who were increasingly viewed as unfit for service.[53] Not only were homosexuals the subject of the usual ridicule and occasional violence, but now anti-homosexual activity could be bolstered by an official diagnosis that justified and promoted social exclusion and aggressive repression. Of

course, the military's increasingly virulent attacks on homosexuals were not uniformly applied, and there were plenty of lesbians and gay men serving in the military despite the injunction.

Cadmus chose an obscure gay Latin American composer who died in Paris in 1947 for his 1963 canvas, *Le Ruban Denoue: Hommage à Reynaldo Hahn* (pl. 50). Best translated as "The Ribbon Unfurled," this homage is named after the composer's own 1914 suite of piano waltzes. It stands—as Lincoln Kirstein observes in his book on Cadmus, as a conscious tribute to the "minor" figures of cultural history, those who, like Cadmus himself, elect a style and subject matter out of keeping with their times.[54] Hahn, who was a close friend of Marcel Proust's, is depicted seated on a Beaux-Arts plinth, the lights of Paris twinkling behind him. And in a metaphor for artistic inspiration—or at least Cadmus's version of it—Hahn is kissed by a beatific figure of Eros while being groped by a handsome, devilish Pan. The result is an ejaculatory stream of musical compositions. The red robes of the earthy Pan, which camouflage his erection, twist and are converted to the same ethereal blue of the Virgin's robes in Renaissance painting as they cloak Hahn and go on to encircle the moon, itself poised above a statue of the child Mozart in the act of composing. These then are the twinned springs of art—love and sex—and they are one, merely different sides of the same cloth.

The photographer Minor White also twins his subjects as two incarnations of the same impulse, but he parallels natural and human beauty. His detailed images of an untrammeled nature have haunting echoes with his other notable body of work, images of men. Together, these two evocations of natural beauty can be thought of as an attempt to naturalize, even justify, the beauty he found in his own sex. In works like *Double Navel* and *Cypress Grove Trail, Point Lobos* (pl. 33), nature is mined for its rich store of human metaphors, which are then "recovered" as well from the body of *Tom Murphy* (pl. 34), whose form and pose mimic aspects of the natural world. This process of infusing the nonhuman with human qualities, which is also seen in the work of Ellsworth Kelly, allowed ostensibly abstract or nonfigural imagery to assume the weight and force of figuration, but in such a way as to make its figurative potential a function of the viewer's cognition and not the artist's. As the Cold War continued its chill, and "the homosexual" was transformed from harmless aesthete or mannish invert into an increasingly dangerous security risk, such built-in deniability was increasing instrumental. In this fraught context, LGBTQ artists

began to enforce a distinction between their work and their persona, in the process developing that theoretical position that we now call postmodernism.

Sexuality and the Advent of Postmodernism

Immediately after the Second World War, building on the military's classification of homosexuals as unfit for service, the right wing began to aggressively demonize homosexuality as a significant threat to national security. The release of Dr. Alfred Kinsey's *Sexuality in the Human Male* in 1948 (the volume on female sexuality would be released in 1953), paradoxically, only served to further that process. The Kinsey report's attempted displacement of the homosexual/heterosexual binary by what came to be called the Kinsey scale, in which 0 represented absolute heterosexuality and 6 absolute homosexuality, was essentially an attempt to replace the polarized relation of homosexuality and heterosexuality with an image of human sexuality as a continuum always in flux. As Kinsey wrote, "The living world is a continuum in each and every one of its aspects. . . . A seven-point scale comes nearer to showing the many gradations that actually exist."[55] To great social consternation, Kinsey's report also indicated that nearly half of all men had responded sexually to both sexes at least once and that more than a third had at least one homosexual experience. But this statistical evidence of the high incidence of same-sex desire, in the face of all the laws, codes, creeds, and customs against it, also incited fears of a vast effeminization of men and masculinization of women in America. The more widespread and ordinary homosexuality was made to seem, the more strenuous were the efforts to mark it out as discrete, delimited, and pathological.

Perhaps no one better tapped into these fears of a vast and advancing underground homosexual legion than Senator Joseph McCarthy. Between 1950 and 1954, McCarthy rode the issue of what he repeatedly called "perverts in the halls of government," and especially in the State Department, to ever-increasing attention. Despite the fact that his henchman was the homosexual Roy Cohn (pl. 67), and that sexual innuendo flew about Cohn's relationship with David Schine, yet another member of the senator's staff, McCarthy tirelessly promoted the idea that a vast homosexual underground was undermining our national security. The resulting purge has come to be called the Lavender Scare. As a result of it, more homosexuals than Communists lost their position, and many of them found themselves publicly named, shamed, or otherwise blacklisted.

Before long, the issue of homosexuality, under Kinsey a general aspect of human sexuality, was now articulated as a particular sexual perversion, and this pathological model achieved a new prominence in mainstream publications, discourse, and debate. Yet the right wing kept trying to turn up the heat even higher: one author who went by the name Dr. Guy Matthews, writing in an illustrated bodybuilding periodical entitled *Bernarr Macfadden's Vitalized Physical Culture*, wrote a series of articles throughout 1953 proclaiming that homosexuals were working in concert with Communism to effeminize and thereby weaken American men, rendering a newly emasculated America open to a Soviet invasion. In articles with titles like "Homosexuality is Stalin's Atom Bomb to Destroy America" (subtitled "Drive Out the Pink Pansies") and "Lesbians Prey on Weak Women," he specifically targeted Kinsey's sexuality re-search.[56] Ironically, the magazine's publisher, Bernarr Macfadden, a bodybuilder who became a health and fitness guru in the early decades of the twentieth century, was himself hauled before a government commission on charges of indecency because his early publication of physical culture photographss was deemed obscene.

Still, Dr. Guy Matthews's fears about the utility of homosexuality to foreign threat were evidently echoed at the White House. The *Los Angeles Times* reported on April 27, 1953, that "President Eisenhower today set up a tough new loyalty-security program designed to rid the government of homosexuals, alcoholics, and 'blabbermouths.'" The article mentioned that the president specifically discussed the new order with McCarthy.[57] Two months later, the same paper reported that 531 homosexuals had been fired from the State Department alone.[58] *One Magazine*, the first journal of the modern lesbian and gay-rights movement, published an editorial in 1953 decrying the deleterious effects of the conjunction of homosexuality with Communism:

Deviants who pride themselves in having no interest whatever in dull-old-politics, are shocked to find themselves classed with communists and criminals as far as Senator McCarthy and the present and previous administrations are concerned."[59]

Fanned by political operatives on the right, the concept of "sexual deviance" was found to slip quite easily into the same metaphors used to characterize the Communist threat: both represented homegrown internal enemies that relied on recruiting the young and vulnerable; both featured underground or camouflaged populations who would only reveal themselves

when it was too late and their goal had been
accomplished; both were framed by metaphors
of disease and infection. No wonder that the
closet would become the watchword of American
queer life in the Cold War era, or rather, as the
metaphor they employed, the spy.

The San Francisco-based artist Jess boldly
outed himself at the height of antigay hysteria.[60]
Jess's partner was the celebrated poet Robert
Duncan, author of one of the earliest gay-rights
tracts in American letters, the controversial
The Homosexual in Society, published in 1944 in
the journal *Politics* at great personal cost.[61]
The essay's comparison of homosexuals with
Jews and African Americans was one of the
earliest articulations of a nonpathological queer
minority identity. Duncan and Jess met in 1951,
and shortly thereafter Jess decided to act, rather
courageously, on his moral outrage at the homo-
phobic witch-hunt of the period, albeit with images,
not words. Significantly, in a pattern repeated
in the lives of other Cold War artists like Robert
Rauschenberg and Jasper Johns, Jess completed
his first gay-themed work the very same year
he met the love of his life, Duncan. As with Johns's
and Rauschenberg's early work, Jess's references
to same-sex sexuality are encoded, but unlike
them, not so hermetically as to be almost unde-
tectable. That first gay work, *The Mouse's Tale*
(pl. 37) of 1951-54, is in fact a highly politicized
jeremiad in collage form. Its central image,
a kind of collective homosexual self-portrait, is
composed of a series of cutouts, many taken
from the ubiquitous "posing strap" magazines of
the period. These magazines were soft-core gay
pornography, illustrated with photos of nearly
nude young men under the guise of providing
role models and inspiration for bodybuilding or
other kinds of physical fitness.

The title *The Mouse's Tale* is derived from
the eponymous poem by Lewis Carroll that
appears in *Alice in Wonderland*. The poem, like
the collage itself, punningly takes the form of
its subject, a mouse's tale—or tail. And that tale
appears verbatim, collaged into a circle com-
posed of clown heads. The heads form a hang-
man's noose, and thus the large crouching figure,
himself composed of smaller posing figures,
is represented flexing his muscles in a mirror of
clown's heads ending in a noose. In that context,
Carroll's light verse assumes a distinctly cloudy
allegorical cast:

Fury said to
a mouse, That
he met
in the
house,
"Let us
both go
to law:
I will
Prosecute
you.—
Come, I'll
take no
denial;
We must
have a
trial:
For
really
this
morning
I've
nothing
to do."
Said the
mouse to
the cur,
"Such a
trial,
dear sir,
With no
jury or
judge,
would be
wasting
our breath."
"I'll be
judge,
I'll be
jury,"
Said
cunning
old Fury;
"I'll try
the whole
cause,
and
condemn
you
to
death."

Thus *The Mouse's Tale* uses the metaphor of men posing for other men as to address the homophobia structuring the reflection of queer people in the eyes of straights; sharply, and with ill-concealed disdain, Jess represents this process at the dawn of the Lavender Scare as one of being mirrored by clowns. In violation of due process, these gay subjects get no benefit of an impartial judge or fair trial. Yet the fury animating this image is communicated in so baroque a web of associations that it has long been able to fly under the radar of the very censors it excoriates.

Jess's 1966 *A Lamb for Pylaochos: Herko in New York '64: Translation #16* (pl. 55) is a portrait of the dancer Freddie Herko, a gay habitué of the Warhol factory scene and a dancer/choreographer. Two years before Jess made this painting, the troubled Herko had promised his friends a suicide performance and indeed, after a bath at a friend's flat, he danced naked and strung-out across the apartment and out a fifth-story window. Warhol, when asked about the incident, famously replied that it was too bad he wasn't there to film it. Jess's image is part of series he called *Translations*, in which, starting from a found image (rather than using collage, as was his usual practice), he "translated" his source material into a new painting built up out of a thick, painterly impasto. The resulting *Translation* was identical in form to the found image, but in every other respect, not least in its thick surface, often more than a quarter-inch deep, manifestly a new and original painting. Jess's idiosyncratic take on the cultural givens of pop art, the *Translations* are not, however, nearly as indifferent as pop in terms of subject matter. Indeed, Jess offers a clue to his own motivations in the selection of the source image by titling his work *A Lamb for Pylaochos*. Pylaochos is the guardian of the entrance to the underworld or Hades, and in Dionysian rituals he had to be propitiated with the sacrifice of a lamb. Herko is thus made over into an innocent victim of a drug-fueled avant-garde culture increasingly seen as demanding—as is the case with Herko or, even more famously, Edie Sedgwick—the blood of its own.

Jess's was a distinctly anomalous voice in American art, far more politically oriented and explicitly gay than most artists at the time.[62] As a West Coast artist—he lived in San Francisco almost his entire life—New York and the then-prevailing abstract expressionist winds simply did not register with him. He claimed no interest in abstract expressionism; indeed, he said that he barely knew of it.[63] Yet there is no doubt that Jackson Pollock, Willem de Kooning, and other gestural painters were at the forefront of a whole-sale remaking of what it meant to be an American artist. At the beginning of Jess's career, just after the war, New York was just starting to come into its own as an art center; within a decade, it would supersede Paris as the new art capital of the globe. To be an American artist was no longer to be consigned to marginality in the rest of the world. In no small measure, this seismic shift in art-world geopolitics can be credited to a small group of abstract expressionist painters, and strikingly, there was not a gay or lesbian artist among them.

Having emerged from World War II not only victorious, but the leading country in the world in economic, military, and industrial terms, the United States was incontestably a much greater power after the war than before it. Still, it was embarrassingly far behind Europe as an innovator in the arts. So it is perhaps no surprise that shortly after the conclusion of the war, befitting America's newfound assertiveness, a group of U.S. artists who could be construed as emblematically American were quickly seized upon, promoted, and elevated to global stature by a number of forces working together to mint a new American art.[64] For example, one of these artists, Jackson Pollock, was profiled in an August 8, 1949, four-page spread in *Life* magazine, under the heading "Is he the greatest living painter in the United States?"[65] Although there were many better-known American artists at the time who could have more logically claimed that title of "greatest," they had the disadvantage of having an established reputation—and style. Outside the narrow confines of the art world, few had even heard of Pollock by 1949, and that proved advantageous to the proclamation of a new American avant-garde culture. The postwar reinvention of the United States as the epicenter of global innovation needed its correlate in the cultural sphere, and artists like Pollock were made to fit national needs, not least in modeling perhaps the most prominent problem that surfaced in the Cold War between the United States and the USSR: the relation of the individual to the collective.

Broadly, the great theme of the cohort of artists who came to be known as the abstract expressionists was the struggle for self-expression. But despite its resonance with Cold War muscle-flexing, this pursuit of self-expression was neither as jingoistic, inward-turning, or narcissistic as it may at first appear. Rather, very early on, the abstract expressionist painters came to recognize that self-expression led both them and the viewer toward the recognition of a broadly shared sense of common emotion and feeling.[66] The abstract expressionists thus implicitly painted

Fig. 15 / *Target on an Orange Field* by Jasper Johns (born 1930), watercolor and pencil on paper, 1957. The Museum of Contemporary Art, Los Angeles; bequest of Marcia Simon Weisman

the United States as a nation united by a freely shared expressive language, as opposed to the Soviet Union, which bloodily enforced a codified, orthodox visual language through the brutality of gulags and secret police.

The abstract expressionists thus merged the individualism of expressionism with credence in a deep, emotive commonality, a combination of individual liberty within an overarching "natural" national unity and harmony that would ensure victory in the Cold War. But as credence in this communal ethos edged too close to the bugaboo of Communism, they clothed their communalism in a comfortably traditional, highly individualized American persona, that of hard-drinking masculine archetypes closer in spirit to the Western frontiersman than the intellectuals of European art. Still, their embrace of what David Riesman described as an "inner-directed" individual was a fiction that was growing increasingly hard to maintain. And they knew it. As Valerie Hellstein has discovered, the Club, the abstract expressionist meeting place in New York, sponsored multiple lectures by intellectuals such as Paul Goodman on a communal ethos and the necessity of rethinking the social in terms of a shared community. Although the abstract expressionists may have performed a kind of frontiersman autonomy, their work was most centrally concerned with the communication of shared feeling.

By 1961, even the celebrated early booster of abstract expressionism, poet Frank O'Hara, in concert with his then-former partner Larry Rivers, published a withering satire of what he came to see as the increasing ossification of abstract expressionism's autographic sensibility into a collective style: "We all know Expressionism has moved to the suburbs. . . . If you are interested in schools, choose a school that is interested in you. . . . Schools are insurance companies. Enter their offices and you are certain of a position."[67] O'Hara's dismissal of abstract expressionism as an avant-garde that had moved to the suburbs underscores how rapidly credence in an art of expressive individuality had soured.

Ironically, the sense of avant-garde possibility returned to American art via a small group of artists who seemed to be anything but dissident. In fact, they achieved acclaim for representing some of the great commonalities of modern American life—our shared symbols like the flag, for example, or the banality of our commodity culture, or the detritus of everyday life. They tended to marry the brushy eloquence of the abstract expressionists with recognizable subject matter—flags, targets, Coke bottles, cigar boxes,

and the like. These post–abstract expressionist painters—chiefly Robert Rauschenberg, Jasper Johns, and to a lesser extent Larry Rivers—worked to invert the operations of abstract expressionism. Whereas abstract expressionist painting's content was idiosyncratically individualistic but communal in its emotional resonance, now the content was entirely communal—anyone could identify a flag or any of their other subjects—but the emotional resonance was completely idiosyncratic and individual. You could generally identify the subjects in and of post–abstract expressionist painting—you just couldn't determine what they meant or why they were represented in the first place. Sexuality turns out to be key to the difference between the abstract expressionists and this post–abstract expressionist generation: while the former were almost exclusively heterosexual, the latter had all, to a greater or lesser extent, been involved with members of their own sex. This begs the question of the import of sexual orientation to the development of postwar art.

The post–abstract expressionists aren't "post" in any chronological sense: Johns, Rauschenberg, and Rivers were working in more or less the same time frame as the abstract expressionists, whom they knew fairly well. (Johns, Rauschenberg, and Rivers were a generation younger than the lions of abstract expressionism, but there were plenty of young painters in the abstract expressionist camp.) Rather, they are deemed post–abstract expressionist for the way they supplied a new intellectual approach to the operations of meaning-making in art.

Jasper Johns's work represents the clearest instance of this approach. His earliest subject matter—such as flags, letters, numbers, and targets (fig. 15)—features intellectual abstractions that assume the status of real things. We act as if flags, letters, numbers, or targets exist in the world as material facts, but in truth they're only ideas cemented into entities by virtue of a common agreement. A flag is a particular design that, by consensus, assumes the representational weight of a nation, while numbers or letters exist solely as the material form of certain notions or sounds. Thus Johns's early subjects share a quality of abstraction, not in their form, but notionally, as things that accrue meaning only through common agreement: they mean what they do only because we say they mean what they do.

As with Johns's flags and targets, we can follow his lead to see how other seemingly real entities—including sexual orientation, gender, or race—reveal themselves to be mere social constructions. Under pressure from this

Fig. 16 / *The Greatest Homosexual* by Larry Rivers
(1923–2002), oil, collage, pencil, and colored pencil
on canvas, 1964. Hirshhorn Museum and Sculpture
Garden, Smithsonian Institution, Washington, D.C.

skepticism, even that most central pillar of
abstract expressionism, the self, begins to break
down. Before long, instead of a singular self-
hood, the individual emerges as the site of many
different identities—what Frank O'Hara famously
called "the scene of my selves" in his poem
"In Memory of My Feelings"—the very poem that
Jasper Johns adopts as the title, and subject,
of one of his most significant paintings (pl. 46).
The phrase "the scene of my selves" suggests
that, rather than being a single unchanging
entity, selfhood instead encompasses a series of
costume changes, different outfits keyed to the
differing demands of separate social worlds—
a self for work, a self for home, a self relaxing
with friends, etc. The transformation of "the self"
into "the scene of my selves"—a fluid concep-
tion of identity—is considered one of the singular
achievements of postmodernism, but here it is
at midcentury, contemporaneous with some of
the greatest paeans to "the self" that abstract
expressionism ever produced.

In place of accounts of the advent of post-
modernism in American art that focus on histori-
cal antecedents like Marcel Duchamp, I hope
instead to suggest how profoundly this postmod-
ernist perspective correlates to the experience
of the largely gay male artists who first engineered
a non-self-expressive art at the height of Cold
War. In place of the abstract expressionists' reli-
gion of authenticity, these gay artists introduced
feints and dissimulations into portraiture. Whereas
the abstract expressionists sought the minimal
interference in the process of self-expression,
these gay artists cultivated a self-portraiture that
was all mediation, its imagery appropriated from
mass culture. And in the process of covering
over their queer selves, they also resuscitated,
even rescued, portraiture, which in its assump-
tions of a true or authentic self, was fast becom-
ing an anachronism in a culture that increas-
ingly defined distinctions between private and
public identity.

It was gay artists and writers such as Frank
O'Hara who underscored how profoundly
"the self" was always a product of interactions
with others, that even our own identity was
merely catching a glimpse of our reflection in
another's eyes. Amid the extraordinary perse-
cutions of the Lavender Scare era, wherein
queers were psychoanalyzed, ostracized, incar-
cerated, and repeatedly blamed for a host
of social ills that were very far from anything to
do with same-sex desire, it was patently clear
that gay people did not have the privilege of
defining themselves. In short order, the inau-
thentic trumped the authentic as the defining

mode of portraiture, and the postmodernist
portrait was born.

Larry Rivers was a liminal figure poised at
the edge between the modern and postmodern
portrait. From the very beginnings of his career,
Rivers produced portraits of his friends and family,
including, most controversially, nude images of
his aging mother-in-law, with whom he lived, and
his teenage sons. Rivers and his longtime friend
Frank O'Hara often represented or addressed one
another in their respective works. Rivers's slightly
over-life-size 1954 painting *O'Hara Nude with
Boots* (pl. 40) became infamous as a portrait of
the influential poet, curator, and art critic de-
picted as a standing nude odalisque by the man
widely recognized as his occasional lover. Rivers's
pictorial tribute was in some measure recipro-
cated in O'Hara's poem "On Seeing Larry Rivers'
Washington Crossing the Delaware at the Museum
of Modern Art," as well as in other poems. But
while Rivers's painting and O'Hara's poetry is
profoundly, even intimately autobiographical, it
also refutes any presumption of the truth or even
the singularity of its representations. Rivers's
brushy appropriations of stock nationalist paint-
ings like Emanuel Leutze's famous *Washington
Crossing the Delaware* or Jacques-Louis David's
famous portrait of Napoleon with his hand in
his shirt, retitled by Rivers as *The Greatest Homo-
sexual* (fig. 16), profoundly ironize their prec-
edents, yet his images of family and friends have
a palpable tenderness.

As someone who primarily identified as
heterosexual, Rivers did not always feel the need
to obfuscate and redirect his sensibility in por-
traiture. He could be an inauthentic, ironic post-
modern artist in some works, and an old-school
romantic in others. His combination of earnest
self-expression and mocking satire only serve to
emphasize the multiplicity of identities that
O'Hara identified as "the scene of my selves." From
the early 1950s to the early 1960s, Rivers and
O'Hara would sometimes work collaboratively,
perhaps most notably in the ten-plate lithographic
series *Stones* (1957–60). In *Stones*, O'Hara's
handwritten poems and Rivers's graphic imagery
meld into an inseparable pictorial whole, a literal
take on the multiplicity of selves increasingly
in evidence in artworks of the era.

As far back as 1959, collector Ben Heller
wrote in the earliest catalog essay on
Jasper Johns, "By contemplating these objects
and not himself, the artist runs counter to the
current expressionistic sense of self."[68] Johns
articulated largely the same the sentiment in
his famous statement:

Fig. 17 / *Tennyson* by Jasper Johns (born 1930), encaustic and canvas collage on canvas, 1958. Nathan Emory Coffin Collection of the Des Moines Art Center (1971.4); purchased with funds from the Coffin Fine Arts Trust

I have attempted to develop my thinking in such a way that the work I've done is not me— not to confuse my feelings with what I produce. I didn't want my work to be an exposure of my feelings. Abstract expressionism was so lively— personal identity and painting were more or less the same, and I tried to operate the same way. But I found I couldn't do anything that would be identical with my feelings. So I worked in such a way that I could say that it's not me. That accounts for the separation.[69]

In truth, Johns did make work that was more or less a product of his feelings, but he did this covertly, seeding enough other meanings into his canvases to ensure that we would be distracted enough not to notice the more private and emotional dimensions. He declares this as his intention in some sense in a series of largely gray paintings made throughout the latter half of the fifties, beginning with *Canvas* (1956). In these works, the metaphor of a visible silencing is very much in evidence. *Canvas*, for example consists simply of two stretched canvases attached to one another face to face, so that the image is primarily the back of one canvas covered with paint. The painting is all refusal, a literal turning away from the viewer, a manifest denial of our solicited gaze. Not only is the central canvas—the presumptive "subject"—turned away, but the entire image is shrouded in a dense coat of thick gray encaustic paint. Paintings like *Canvas* tell us that there is something being withheld, foreclosed.

After completing this picture, Johns continued to paint over a host of objects, sometimes identifiable only through their titles, hiding, burying, or making them illegible. He obscures a newspaper with encaustic in *Newspaper*, slathers encaustic over a drawn window shade in the painting *Shade* (1959), covers a book with thick paint in *Book* (1957). He paints drawers that can't be opened in *Drawer* (1957). Items like shades, books, newspapers, and drawers can only signify meaning when they are opened, and yet Johns offers them always painted shut. These are pictures of great reticence and hiding, but in ostentatiously painting over subjects that solicit, then frustrate, our gaze, they give form to the play between secrecy and disclosure that is the essence of the closet. For the closet is never an absolute refusal or silence; for then it would simply be what it proclaimed itself to be. In order to qualify as the closet, a difference must somehow become visible not as silence but *as* a silencing, a denying, a withholding from view. In these images, the closet achieves physical representation, materializing what Johns wrote

in one of his early sketchbook notes, "An object that tells of the loss, destruction, disappearance of objects. Does not speak of itself. Tells of others."[70] Is this not a precise formulation of the postmodernist self?

Johns's 1958 painting *Tennyson* (fig. 17) manifestly attempts, in Johns's words, not to not speak of itself, but tell of others in that oxymoronic formulation, as critic Leo Steinberg put it, both "secretive and confessional."[71] Its headstone shape and color, with the name "Tennyson" seemingly chiseled into the bottom, recalls a grave marker and thus arguably Tennyson's greatest poem—"In Memoriam A.H.H.," an elegy written after the premature death of his friend Arthur Henry Hallam. Throughout "In Memoriam," Tennyson structures the poem as an imaginary dialog between the speaker and the absent figure of his friend, whose death has left, in the words of the poem: "A void where heart on heart reposed; / And, where warm hands have prest and closed." Tennyson's poem consistently images Hallam as physically entwined with the poet, such that each man is made the mirror of the other: "But thou and I are one in kind,/As moulded like in Nature's mint...As his unlikeness fitted mine."

This suggestion of a mirroring in the poem is made physical in Johns's painting through twinned vertical canvases bolted together and covered by a third piece of unlined canvas, like a shroud. The image was initially underpainted in bold red, yellow, and blue, the Johnsian leitmotif that he profoundly associated with Rauschenberg. But "In Memoriam" is also an elegy, and the painting follows suit. Why did Johns employ the trope of memorialization to address, if indeed it is an address, his feelings for Rauschenberg? Perhaps Johns found something familiar in the stanza of the poem that understands silence as articulate, as capable of saying something that speech cannot: "And strangely on the silence broke/The silent-speaking words."

Out of this communicative silence comes an image of two souls conjoined, mirroring in each other a silence that for all its inarticulateness, nonetheless comes to express what words cannot—how, in the words of the poem, "The living soul was flash'd on mine." In this image of silent speech that needs no utterance to reach, as Tennyson put it, "empyreal heights of thought," Johns found both his precedent and program. As Michel Foucault reminds us in his history of sexuality, "There is no binary division to be made between what one says and what one does not say. . . . There is not one but many silences, and they are an integral part of the strategies that underlie and permeate discourses."[72]

Fig. 18 / *Untitled* (self-portrait) by Robert Rauschenberg (1925–2008), gelatin silver print, c. 1952. The Estate of Robert Rauschenberg

Fig. 19 / *Trophy I (for Merce Cunningham)* by Robert Rauschenberg (1925–2008), combine painting: oil and collage on canvas, 1959. Kunsthaus Zürich, Switzerland

They were like the tortoise and the hare: Robert Rauschenberg tossing off brilliant ideas with the ease and facility of his impatient genius—making one painting then moving on; Jasper Johns then seizing upon these ideas with the slow deliberation of his philosophical character, boring in, deepening and exploring of these ideas across numerous paintings over decades. Theirs was an unparalleled symbiosis, and it is impossible to imagine what their work—much less the course of American painting—would have been like had they never met. Their relationship was doubtless the crucible of their artistic development, of their signature styles, and of their lasting import to the history of American culture. Together they developed a means of encoding their thoughts and feelings in works of art that were seemingly indifferent. They would be partners for nearly a decade after their first meeting in the winter of 1953/54—so close that, according to John Cage, they finished one another's sentences—and then bitter rivals for the rest of their lives.

Notably, when Johns and Rauschenberg were young and powerless, critics and scholars were much less reticent to maintain the silence, still routinely observed, about their relationship (fig. 18). In a 1961 review, critic Jack Kroll, writing in *ARTnews*, condemned Rauschenberg's work in such indulgently homophobic terms as to leave no doubt as to his frame of reference:

But Rauschenberg sometimes snags his sweater between the sanctum of private reference and the littered tundra of commemorative decay. A poof of incense disperses the bracing pungency of the urban miasma; the sharp punning weapons of the inscrutable ironist corrode gracefully with a lavender rust. . . . We get too close to the artist in the wrong sense.[73]

From the lavender rust to the poofing incense, this veritable catalog of homophobic imagery is all marshaled to bear witness to, in Kroll's felicitous phrase, "Rauschenberg's Capotean indulgence." Today such a review is literally unthinkable, in large measure because, through Johns and Rauschenberg's diligent editing of their own images, we are very far from knowing "the artist in the wrong sense."

From very early in 1954, Johns had become the major focus of Rauschenberg's attention. Rauschenberg took the shy younger artist around, introducing him to dealers and older artists. A mere five years apart in age, they nonetheless differed vastly in experience. As Johns put it, "He was kind of an *enfant terrible* at the time, and

I thought of him as an accomplished professional. He'd already had a number of shows, knew everybody, had been to Black Mountain College working with all those avant-garde people."[74]

Johns had recently moved to New York from South Carolina and, after a brief stint in the navy, got a job on the evening shift at the Marboro bookstore, unsure of whether he was working toward becoming a poet or a painter. In short order, Rauschenberg convinced Johns to quit his job at the bookstore and join him in doing window designs for department stores. They were so successful at it that neither had to take regular shift work ever again.

Despite being a couple, Rauschenberg and Johns remain the great individualists in postwar American art. Yet they showed together, were written about together, and were even discovered by their dealer together. Yet, for all their commonality, their sensibilities were very different. Robert Rauschenberg tells the story that one day Johns finally allowed him, after much begging, to paint a single line in one of his famous flag paintings. "I knew I had only one stroke to make. I put some red in a white stripe. He was furious. He was *furious*. But I just thought, God, a little red would look great here."[75] It's a telling anecdote. Where Johns was deliberate, intellectual, and shy, Rauschenberg was impulsive, intuitive, and playful. According to Rauschenberg biographer Calvin Tomkins, a lot of friends who knew them said that two more different individuals could not be imagined, and yet nearly all agree that at least early on, "They sort of struck sparks off each other all the time in conversation. It was exhilarating to be around them. It [their break-up] was a source of regret to people like John Cage who had been part of that excitement."[76]

In a sense, Johns and Rauschenberg were almost a world unto themselves during the first few years of their relationship. Johns has said, "our world was very limited. I think we were very dependent on one another. There was that business of triggering energies. Other people fed into that but it was basically a two-way operation."[77] Their intense emotional and intellectual rapport, in concert with the homophobic context of Cold War culture, created the conditions for a shared private language in their art, an expressive mode keyed to an audience of one. By design, this private language was hard to read and complicated, as it had to be in order to escape other, hostile eyes. Rauschenberg said that "He and I were each other's first serious critics."[78]

Both Johns and Rauschenberg would later deny any meaning to the specific content in their art at this time. Rauschenberg even denied

Fig. 20 / *Canyon* by Robert Rauschenberg (1925–2008), combine painting: oil, pencil, paper, fabric, metal, cardboard box, printed paper, printed reproductions, photograph, wood, paint tube, and mirror on canvas, with oil on bald eagle, string, and pillow, 1959. Courtesy Sonnabend Collection

Fig. 21 / *Pail for Ganymede* by Robert Rauschenberg (1925–2008), sheet metal and enamel over wood with crank, gear, sealing wax, and tin can, 1959. The Estate of Robert Rauschenberg

working with any intentions at all, saying that his working method consisted simply of "random order," producing a conjunction of things as the artistic equivalent of looking out the window of a speeding car. "Meaning belongs to the people" was how he once put it. Yet the seed of a challenge to this commonly accepted view of their art was planted by none other than Rauschenberg himself. Once, in an apparently unguarded moment, Rauschenberg was asked, "How much of your work is autobiographical?" He replied, "Probably all of it."

This is most palpable in a series of combines that are manifestly biographical. *Trophy 1 (for Merce Cunningham)* (fig. 19), one of a series of five combines dedicated explicitly to close friends, includes numerous references to an incident in Japan wherein Merce Cunningham accidentally stepped through a bad board and hurt his foot—calamitous for a dancer. Rauschenberg, who was traveling with the company at the time as its costume, set, and lighting designer, memorializes this incident with a gap between boards, a warning sign, a photograph of Cunningham and numerous other elements that convert what seems a random agglomeration into something approaching thematic coherence. Similarly, in his famous combine *Canyon* (fig. 20), he places a photograph of his young son (middle left, outlined in black) next to an image of the Statue of Liberty, which itself appends a collaged field of words, probably advertising, out of which the terms "can" and "ass" can be made out. Below this is a stuffed golden eagle. The conjunction of these elements call to mind the story of Ganymede, and to Kenneth Bendiner, specifically the Rembrandt painting of a crying boy being carried heavenward in Zeus's talons after the god converts himself into an eagle. In nineteenth- and twentieth-century glossovers of the tale, Ganymede served as cupbearer to Zeus, and indeed opposite *Canyon* when it was first displayed was the sculpture *A Pail for Ganymede* (fig. 21), with a cup that went up and down when you turned the handle. Of course, the title of Rubens's famous painting of the scene, *The Rape of Ganymede*, suggests that cup-bearing was not all Zeus had in mind, begging the question of why Rauschenberg would place his own son in this scene, not least opposite the premier emblem of individual freedom, the Statue of Liberty, and puns on "ass" and "can"? Zeus was no mean connoisseur of male beauty, and perhaps Rauschenberg was merely being the proud father, but the boy, with his hand upraised, in conjunction to the statue also indicates a potential political reading, recasting the abduction as a flight to freedom.[79]

Two ragged comic strips peek out of a sea of collage. They're tiny, no more than fragments really, integrated into much larger pictures and thus very easy to overlook. Shortly after Rauschenberg first fell in love with Johns, he cut them from the newspaper and glued them to two different canvases just weeks apart. In the first image, *Yoicks* (1954), a vast expanse of fabric supports a few comics generally so overpainted as to be completely illegible. But emerging out of the murkiness, framed by dripped and scumbled paint, one phrase is strikingly clear, "five foot ten, hair sandy, eyes blue, 160 lbs. You're not as guilty as you think." It's a precise, careful description, physically and emotionally, of Jasper Johns at the time. Titled by an exclamation of discovery taken from a comic strip, *Yoicks* is not only much lighter and more celebratory than any of Rauschenberg's previous paintings, it also trafficks in precisely the signs of expressiveness and emotiveness—drips, high-keyed color, loaded gesture—so familiar in abstract expressionism and until this point so rigorously excluded in Rauschenberg's then-austerely anti-expressive art. Pre- and post-Johns works by Rauschenberg seem to be by two very different artists, with the pre-Johns works characterized by emptiness, erasure, and pictorial negations, as in his utterly blank White Paintings. *Yoicks* also inaugurates what would turn out to be a long-term interpictorial dialog between the two men. One of the green dots at the bottom of Yoicks is surrounded by a series of concentric pencil lines, evoking Johns's *Green Target*, then under completion in a studio one floor below Rauschenberg's. The alternating red stripes of *Yoicks* evoke Johns's now-famous *Flag* painting—also then under construction—especially as the canvas is divided into two flag-shaped sections, the lower one with a collage of comics precisely where the dense field of blue stars would be on an American flag. Among these comics is a Terry and the Pirates strip reading in part: "In view of the circumstances, I imagine your request to delay en route at Hawaii for a honeymoon will be granted, Capt. and Lt. Charles." Note how the address to "Capt. and Lt. Charles" in the context of a honeymoon seems to signify the beginning of a male/male relationship.

The invention and development of Rauschenberg's signature format, the combine, in fact tracks his relationship with Johns almost precisely. He made his first combine beginning in the winter of 1953/54—shortly after they met—and moved into his silkscreen paintings during the winter of 1961/62, exactly when they broke up. But Rauschenberg didn't want a conventionally expressive art. Directly autobiographical materials,

Fig. 22 / *Pan* by Cy Twombly (born 1928), collage, 1975. Collection of the artist

including letters and precious family photographs, share the canvas with other items such as taxidermied animals, urban detritus, and scraps of fabric and paper. As a result, the combines appear to be mere agglomerations of stuff, and that is the way they have been overwhelmingly understood. But in fact, Rauschenberg very carefully and self-consciously covered his tracks, burying the expressive elements in a sea of other random materials. Art thus came to operate on two levels for both Rauschenberg and Johns, one public and and one private, thereby replicating the conditions of their daily lives. In short, the works of Johns and Rauschenberg have multiple audiences—a general audience, an audience among a circle of friends, an audience of each other—all of whom read the work differently. In ordinary discourse, we of course readily accept the notion that couples maintain private codes and meanings; why should it be a surprise to find the same dynamic in artwork? And as code-makers know, nothing is as effective as a superfluity of messages to camouflage particular meanings. For example, in *Collection* (1954), one of the earliest combines Rauschenberg made after meeting Johns, he included a small, easy-to-miss fragment of a comic in the upper-right corner that read, "How depressing life would be, if our lucky stars hadn't introduced you to me."

In another combine of the same year, *Minutiae*, Rauschenberg signaled how knowingly he employed these comic fragments. *Minutiae* is indeed composed of minutiae, and among the numerous small fragments one comic shows two men hiding under a stage. The first asks nervously, "Hey suppose they spot us under here?" And the other reassures him, saying, "They won't, they'll all be looking at the zebra." It's a deliciously self-conscious assessment in this, one of Rauschenberg's earliest combines. And its title underscores how such small fragments are keyed to Rauschenberg's objectives for the piece as a whole—one had to be a member of his inner circle to understand such whispered forms of reference. Clearly, he counted on our ignoring those two men hiding together in favor of that zebra, and by and large he was right, for it has never been noticed before, just like the vast majority of the other fragments that litter the surface of this and so many other combines of the period.

Yet for all that, Rauschenberg never hid his duplicitous intentions in the making of the combines. At the symposium accompanying the "Art of Assemblage" show at the Museum of Modern Art in 1961, where *Minutiae* was shown, Rauschenberg said to William Seitz, the exhibi-

tion's organizer, when asked about meaning in his work, "Also, being a good artist is like committing the perfect crime—you don't get caught."[80]

Within six months of meeting Johns, Rauschenberg had embarked on the significant changes of direction in his art that would establish and sustain his critical reputation. Likewise, it was only after meeting Rauschenberg, Johns has said, that he "decided to stop *becoming* and to *be* an artist."[81] Little record remains of Johns's work during the early months of his relationship with Rauschenberg because he tried to destroy it all. But enough pieces survive to leave a record of what some of it must have been like. And judging from these few works, they seem very much in the spirit of Rauschenberg.[82] While Johns has never clarified his rationale for destroying these early works, perhaps he did so because in their use of found objects and collage they seemed too close in spirit to the work of his mentor.

Cy Twombly was Rauschenberg's first male partner, as letters from Black Mountain College in the winter of 1951–52 attest.[83] These letters further underscore that their relationship was common knowledge at the college. While they had a falling-out on a trip to Europe and North Africa, they continued to remain close, occasionally even still working together in the period before Rauschenberg met Johns. Twombly's work, notable for its graffiti-like, often scatological imagery, shares with Rauschenberg's a density of surface that relies on the superfluity of imagery to camouflage the significance of any particular cluster of signs. Despite its often-explicit eroticism, there is simply too much going on in a Twombly canvas to be reducible to a clear statement, just as there is in a Rauschenberg combine. As with Johns and Rauschenberg, Twombly, too, seems to cultivate multiple levels of meaning, demonstrating an awareness of audience's tendency to surrender the search for significance amid a forest of signs. But several Twombly works, such as *Pan* (fig. 22), pare back the imagery sufficiently to yield a recoverable meaning. *Pan* pictures two phallic leaves of Swiss chard that flop over one another with the caption "pan," the Greek personification of phallic libido. But the implicit homoeroticism of the scene is ruptured by the parenthetical word "panic," suggesting that Twombly's relationship to this homoeroticism is notably fraught.

Rauschenberg, too, occasionally turned his art into a species of therapy, using his combines to negotiate complex interpersonal relationships that were perhaps less easily solved in his life. An untitled work of 1955 (*Man with the White Shoes*) contains so many distinctly autobiographical

Fig. 23 / *Odalisque* by Robert Rauschenberg (1925–2008), combine painting: wood, material, wire, grass, paper, photographs, metal, stuffed rooster, four lightbulbs, 1955–58. Rheinisches Bildarchiv Köln (Museum Ludwig, Cologne, Germany)

Fig. 24 / *Canto XXXIII* (from *XXXIV Drawings from Dante's Inferno, including KAR)* by Robert Rauschenberg (1925–2008), offset lithographs (thirty-four), edition 202/300 (with one original), 1959. The Museum of Contemporary Art, Los Angeles; gift of Marcia Simon Weisman

fragments that it seems to be almost a scrapbook, and some of the materials collaged on its three-dimensional surface must have been very valuable to Rauschenberg, for he preserved them for many years.[84] These materials include a seven-year-old announcement of his parents' twenty-fifth wedding anniversary featuring the news that Milton Rauschenberg (his given name) painted the baptistery of the local church. In addition, the combine also features more recent images of and from lovers and friends, including two sheets of Cy Twombly's drawings; two letter fragments, one of which looks to be by Johns;[85] a photograph of two soldiers, one tenderly embracing the other; a comic strip revealing the lines "Ever see this before," "Never, honest, I never saw it before"; and finally, next to a stuffed hen, an image of the American flag (at precisely the time Jasper Johns was completing his famous painting of one), along with a photograph of Johns that Rauschenberg once termed "gorgeous."[86] In nearly every instance Rauschenberg juxtaposes an old or family-oriented image or item next to an element drawn from his newer gay life, in what seems a poignant attempt at reconciliation.

Untitled, moreover, has a pendant in another Rauschenberg combine produced around the same time, *Odalisque* (1954–58), which is topped, instead of *Untitled's* hen, by a cock, a large rooster. The title is a pun on two seemingly opposing gendered constructions—the reclining female nude odalisque and the phallic form of the obelisk—and in distinct contrast to *Untitled,* the combine abounds with heterosexual implication (fig. 23). One side of the free-standing combine is bedecked with images of women. On the other sides of the box are images of masculinity and its social performance: businessmen, athletes, matadors fighting bulls, and two illustrations for throwing a punch, labeled "correct fist" and "incorrect fist." Linking the male and female imagery in this heterosexual image bank is the postcard reproduction of Picot's *Cupid and Psyche,* showing Cupid leaving Psyche's bed.

In his original conception of the piece, Rauschenberg revealed in an interview, he intended to have the thrusting balustrade pierce a cardboard wedding cake he had seen in the window of a Woolworth's, but as the icing kept falling when he sawed into it, he substituted a series of pillows for the cake.[87] Taken together, these images correlate *Odalisque* to a performative heterosexual masculinity—one literally topped by a cock—in contrast to the homosexual intimacy of other combines such as *Untitled (Man with the White Shoes)* of 1955 and its stuffed hen.[88]

The central project of this period in Rauschenberg's life was a series of drawings, each one an illustration of a canto of Dante's *Inferno* (fig. 24). As was the case with the original Italian poem, Rauschenberg uses the tale to settle scores, using the rich analogy of infernal damnation to comment on those around him. In *Canto XIV* (pl. 44)**,** Rauschenberg illustrates Dante's account of his homosexual teacher, Brunnetto Lantini, a man Dante placed among other sodomites roughly halfway down in hell. Their punishment was to run eternally barefoot over hell's hot sands, presumably an account of placelessness and persecution. In *Canto XIV,* Rauschenberg outlines his own foot in red. This coded self-identification with a sodomitical hot foot implicates Johns as well, for tiny footprints travel down the left edge of the image, ending in what is clearly a furling edge of an American flag—shorthand for Johns in many of Rauschenberg's works.

Johns's pictorial referencing of sexuality was, if anything, even more oblique. As their relationship came to a close, Johns produced a series of gray paintings still burning with anger and accusation. In quick succession he painted such totems of negation and hostility as his *Liar, No, Good Time Charley,* and *Painting Bitten by a Man,* all of which, even at the superficial level of their titles, are redolent of accusation and despair.[89] But, as was typical of Johns, such expressive painting could not stand unmediated by any other kind of semiotic play. For example, while the word "liar" appears to be printed by the printer's woodblock at the top, this printing device is in fact merely drawn, an illusion, thus making *Liar* also lie about its own making and appearance—a superficial lie masking a deeper one.

But one painting more than any other conveys Johns's feelings of loss, ventriloquized through Frank O'Hara's great poem "In Memory of My Feelings," which was itself a coda to the end of a love affair. In the poem, O'Hara describes how in the act of making a poem, he tried to contain and assuage the pain he was feeling by turning these emotions into art and thereby ossifying them. But he fails, considering this state of all-consuming loss analogous to a "cancerous statue" in the final stanza of the poem.

But even making art out of loss, as this poem does, cannot not serve to distance the pain ("I could not change it into history and so remember it"), so in a self-saving gesture, the poet seeks the eradication of the "scene of my selves." Following the end of the affair, the poet now must literally pull himself together. But in so unifying his diverse identifications, he is left with a pervasive sense of loss ("which I myself and singly

must now kill/and save the serpent in their midst"), for the singular, reactive self is a "serpent"— selfish, jealous, devious, and deceitful. In short, O'Hara's poem is about the necessary end of empathy in moments of crisis, the closing down of feeling in order to reinforce a self threatened with its own dissolution.

While hardly an illustration of O'Hara's poem, Johns characteristically uses the literary precedent to voice his emotions. The image as a whole is a gray negative of Johns's first painting of the American flag, the key image with which he inaugurated his relationship to Rauschenberg. But *In Memory of My Feelings—Frank O'Hara* (pl. 46) is also clearly divided down the middle into two hinged halves. These two sides roughly correspond to the period during and after his relationship with Rauschenberg. On the left, a prominent fork and spoon are wired together— an emblem of domesticity, "spooning." These implements have been forced apart on the other side, barely visible in light gray on the far right. (Johns would paint this separated spoon and fork very subtly, sometimes almost imperceptibly, in the background of five subsequent canvases.) *In Memory of My Feelings—Frank O'Hara* is an attempt to recast his relationship to Rauschenberg through conjuring the "serpent" of O'Hara's poem—all the anger, jealousy, selfishness that animates works such as *Liar, No, Good Time Charley,* and *Painting Bitten by a Man* as well. Johns even painted a skull and the words "DEAD MAN" on the right panel of the painting, only to paint it over—a cathartic gesture obscured, just as the entire painting can be folded up, its fraught surface disappearing.

In his subsequent painting *Voice,* these now-divorced piece of cutlery—an actual fork and spoon hang separated by a few inches—together pull down a counterweight that causes a wooden block to wipe away the word "voice." Plaintively, this picture seems to underscore Johns's worry that absent the sole partner with whom he could speak, he would, as it were pictorially, lose his voice. But John's 1964 *Souvenir* (pl. 53) is a recovery of sort. *Souvenir* is a complex self-portrait machine (a flashlight illuminating a mirror reflecting a self-portrait photograph printed onto a plate), yet the promised self-revelation of this self-portrait stands endlessly deferred behind a flurry of strokes insolently denying the viewer's gratification. The refractions among flashlight, mirror, and portrait plate never quite square up, creating the emblematic frustrated, and frustrating, Johns self-portrait.

But in *Ventriloquist* (pl. 80) Johns finally begins to open up, revealing himself, albeit indirectly, through objects, themes, and symbols of personal significance, which include his private collection of pots from the eccentric turn-of-the-century potter George Ohr; a reproduction of a whale, mouth agape, from the frontispiece of a limited edition of *Moby-Dick;* two variants of his trademark flag images; the hinged canvas from *In Memory of My Feelings—Frank O'Hara;* a so-called portrait vase of Queen Victoria and Prince Albert, showcasing either their profiles or the fine lines of the vase, but not both at once, etc. What connects these disparate objects, aside from their relationship to Johns, is their distantiated relation to self-revelation. The upper-right framed image is an untitled 1961 print by Barnett Newman, situated above two of Johns's flag prints, the trailing edge of a normal red, white, and blue one, and then a green, orange, and black variant that, if you stare at it long enough and then stare at a white sheet, will reverse itself into red, white, and blue. Though painted by the artist, this reversed flag literally achieves its identity only in the eyes of the viewer, and as such makes literal the ventriloquism of this painting, as does the figure of Moby-Dick. As Ahab's relationship to the white whale to whom he was bound in hate ventriloquized Melville's relation to his own sexuality, so too does Johns's referencing of that great gay novel ventroquize his.[90]

At the same time Johns and Rauschenberg were living in a cold-water flats in Coentes Slip, abstract painters Agnes Martin and her good friend Ellsworth Kelly lived nearby. Coentes Slip was a nineteenth-century neighborhood of shipping company warehouses that by the mid-fifties constituted the bohemian tip of Manhattan— it has now been torn down and has become more or less Battery Park. But in the fifties, rents were low and lofts large. Martin had moved there from New Mexico to earn her M.A. at Columbia Teacher's College. Within a few blocks lived a coterie of the early post–abstract expressionist queer avant-garde, including artists she knew glancingly such as Cage, Cunningham, Johns, Rauschenberg, and Twombly, and those who made up her immediate circle. In the latter category was Martin's then-partner Lenore Tawney, a noted fiber artist, and the artists Ann Wilson and Ellsworth Kelly. Despite the centrality of Martin's transformative years in Coentes Slip, the specific social character of what was then one of America's only largely queer artistic enclaves is rarely referenced. Yet it was here that Martin first finally made work that satisfied her, even if, after returning to New Mexico, she largely left this queer social world behind. Martin left New Mexico a middling representational painter and

in Coentes Slip transformed herself into perhaps the most nuanced abstract painter America had yet to produce, the consummate painter of grids.

Central to this transformation in her work is an embrace of Zen, less as a form of religious practice than as a habit of mind. Only in retrospect does it make sense that the zenith of Zen Buddhism's influence in American cultural life was probably the mid-fifties. A doctrine intimately tied to a recently vanquished Japan would hardly seem poised for success amidst the Cold War's managed xenophobia. Moreover, Zen's rapid cultural ascent had yet another Achilles heel: at the height of the so-called Lavender Scare, the leading proponents of an American Zen aesthetic were largely homosexual.[91] Composers such as John Cage and Lou Harrison, poets such as Allen Ginsberg, and visual artists such as Mark Tobey all produced work clearly indebted to Zen precepts. Agnes Martin, too, belongs in this company, and though she was not a practicing Buddhist, she can often look and sound like one.[92]

In place of most religions' tendency to value revelation as generalized and textual, Zen instead made it individuated and experiential, a "turning the eye inward." Martin's mature paintings have been widely discussed in terms of this inward eye, and their combination of rigorous discipline, painstaking execution, and transcendental ambitions have clear affinities with Zen. The grid, with its equilibrium of verticals and horizontals, its inherent limitlessness, its seamless incorporation of any singularity into a coherent overarching structure make it almost a metaphor for Zen's pursuit of that meditative state where interiority and the outside world meet. Moreover, once the first vertical and horizontal marks are laid down, a grid almost generates itself, becoming an exercise in pure execution, a kind of manual mantra.

The repeated invocation of water in Martin's early titles—i.e., *Deep Blue, Dark River, This Rain*—amplifies the Zen connection, for water is perhaps the most important metaphor of Zen consciousness. Water is at once always different and always the same, the material, time-traveling incarnation of the Zen vision of interconnectedness across time, space, and being.[93] Zen meditation is in part an attempt to quiet the hungry ego in order to catch a glimpse of that continuum. As Martin put it in her "The Untroubled Mind," "By looking in to my mind, I can see what's there. . . by bringing thoughts to the surface of my mind I can watch them dissolve."[94]

For closeted homosexuals at the height of the Cold War such as Martin, Zen offered a distinctly different, and far more salutary, relation to a pro-scribed identity than did any of the dominant Western traditions. In Western thought, to not address or articulate something was to engage in an unhealthy suppression and, following Freud and others, repression had but two courses: either to stay damned up and fester, or to burst through. Both formulations consequently understood the closet as an evasion that would ultimately wreak emotional havoc, but since homosexuality was then against the law, the Western tradition had only the bleakest of prospects to offer. On the other hand, Zen understood silence as healthy and productive, for in allowing thoughts to arise and disappear, the self was better able to sound its deep connection to other forms of being. Paradoxically then, the evasion of sexual difference, inevitably eventually sorrowful in the Western tradition, under Zen became its own palliative. No wonder closeted homosexuals like Martin chose a Zen ethos amidst a violently repressive era.

While Martin assiduously destroyed the vast majority of her early work, there survive several female nudes from around 1949 that are in all likelihood portraits, most probably of her then-partner.[95] Martin herself tells us that another early painting, from around 1951 and now destroyed, was entitled *Fathers and Sons*. This painting, which won first prize in the Taos art fair, is described by Martin in an early article by Lizzie Borden: "Martin has indicated that the subject of the painting is a father worrying that his son is not masculine enough, forgetting that sons are not born manly."[96] Nude female portraits and fraught scenes of gender nonconformity are hardly what we think of when we consider Martin's serene art.[97] But that that came to be the case is itself a telling art-historical development, and one in which Ellsworth Kelly plays at least a small part.

Kelly first began to work in his celebrated hard-edged style in France, where he went to study under the GI Bill. His earliest works are abstract distillations of everyday objects, such as windows and toilets, but soon Kelly was making boldly colored multipanel works of remarkable surety. In time, these geometric abstractions often (though hardly always) carried resonances that were distinctly bodily, as if his hard-edged geometries could be animated by more fleshly desires. In a self-portrait photograph, Kelly stands nude, his torso obscured by a painting of opposing curved lines that echo the feminine form, playfully feminizing his highly masculine body. In other works, hard geometries seem to pull toward or against each other, as if seeking to break out of pure abstraction in response to something that looks like bodily desire—two phallic forms flopped atop one another.

Fig. 25 / *Self-Portrait with Thorn* by Ellsworth Kelly (born 1923), oil on wood, 1947. San Francisco Museum of Modern Art, California; gift of the artist

While Kelly, like Martin, was once a more figurative painter, unlike her he has continued to make portraits and other figurative works alongside his more geometric mode. Some of his earliest portraits are self-portraits, and several of these almost vibrate with a self-conscious intensity that marks a profound difference from other figurative work of the period. In his 1947 *Self-Portrait with Thorn* (fig. 25), Kelly paints himself holding a prickly bush, a literally self-lacerating portrait. His face is a mask of determination as he gingerly, yet firmly grasps that which he knows will wound him. A self-portrait that is a performative acknowledgment of self-inflicted injury, this image beautifully lends itself to psychological interpretation as a metaphor, if elusively so.

Kelly's *Portrait of David Herbert* (pl. 43) also marries a physiognomic likeness with nuanced psychological insight. Herbert was an art gallery manager, most notably for Betty Parsons's highly influential gallery (1951–53), and its successor as the chief purveyor of abstract expressionism in its formative years, the Sidney Janis Gallery (1953–59). Later he would own his own eponymous art gallery. Herbert discovered the work of Ellsworth Kelly, who had previously exhibited only in France, and introduced him to Parsons, thereby securing his first U.S. exhibition and effectively launching his career. Here Kelly returns the favor in a portrait that is as notable for its casual intimacy as it is for its departure from Kelly's celebrated mode of geometric abstraction. A shirtless Herbert relaxes in an Adirondack chair, his hands placed, seemingly casually, on his lap. But this hint of eroticism, no more than a suggestion, transforms the portrait into something altogether more charged, an exemplar of the subtly modulated gestures through which gay people could communicate fellowship under the very nose of an unseeing, often hostile, dominate culture.

Ray Johnson, like Johns, Rauschenberg, and Kelly, also directed much of his artistic attention to a small circle of friends and like-minded figures, larding his work with signs, codes, and other content legible only to a select few. But Johnson went further than his peers by electing to circumscribe his audience largely to these figures, refusing wider circles of distribution and display by pioneering a new genre—mail art. Johnson would post, unsolicited, works to friends and people he wanted to meet, and if they were responsive, a correspondence would ensue that entailed the exchange of work by mail. As a result, Johnson can be understood as an exemplar of what the poet and essayist Paul Goodman had argued in 1951 was the best palliative for an avant-garde in what he termed the "shell shocked" Cold War society of his time: to be an avant-garde artist was to concentrate on a community of like-minded friends, create work specifically for them, and thus safeguard an independent culture.[98]

Goodman's elevation of the power of community and fellow feeling not only melds seamlessly with Johnson's peculiar means of circulating his art, but with a longer tradition of queer artistic circles and salons. From Gertrude Stein's famous gatherings at 27 rue de Fleurus and Frank O'Hara's occasional poems (poems written for friends at birthdays and other parties), to Rauschenberg's fossilized missives to friends embedded in his combines, queer work has often reified a particular construction of audience as friends or intimates. Thus "occasional poetry" became the means through which queer artists established culture, commonality, and community in the face of the overt homophobia of postwar America. The postwar period's triumphant psychoanalytic models worked to isolate, individualize, and pathologize sexual difference as one's own personal neurosis and private failure—thereby cleaving queer people from one another. In its place, queer artistic *communitas* instead linked people.[99] At a cultural moment in which early queer activist groups like the Mattachine Society actually invited psychologists to lecture their membership on the relationship between same-sex desires and neurosis, the impulse to contain and delimit the audience to one's work can seem merely a rationale response to a truly hostile culture.

Andy Warhol, no less a painter of friends and acquaintances, nonetheless produced a body of work that is the polar obverse of autobiographical. While the various incarnations of his studio (deemed, with typically Warholian irony, the Factory) always included friends and hangers-on who generally found themselves one way or another impressed into or otherwise incorporated into artwork, there is nothing particularly intimate or revelatory, much less autobiographical, in Warhol's variant on occasional poetry. In fact, Warhol's art seems keyed to resist self-revelation, as if he took dominant culture's refusal to countenance queerness as a literal injunction. Warhol became all surface, so much so that when he describes himself in 1975, the terms he used to depict the face staring back at him in the mirror consisted of a compilation of journalists' descriptions of his own physiognomy. As Warhol once famously wrote, "People are always calling me a mirror and if a mirror looks into a mirror what is there to see?"[100]

Fig. 26 / *Marilyn Monroe's Lips* by Andy Warhol (1928–1987), synthetic polymer, silkscreen and pencil on canvas, 1962. Hirshhorn Museum and Sculpture Garden, Smithsonian Institution, Washington, D.C.

Fig. 26 / Detail

Yet Warhol's consistent refusal to go beneath the surface becomes a kind of performance. A kind of walking, talking personification of the closet, Warhol's performance of his self-shielding is so perfectly obvious that the central purpose of the closet—the closeted subject's seamless integration into dominant, heterosexual culture—is instead turned inside out, its seams showing for all to see. Characteristically, when Warhol decided to buy a wig to cover his thinning hair, in place of the usual naturalistic hairpiece, he chose one that unambiguously broadcast its identity as artifice. Warhol so frontloaded his persona with similar obstacles to sympathetic identification—his monosyllabic responses to inquiries, his schoolboy vocabulary, his emotional illegibility—that there could be no doubt that whatever reading we produced of him was our own projection. So it is no surprise that the large self-portraits he produced just before his death cloak themselves in a camouflage pattern. Even in that most self-revelatory of genres, Warhol's depiction of self-hood is not just camouflaged, it is manifestly, performatively so (pl. 83).

But earlier in his career, Warhol wore his heart—and his politics—on his sleeve. He produced drawings of friends and lovers suffused with tender intimacy and frank eroticism. And he shrewdly connected his name to celebrities for whom he felt a particular connection or affection, as in his imaginative drawing of Truman Capote's shoe (pl. 41). More aggressively, he proposed an exhibition of boys kissing boys around 1956 for the Tanager Gallery, an artists' cooperative gallery on Tenth Street that listed Willem de Kooning as a charter member.[101] The proposal was, not surprisingly, rejected. But Warhol nonetheless produced numerous delicate drawing of boys kissing each other, along with other images of an express homoeroticism long before the modern LGBTQ liberation movement. Yet it was precisely this prescient, forthright homoeroticism that he rejected in seeking to leave a successful career as a graphic artist behind and become a fine artist. As he moved toward this goal, he took to emulating artists such as Johns and Rauschenberg, learning to code and otherwise connote what was once explicitly evident in his work. The now-banished explicit homoeroticism of his graphic work instead resurfaced in his films, notable for their unabashed evocations of same-sex desire at a political moment when such representation were still subject to legal sanction. In addition to their explicit queer content, the films also pervasively reoriented the eye of the camera, and thereby of the audience. Whereas in mainstream film, the lens so often luxuriated in following the

form of a beautiful woman, in Warhol's cinema, it tracked a man's body, and the audience, whatever its inclinations, had no choice but to follow suit. In Warhol's hands, the cinematic gaze acquired a pervasive and unabashed dissident sexuality.

Still, Warhol didn't really banish his queer politics from his painting; he merely learned to sublimate and channel sexuality in a carefully calibrated way. For example, in place of his earlier drawings of the male nude, he produced a large painting of a male torso in cross-section, but since its flat, linear style made it look like a medical textbook illustration, complete with arrows pointing to various parts of male anatomy, the painting recast itself as a much more acceptable citation of a drawing of a nude man, and not a nude man itself. He silkscreened several handsome photos of his painterly idol Robert Rauschenberg, naming some of the resulting paintings *Let Us Now Praise Famous Men* in emulation of the famous Walker Evans/James Agee collaboration about sharecroppers in the dust-bowl—precisely the place Rauschenberg himself was born. In these, and in other images of wigs or nose jobs (shortly after he had his own nose medically treated) Warhol found a way to deploy his subjectivity indirectly, even illegibly.

In time, as he learned to sublimate and modulate his authorial voice ever more completely, it seemed he was truly transforming himself into the mirror he claimed to be. Yet careful attention reveals the other side of that mirror. For example, Warhol seems to have been attracted to celebrities largely at the moment when their mask began to slip, when events ruptured the seamlessness of their facade. He painted Elizabeth Taylor as gossip swirled about her bad behavior on the set of *Cleopatra*, silkscreened Jackie Kennedy following the assassination of the president, and tracked Marilyn Monroe only after her death revealed the pain she was in (fig. 26). His very first silkscreen painting was of Troy Donahue (pl. 48), the handsome blond sixties star who was rumored, incorrectly, to be gay (and often confused with Tab Hunter, who in fact was).[102] In short, Warhol was attracted to the cracks in celebrity facade at precisely the moment he was crafting his own, transforming himself from a bookish intellectual with season tickets to the ballet into the reflective surface he became.

English-born David Hockney also recast himself, with great deliberation, as a Californian, rectifying an accident of geography. His image of California, informed by the photos of tanned hunky surfers reproduced in such soft-core gay publications such as *Physique Pictorial*, made it seem Edenic, and if anything, his own subsequent

Fig. 27 / *Myself and My Heroes* by David Hockney (born 1937), etching and aquatint on paper, 1961. Tate Gallery, London

Fig. 27 / Detail

paintings have only further burnished the myth. He was able to subsidize his first year in California through the sale of a series of prints that updated William Hogarth's famous eighteenth-century *Rake's Progress*. In Hockney's version, he casts himself as the Rake, arriving in New York, going to gay bars, dyeing his hair blond, and in many other respects mirroring his real life. From his earliest exhibitions, Hockney has been forthright about his sexuality, making it perhaps his chief subject, even when still in art school in England. In interviews, he has had no compunction about calling his early work, in part, propaganda, because he felt that no one in the art world at the time was willing to stand up and acknowledge a gay identity publicly.

In one such early work, *We Two Boys Together Clinging* (pl. 47), Hockney reimagines the eponymous poem in Walt Whitman's Calamus section of *Leaves of Grass* as an erotic exchange between two abstracted figures. They are bound in a web of mutuality itself drawn from Whitman's notion of adhesiveness, the Whitmanic ideal of deep friendship becoming physical. Redeploying Whitman's simple schoolboy numerical alphabet (such that the "4" in the painting equals the letter "D" as in David), Hockney makes the imperative to encode homosexuality literal at a time that it is against the law. But the code is so simple, so manifestly a code, that it shares almost nothing with Johns and Rauschenberg's baroque redirections and instead seems born more of protest than precedent (fig. 27).

That the 1969 Stonewall riots constituted the defining moment in the development of the modern gay and lesbian liberation movement was recognized even shortly after they concluded. Yet this watershed historical moment, like most such moments, had clear historical antecedents and unclear ramifications. Indeed, the riots pointed up one of the great debates of the early days of gay and lesbian liberation, namely whether LGBTQ rights were best secured through a minority model, which involved the articulation of particular sexual differences, or whether freedom was best won through a general liberation that deemphasized differences in favor of a universal humanity. These debates had real-world consequences. For example, less than five months after the formation of the Gay Liberation Front in the aftermath of the Stonewall riots, there was a vote on whether or not to support the Black Panthers. A group of activists who were instead interested only in the pursuit of gay liberation walked out and formed a competing organization, the Gay Activist Alliance.

For many in the early days of gay liberation, sexuality was merely one of many forms of human difference suppressed by the dominant straight, white, male majority. For these more radical liberationists, gay rights was of a piece with gender equality, the civil rights movement, opposition to the war in Vietnam, and capitalist exploitation, and so to succeed on gay liberation alone would be to perhaps win the battle but lose the war. As Nick Benton, writing in the early gay publication *San Francisco Gay Sunshine*, explained, the gay movement was dedicated to

Those who see themselves as oppressed—politically oppressed by an oppressor that not only is down on homosexuality, but equally down on all things that are not white, straight, middle-class, proestablishment. It should harken to a greater cause— that cause of human liberation, of which homosexual liberation is just one aspect.[103]

Japanese-born painter and performance artist Yayoi Kusama conducted a "homosexual wedding" in 1968 (pl. 56), the year before the Stonewall riots. She hired the performers, designed and sewed their costumes, alerted the press, and choreographed the entire event. But the performance of a homosexual wedding was something of a departure for Kusama, whose pursuit of liberation in her art leaned toward a universalist ethic of human commonality, as her famed *Self-Obliteration* performances underscore. These were a series of similar guerilla performances at different prominent sites around the world, including, for example, in New York at the Brooklyn Bridge and the garden at the Museum of Modern Art. For each performance, Kusama organized a group of dancer/performers to show up at a particular time at a particular place— always carefully alerting the press to the event, but not seeking official permission. Then, as music played, the participants danced and stripped as Kusama painted their bodies with her signature equalizing polka dots, transforming specific bodily differences into a scene of overarching similarity. These self-obliterations achieved a distinctly political cast in underscoring how differences in gender, race, sexuality, etc.—the normative social differences we deploy to classify people—fell away before a unified visual field of polka dots. In her work, the radical post–Stonewall liberationist ideology secured a visual cognate.

Robert Morris's work of the early 1960s bears striking similarities to the art of Jasper Johns, employing many of the same materials and motifs. Morris and Johns were extremely close

Fig. 28 / Lynda Benglis's advertisement in *Artforum* (New York), November 1974. Courtesy Cheim & Read, New York City

at this time, collaborators and intimates. His 1962 sculpture *I-Box,* shaped like the eponymous letter, certainly resonates with Johns's celebrated images of isolated letters or numbers, but marks out a difference from Johns in being more self-revelatory—literally so. When the small handle of *I-Box* is opened, there is a small nude portrait photo of Morris inside. Perhaps the most striking thing about the nude photograph that Morris selected is how ordinary, friendly, and unposed he seems, his body in no way conforming to the heroic masculinity that generally underwrites a man's willingness to disrobe in public. This is neither the active masculinity of, for example, Hans Namuth's famous photos of Pollock painting, nor the passive, but indubitable masculinity of the male pinup or Hollywood star. Indeed, if anything, *I-Box* seems an attempt to pierce the many poses of masculinity—not least those adopted by a generation of closeted post–abstract expressionist artists—by appearing both accessible and unposed.

But in the poster for his "Labyrinths Voice, Blind Time" exhibition at the Castelli/Sonnabend Gallery in 1974, Morris adopts the obverse posture. Dressed like a gay leatherman, with all the accoutrement of S&M tastes, he flexes an impressively developed, oiled bicep while leveling a hard stare at the viewer from behind the requisite sunglasses (pl. 60). How do we account for the enormous distinction between these two self-portraits? It's important to note that the "Blind Time" poster appeared in the magazine *Artforum* at around the same time as Lynda Benglis's infamous nude self-portrait with a double-headed dildo (fig. 28). Benglis was ridiculing the active misogyny of the art world and its masculinist presumptions, presumptions that, on the face of it, Morris, too, seems to have embodied in his poster. But interpreted alongside his earlier *I-Box,* and in concert with his performance work at Judson Church, a more nuanced picture emerges of an artist exploring the many poses of masculinity, who understands maleness as a kind of drag.

Lucas Samaras's series of self-portrait Polaroid photos, what he called his *AutoPolaroids,* also engage the performance of masculinity, albeit along the full spectrum of gender (pl. 58). Occasionally donning a wig and makeup, Samaras adopts a series of stereotyped identities and poses—ingénue, shyster, femme fatale, hack—in the process detouring self-portraiture away from the exploration of authentic self and back toward a Duchampian marshaling of competing identities. In the same series, Samaras took photographs of his erect penis in the bathtub

and his nude body from such an angle as to reveal his anus—again ranging masculinist phallic autonomy against the site of potential male penetration. These *AutoPolaroids* call to mind works like Vito Acconci's 1974 filmed performance *Open Book,* in which he attempts to speak while never once closing his mouth. As he recites phrases like "Come inside, I'm open to you, I want to feel you in me," the disjunction between his craggy male face and stubble, the obvious effort required to speak without closing his mouth, and the stereotypically female phrases he utters puts pressure on gender in the way Samaras did a few years before. Morris, Samaras, and Acconci all sought to use their maleness as parody, and like all such parodies, they necessarily relied on the very category they were critiquing to score their points, leaving them open to misunderstanding.

David Wojnarowicz's *Arthur Rimbaud* series (cats. 63 a–d) buries a kernel of earnestness in its reanimation of the nineteenth-century homosexual poet and dissident, now made to wander the streets, byways, and arteries of New York like an anti-Whitman. Rimbaud, perhaps most famous for having written "Je est un autre," or "I am another," appropriately enough literally becomes another, by way of lending his visage to a mask animated a century later. But Wojnarowicz's decentering of selfhood through this act of appropriation, which on the surface shares so much with works by Morris, Acconci, and Samaras, betrays a key difference. In one image in the series, the Rimbaud avatar stands at the piers, the epicenter of gay male cruising in 1970s New York. He is posed before a wall featuring a drawing of a male nude and a spray-painted graffito reading, "The Silence of Marcel Duchamp is Overrated." Originally uttered by the German postwar artist Joseph Beuys in 1964 as protest against what he saw as the accommodationist tendencies of that pioneering postmodernist, by 1978, when Wojnarowicz began this series, it could as well refer to the celebrated—and closeted—artists most responsible for reinvigorating Duchamp's career in the 1960s: Jasper Johns and Robert Rauschenberg. Wojnarowicz, the image suggests, found their emulation of a Duchampian silence overrated as well.

Indeed, LGBTQ art of this period was often anything but silent, and portraiture—and often self-portraiture—became perhaps its chief métier. Portraiture had the clear advantage of exploring, and more to the point, *declaring* identity and community within a post–Stonewall political moment that still saw "coming out" as its chief political strategy. When all LGBTQ people were finally visible as such, it was widely held, so

many people would have family or friends who were LGBTQ that prejudice would just disappear. But Stonewall also engendered two very different ideas about what coming out entailed. For some, it meant the declaration of an LGBTQ identity, an unambiguous assertion of being. Yet for others, such as was likely for Wojnarowicz in his Rimbaud series, coming out did not mean taking up an identity already scripted, but rather denying the seamless truth claims of any particular identification. However, what made the post–Stonewall visions of identity distinct from the earlier postmodernist refusal of an essential self, as authored by figures like Johns and Rauschenberg, was that it had nothing to hide. While a pre–Stonewall skepticism about expressivity was deployed as cover (and as we've seen, plenty of expression took place beneath it), post-Stonewall forms instead were, like O'Hara's poetry, abundantly clear about an author's sexuality—yet equally unclear about knowing exactly what that meant or what significance it contained. Why couldn't one be both public about one's sexual orientation and still refuse to participate in a conceptual framework that cleaved gay from straight, defined sexuality as the most salient aspect of character, and denied the possibility that absent oppression, sexuality was a particularly useful or important category? For many portrait photographers of the post–Stonewall period such as Peter Hujar, Mark Morrisroe, Nan Goldin, Robert Mapplethorpe, and Annie Leibowitz, all of whom began working in this period, this was their challenge. A post-Stonewall politics of making visible—and articulate–sexual difference suffuses their work, but what this visibility means is still a question.

Perhaps no work better crystallizes this dilemma of visibility than a striking painting by Andrew Wyeth, son of N. C. Wyeth, father of Jamie, and celebrated incarnation of a form of American painting widely believed to be under siege. The remarkable thing about his 1979 painting *The Clearing* (pl. 65), a nude portrait of a young friend of the Wyeth family named Eric Standard, is how fully it traffics in homoerotic codes and standards. The young model, beautifully built, with long blond hair blowing in the wind, is portrayed as a late, gay Botticelli *Birth of Venus*, a male Aphrodite, a generalized object of desire. Politically progressive works by Andrew Wyeth are hardly rare, and assumptions about his politics based on his realist style don't hold water, but *The Clearing* takes this to extremes. Not surprisingly, it has long been something of a gay icon, widely reproduced in gay magazines in the early 1980s, where the magic of the Wyeth name, the aura

of his traditional style, and the flagrant display of nude male beauty ensured the work's popularity, especially at a moment when a flood of images of people with AIDS was causing the more traditional representation of ephebic beauty to disappear. Testimony to the convergence of high culture and low, Wyeth's painting unabashedly plays along the line, its provocation undimmed. It is a painting of a beautiful male youth—there is nothing else to look at, no literary or historical conceit to justify the expanse of bare flesh—and it was rare to find a painting of a man so unapologetically unafraid of his beauty, all the more so when painted by a celebrated family man, renowned for his female nudes.

Duane Michals's *Chance Meeting* (pl. 57), photographed only a year after the Stonewall riots, is an exercise in the new politics of gay visibility. Organized like a storyboard, the sequence captures two men passing one another in an urban setting; one looks at the other, but the object of his gaze does not return his glance. Only when they are far apart does the object of the gaze turn around. Eloquently and economically, Michals's photograph sequence suggests the fear of public acknowledgment, and perhaps even self-acknowledgment, that had so long isolated LGBTQ people; implicitly, and in keeping with its moment, the image is undergirded by a call to come out.

But the LGBTQ coming-out catechism also papered over key ideological and political divides in a period that still saw widespread racism and sexism even within its own ranks. The term "gay" was sometimes refused as an inherently white nomenclature, and some lesbians, in response to a sexism so profound that a form of male separatism—at clubs, organizations, bars, and other community venues—went completely unremarked, instead decided that separatism was the only way forward. Artists, and in particular portrait artists, went a long way toward explaining aspects of a divided body politic to one another. Tee Corinne was exemplary in this regard, as an artist, art historian, and, in perhaps her most widely known guise, as author of *The Cunt Coloring Book*, a multi-editioned mainstay of lesbian self-determination first published in 1975. *The Cunt Coloring Book*, deliberately printed on cheap paper and sold at a price deemed within the reach of nearly everyone, consisted of a series of black outlines of different vaginas with detailed images of labia, alongside several blank pages in which the reader was encouraged to draw her own "cunt, and the cunts of her friends." In self-consciously adopting the highly charged language of its title and in encouraging

Fig. 29 / Georgia O'Keeffe place setting, from *The Dinner Party* by Judy Chicago (born 1939), mixed-media installation, 1974–79. The Elizabeth A. Sackler Center for Feminist Art at the Brooklyn Museum, New York

contemplation of the vagina as not only worthy of note but of artistic embellishment, Corinne sought to demystify and celebrate an aspect of female anatomy that generations of women had been taught to ignore. Indeed, the best-selling feminist classic, *Our Bodies, Ourselves*, first published by the Boston Women's Health Book Collective in 1970, encouraged women to squat over a mirror so as to become familiar with their own anatomy. Roughly coterminous with Corinne's coloring book was the development of Judy Chicago's iconic feminist installation *Dinner Party* (1974–79), an enormous installation featuring thirty-nine finely wrought place set-tings, largely in a vulvar format, for significant historical women at a triangular table (fig. 29).

Corinne's photographic work often took the form of solarizations, a simple process whereby a diffused light is shone on a developing negative, resulting in an image that is part negative and part positive. Corinne chose the process to enable her to work with images of nude women but maintain anonymity for her models, as well as not risk having her lesbian imagery resurface as pornography for heterosexual men. In her 1982 series *Yantras of Womanlove,* she deploys solarization and multiple prints to create a kaleido-scopic, nearly abstract imagery nonetheless anchored in photography. It takes much dedicated looking at her *Yantra of Womanlove #41* (pl. 69) to parse the erotic scenario at its center.

Tseng Kwong Chi's photographs of landmarks like the Eiffel Tower, Disneyland, or the former World Trade Towers (pl. 75) ironically appropriate Asian stereotypes in order to deconstruct them. Though born in Hong Kong, he moved to Canada as a teenager in 1966 and was named Joseph Tseng. He officially changed his name to Tseng Kwong Chi in 1979, moved to the United States, and began his decade-long *East Meets West* photographic series. Donning a Mao suit, he posed as a Chinese tourist taking photos of Western landmarks. The resulting photographs succeed by contrasting his deadpan inhabitation of a Western stereotype of a Chinese Communist identity with the inherent individualism of a portrait photograph snapped before the very temples of Western capitalism. Tseng also pursued documentary photography, chronicling the then-burgeoning East Village art scene and its denizens such as Keith Haring, who be-came a friend.

Peter Hujar's portrait photography and the work of Nan Goldin both seem to turn on a mea-sure of preexisting intimacy between photographer and subject—Paul Goodman's vision of an art of friendship, albeit realized long after

the Cold War period he was addressing. In this incarnation, the photographer charts the inhabitants of a social world that was self-consciously not normative. Goldin's long photographic project, first published under the title *The Ballad of Sexual Dependency* in 1986, began as a series of slide shows, one photograph rapidly following another, collectively evincing a strong sense of place and character. A product of a social compact that enabled Goldin to photograph her subjects intimately—on the toilet, having sex, in or in the aftermath of a fight—she always implicated her presence in the scenarios she captured (cats. 59, 87). *The Ballad of Sexual Dependency* was a visual diary of a historical moment and its interwoven subcultures, wherein the categories of gender, race, sexuality, class, and nationality seemed suspended in favor of a new, manifestly hip, "downtown" scene.

But whereas Goldin's work offers the voyeuristic pleasures of unguarded glimpses into other people's lives, Hujar was more of a studio photographer, and his subjects seem aware that they are being photographed even when they aren't looking directly at the camera or posed in a studio. Intimate yet formally composed, Hujar's works strip away the very accoutrements that would place his figures in a context—Goldin's defining aspects. This enables us to concentrate not on actions or dress, but the very traditional stuff of portraiture—a sense of interiority, presence, and the performance of selfhood. Hujar is aided and abetted in this by choosing individuals who were, or would shortly become, significant cultural figures, and he produced images of them that, while not trafficking in their traditional personas, nonetheless rely heavily on their character as compelling people. In another contrast to Goldin's work, Hujar's emphasis is less on his own presence in the scene and more directly focused on his sitters, which included early photographs of his one-time lover David Wojnarowicz (pl. 78), along with the great drag impresario Ethyl Eichel-berger (pl. 68), and an unusually unguarded Susan Sontag (pl. 62). These images are equally documents of a scene, a place, and context at a particular historical moment, but that is not their raison d'etre.

Straddling these two very different photographers of a human occasional poetry is the work of Robert Mapplethorpe. His works constitute an admixture of Goldin's self-implicating evocations of a scene and Hujar's sensitive characterizations, with the additional fillip of his own very clear authorial and editorial stamp. His portrait of Brian Ridley and Lyle Heeter (pl. 64) is a case in point. He photographs the men, devotees

Fig. 30 / *Five Times for Harvey #4* by Robert Arneson (1930–1992), mixed media on paper (one of five parts), 1982. Promised gift to the San Jose Museum of Art by J. Michael Bewley, in honor of the museum's thirty-fifth anniversary

of an increasingly visible gay leather subculture in a standard suburban interior, indulging in the ironic interplay between the bourgeois setting, the couple's deadpan parody of shopping-mall studio photography (dad standing, mom seated beside him), and of course their obvious embodiment of a gay leather erotic. At once affirmative of the couple and satirical of the larger context, Mapplethorpe's photograph limns a very different kind of scene than the hip downtown life of Goldin's work, but one that is no less self-consciously dissident. What marks it as peculiarly Mapplethorpe's, however, is its aggressive appropriation of traditional photography—the domestic interior, the patriarchal posing—for other purposes. The furor that erupted over Mapplethorpe's work was in part born of a pushback against his insubordinate appropriation of a range of comfortable and familiar photographic conventions. His work thus managed to look both conservative and defiant at the same time, making it, at the very least, harder to dismiss as "merely" political. Worse even than his insolent appropriation of photographic conventions was his deliberate framing of the most extreme, the most stereotyped, the most undomesticated of subjects, of course all rendered with the beauty, pomp, and circumstances of a glossy fashion photograph.

Lisa Lyon is a case in point. His photographs of the celebrated female bodybuilder (pl. 66), born of a true collaboration with his model, utterly overturned the conventions structuring men's photographs of women. No passive object of the gaze, Lyon insistently performs for the camera, acknowledging our glance and making it the source of her power. Her body and her presence, in equal measures erotic and threateningly powerful, recalibrate the settled arithmetic of heterosexual male desire. A similar projection of power animates Mapplethorpe's head shot of Roy Cohn (pl. 67), the homosexual homophobe who, as a chief architect of McCarthyism, precipitated the Lavender Scare and then fed off its wreckage. But in affording Cohn a dignified and beautiful portrait, Mapplethorpe underscores his unwillingness to abide by any form of orthodoxy, even the gay community's. His portrait of a pariah is above all respectful, affording his subject the fullness of his character; like him or hate him, Mapplethorpe's Roy Cohn is a man to be reckoned with.

So too, of course, was Mapplethorpe himself, who in a lifelong series of self-portraits shifts from youthful wan innocence (pl. 61) to devilish provocation to, in his last self-portrait, a wise and steady gaze at death—not his death, but ours. In this 1988 self-portrait (pl. 70), Mapplethorpe

chose to inhabit precisely the shadowy specter then so often said to inhabit his work: that he and artists like him had made pleasing—aesthetically and otherwise—an assertively sexual gay culture which now, through AIDS, was claiming its pioneers as its first victims. Before this demonizing victimology of people with AIDS, the dominant tenor even in enlightened sectors of the United States in the 1980s, Mapplethorpe sits in judgment, scepter in hand. Using black clothing and a black background to obscure his own sickly frame, his gaze is even and his verdict firm. He has transformed himself into a *memento mori,* the reminder of death so often found in Christian works celebrating the pleasures of the flesh. One last time Mapplethorpe has appropriated our expectations and insolently transformed them. The victim became the judge, and his photographic rebuke to all who would point a finger at him was a steady hand on a death's-head cane, mirroring that pointed finger back.

The open, assertive, and openly self-contesting LGBTQ culture that took hold after Stonewall is in danger of disappearing because we have tended to view it through this late Mapplethorpe. When San Francisco Mayor George Moscone and the first openly gay elected official in the nation, City Supervisor Harvey Milk, were both assassinated by a former colleague and cop who claimed—successfully—that he was temporarily deranged due to a diet of Twinkies, the city commissioned a memorial only to Moscone. The artist who received that commission, Robert Arneson, inscribed a Twinkie on the pedestal and the words Harvey Milk, too (fig. 30). The sculpture was rejected as insufficiently respectful.

We misremember how often, at least in urban centers, LGBTQ communities and the art communities locked arms in a shared battle for social liberation. Instead, we tending to view this moment of mutuality through the political filter of that which came immediately after, most notably the long putsch against LGBTQ self-representation fomented by the radical Christian right and its political arms, and the horrific happenstance of epidemiology that gave a garden-variety reflexive homophobia a broader and deeper bite—the AIDS epidemic. Yet in urban communities like New York, San Francisco, and even Chicago from the mid-1970s to the early 1980s, it would have been reasonable to foresee that homophobia was increasingly becoming a thing of the past, as gay and straight artistic and popular cultures found greater and greater commonality. Studio 54, the epicenter of Manhattan's druggy nightlife scene in the 1970s, had been in part premised on a refusal of such categorical divisions. "Everyone

wanted to go to Studio 54 not because it was gay, but because it broke down all the old-fashioned barriers between gay and straight, young and old, rich and poor. . . . 'A tossed salad' is what Steve [Rubell—a co-owner], always said he wanted it to be, and that's what it was."[104] It was entirely possible to find Margaret Trudeau, estranged wife of the Canadian prime minister, dancing on the ground floor while groups of gay men enjoyed public sex on the balcony above. Indeed, the general rapprochement between straight and gay cultures was widely evidenced in disco, and as with Studio 54, groups as diverse as the Village People and Two Tons of Fun played with gay stereotypes to mainstream success. When an old gay bathhouse in New York, the Continental Baths, became Plato's Retreat, a giant sex club for straights, it simply underscored the new mingling of gay and straight sexual culture—and Andy Warhol, especially through his *Interview* magazine, became its Boswell.[105]

It's important to remember that Robert Mapplethorpe once won a large National Endowment for the Arts grant for his work and that Andy Warhol was invited for dinner at the Reagan White House only a few years after completing a series of works featuring same-sex sex acts and nude male torsos. This was, of course, before the culture wars had made homosexuality not only taboo, but, in the eyes of Senator Jesse Helms, the vehicle for a resurgent power to redefine not just the arts, but "morality" itself. Today, it strains credulity to recall that at one time—December of 1981 to be exact—Nancy Reagan, wife of Republican president Ronald Reagan, chose to give her very first in-depth print interview at the White House as first lady to Warhol's *Interview* magazine, which, moreover, graced its cover with her visage. That same issue featured photographs of Robert Mapplethorpe out on the town and homoerotic photographs by George Platt Lynes. Also included was an illustrated interview with Prince, the singer provocatively posed as an upright, full-length odalisque in the shower, dressed only in a low-cut thong with his pubic hair curling over, and a crucifix dominating the wall behind him. A nearly naked Prince and a crucifix, Nancy Reagan, George Platt Lynes, and Robert Mapplethorpe, all in Andy Warhol's magazine—the battle lines for the coming culture wars had clearly not yet been definitively drawn.[106]

Only eight years later, on June 12, 1989, Christina Orr-Cahall, director of the Corcoran Gallery of Art in Washington, D.C., cancelled the long-awaited Mapplethorpe retrospective, "The Perfect Moment," a few weeks before its opening and a few months after the photographer's death from AIDS. By this point, conservative politics had become the sworn enemy of progressive art, and the National Endowment for the Arts (NEA)—the only federal-level funding body for the arts in the United States—was fighting for its life. Brilliantly manipulated as a polarizing wedge issue by the Christian right and the Republican-dominated Senate, the question of federal support for an art focusing on sexuality came to dominate a broader debate over whether funding bodies such as the NEA were indeed the proper business of government at all. The NEA would shortly be forced to implement the so-called Helms amendment, which imposed content restrictions on all art supported by the NEA while drastically cutting the agency's budget. These restrictions overwhelmingly turned on the question of the representation of sexuality, and homosexuality in particular was defined as inherently obscene. While the House of Representatives would eventually temper some of the amendment's virulence, by the late 1980s a new era of highly polarized art-making and art-exhibiting had been launched, turning more or less on the question of LGBTQ self-representation.

The chief difference between the period of relative tolerance before 1982 and the virulence thereafter boils down to AIDS. AIDS didn't fundamentally change the roster of foes to LGBTQ self-determination and civil rights, it simply gave them a bully pulpit. What was once old-fashioned prejudice could be camouflaged as sound public health policy; the old saws about homosexual contagion, misery, promiscuity, dissipation, threat to children, and of course, early death (always early death) had under AIDS hideously achieved a statistical concreteness. That AIDS was also of course decimating non-homosexual communities was irrelevant; it was simply too useful, too "natural," to make AIDS "God's judgment on homosexuals," as a score of preachers on the Christian right such as Fred Phelps had put it. Their political handmaiden, Senator Jesse Helms, repeatedly and aggressively sought to twin homosexuality with AIDS—from his 1987 call for the federal quarantine of the HIV positive, to his 1989 amending of a federal AIDS bill that outlawed any educational materials that could be taken to "promote, encourage or condone homosexual sexual activities." In an exceptionally clear instance of his regular conflation of homosexuality with AIDS, Helms said on the Senate floor on June 23, 1989, "Mr. President, instead of denouncing the homosexual 'lifestyle,' countless politicians, some in this Chamber, fall in line with a repugnant organized political movement—and that is what it is—attempting to persuade the American

Fig. 31 / *2024031* by Marsha Burns (born 1945), Polaroid C5, 1983. Charles Cowles

Fig. 32 / "Untitled" by Felix Gonzalez-Torres (1957–1996), billboard, 1991. Installation at East 167th Street west of Southern Boulevard, Bronx, for "Floating a Boulder: Felix Gonzalez-Torres and Jim Hodges," FLAG Art Foundation, New York, 2009

Fig. 33 / "Untitled" (Perfect Lovers) by Felix Gonzalez-Torres (1957–1996), wall clocks, 1987–90, edition of three, one AP. Installation view of "Felix Gonzalez-Torres: Specific Objects Without A Specific Form" at Wiels, Brussels, Belgium, 2010

54/55

people that this is a desirable way to conduct their lives. . . . In the meantime, thousands more in this country will continue to die from AIDS while the homosexuals continue to proclaim the virtues of their perverse practices."[107]

As a result of this chilling political atmosphere, museums and galleries grew more circumspect about what art they were willing to exhibit. Free expression groups of course protested; grass-roots activists projected the banned Mapplethorpe photographs onto the white-marble exterior of the Corcoran building at night, turning the entire elegant structure into a vast outdoor theater of the art that was not permitted inside. In San Francisco that same year, in response to the same federal content restrictions, an anonymous collective called Boys with Arms Akimbo plastered the San Francisco Federal Building with large images of nudes while a small gallery nearby called Kiki, founded by Rick Jacobsen, a man with HIV who used his disability payments to get it off the ground, showed queer art that other galleries wouldn't touch, including artists such as Jerome Caja and Catherine Opie.

Caja, a performance artist/painter who thought nothing of appearing in public swathed largely in Saran Wrap, adopted a "bad" drag queen character, and in torn lingerie and smeared make-up made his persona, Warhol-like, coterminous with his art. His small paintings were often executed in nail polish, eye glitter, and other unconventional materials, including, in the case of *Charles Devouring Himself* (pl. 86), human cremation ash. Broadly modeled on Goya's dystopian *Saturn Devouring His Children*, Caja's painting depicts his friend and muse Charles Sexton engaged in an act of self-cannibalism. Literally painted on Sexton's ashes after his death from AIDS, *Charles Devouring Himself*, like Caja's *Bozo Fucks Death*, an image of a heavyset clown engaged in anal intercourse with a grinning skeleton, hit that sweet spot, so often historically associated with drag queens, between pathos and aggression. In Caja's work, searing anger is transmuted into low comedy and high camp, and as Caja himself grew increasingly ill, AIDS and its constant satellites—sex, politics, religion, and death—became his chief subjects. Like Catherine Opie's photographs of drag kings in her *Being and Having* series (cats. 85 a–d), or in her formally composed self-portraits that underscored an S&M sensibility, at this brittle political juncture even the scent of dissident desire alone was a form of potent political redress. This work marked a distinction from such powerful historical precedents as the work of Marsha Burns, by virtue of its highlighting of a collective, even communal,

sexual nonconformism—in these works it is community above all that is represented (fig. 31).

In the period before the advent of drug combination therapies for HIV, AIDS hysteria had reached a fevered pitch: for some artists it came to seem as if two Americas were existing side by side, one living amid decimating plague with its constant injustices big and small, political and biological, and another America seeming only concerned with isolating and punishing those already under siege. In a now-infamous 1986 *New York Times* op-ed piece, conservative commentator William F. Buckley urged that "everyone detected with AIDS should be tattooed in the upper forearm, to protect common-needle users, and on the buttocks, to prevent the victimization of other homosexuals."[108] (In 2004, despite criticism that his original proposal would not have been out of place in Nazi Germany, he attempted to reanimate it as sound policy.[109]) Following years of such repeated attacks on basic civil liberties, some queer artists decided to fight back. David Wojnarowicz's formerly allusive work now became a torrent of declaration. In photographs, paintings, videos, and especially performative rants in which he spat out his words in rapid-fire patter, Wojnarowicz earned a reputation for public, and for many, an utterly cathartic, portrayal of rage:

"If you want to stop AIDS shoot the queers" . . . says the governor of texas on the radio and his press secretary later claims that the governor was only joking and didn't know the microphone was turned on and besides they didn't think it would hurt his chances for re-election anyways and I wake up every morning in this killing machine called america and I'm carrying this rage like a blood filled egg and there's a thin line between the inside and the outside a thin line between thought and actions . . . and I'm waking up more and more from daydreams of tipping amazonian blowdarts in "infected blood" and spitting them at the exposed necklines of certain politicians or government healthcare officials or those thinly disguised walking swastikas that wear religious garments over their murderous intentions . . . all I can feel is the pressure and the need for release.[110]

But such a directly oppositional voice was only one possible response to this newly polarized art world. Other artists, such as Felix Gonzalez-Torres (figs. 32 and 33) and Robert Gober (pl. 88), preferred to deploy subtlety, stealth, and indirection to create an art that flowered in the gulf between artist and audience, inviting viewers to make what meanings they may. This strategy of addressing multiple audiences with different

Fig. 34 / *After Sir Anthony Van Dyck's King Charles I and Henrietta Maria* by Kehinde Wiley (born 1977), photograph, 2009. Courtesy of the artist

competencies of course found precedent in the work of Johns and Rauschenberg, but unlike that earlier generation, these younger artists offered just enough information—through titles, imagery, and other visual or narrative content—to clue the viewer in to sexual politics. That said, for these artists meaning was precisely not an exercise in self-declaration, but an open-ended inquiry into all forms of difference. In the overheated sociopolitical context of the late 1980s and early 1990s, such decentered and allusive forms of referencing sexuality found favor with museums and collectors in a way that the more explicitly didactic work of Wojnarowicz or Caja did not. In their audience-centered focus on meaning-making and the proliferation of readings that this entailed, these artists offered sites for contemporary social and political engagement with none of the explosive potential of implicating the museum, or any of its staff, in any single message. In this sense, Gonzalez-Torres's and Gober's work was perfectly attuned to a dominant art world culture that wanted to see itself as proffering committed resistance to the content controls imposed by the right, yet in no way court controversy itself. Yet for those so inclined to read the work in this way, there was nothing less than radical in, for example, Gonzalez-Torres's *"Untitled" (Portrait of Ross in L.A.)* (pl. 72). A pile of candy spilled on the floor with an ideal weight equal to that of his partner, Ross, who predeceased him, its diffusion of significance begins the minute we interact, as we are called upon to do, with the work. We take a piece of candy and pop it in our mouths. In so doing, is this holy communion or an act of cannibalism, an attempt to transcend death on a spiritual plane or a stunningly material reminder of our implication, as a society and individually, in the death of his beloved, for we literally consume him? Is each piece of candy a memento mori, or an aesthetic object we are given as a gift? As Gonzalez-Torres consistently refused to mediate his work for us, its meanings are necessarily our meanings.

For lesbian artists whose chief constraint was often not the political ramifications of making a statement, but an art world that proved uninterested in a female, and especially lesbian, presence itself, the appropriation and subversion of dominant masculine narratives offered a tempting target. In appropriating familiar scenarios in which a female presence was enabling but made incidental, artists such as Deborah Kass and Deborah Bright reworked the image to expose a lesbian counternarrative. In so doing, they didn't seek to create a new, viable lesbian representation so much as, through the ensuing shock of

(mis) recognition, underscore how profoundly the canon assumed a masculine perspective. Deborah Kass's self-portrait remake (pl. 77) of Christopher Makos's famed image (pl. 76) of Andy Warhol in drag offers a lesbian as a gay man as a woman, a notable inversion of the usual direction of gender inversion and a celebrated seizure of primogeniture. Deborah Bright's reworking of Hollywood film stills (pl. 84) to "excavate" buried lesbian narratives works similarly, for both interventions don't seek to define a lesbian identity so much as ask how lesbianism, as we understand it, affects the unexamined gender/power relations of contemporary culture.

A similar unleashing of the nexus of race and sexuality unsettles dominant narratives in the work of artists such as Glenn Ligon (pl. 89) and Lyle Ashton Harris (pl. 90). Not unlike Kass and Bright, these artists don't substitute one racialized entity for another, but rather ask how race and sexuality together inflect culture inseparably. In this sense, these artists mark a telling distinction from a contemporary portraitist such as Kehinde Wiley, whose attempts to proffer black versions of iconic Western masterpieces instead tend to reify the distinction between the dominant cultural tradition and other cultural traditions (fig. 34). While *Runaways* queers a nineteenth-century runaway slave poster with a list of anachronistic self-descriptions that include the artist's "short sleeve button-down 50's style shirt," it is the psychological profile that has him "not look at you straight in the eye when talking to you" that is the most anachronistic for its implication of a sensitive interiority in a context that valued only bodily capacity. Ligon also appropriates Jasper Johns's celebrated late 1950s paintings of serial numbers and letters. But instead he deploys these fugitive, coal-dust letters to announce an ephemeral subjectivity, caught between the categories of race and sexuality through which one is inevitably named, boxed, defined. But such broad sociological categories can never completely capture a person. Rather, it is the individual and idiosyncratic qualities of character that most truly define; yet these very qualities, in not having labels, always escape categorization. Harris's panel, part of a large triptych, presents the artist nude kissing his brother while leveling a weapon. A meditation on a titular brotherhood's complex of attraction, identification, relation, and repulsion, Harris work articulates a selfhood always in uneasy negotiation between identification and disavowal.

For many contemporary queer artists, queer identity has ceased to be an empirical category, but like Warhol's self-definition in and through the ways others had described him, it has become no more than a tissue of citations, a palimpsest of more than one hundred years of shifting meanings. Born of the age of the steam locomotive in an attempt to secure a class of people as delimited, visible, and knowable—in large measure in order to penalize and control them—its effect has been the opposite, to let loose a proliferation of meanings that threaten to swamp the very binary that was once its reason for being. Bisexual, metrosexual, and transsexual conspire to dispatch any lurking binarisms, threatening gay and straight with the fate that befell the "queer/trade" binary in the late twentieth century—irrelevance. Increasingly queerness inheres not to sexual practices but to sexual ideologies—you're queer if you call yourself queer, for like political affiliations, it's a matter of identification alone, not biology, not body. How then, to figure, a decorporealized identity in portraiture, a pictorial means that after all depends on the body as its locus and guarantor of meaning?

Expansive and unrestrained, a new queer art works to challenge the very grounds of difference while still articulating dissimilarity. Anthony Goicolea (pl. 94) courts a proliferation of identities in his work by using his own body as every figure, such that his body ceases to be anything but, in O'Hara's words, "the scene of my selves." Cass Bird (pl. 96) ironizes patrolineage, remaking an account of our cultural inheritance in her own image, and Jack Pierson (cats. 97 and 98) shoots multiple "self-portraits" using many different models. For many queer artists working today, difference and sameness are two sides of the same coin, for each term, like homosexuality and heterosexuality, needs the other to make itself cohere. Better, many are now saying, to step out of the binary altogether. But the disappearance of a queer identity is still at this juncture utopian, for queerness is enforced anew on each generation made to suffer for its expression of love. Electing to step out of a binary doesn't make it disappear. And historically queer art has drawn power from oppression and from the inventiveness, ingenuity, and originality it encouraged as a strategy of survival. Absent constraints, after all, queer portraiture would not need to look or operate any differently than any other portraiture. In time, perhaps this book itself might be viewed as something akin to a survey expedition, a means of chronicling a species just prior to its disappearance.

Endnotes

1. The obligatory note on nomenclature: the choice of terms to denote a sexual or emotional connection to someone of the same sex is a fraught one. On the one hand, the deployment of a historical terminology such as "homo," "queer," "trade," and their more vulgar variants, while serving to remind the reader of the very different historical and social conditions governing same-sex desire in the past, risks alienating some contemporary readers, even amid the current reclamation of queer by a younger generation. Other terms, like the ubiquitous "gay and lesbian," are primarily linked to specific sociopolitical formations of the post-liberation era. As a rule, authors writing about historical same-sex desire have worried themselves sick about the issue of historically accurate and precise terminology. Yet at the same time, words like marriage, prostitution, and even desire are employed with no similarly specific justification, despite the fact that each of these terms also meant something very different in the nineteenth century. The great value in using historically accurate terminology—to enforce the recognition that the past was fundamentally different from the present—thus puts differential pressure on the historical precision of only *some* of its terms—those terms with a contested present. Thus there is a presentist bias in even the most historicist terminology. In an effort to evade this problem, and to create a more fluid experience for the reader, I have elected to vary the terms I use for same-sex desire so as to make very clear that I am not deploying my language in any consistent way. It is my hope that the profound difference in historical constructions of same-sex desire can instead be conveyed textually, so as not to make individual words bear the brunt of any historical argument.

2. The historical data for this incident has been admirably plumbed by George Chauncey. See his "Christian Brotherhood or Sexual Perversion? Homosexual Identities and the Construction of Social Boundaries in the World War I Era," in *Hidden From History: Reclaiming the Gay and Lesbian Past*, ed. Martin Duberman, Martha Vicinus, and George Chauncey (New York: New American Library, 1989), 294–317.

3. LGBTQ stands for Lesbian, Gay, Bisexual, Transgendered, and Queer, marking the ever-increasing specification of identities conceived with the laudable intentions of not leaving any variant identity out. But this term, which will be used throughout the book, also reveals how profoundly the battle for equality has tended to become, to one extent or another, a linguistic one, in which rights are sued and won through discursive means.

4. Of course, men of means could also visit baths, but they also had recourse to more discreet and comfortable environments, from private parties to male brothels, in which to meet their erotic needs.

5. Only a small percentage of top men, known as "husbands," formed emotional bonds with queers. For a careful analysis of this social formation, see Chauncey, "Christian Brotherhood."

6. For more on this and the culture wars in general, see Stephen Dubin's *Arresting Images: Impolitic Art and Uncivil Action* (London and New York: Routledge, 1992).

7. Helms, in Douglas Crimp and Leo Bersani, *AIDS: Cultural Analysis, Cultural Activism* (Cambridge, Mass.: MIT Press, 1988), 259.

8. 101st Congress, 1st sess., *Congressional Record* 135, no. 127 (September 28, 1989).

9. Fox Butterfield, "In Furor Over Photos, an Echo of the City's Past," *New York Times*, July 31, 1990, A8.

10. See Jennifer Doyle, "Sex, Scandal, and Thomas Eakins's *The Gross Clinic*," *Representations* 68 (Autumn 1999), included in *Sex Objects: Art and the Dialectic of Desire* (Minneapolis: University of Minnesota Press, 2006), 1–33 and 7.

11. Lloyd Goodrich, *Thomas Eakins*, Alisa Mellon Bruce Studies in American Art, vol. 2 (Cambridge, Mass.: Harvard University Press for the National Gallery of Art, 1982), 109–10.

12. Peter Schjeldahl, "The Surgeon: Philadelphia Celebrates Its Most Prodigious Native Son," *New Yorker*, October 22, 2001.

13. See Doyle, "Sex, Scandal, and Thomas Eakins's *The Gross Clinic.*"

14. Coates to Eakins, November 27, 1885, in Kathleen A. Foster and Cheryl Leibold, eds., *Writing About Eakins: The Manuscripts in Charles Bregler's Thomas Eakins Collection* (Philadelphia: Pennsylvania Academy of the Fine Arts, 1989).

15. Doyle, "Sex, Scandal, and Thomas Eakins's *The Gross Clinic,*" 3–4.

16. Indeed, Anschutz, who also taught at the Pennsylvania Academy, dismissed Eakins's practice for precisely conflating these two distinct realms.

17. Walt Whitman, *Leaves of Grass*, sec. 11.

18. Elizabeth Johns, "*Swimming*: Thomas Eakins, the Twenty-ninth Bather," in Doreen Bolger and Sarah Cash, eds., *Thomas Eakins and the Swimming Picture* (Fort Worth: Amon Carter Museum, 1996), 66–79.

19. In this regard, it's worth noting that our etymology of the word "gay," as in "living the gay life," actually derives from men's too-familiar concourse with prostitutes and other women with whom pleasure and not procreation was the only goal. See David Greenberg, *The Construction of Homosexuality* (Chicago: University of Chicago Press, 1988).

20. For further development of this idea, see Doyle, "Sex, Scandal, and Thomas Eakins's *The Gross Clinic.*"

21. Dated "Phila August 15th [1940 or 1941]," the article is William Smith, "Feather-Weight Billy Smith," *Archives of American Art Journal* 4, no. 3 (July 1964): 15–16.

22. Gordon Hendricks, *The Life and Work of Thomas Eakins* (New York: Grossman, 1974), 241.

23. For an example of the industrious but not very convincing "straightening up" of Winslow Homer's life—itself a small cottage industry—see Sarah Burns, "The Courtship of Winslow Homer: Letters Reveal Relationship with Helena de Kay," *Antiques*, February 2002. In it, Burns uses the "letters [to] allow us a rare glimpse into Homer's heart." In contrast, see Christopher Reed's early explication of the homoerotic Homer in "The Artist and the Other: The Work of Winslow Homer," *Yale University Art Bulletin* 40 (Spring 1989): 69–79.

24. For a full account of this painting and its genesis see Trevor Fairbrother, *John Singer Sargent: The Sensualist* (Seattle: Seattle Art Museum and New Haven: Yale University Press, 2000).

25. See W. Graham Robertson, *Life Was Worth Living: The Reminiscences of W. Graham Robertson* (New York: Harper & Brothers, 1931), 233–44, for a full description of the incident, including the quotations here.

26. W. Graham Robertson, *Time Was: The Reminiscences of W. Graham Robertson* (London: H. Hamilton, 1945).

27. http://www.glbtq.com/arts/am_art_lesbian_1900_1969.html, accessed May 19, 2010, and Tee A. Corrine, *The Lesbian Eye of Berenice Abbott* (self-published, 1996).

28. The story is beautifully analyzed by Jonathan Weinberg in "'Some Unknown Thing': The Illustrations of Charles Demuth," *Arts Magazine* 61 (December 1986): 14–21.

29. Inspired by the Robert McAlmon story of Weimar-era social freedoms in Berlin, "Some Unknown Thing" featured a homosexual narrator. Yet the reference was sufficiently obscure as to enable the watercolor to circulate as a general satire of modernism as well.

30. Willard Huntington Wright, "Modern Art: Four Exhibitions of the New Style of Painting," *International Studio* 60 (January 1917): xcviii. See Marcia Brennan, *Painting Gender, Constructing Theory: The Alfred Stieglitz Circle and American Formalist Aesthetics* (Cambridge, Mass.: MIT Press, 2001), 156–202, for a superb discussion.

31. See Wanda M. Corn, *The Great American Thing: Modern Art and National Identity, 1915–1935* (Berkeley: University of California Press, 1999), 196–201.

32. Patricia McDonnell, *Dictated by Life: Marsden Hartley's German Paintings and Robert Indiana's Hartley Elegies* (Minneapolis: Frederick R. Weisman Art Museum; New York: Distributed Art Publishers, 1995).

33. See Christopher Isherwood's *Christopher and His Kind, 1929–1939* (London: Eyre Methuen, 1977), for an account of gay Berlin before the rise of the Nazis.

34. For an elaborate analysis of the painting, and of the symbology of much of Hartley's works, see Jonathan Weinberg, *Speaking for Vice: Homosexuality in the Art of Charles Demuth, Marsden Hartley, and the First American Avant-Garde* (New Haven: Yale University Press, 1993).

35. See ibid., 207.

36. For a rich history of the relationship between the great migration and sexual dissidence, see Eric Garber, "A Spectacle in Color: The Lesbian and Gay Subculture of Jazz-Age Harlem," in *Hidden From History: Reclaiming the Gay and Lesbian Past*, ed. Martin Bauml Duberman et al. (New York: New American Library, 1989), 318–31.

37. The original recording can be heard on AC-DC Blues: Gay Jazz Reissues, vol. 1, Stash Records, 1977.

38. See Garber, "A Spectacle in Color."

39. The title character's name is probably derived from a minor character in the 1748 novel *The Adventures of Roderick Random* by Tobias Smollett; the effete Captain Whiffle is perhaps the first recognizably stereotyped gay character in English literature. In Van Vechten's hands, *Peter Whiffle* in turn abounds with lines like "It was all gay, irresponsible and meaningless perhaps, but *gay*." Original emphasis in Van Vechten, *Peter Whiffle: His Life and Works* (New York: Knopf, 1922), 76.

40. While this famed statement itself is probably apocryphal, its seeming plausibility and repetition in the O'Keeffe literature is my point. Whether Stieglitz actually said this is less significant for my purposes than the perception that he very well could have done so. For a historiographic account of the statement, see Vivien Green Fryd, *Art and the Crisis of Marriage: Edward Hopper and Georgia O'Keeffe* (Chicago: University of Chicago Press, 2003), 230, n. 23.

41. See Barbara Buhler Lynes, *O'Keeffe, Stieglitz, and the Critics, 1916–1929* (Ann Arbor: UMI Research Press, 1989).

42. The essay was unpublished until 1960. Dorothy Norman reprinted it in *Alfred Stieglitz: An American Seer* (1960; reprint ed. New York: Random House, 1973), 136–38.

43. See Corn, *Great American Thing*, 241.

44. Marsden Hartley, "Some Women Artists in Modern Painting," in *Adventures in the Arts: Informal Chapters on Painters, Vaudeville and Poets* (1921; reprint ed., New York: Hacker Art Books, 1972), 116.

45. See Fryd, *Art and the Crisis of Marriage*, 130.

46. Georgia O'Keeffe, "About Myself," in *Georgia O'Keeffe Exhibition of Oils and Pastels* (New York: An American Place, 1939), unpaginated.

47. O'Keeffe carefully presented those paintings based on pelvic forms, not as they would rest naturally, but eccentrically upended. So manipulated, these pelvises now also resonate with the female form, and it's possible to frame works like *Pelvis with Moon* as a possible citation of the *Nike at Samothrace*, the so-called Winged Victory, remade in nature and paired with that totemic female symbol, the moon. But again, instead of a warm, moist penetrability, these pelvises are all dry edges and sharp holes. *Black Place II* equally emblematizes her recurring tendency to map the female body onto the landscape itself, transmuting a ravine into a labial mons.

48. William H. Whyte Jr., *The Organization Man* (New York: Simon & Schuster, 1956) and David Riesman, *The Lonely Crowd* (New Haven: Yale University Press, 1950). For a fuller discussion of the striking parallels between mainstream cultural discourse and queer subjectivity during the Cold War, see my "Passive Resistance: On the Critical and Commercial Success of Queer Artists in Cold War American Art," *L'image* (Paris) 3 (Winter 1996). Also available online at http://www.queerculturalcenter.org/Pages/KatzPages/KatzLimage.html.

49. Lynes's 1941 photo of nude men cowering before a nurse is a metaphor for medicine's pathological reading of the homosexual as the authoritative discourse.

50. E. M. Forster, "What I Believe," in *Two Cheers for Democracy* (New York: Harcourt, Brace, 1951).

51. This is how Forster delicately described such an elite in 1938: "I believe in aristocracy, though—if that is the right word, and if a democrat may use it. Not an aristocracy of power, based upon rank and influence, but an aristocracy of the sensitive, the considerate and the plucky. Its members are to be found in all nations and classes, and all through the ages, and there is a secret understanding between them when they meet. They represent the true human tradition, the one permanent victory of our queer race over cruelty and chaos. I give no examples; it is risky to do that but the reader may as well consider whether this is the type of person he would like to meet and to be, and whether (going further with me) he would prefer that this type should not be an ascetic one. I am against asceticism myself. I am with the old Scotsman who wanted less chastity and more delicacy. I do not feel that my aristocrats are a real aristocracy if they thwart their bodies, since bodies are the instruments through which we register and enjoy the world. . . ."

52. Cadmus's palpable racism, and his notably conservative class politics *vis a vis* labor unions and other traditionally left causes (in his *Herrin Massacre* of 1940, he demonizes striking workers), is only hard to square with his sexuality if we assume the progressive coalition politics of the post–Stonewall LGBTQ civil rights movement. This painting, executed twenty-two years before Stonewall, instead posits homosexuality not as a marker of difference that allies one with others who also know the sting of discrimination, but as an essentially conservative, creative elite, who alone safeguard the artistic advance of the West against its own destructive tendencies.

53. Alan Bérubé, *Coming Out Under Fire: The History of Gay Men and Women in World War Two* (New York: Free Press, 1990), 69–70.

54. Lincoln Kirstein, *Paul Cadmus* (San Francisco: Pomegranate, 1992), 95.

55. Alfred C. Kinsey et al., *Sexuality in the Human Male* (Bloomington: Indiana University Press, 1948), 639, 656.

56. See Arthur Guy Matthews, *Physical Culture*, April 1953, 13.

57. *Los Angeles Times*, April 27, 1953.

58. Ibid., July 2, 1953.

59. Elizabeth Lalo, *One Magazine*, October 1953, 3.

60. Jess's last name is Collins, but he effectively cut off his family and used only his first name.

61. After the essay appeared, John Crowe Ransom rescinded an offer to publish a poem of Duncan's in the *Kenyon Review*, thus inaugurating Duncan's marginalization within modern American poetry until the 1960s at the earliest. See Ekbert Faass, *Young Robert Duncan: Portrait of the Poet as Homosexual in Society* (Santa Barbara, Calif.: Black Sparrow Press, 1983).

62. In one of his very first letters to his lifelong dealer, Jess makes a point of noting that he has "the advantage of having been loved by a great poet, Robert Duncan." See Jess Papers, Box 1, University of California, Berkeley.

63. Author's interview with Jess, September 18, 1998.

64. For an account of this process of promotion, see the work of Serge Guilbaut, especially his now-classic *How New York Stole the Idea of Modern Art: Abstract Expressionism, Freedom, and the Cold War*, trans. Arthur Goldhammer (Chicago: University of Chicago Press, 1983), and his more recent *Be Bomb: The Transatlantic War of Images and All That Jazz, 1946–1956* (Barcelona: Museu d'Art Contemporani de Barcelona; Madrid: Museo Nacional Centro de Arte Reina Sofia, 2007).

65. See *Life*, August 8, 1949, 42–45.

66. For more on the idea of the communal in abstract expressionism, see my "Energy Made Visible: Jackson Pollock, Herbert Matter and the Vitalist Tradition," a chapter in the exhibition catalog *Pollock Matters*, ed. Ellen Landau and Claude Cernuschi (Chestnut Hill, Mass.: McMullen Museum; distributed by the University of Chicago Press, 2007), 59–72. For a more theoretically informed analysis of expressionism, see Hal Foster, "The Expressive Fallacy," *Art in America* 71 (January 1983): 80–83, 137.

67. Frank O'Hara (with Larry Rivers), "How to Proceed in the Arts," *Evergreen Review* (August 1961): 97–101.

68. Ben Heller, in B. H. Friedman, ed., *School of New York: Some Younger Artists* (New York: Grove Press, 1959), 30.

69. Vivian Raynor, "Jasper Johns: 'I Have Attempted to Develop My Thinking in Such a Way That the Work I've Done is Not Me,'" *ARTnews* 72 (March 1973): 20–22.

70. Jasper Johns, sketchbook notes, undated, published in Alan Solomon, ed., *Jasper Johns* (New York: The Jewish Museum, 1964).

71. The eminent art historian and early Johns critic Leo Steinberg recounted a conversation he had with Johns's then-partner Robert Rauschenberg around the time Steinberg was finishing his famous 1962 article on Johns: "I told him instead of the terrible problem I faced near the end, having posed the rhetorical question, 'How improper is it to find metaphorical or emotional content in Johns's work?' Remember we're in 1961, when Johns's claim for his work was deadpan impersonal objectness, and that emotional content was neither overtly nor implicitly present. . . . Whereas Johns's early work, the longer I looked at it, seemed to grow ever more secretive and confessional; it spoke mutely of solitude, abandonment, desolation. . . . And so I blurted it out—and Rauschenberg listened. . . . And when I had done, he said quietly and in dead earnest, 'I think you are very close.'" See Steinberg, "Jasper Johns: The First Seven Years of His Art" in Other Criteria: Confrontations with Twentieth-Century Art (London and New York: Oxford University Press, 1972).

72. Michel Foucault, The History of Sexuality: An Introduction, vol. 1, trans. Robert Hurley (New York: Vintage, 1978).

73. J. K. [Jack Kroll], "Reviews and Previews," ARTnews 60 (December 1961): 12. "Poof," is of course a homophobic slur, as was the reference to snagging his sweater. Capote was still the leading gay novelist of his time.

74. Grace Glueck interview with Jasper Johns, New York Times, October 6, 1977.

75. Dodie Kazanjian, "Cube Roots," Vogue, September 1989, 728–29, 798, 800–801.

76. Author interview with Calvin Tomkins, June 9, 1990.

77. Tomkins, unpublished notes, quoted in Roni Feinstein, "Random Order: The First Fifteen Years of Robert Rauschen-berg's Art, 1949–1964" (Ph.D. diss., New York University, 1990), 249.

78. Calvin Tomkins, Off the Wall: A Portrait of Robert Rausch-enberg (New York: Doubleday, 1980), 118.

79. Kenneth Bendiner, "Robert Rauschenberg's 'Canyon,'" Art Magazine 56, no. 10 (June 1982): 57–59.

80. Unpublished transcript from 1961 MOMA symposium, "The Art of Assemblage," 22.

81. Calvin Tomkins, The Bride and the Bachelors: Five Masters of the Avant Garde (1976; rev. ed., Harmondsworth, Eng. and New York: Penguin, 1968), 117.

82. Roni Feinstein speculates on this point in "Random Order," 243.

83. See Charles Olson and Robert Creeley, The Complete Correspondence, ed. Richard Blevins (Santa Barbara, Calif.: Black Sparrow Press, 1990), vol. 9, 60–65. For a fuller account of the relationship between Rauschenberg and Twombly, see my "'Committing the Perfect Crime': Sexuality, Assemblage and the Postmodern Turn in American Art," Art Journal 67, no. 1 (Spring 2008): 38–54.

84. This description is largely based on close personal observation. Certain identifications are in Mary Lynn Kotz, Rauschenberg: Art and Life (New York: Abrams, 1990), 87, and Walter Hopps, Robert Rauschenberg: The Early 1950s (Houston: Menil Collection, 1991). I have studied the surface of Untitled carefully on three separate occasions at the Los Angeles Museum of Contemporary Art. My thanks to the curatorial and registrar's staff for access to the work while it was in storage.

85. While Rauschenberg has confirmed that the sheets of drawings are by Twombly, he has remained silent on the origins of the letter fragments. I attribute them to Johns, based on a careful comparison of handwriting and drawing style, as evidenced by an early poem by Johns—dated by the auction house as c. 1952—that was sold in New York in 1988. The text, addressed "Dear giant," is as follows: "Astrologists find stars/ Astronomers doubt . . . / Stars find astrologists/Astronomers doubt . . . /Astronomers doubt stars/ And astrologists . . . / But listen . . . / Astrologists never / Doubt stars . . . /Stars never doubt/Astrologists . . . /love/elf." Auction catalog, Sotheby's, New York, July 6, 1988. Rauschenberg's confirmation is in Kotz, Rauschenberg: Art and Life, 87.

86. Some of these observations have been confirmed in Kotz, Rauschenberg: Art and Life, 87.

87. Rauschenberg, "Conversations with the Artists at the National Gallery," January 6, 1985, unpublished transcript.

88. My own study of this combine in situ at the Museum Ludwig in Cologne has been aided by a description found in Feinstein, "Random Order," 198–201, who analyzes it as nonspecifically autobiographical.

89. In a letter, Rauschenberg acknowledges that he knows that Liar refers to him.

90. In private, Johns was occasionally more loquacious. Turn over his Study for Two Flags completed in 1969, the year the Stonewall riots in New York announced the arrival of the modern gay and lesbian civil rights movement, and you'll find the words "Study For Two Fags" placed above his signature. Johns can offer his own small, private statement of solidarity, but always a private one, not a public declaration of what was doubtless the singular defining personal and professional partnership in postwar American art.

91. For a careful history of the Lavender Scare, see David Johnson's The Lavender Scare: the Cold War Persecution of Gays and Lesbians in the Federal Government (Chicago: University of Chicago Press, 2004).

92. Several articles, books, and a master's thesis have been given over to establishing Martin's Zen bonfides. Among the best are Thomas McEvilley, "Grey Geese Descending," Artforum 25, no. 10 (Summer 1987): 94–99; Jacquelynn Baas, Smile of the Buddha: Eastern Philosophy and Western Art from Monet to Today (Berkeley: University of California Press, 2005), 207–19; and Marianne Nadler McGonigle, "Elements of Buddhisms in the Work of Mark Tobey and Agnes Martin" (M.A. thesis, Texas Women's University, 1993).

93. As Anna Chave notes, this formulation may itself be drawn from Lao Tzu, "Nothing is weaker than water;/Yet for attacking what is hard and tough/Nothing surpasses it, nothing equals it." Quoted in Chave, "Agnes Martin: 'Humility, the Beautiful Daughter . . . All of Her Ways Are Empty,'" in Barbara Haskell, Agnes Martin (New York: Whitney Museum of Art; distributed by Harry N. Abrams, 1992), 131–53, here p. 142. Chave cites Lao Tzu, Tao Teh King, trans. Archie J. Bahm (New York: Frederick Ungar, 1958), 66–67.

94. Martin, "The Untroubled Mind," Writings of Agnes Martin, ed. Dieter Schwarz (Winterthur: Kunstmuseum Winterthur/Edition Cantz, 1992), 41.

95. My thanks to the Peyton Wright Galleries for making these images available. According to the gallery, these early portrait works survive only because Martin's then-partner hid them, preventing their destruction.

96. Lizzie Borden, "Early Work," Artforum 11 (February 1973): 39–44.

97. For more on sexuality and Agnes Martin, see my "Agnes Martin: the Sexuality of Abstraction," in Lynne Cooke and Karen Kelly, eds., *Agnes Martin* (New Haven: Yale University Press, 2010).

98. Paul Goodman, "Advanced-Guard Writing, 1900–1950," *Kenyon Review* 13 (Summer 1951).

99. See Martin Duberman's "Gay in the 50's," an annotated reprint of his personal diary from this decade, which eloquently reveals the power of community. Disturbed by his homosexuality, Duberman writes that he visited a psychiatrist, who insisted that he sever all relations with other gay people, as such interactions would only serve to retrench his pathology. The dominant clinical picture of the time was that homo-sexuality was an individual pathology and that gay people got together in communities of like-minded "wounded souls" in an illusory pursuit of normalcy. The only way to break the illusion that you were not sick was to sever contact with other sick people and embrace the dominant (homophobic) culture. Repeatedly, Duberman's psychiatrist insists that contact with other gay people can only produce the false, neurotic happiness of the deluded. In *Salmagundi* (special issue) *Homosexuality: Sacrilege, Vision, Politics* 58–59 (Fall 1982–Winter 1983): 42–75. See also Duberman's *Cures: A Gay Man's Odyssey* (New York: Dutton, 1991).

100. Andy Warhol, *The Philosophy of Andy Warhol: From A to B and Back Again* (New York: Harcourt, Brace, Jovanovich, 1975), 7.

101. Michael Lobel, "Warhol's Closet," *Art Journal* 55, no. 4, We're Here: Gay and Lesbian Presence in Art and Art History (Winter 1996): 42–50.

102. So pervasive were the rumors of Donahue's homosexuality that in 1984 he felt the need to "come out" to *Time* magazine as straight.

103. Nick Benton, "Who Needs It?" *San Francisco Gay Sunshine*, August–September 1970.

104. Bob Colacello, *Holy Terror: Andy Warhol Close Up* (New York: HarperCollins, 1990), 354.

105. James Boswell (1740–1795) a Scottish writer whose journals are perhaps the most famous eyewitness chronicle of their time.

106. *Interview* 11, no. 12 (December 1981).

107. 101st Congress, 1st sess., *Congressional Record* 135, no. 86 (June 23, 1989).

108. William F Buckley, *New York Times*, March 18, 1986.

109. "Conservatively Speaking," William F. Buckley interviewed by Deborah Solomon, *New York Times Magazine*, July 11, 2004.

110. David Wojnarowicz, *Close to the Knives: A Memoir of Disintegration* (New York: Vintage, 1991), 161–62.

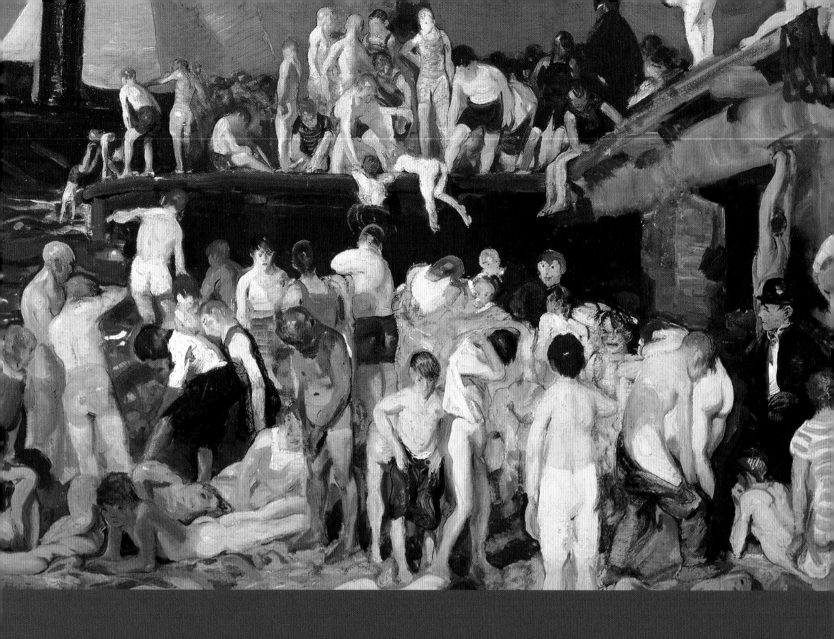

River Front No. 1 (detail) by George Bellows
Reproduced in full as Plate 7.

In the winter of 1862, Walt Whitman went to Washington to search for his brother George, a Union officer who had been wounded at the Battle of Fredericksburg. So unprepared were both armies for the magnitude of the Civil War that there was practically no organized medical care for the wounded, nor was there any organized system for tracking casualties and notifying their families. So Whitman left New York, where he was haphazardly marking time in a literary career that had not taken off after the publication of *Leaves of Grass* (1856). Whitman got to the capital and soon found George, who fortunately was not seriously wounded. Whitman discovered—or rediscovered—something else after he arrived in Washington and looked around: his career as a poet. Wartime Washington rescued Whitman's poetry by reenergizing a project that had languished after *Leaves of Grass* failed to sell many copies among the people it celebrated—Americans—despite high praise from eminent critics such as Ralph Waldo Emerson. In Washington, close to the eastern theater of operations, Whitman reignited his artistic vision of American democracy and individualism in the heroic struggle of the Union troops.

Whitman stayed in Washington and became a nurse, tending to the battlefield casualties who were housed in federal buildings, such as the Patent Office, or in hastily rigged hospitals that were thrown together with tents and temporary buildings. Whitman was not a nurse in the modern sense: he had no medical training and did not actually treat wounds or sickness. Instead, he ministered to the troops, bringing them treats, talking to them, and writing letters for them to the folks back home. He bore witness to their suffering. And he turned that witness into art in poems such as "The Wound Dresser" or "Come Up From the Fields, Father." A compulsive list-maker, both in his notes and in his poetry, Whitman kept a record of the men he comforted and noted their circumstances and what he did to help them. This act of "tallying" was crucial to Whitman's poetic politics of "adhesion" and the "camerado," the sense of a unifying life spirit that bound men together both in life and death. The cauldron of war and the sacrifice that Whitman observed up close forced him to sharpen his sense of the ties that bound men together and zero in on the redemptive power of manly love.

Within the overall project of *Leaves of Grass* (which would grow to nine editions), Whitman created two books out of the Civil War that counterpoised each other: *Drum Taps* and *Calamus*. *Drum Taps* was the more public of the two sections, dealing in imagistic fashion with the events of wartime, from "Cavalry Crossing a Stream" to "An Army Corps on the March." *Calamus*, on the other hand, was the emotional and private concomitant to the rigors of wartime America: It was his refuge. And it was a refuge for men. In manly comradeship, Whitman metaphorically repaired the damage that the war inflicted on both individuals and America as a whole, as these passages from "A Glimpse" demonstrate:

*A long while, amid the noises of coming and
 going, of
drinking and oath and smutty jest,
There we two, content, happy in being together,
 speaking
little, perhaps not a word.*

It tells of a moment out of the war, in other words. Ultimately, though, in limning the intense connection that grew between men during wartime, Whitman blurred and finally transgressed the line between the homosocial and the homosexual. Whitman was always cagy, both personally and poetically, in posing himself as polymorphous, not to say omnivorous in his sexuality; he claimed to have fathered several children and his paean to New Orleans's mulatto women was lusciously libidinous. Now, Whitman grew bolder in writing about the lineaments of gay desire. In "We Two Boys Together Clinging," male bonding was simply a way of resisting the hardships of war ("We two boys together clinging,/One the other never leaving,/Up and down the roads going, North and South excursions making). But desire would be openly expressed in poems like "Whoever You Are Holding Me Now in Hand": "Here to put your lips upon mine I permit you,/With the comrade's long-dwelling kiss or the new/husband's kiss,/For I am the new husband and I am the comrade." Or as Whitman also put it, "I lift the veil."

In his celebration of the homosocial and homosexual, Whitman was making a personal point that merged with the political. Whitman was a Jacksonian Democrat, steeped in the artisanal politics of New York City and an ideology of individual autonomy and empowerment. The "producer ideology" of self-sufficiency was extended by Whitman from occupation ("the butcher boy with his shuffle and his breakdown") to an ideal of masculinity that would re-create the body politic: "I will make inseparable cities with their arms about each other's necks/By the love of comrades,/by the manly love of comrades." The ideal of perfect individual fulfillment would lead ineluctably to the perfection of the body politic, with the freedom of each individual

coalescing into the pluralistic and enabling structure of the whole.

In making this audacious claim, Whitman ran afoul of official Washington. In 1865, he was fired from his position in the Interior Department when a copy of *Leaves of Grass* was found in his desk, and he was revealed as the author of the "immoral work." But Whitman's transgression was not his "homosexuality"—the term had yet to be created—but his frank and sensually open acceptance of physical love, *tout court*. In the midst of all the wartime carnage, Victorian Americans were intent on repressing the body altogether, let alone even literary effusions of love and passion. What Whitman created in his poems was an idyll that was an imagined world, but also a sharp critique of contemporary practice. It was the verbal equivalent of the artist Thomas Eakins's paintings of innocent, sylphlike boys skinny dipping, carefully admired by the swimming artist himself. And Mark Twain's mordant *Huckleberry Finn* (1884) contained a ghostly remnant of the *Calamus* poems' utopian interminglings in the relationship between Jim and Huck: "ain't it lovely to live on a raft." But in the midst of postwar American politics, there would be no refuge for Whitman, and he lost his job.

It was probably just as well, although Whitman would lead a difficult and poverty-stricken life until his death in 1892, growing more mage-like and oracular through the years (pl. 1). Truth be told, the authorities had never been comfortable with Whitman as a "nurse" in the hospitals. He had served to fill a gap in the treatment of the wounded and dying. But as the war continued, organizational efforts on the home front took hold to professionalize the care and treatment of battlefield casualties. In the world of people like Dorothea Dix and the army medical corps, amateurs like Whitman only got in the way. Similarly, Whitman was a government employee with the Interior Department in name only. He basically used the position as a sinecure, doing little work and coming and going as he pleased. That he was the author of *Leaves of Grass* was only a charge in the bill against him as the new secretary of the interior ramped up an efficiency campaign to create a government bureaucracy equal to the new society that was being built after the war. Whitman was also fired because he was a Democrat in a period of Republican ascendancy.

The utopian dreams Whitman had of a seamless interweaving of male affection and democratic polity fell apart for the poet in the reality of post–Civil War America. As for many Americans, who thought they were fighting for one thing—individual independence—the reality of war-making created a mighty industrial power in which individuals became only small parts in a monstrous whole. With all the money sloshing through the American system, the combination of unreformed politics and unregulated business had a notorious result—the corruptions of the Gilded Age. Whitman, his hopes dashed, became one of the most embittered critics of democracy, wondering even if the game was worth the candle and that some form of autocracy might be desirable. Whitman never became an American Carlyle or a version of Henry Adams in his deploring of modern industrial society. Instead, he devolved gently into an increasing bucolic pastoralism in which his own ever-expansive beard seemed not so much an adornment as something to hide behind. The once vigorous Jacksonian—"one of the roughs"—rambled around Camden, allowing butterflies to perch on his outstretched hand.

Wars engender consequences that no one can foresee. Often they are fought for ideals that turn into something quite different with the onset of peace. As the historian Michael McGerr has written, most northerners fought to restore the Union on the basis of individual self-sufficiency and autonomy. But once the war was won and the Union restored, they found their dream had been erased by the economic processes created to fight the war. The vast expansion of industry, the growth of the power of the federal government, and changes in the law all seemed to favor the mass and the conglomerate over the individual. Whitman's dream of society based on the manly embrace of the "camarados" was wiped out by the hyperaggressive pursuit of profit by industrialists like Cornelius Vanderbilt, capitalist and speculator extraordinaire, who was known as "The Commodore" and more balefully as "The Vampire of Wall Street." Untrammeled capitalism was a ferocious thing to watch in operation, and rarely has it been as untrammeled as it was in post–Civil War America. Its achievements were legion, when measured in terms that are easy to measure: miles of railway, tons of steel, industrial outputs, population growth, and so on. It was progress, but progress whose costs could get prohibitively high, as when racing steamboats piled on too much steam and erupted into fiery wrecks. Major downturns in the business cycle occurred regularly throughout the Gilded Age, with particularly bad "panics," as depressions were then called, in 1873 and 1893.

Against Whitman's prewar dream of union, a measure of the volatility of American society can be gleaned from the now largely forgotten ubiquity of violence against labor (to say nothing about the violence against African Americans in

a South that was mightily resisting Reconstruction). As labor scrambled to come up with a strategy of resistance to the power of industry and the corporation, strikes, either impromptu or called by one of the embryonic unions, caused business to react with fury against labor. For instance, a nationwide rail strike in 1877 resulted in hundreds of deaths from Martinsville, West Virginia, to Chicago. In Pittsburgh, Thomas Scott of the Pennsylvania Railroad declared that the strikers should get "a rifle diet for a few days": on July 21 twenty strikers were killed, and on the following day, twenty more. The body count was similar in other industrial conflagrations: the Homestead Strike of 1892 saw a pitched battled between striking workers (and their families) and the 300 Pinkerton detectives brought in to end the confrontation; the Pullman Strike of 1894 saw thirteen strikers killed and fifty-nine wounded by the authorities. The deployment of state violence on the side of business became commonplace. Similarly, the law evolved to reflect changing social realities, both in confronting the labor "problem" and to facilitate the untrammeled operations of business. It is ironic that the great civil rights amendments enacted to give citizenship to slaves now were read so as to treat corporations as "individuals" with inalienable rights.

Something had to give, and it dawned on the more alert capitalists that they were running the risk of long-term loss in place of short-term gain. Economic issues aside, the upper classes became split on ideological and cultural questions that threatened to founder the whole edifice. For instance, it seems clear that Vanderbilt wanted to create a near-hereditary American ruling class on the European model. This strained credulity for businessmen who had at least a nostalgic remembrance to the self-reliant tenets of an earlier phase of market capitalism. Moreover, there was an intra-ruling class crisis not unconnected with this image of itself as republican, in the virtuous sense of the word. Namely, the luxurious lifestyle of the Gilded Age's rich and famous engendered a crisis of masculinity. As men ruled business, women ruled society, including the elaborate social conventions that many, such as Vanderbilt, thought could be codified into an actual, not simply a virtual, aristocracy. Men became concerned that in a public world that revolved around the office and its world of paper, they were losing the central core of their male identity. To wit, they were losing their bodies, and hence, their authority. It was all very well for their wives to plan elaborate balls, but did real men really want to spend their time dressing up as Louis XIV? In this crisis of masculinity, the

career of Teddy Roosevelt is a case in point. The young Teddy, a privileged, asthmatic mama's boy, was packed off to the Badlands of the Dakotas to learn how to be a man. There he learned to ride and rope and had the satisfying experience of winning a fistfight with a cowpoke who called him "four eyes." Renewed and regenerated, he returned east to become the public face of the Progressive movement and to espouse a philosophy of the "strenuous life."

The renewal of interest in the male body as a bulwark against societal deterioration and a reaffirmation of masculine primacy had the ironic effect of reintroducing the overt display of homosociality, although on terms radically different from Whitman's transcendental bodies. For instance, the physical culture movement became all the rage, as did sports ranging from college football and professional baseball to race-walking, bicycling, and boxing. The growth of organized sports was indeed a concomitant of the society's own tendency toward agglomeration and incorporation. But underlying this business model were more primal instincts. For one thing, sports became a way of expressing aggression in ways that were short of war but rehearsed its virtues. (As president, Roosevelt had to intervene, telling colleges to reduce the violence in football—athletes were being killed and maimed—or he would ban the sport.) Moreover, another aspect of the ruling-class crisis of the late nineteenth century was the abuse of women, either directly (abusing them physically) or indirectly (frequenting prostitutes). Manly sport was a way for men to let off steam, and its codes were a way of rehearsing courtly or chivalric behavior toward both the opponent and to women. Masculinity was being recoded in a way that Whitman never could have envisaged, not least because it was being put in the service of Social Darwinism, not comradely love.

The ambiguities about the attractiveness of the male body and the ironic place of sport in American society are fully on display in Thomas Eakins's great painting *Salutat* (1898) (pl. 2). The painting was based on a fight by the featherweight Billy Smith; Eakins also included actual people, such as his own father, in the crowd. But within this conventional framework of realism, Eakins, who had returned to the male nude as a subject, fills the image with tension by indicating the conflicted state of masculinity and the nature of the male gaze when it was turned on other men. Within the "safe" confines of the sports event, it was permitted—encouraged—for the spectator to admire the sportsman, as here, with the undraped figure of the lithe boxer returning to the

dressing room with an arm raised in triumph. That the boxer is shown from the back only adds to the homoerotic charge of Eakins's document. But what really raises the emotional stakes is the baying crowd who celebrate "Billy" not for his pugilistic skill but for his physique: He is in victorious repose, and the crowd noisily lionizes him. That Eakins titled the portrait with a Latin tag— "He Salutes"—aestheticizes the image by referring us to its classical antecedents, possibly as a reference to gladiatorial combat. But the Latinism is just a fig leaf to Eakins's delectable rendering of the boxer's flesh and its availability under a tightly pulled loincloth. As with modern football players who pat each other on the ass while wearing skintight pants, the homoerotic is always lurking in the homosocial environment of exclusively male worlds like sport. And for the viewer of the portrait, possession and voyeurism are intermingled as he (the pronoun is deliberate) simultaneously views the reaction of the crowd and takes in the boxer's body as well. The rough verisimilitude of Eakins's scene setting was necessary to his realism. But it also becomes a way of disguising the object of desire by enveloping it in the aura of the documentary. At its core, *Salutat* is a variation on the traditional theme of respectable "pornography," as in Hiram Powers's *The Greek Slave*, with the object of desire now a near-naked man, not a near-naked woman.

The slipperiness of sexual desire—that men could have copies of works like *Salutat* and the *Greek Slave* in their studies—persisted despite, or perhaps because of, the ratcheting up of a self-conscious masculinity. The term "homosexuality" was coined about 1869–70, and the creation of such a taxonomic category was part of the organizational impulse of the increasingly bureaucratized state. Adding to the persistence of old Enlightenment ideals about classifying and cataloging the world, there now entered a new element of surveillance in which the vagaries of human behavior would be categorized for use; at this time, the various attempts to chart "criminal types" by physiognomy or other "signs" took off in earnest. The reduction of sexuality into a binary model consisting of the normal and permitted versus the abnormal and proscribed formed the basis for the policing of "deviants" not simply for their acts but for their supposed innate nature. This surveillance and identification was a response to both a real and a felt need as cities grew bigger, with their attendant social problems, and the bonds between individuals disappeared. This new surveillance combined the new with the old as the policing power of society not only controlled people's behavior but also

wanted to know who they were. Inevitably, the two functions became linked, and "scientific" studies of race or ethnicity "proved" the propensity of certain groups, including gays, to behave in predictable, antisocial ways. All this modernity (science, bureaucracy, governmental reform) was in the service of the traditional desire to know your neighbor. It would be incorrect, however, to see this as a wholly backward-looking attempt to cling to, or restore, so-called traditional society— the society that industrialization and urbanization had replaced. Yet the Progressive movement evinced a great deal of anxiety at a perceived loss of social control and a sense that the ills of society could be cured through a medicalized or naturalized analysis of it, one in which the toxins and foreign bodies could be expunged. City reform and moral reform were inextricably linked in the latest justification for capitalism's status quo.

Urban and moral reformers did have reasons to worry: in the realm of gender and sex, the city became the liminal space for free play that undercut the binary classification that sought to outlaw such transgressive behavior in the first place. Read as a text, the city projected a master narrative that sought to destroy difference, yet subcommunities and counter-institutions vied with that narrative in a restless dialogue of opposition and resistance, creating a kaleidoscopic terrain where every surface could become jumbled, appearances were deceiving, and control difficult to achieve. In New York, as George Chauncey's exhaustive survey, *Gay New York*, makes clear, a gay subculture developed and was allowed to flourish precisely because normative standards were impossible to maintain consistently in the huge instrumentality of the city. There thus grew up a gay counter-life, which contained multiple communities based on the diversity in the city. In one of the most dramatic cases, Chauncey describes how Harlem's "drag balls," the gay answer to debutante season, were wildly popular and widely reported, even in the straight press. Of course, the possibilities in Harlem were always wider; society did not expect it to function normally since African Americans, another despised minority, lived there. But in other parts of the city, gays and lesbians had to be more careful and discreet. An elaborate system of verbal and visual codes and signals developed so that people could make connections and evade the surveillance of straight society. There was an ebb and flow of gay patronage of public spaces where people could congregate freely, and the word would go out that certain diners, bars, and cafeterias were safe. Then fashion or the temperature would change, and the gathering place would

shift. More permanently, an established network of gay amenities such as clubs, theaters, and restaurants served its clientele. They were able to survive because the cost of suppressing them all was generally too high for the city. Moreover, it was not unknown for gay establishments to pay the local police precinct to turn a blind eye. But periodic crackdowns against vice were inevitable. (The Stonewall Riots of 1969 were sparked by this dynamic: the Stonewall Inn paid off the police but that *modus vivendi* broke down when Mayor John Lindsay decided it was time to "clean up" Greenwich Village.)

These "institutional" aspects of gay life in New York are familiar to anyone who has read even shallowly in the history of modern cities. More interesting, in terms of the continued problematic and shifting nature of what constituted "gayness," was the way that gays colonized public spaces like the waterfront, parks, and public conveniences. Chauncey makes the simple point that public space became sexualized precisely because privacy was so difficult for a population that lived in overcrowded housing; this was true for heterosexuals as well, of course. Sex in quasi-public might have been a necessity, but it also developed a special frisson on its own; cruising became a key part of gay culture. These sexual encounters had a political motivation as well since they were a direct violation of late Victorian moral strictures and a deliberate flouting of community norms.

Not only did overcrowding force people into public to avoid the minatory eye of their family and neighbors, but an immigration pattern of both transients and settlers created a population that skewed young and male, which meant that binary distinctions were honored in the breach as much as in the observance. Moreover, Chauncey finds that among certain immigrant groups, male sexual contact was considered tacitly permissible because of the rigid restrictions on pre- and non-marital relations. In both instances, these interactions were considered matters of behavior, not nature, and the boundaries of identity were fluid enough to accommodate multiple, sometimes transgressive roles. This multiplicity was a particular and special function of the modern city as appearances and actions became multi-faceted and variable, the parts always suggesting, but never quite completing, the whole. It was this creation of the modern city that inspired the development of the novel during the nineteenth century; fiction became simultaneously more realistic and more hallucinogenic as novelists from Balzac to James Joyce navigated their characters through the city.

More prosaically, in the lives of the urban poor and working classes any opportunity for recreation and relief was eagerly grasped. George Bellows's remarkable paintings (pl. 7) of the waterfront and piers crowded with masses of young men simultaneously suggest the pathology of a city with few services as well as the resourcefulness of a population looking for some fun. Inevitably Bellows's urban waterfronts contrast with Eakins's "swimming" pictures (fig. 3). The latter is an idyllic dream resonating of a timeless Arcadia, the former a feverish respite from the perils of modernity. Ominously, the boys are surveilled by a clothed, behatted figure to the lower right. Is he a middle-aged voyeur? Someone cruising for "trade"? Or is he a guardian of morality, either from a private watchdog group or officialdom? The clothed man is in direct opposition to Eakins swimming toward the rock, seeking to join the boys in appreciative, democratic communion in a state of nature. What Bellows's painting suggests is not just what had changed but also what will occur: Whitman's vision of a republic based on the manly love of comrades was lost in the distance, both as dream and reality. Instead, there would be a consistent sine wave of tolerance and oppression in which a minority sought to resist marginalization through the construction of elaborate defensive strategies. The idea of a full assault on normative values was problematic, if not suicidal. Whitman's two boys "together clinging" could no longer serve as the basis for a new society. Instead, that image of intimacy would become an alternative vision aimed at personal survival and resistance—a vision born out of an acute awareness of marginalization and ostracism.

Plate 1
Walt Whitman

Through me forbidden voices;
Voice of sexes and lusts—voices veil'd,
and I remove the veil; Voices indecent,
by me clarified and transfigur'd.

—Whitman, _Leaves of Grass_

Thomas Eakins took this photograph of Walt Whitman (1818–1892) a year before the poet's death. Aged and fragile, Whitman had become a skeptic about the course of American society, not least because of the persecution he suffered as the author of what many called that "immoral book," _Leaves of Grass_. Nonetheless, Whitman's poems endured as a testament both to artistic innovation and to a vision of American democracy as capacious and all-embracing. Especially as society became more stratified, industry imposed the division of labor, and the law parsed gender differences, Whitman's evocation of a transcendental republic rooted in the physical intermingling of free individuals in both same and different-sex relationships was an inspiring counterpoint that would animate American culture into the new century. Borrowing categories from phrenology, Whitman labeled this democracy of desire "adhesive," which was the capacity to extend true friendship, as opposed to "amative," which instead signified traditional notions of love. Whitman's refusal to accept the existence of boundaries and limits on the body and its capacities, physical and emotional, is the most radical statement ever of American individualism.

By Thomas Eakins
(1844–1916)
Platinum print, 10.3 × 12.2 cm (4 1/16 × 4 13/16 in.)
1891 (printed 1979)
National Portrait Gallery, Smithsonian Institution, Washington, D.C.

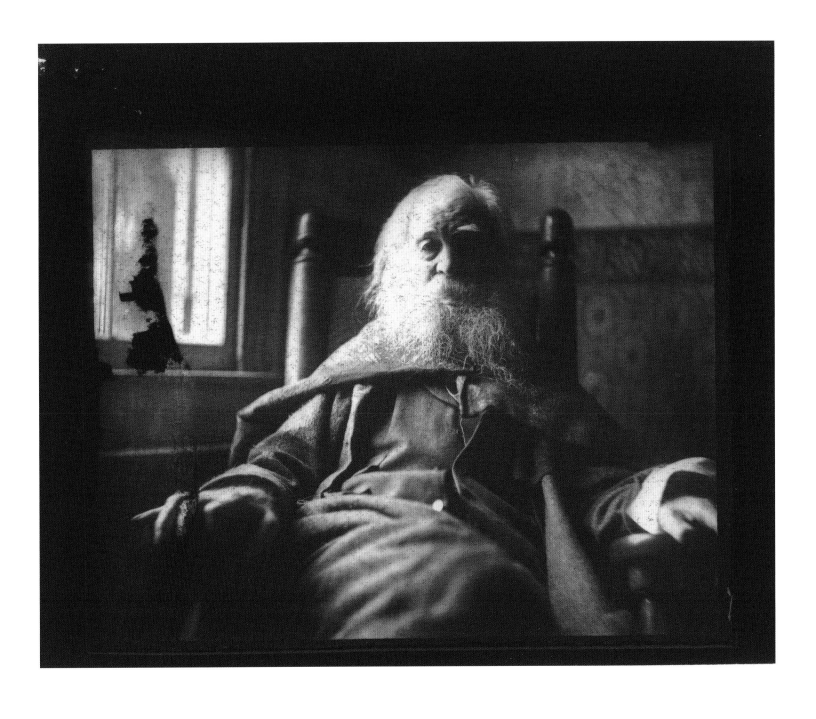

Plate 2
Salutat

By the turn of the century, an expansive capitalism was colonizing the cultural world, creating the outlines of the mass-entertainment industry we know today. This occurred in part because elites felt their position threatened by new immigration and the chaotic nature of the economy that was its very lifeblood. The "strenuous life," an emphasis on physical vigor, became the watchword for reformers anxious about both moral and social slippage. College football, rowing, and especially boxing became sites of masculine revitalization. Yet these sites were fraught with new tensions, especially as the overt cultivation and celebration of the male body became an opportunity for homoerotic admiration. These tensions become palpable in Thomas Eakins's portraits of athletes. In *Salutat*, an adoring, all-male crowd of "swells" bays its approval of the near-naked pugilist exiting the arena. Yet

Eakins turns Gilded Age conventions of the male gaze on their head. By making the object of desire an undraped male instead of a nude female, Eakins resisted social norms. He furthered his deviation from convention by having his boxer not box, thus stripping away the sole acceptable rationale for contemplating a nearly naked male form. The crowd is not admiring the boxer's jab, but his body, especially his buttocks. The boxer is also hardly a paragon of masculine power: he was a featherweight twenty-two-year-old working-class lad named Billy Smith, who became much admired in Eakins's circle for his continuing devotion to the painter.

By Thomas Eakins
(1844–1916)
Oil on canvas, 127 × 101.6 cm (50 × 40 in.)
1898
Addison Gallery of American Art, Phillips Academy, Andover, Massachusetts
Gift of an anonymous donor

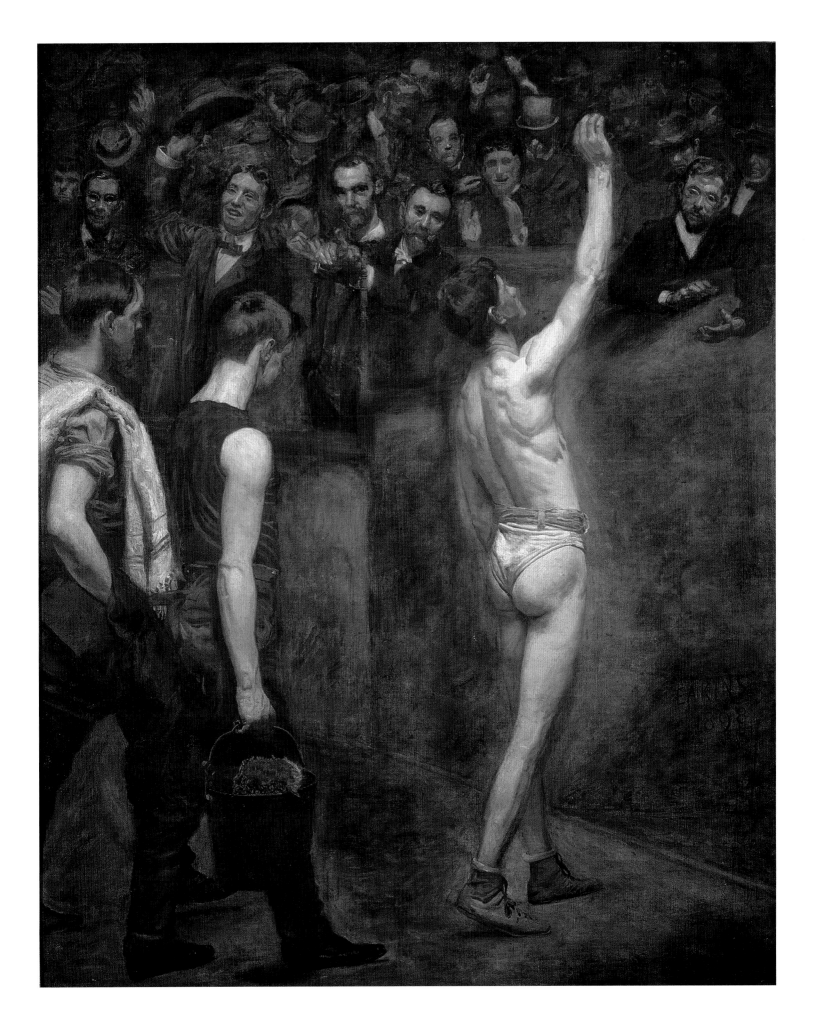

Plate 3
Nude Male Standing

John Singer Sargent invested his luxe and voluptuous portraits with an exotic and erotic flair that frequently caused them to become objects of public titillation and scandal. Most famously, his 1884 portrait of Virginie Gautreau caused such an uproar because of its palpable sexuality—originally, Sargent painted one spaghetti strap of her dress draped lasciviously off her shoulder—that it was exhibited as *Madame X*. Sargent's other paintings might not have carried the same charge, but they all carried at least a sense of the sitter's sexual allure. This was as true of his portraits of men as it was of women, and when Sargent sought out the ephebic Graham Robertson for a portrait, it was not lost on the sitter why (see fig. 7). Sargent negotiated eroticism by swathing it in luxury and by classicizing it. For artists, classicizing the subject was a time-honored way of making the erotic respectable, and it was especially useful in masking same-sex tendencies. When it came to painting the muscular figure of Thomas McKeller, a hotel employee whom Sargent convinced to model for him, race cut across the conventions of portraiture. It was safe to paint an African American of a "lesser" class completely in the nude and as an object of delectation. But Sargent still gestures to classical antecedents in his portrayal of McKeller to frame his subject in acceptable aesthetic categories. The erotic charge of Sargent's drawings and studies of McKeller overpowers the perfunctory attempt to turn his nude body into allegory or myth, however.

By John Singer Sargent
(1856–1925)
Charcoal on paper, 63.2 × 48.3 cm (24 7/8 × 19 in.) sheet
c. 1917–20
Philadelphia Museum of Art, Pennsylvania
Gift of Miss Emily Sargent and Mrs. Francis Ormond, 1929

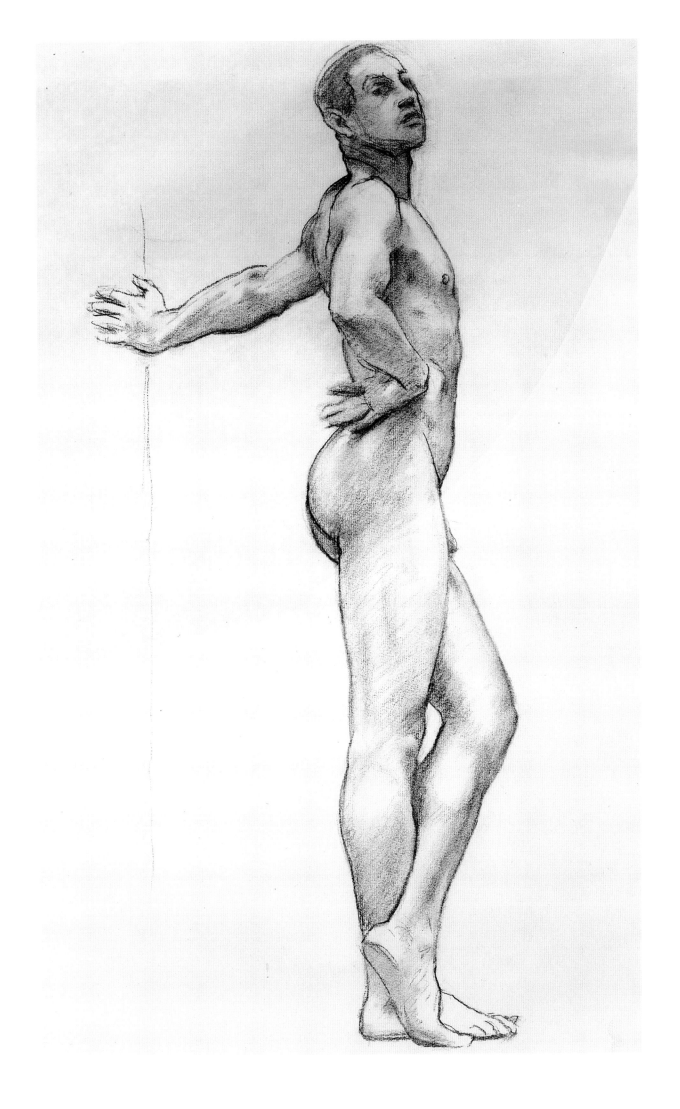

Plate 4

**The Vision
(Orpheus Series)**

In Greek mythology, when the singer, poet, and musician Orpheus went down into the underworld to rescue his beloved Eurydice, his singing so beguiled the gods that they permitted him to take her back to life, provided that he did not look at her as they traveled back to the earth's surface. Fatally, at the last moment Orpheus stole a glance at Eurydice, and she had to return to the underworld. Thereafter, Orpheus turned his face against women and consorted only with young men, creating a link between sexual difference and artistic creation that exists, albeit frequently unacknowledged, in discussions of artistic creativity to this day. In this photograph, F. Holland Day "documents" Orpheus's return to earth, creating a deliberately archaized modern re-creation of the myth. The soft-focus, blurred image and the double exposure of a male head over another male body combine to give mythic sanction to what is without doubt a homoerotic retelling of this foundational myth. Moreover, there was an exotic element to Day's vision, redolent of the period's exoticizing (and eroticizing) of the "Orient." While *The Vision* established the lineages of homosexual creativity, the aestheticizing of that vision in a deliberately reactionary way, one appropriate to a *fin de siècle* culture preoccupied with decadence and decline, would soon be overtaken by the recasting of art and culture as the twentieth century truly began with World War I in 1914. The myth of Orpheus would never disappear, but it would be shaped to suit the contingencies and necessities of an increasingly violent modernism.

74/75

By F. Holland Day
(1864–1933)
Platinum print with hand-coloring, 24.1 × 18.7 cm
(9 1/2 × 7 3/8 in.) sheet
1907
Prints and Photographs Division, Library of Congress, Washington, D.C.

Plate 5

Painting No. 47, Berlin

Marsden Hartley spent his life and career in search of a style that would express the restless, contradictory aspects of his character and personality; at various times he painted like Albert Pynkham Ryder, Paul Cézanne, and Georgia O'Keeffe. A member of the Stieglitz circle, he was never favored by his patron, who treated Hartley rather shabbily even as he acted as his dealer. The one time in his life when Hartley seemed to find peace was, ironically, just before World War I, when he went to Germany, fell in love with a German officer named Karl von Freyburg, and became entranced with Germany's modern speed, efficiency, and color. Reacting to Berlin and its culture—including German militarism, which the artist adored—Hartley developed a wholly original style of abstraction that crystallized his, and the city's, experience in the signs and emblems that signified German life: the Iron Cross, the abbreviations of military units, the initials of von Freyburg, his age at death, his position in a cavalry unit, and so on, were all woven into his large abstractions. Abstraction allowed Hartley to express his feelings toward von Freyburg and the entirety of modern German society, including its warriors, in code—a necessity near the U.S. entrance into World War I, after which the Germans became the enemy. *Painting No. 47, Berlin*, like most of Hartley's portraiture, was a mourning portrait, as von Freyburg was killed early in the war. The entire image, topped by an officer's ceremonial helmet, evokes a figure, and the number "9," and halo surrounding the helmeted head, signify resurrection.

By Marsden Hartley
(1877–1943)
Oil on canvas, 100.3 × 80.3 cm (39 1/2 × 31 5/8 in.)
1914–15
Hirshhorn Museum and Sculpture Garden, Smithsonian Institution, Washington, D.C.
Gift of Joseph H. Hirshhorn, 1972

Plate 6
Men Reading

"You're the top! You're an Arrow Collar!" proclaims
cabaret performer Reno Sweeney in an effort
to comfort the lovesick Billy Crooker in the 1934
Broadway musical *Anything Goes*. Indeed, by
the mid-1930s, the "Arrow Man" had come to
represent the pinnacle of upper-class American
masculinity. Tall, muscular, and impeccably
turned out, the "Arrow Man" enjoyed playing
sports and rubbing elbows with his old buddies
from Harvard, Yale, and Williams. This desire
for all-male camaraderie among the most sophis-
ticated of American men treaded a thin, and
often shifting, line between homosocial bonding
and homosexual yearning. J. C. Leyendecker—
the creator of the "Arrow man"—knew full well
that he could exploit this ambiguity to increase
desirability, both for the men and for the clothes
that they wore. Here, two young men share an
ambiguous domestic space (perhaps their living
room, perhaps a den at the Harvard Club) and
an equally ambiguous gaze as one of them,
modeled on Leyendecker's lover Charles Beach,
lowers his book as the other continues to read
his newspaper with icy indifference.

By J. C. Leyendecker
(1874–1951)
Oil on canvas, 48.3 × 99.1 cm (19 × 39 in.)
1914
American Illustrators Gallery, New York City

Plate 7

River Front No. 1

The industrial city of late-nineteenth-century America was very much a city of men. Young working-class males from both the hinterland and abroad flocked to cities, seeking jobs, social mobility, and independence from the societies they had left behind. For the urban poor and working classes, the city had few amenities, and during the sweltering summer heat boys and men would throng the docklands to swim in the river and socialize. The social realist painter George Bellows captured this and other scenes of city life in paintings that were both celebrations of urban vitality and indictments of the conditions under which the poor lived. The excess population of young men (and the relative absence of

eligible women) at loose in the city encouraged a fluidity in sexual behavior that would not have occurred otherwise. In this Rabelaisian display of male flesh, Bellows was a scrupulous observer of the homosociality of city life as well as its class separations. Clearly visible among the working-class mothers picking up their children is a dandified male figure who seems to have no reason for being there, save to watch.

By George Bellows
(1882–1925)
Oil on canvas, 115.3 × 160.3 cm (45 3/8 × 63 1/8 in.)
1915
Columbus Museum of Art, Ohio
Howald Fund Purchase (1951.011)

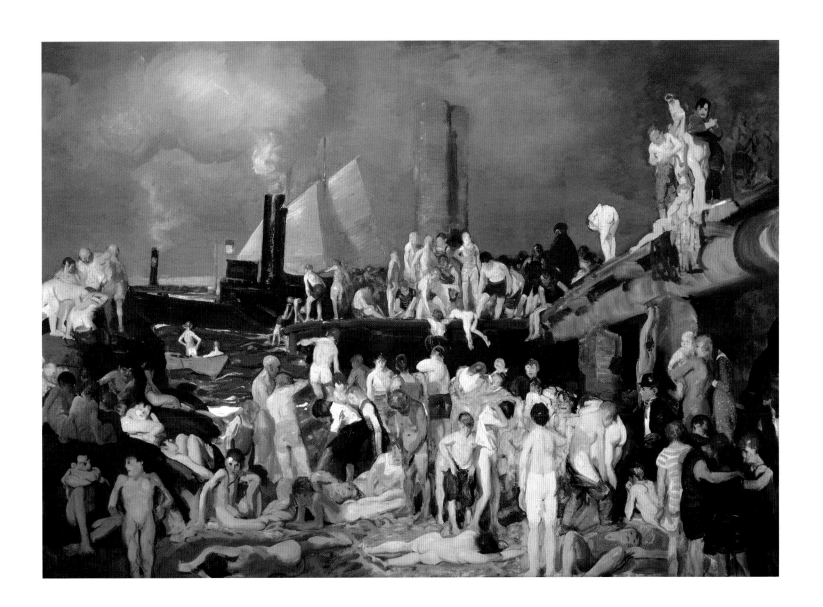

Plate 8
The Shower-Bath

The coinage of the term "homosexual" around 1870 was part of the late-nineteenth-century impulse to classify and control. Yet the act of classifying revealed fears about the breakdown of traditional society and its roles, especially regarding gender and sexuality. Despite the rigid wall between right and wrong conduct, in practice, matters were much more ambiguous and complicated. This remarkable work by the realist artist George Bellows helps document the ambiguities of sexuality and sexual mores in the big city. A ribald "backstage" look at one of the male bathhouses that were legion in New York City before the era of common indoor plumbing, Bellows's lithograph highlights an assignation between an effeminate man and a bullish figure whose towel looks suspiciously rigid. In the parlance of the period, the effeminate man is queer because he contravenes his gender, but the bullish man, who was "only" doing what men do, would have been utterly unmarked. The import of *Shower-Bath* is that it depicts a practice that everyone knew occurred and tolerated—even though it was legally proscribed. Bellows's print is a document about social and sexual habits and practice, but while it is satirical, it is not condemnatory. That the print depicted behavior that could be quietly accepted, if not publicly condoned, is indicated by the fact that it went through a remarkable three printings, selling out every time. Clearly *Shower-Bath* struck a chord in its permitting the open depiction of sexual difference within the liberating confines of both the bath-house and the city itself.

By George Bellows
(1882–1925)
Lithograph, 40.8 × 60.6 cm (16 $^1/_{16}$ × 23 $^7/_8$ in.)
1917
Dorrance Kelly

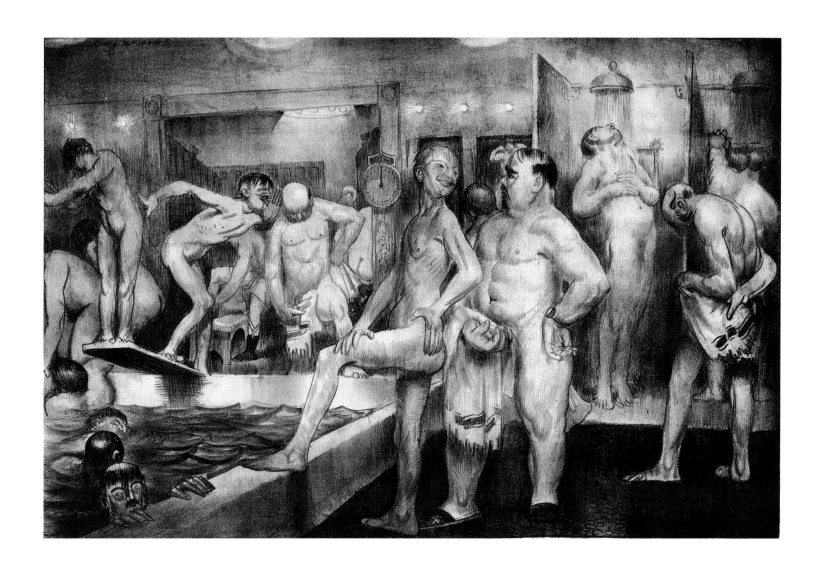

Plate 9

**Cabaret Interior
with Carl Van Vechten**

Charles Demuth's genre scenes of a highly sexualized urban atmosphere tended, like most genre scenes, to feature anonymous "types": sailors, swells, and hangers-on who caught the frisson of desire that pulsed through the city's crowds. In the anonymity of his subjects, Demuth also hit upon the way in which the city broke down barriers of class, race, and sex, providing the opportunity for casual encounters that were unthinkable in the traditional, hermetic world of the American town and country. That Demuth typically made these genre scenes in watercolor and graphite, fleeting media that require quick and dexterous relations between the eye and hand, added to the sense that the pictures captured revealing snapshots of the city at play. This small watercolor features a familiar subject for Demuth—a cabaret—but he places in it

a portrait of the as yet largely uncelebrated photographer and writer Carl Van Vechten (1880–1964). As much as anyone, Van Vechten served as straight America's tour guide of the libidinous world of the city, especially Harlem. So Demuth shows Van Vechten in his element, both observer of and participant in the life he celebrated. Just as Demuth divided his art between austere abstraction and earthy genre paintings, Van Vechten lived a bifurcated life: downtown, respectably married, he was the epitome of the white intelligentsia; but in the evenings he would venture up to Harlem, where he delighted in the company of young black men.

By Charles Demuth
(1883–1935)
Watercolor on paper, 19.7 × 27.3 cm (7 3/4 × 10 3/4 in.)
c. 1918
Barbara B. Millhouse

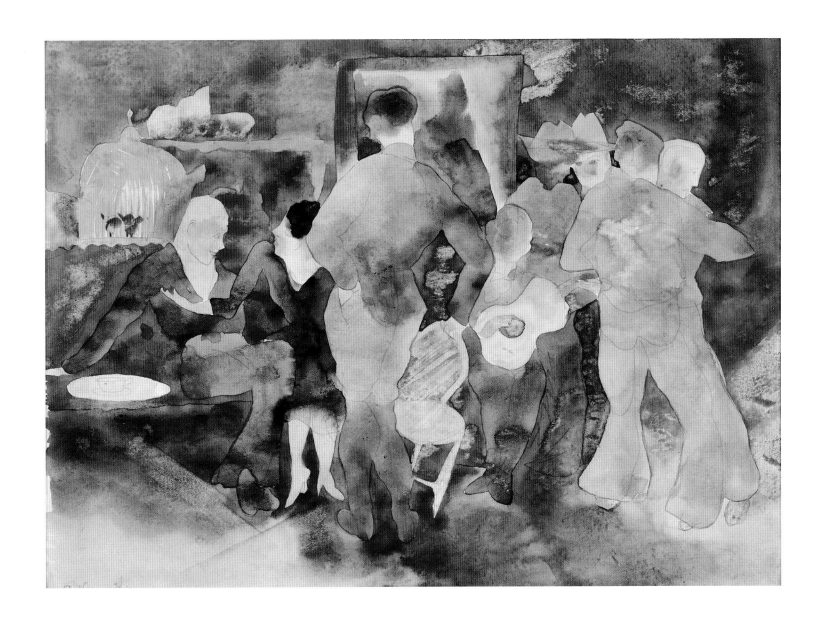

Plate 10
Dancing Sailors

While painters like Marsden Hartley and Agnes Martin turned to abstraction as a way of sublimating and expressing their same-sex desires, Charles Demuth divided his artistic work into two distinct strands because of his homosexuality. As a member of Alfred Stieglitz's 291 group, he produced requisite works of high modernist abstraction such as his industrialized landscapes of Pennsylvania or his iconic *I Saw the Figure 5 in Gold*. Yet he also, as a gay man, made abstract works in order to reference the queer world, as in his Poster Portraits of Hartley or Bert Savoy. More provocatively, he also produced for private audiences a series of realistic genre scenes of gay life in the city that revealed the coded interchanges hidden from straight society. In this picture, Demuth paints himself as an observer of sailors who are in New York City on shore leave, a favorite subject of the artist. Demuth's scene evokes the demimonde of homosociality and gender-bending that arose in the all-male, and isolated, environment of naval vessels, making sailors a favorite subject of the homosexually inclined on land, as well.

By Charles Demuth
(1883–1935)
Watercolor over graphite on paper, 20.4 × 25.7 cm
(8 × 10 in.)
1917
The Cleveland Museum of Art, Ohio; Mr. and Mrs. William H. Marlatt Fund

Carl van Vechten (detail) by Romaine Brooks
Reproduced in full as Plate 24.

New Geographies/
New Identities

"How ya gonna keep 'em down on the farm after they've seen Paree?" The lyric from the popular 1918 tune provides a jaunty explanation for the changes in American culture that occurred in the aftermath of World War I. Alone among the great powers, the United States emerged from the war not only relatively unscathed but with its economic and political power enhanced and growing. Reluctantly drawn into the quarrels of "Old Europe," America could not avoid the cultural and societal changes that that engagement entailed. The song was right: in the first decades of the century, Americans were moving from the country to the city in increasing numbers. But this was a general process that had been going on for years.

Of course, very few Americans had actually seen "Paree"—the Allied Expeditionary Force was only a small percentage of the country's population. Most of the people who left the family farm didn't go to Paris but to the major city in their state. Rather, the message of the lyric suggested a sea change in American attitudes about both themselves and their place in a wider world. Namely, having abandoned isolationism, Americans were eager to become more cosmopolitan and sophisticated—urbane as well as urban. In particular, there was a knowingly sexual implication to the song lyric, since Paris had always been a byword for moral permissiveness and license. There was a clear hint that a sexual, as well as a cultural, revolution was in the air. Yet the cultural conflict between "farm" and "Paree" would not be resolved so neatly in favor of the latter. The contradictory legacy of World War I, as it played out in the United States, would decisively influence both modernist art and sociocultural mores. In this struggle, the "farm" was not always the loser.

The war destroyed the political arrangements of nineteenth-century Europe, but its most immediate and appreciable impact in little towns to big cities, from the Orkney Islands to Moscow, was the decimation of the population. Battlefield casualties were simply staggering: the Allied powers lost about 5.7 million soldiers and the Central powers, led by Germany, lost 4 million. But casualties were not confined to the battlefield, and in this first total war there were about 16 million total deaths, both military and civilian. (It's also worth noting a macabre addendum to this carnival of death: the war was succeeded by an epidemic of Spanish influenza that wiped out another 17 million lives worldwide.) America, given its late and partial involvement in the war, suffered mildly in comparison: 116,000 deaths. Whereas France lost 4.29 percent of its population, and the United Kingdom lost 2.19 percent, the United States suffered a minute .13 percent loss. The United States, of course, suffered none of the damage to its land and infrastructure that affected the European battle zone. But the cultural and political impact of the war on America was out of proportion to its material and human losses. Like Europe, America was wrenched from its moorings, and even its status as the acknowledged victor in the war could not compensate for an unclear and uncertain future.

In the aftermath of the war, the shape of the world to come became the subject of intense debate among all parties. There was a sense that everything was in play, and issues from the future of the nation to women's rights became matters of intense, violent debate among people of every political persuasion. An immediate example of the contest over the nature of that future occurred over America's entry into the League of Nations. Woodrow Wilson's attempt at progressivism abroad was met by immediate opposition by a coalition politically opposed to foreign entanglements and culturally resistant to intercourse with Europe. The battle over the league opened a huge fault line in American culture, not only over issues of international engagement but also over the nature of American culture and sovereignty. The fact was that many Americans wanted nothing to do with "Paree." For instance, the Prohibition movement, which culminated in the Volstead Act and the Eighteenth Amendment, was not the last act of the Progressive movement, as it has sometimes been portrayed. Instead, it was part of a cultural counterattack that, roughly speaking, pitted the country and the South against the city. Underlying the battle over Prohibition were all sorts of ethnic and cultural tensions and hostilities that played themselves out. Moreover, the issue was shot through with a moral indictment that it was the lax and undisciplined character of our people and civilization that had permitted the hideous carnage of the Great War; Prohibition was penance. In hindsight, we can now see Prohibition, and the cluster of issues that orbited it, as the last stand of the older America against modernizing tendencies that now seem both ineluctable and necessary. Yet it was precisely in this conflict between old and new that the culture of American modernism was formed. Ironies would abound as the country worked its way through the contradictions of postwar reassessment and reorganization. Not the least of these ironies was that Prohibition, a top-down demand for personal and societal self-control, would lead to an orgy of crime and licentiousness that would actually accelerate what the prohibitionists were trying to avoid!

While the government intervened into people's lives to control or monitor private practices and beliefs (during the war and after there was an unprecedented crackdown on civil liberties directed at "subversives"), in the political economy there was a return to *laissez-faire* practices. As historian Michael McGerr and others have argued, the war put an end to the limited attempts at state intervention and reform that had characterized the Progressive Era. The political economy had cycled through a necessary wave of self-scrutiny to curb the worst excesses of *laissez-faire*. But the end of the war provided a convenient stopping point as the country sought a return, in Warren Harding's terms, to "normalcy." The wartime attack on socialists, labor unions, and other radical critics of the status quo also harkened a move to the right on the relationship between government and the economy. "Statist" intervention was off the agenda, and a slackening of the regulatory impulse set the stage for the economy to boom during the 1920s. The overheating of the economy helped contribute to an increasingly overheated cultural climate in which sensation and immediate gratification replaced the older virtues of bourgeois Victorianism. New methods of gaining wealth—especially changes in the stock market that loosened restrictions on investment—seemed to many to usher in an era in which everyone could become wealthy, even as conservatives and other skeptics groused that such wealth was unearned.

A growing component of the economy, and a major part of its growth, was the entertainment industry, as technological developments from the late nineteenth century—radio, the phonograph, movies, and electric lighting—became viable for mass audiences. Cultural nostalgics bemoaned the fact that American households would no longer gather together to sing or read. Instead, such homey entertainments were replaced by professional recordings and public entertainment at the movie theater. The way in which mass entertainment percolated into the economy and culture was a leading indicator of how America shifted to being a nation of consumers. Show business became big business, and the media developed in tandem, feeding the public's appetite for news and views of people of note. As in the economic shift from production to consumption, the 1920s saw the birth of a growing celebrity culture. While celebrity was still linked to achievement—the lionization of Charles Lindbergh, Babe Ruth, or Mary Pickford derived first of all from what they did—the way in which personality was decoupled from biography was manifested in the Roaring Twenties. Just as the

radio undermined family sing-alongs, the growth of a celebrity-driven mass culture began wiping out regional and local differences to create a national culture in which differences were only nominal. A reaction against this homogenizing effect was surely one reason for support of Prohibition in places like Kansas or Nebraska. More ominously, the resurgence of the Ku Klux Klan (reformed in 1915) was caused not just by a recrudescence of racist politics, but by a politics of resentment over the perceived loss of personal autonomy to anonymous forces and shadowy cosmopolitan elites.

While one part of the society reacted against modernism's tendency to melt all that was solid into air (to adopt Marx's phrase), a cultural vanguard of artists and writers embraced the possibilities of creating new forms out of their own uncertainty and bewilderment. World War I not only remade Europe geopolitically, it also undermined and destroyed the values and morality that had been nurtured with the growth of bourgeois society in the nineteenth century. Unquestioning belief in rationality and progress could not be sustained in the face of the incredible carnage created by world war. For postwar artists and writers, everything had to be questioned. As Ernest Hemingway put it in his World War I novel *A Farewell to Arms* (1929): "I had seen nothing sacred and the things that were glorious had no glory and the sacrifices were like the stockyards at Chicago if nothing was done with meat except to bury it. . . . Abstract words such as glory, honor, courage, or hallow were obscene beside the concrete names of villages, the numbers of roads, the names of rivers, the numbers of regiments, and the dates." For Hemingway, the rejection of transcendental concepts meant the recoil into an adamantine individualism, one in which adherence to small rituals—especially the small rituals involved with male activities like sport—was a way of staving off a loss of control that was endemic in postwar society. Hemingway's famously pared-down diction was a mirror to his protagonists' retreat within themselves, hunkered down in a self-protective mode in which they are wary observers of a world in which they cannot participate. It is key to Hemingway's response to the war that Jake Barnes, the narrator of his first novel *The Sun Also Rises* (1926), is impotent from an unspecified wound. In, but not of, the postwar Parisian crowd of expats, down-and-out nobility, and *demimondaines*, he can only vicariously join their heedless and feckless existence. While Hemingway paints a fairly horrible picture of the lifestyles of Lady Brett and her friends, what many people, less censorious and rigid than the

author himself, took away was that by the 1920s all bets were off. The sacrifices of the war sanctioned a hedonistic, devil-may-care attitude in which the success of the carnival was measured by the number of masks one wore.

Moral implications aside, what readers still take away from F. Scott Fitzgerald and Hemingway is the glamour and hedonism of Jazz Age society both as they (and others) wrote about it and as they lived it as expatriates in Paris. Parties, then as now, are fundamentally about courtship and sex. In the 1920s, this connection was made explicit for the first time; moreover, pleasure and the loss of control rather than restraint and codified behavior became the norm. The twentieth century's sexual revolution took place, not in the 1960s, but in the 1920s, with the final shattering of Victorian conventions. Prohibition created a sense among many people that they were outlaws, which helped loosen morals and behavior in other ways. Moreover, it created a sense that other bounds could and even should be transgressed as well. As people went out or gathered in private residences looking for drinks, a whole range of promiscuous social opportunities presented themselves. Expatriation was in vogue, both in the literal sense, so that people like Hemingway and Fitzgerald moved to Paris, and the figural as well. People reacted to the twin shocks of war and peace with an internal and psychological migration away from social norms. Hemingway went to Paris in 1921, looking both for an exotic locale and to learn the writer's trade. In Paris, he was introduced to the most avant-garde literary and artistic tastes at the salon of Gertrude Stein (pl. 20) and by living in an artistic milieu that included Gerald and Sara Murphy, Max Eastman, Ezra Pound, James Joyce, and many others. Salons like Stein's popped up all over, from Carl Van Vechten's (pl. 24) New York City soirees, where Bessie Smith (pl. 25) and others performed, to London, Paris, and Weimar Berlin, which was especially notorious for the frenzy in which it submerged all norms and distinctions. Christopher Isherwood's memoirs of Berlin left an indelible image of sexual and intellectual ferment.

But the strands and influences that helped form postwar modernism cannot be neatly encapsulated in the linear equation of "war plus peace equals liberation." The prism of gender and sexual difference is crucial to understanding both the conservative and radical impulses toward the reorientation of culture and society after World War I. The contrast between Hemingway and Fitzgerald is instructive.

Hemingway broke with Stein and her circle after overhearing a sexual encounter between Gertrude and her companion, Alice B. Toklas. Disgusted, he left her apartment (and by implication, her intellectual influence), never to return. Homophobia was a leitmotif in The Sun Also Rises, and Hemingway's public persona evinced an assertive, hairy-chested masculinity as he became a bestselling author. As his career progressed, many people began to suspect that this belligerently masculine facade hid a more complex mentality, one that found the idea of gender ambiguity an enticing prospect. Indeed, Hemingway's unpublished writings are shot through with instances of gender-bending and gender-crossing: androgyny, and thus the interchange of sexual roles among nominally heterosexual couples, is a theme returned to repeatedly, but by an author who would never reveal this "weakness" in public. The point is not to accuse Hemingway of hypocrisy; rather it is to pinpoint how the public necessity of maintaining hetero-normal styles conditioned his artistic work. Hemingway's lapidary sparseness of style is a result of his refusal to permit any ambiguity or play. In his short stories, he makes the point exhaustively through style alone that sanity can be maintained only through repressive exclusion. Hemingway's characters are always awkward, near-cartoon-like figures because he cannot permit himself to allow them to express genuinely human emotions. To entertain ambiguity or uncertainty was to lose one's self—a prospect too terrifying to be considered.

Whereas Hemingway saw ambiguity as threatening, his contemporary Fitzgerald created the quintessential modern American novel, The Great Gatsby (1922), precisely by embracing and capturing the shape-shifting possibilities created after the war. The mysterious figure of Gatsby (née Gatz) appears in multiple guises, ranging from the dutiful boy who followed a Benjamin Franklinesque regimen of self-improvement—a parody of the Protestant ethic—to a shadowy presence who consorted with gangsters. The magnificence of Gatsby's character—and the limpidity of Fitzgerald's prose—make him heroic and tragic. Even though society and its machinations end up killing him, it is Gatsby's impeccable sense of self that drives the character—and the novel—to its great climactic peroration in which "we beat on, boats against the current, borne back ceaselessly into the past"—a fusion between past and future that was both lyrical and precise in its diagnosis of the predicament of the 1920s.

It might have heartened cultural conservatives that at Gatsby's end, Nick Carraway, the narrator, goes back to the Midwest, chastened by his experience in the vertiginously luminous space of the modern city.

Plate 11

Study for Poster Portrait: Marsden Hartley

Charles Demuth painted abstract portraits of famous subjects who were generally either gay or sexually ambiguous: Gertrude Stein, Bert Savoy, Georgia O'Keeffe, and Marsden Hartley. His great *I Saw the Figure 5 in Gold* was also in this vein, a tribute to the poet William Carlos Williams. Abstraction allowed the simultaneous expression and concealment of his subject's character and personal life; his subjects could "hide in plain sight" from those who could not read the codes. For instance, Demuth's gorgeous painting *Calla Lilies* depicted the famous drag performer Bert Savoy through the device of the trademark lilies that Savoy would toss to the audience at the end of his performance. Demuth's study for a never-finished Poster Portrait of his friend and fellow artist Marsden Hartley (1877–1943) incorporates both Hartley's dark landscapes and erotically charged, phallic still lifes. The study brims with personal references to Hartley, from his trademark gardenia to the overlong stamen of the anthurium flower, satirizing his friend's habit of working references to his sizeable member into the conversation. Interestingly, Demuth inserts himself into this study, marking the cane at the lower left with his initials. This echoes Hartley's own practice of inserting his possible lover's initials ("KvF," for Karl von Freyburg) in his Berlin paintings. Demuth's main concern is to indicate, in his combination of symbolic landscape and blooming flowers, Hartley's association of eroticism and love with death, confirmed for him throughout his life, from von Freyburg's early demise to the deaths of Alty and Donny in a storm—the young Nova Scotia fishermen with whom he lived for a while.

92/93

By Charles Demuth
(1883–1935)
Watercolor and graphite on paper, 25.7 × 20.6 cm
(10 1/8 × 8 1/8)
c. 1923–24
Yale University Art Gallery, New Haven, Connecticut
Stephen Carlton Clark (B.A. 1903) Fund and
Everett V. Meeks (B.A. 1901) Fund

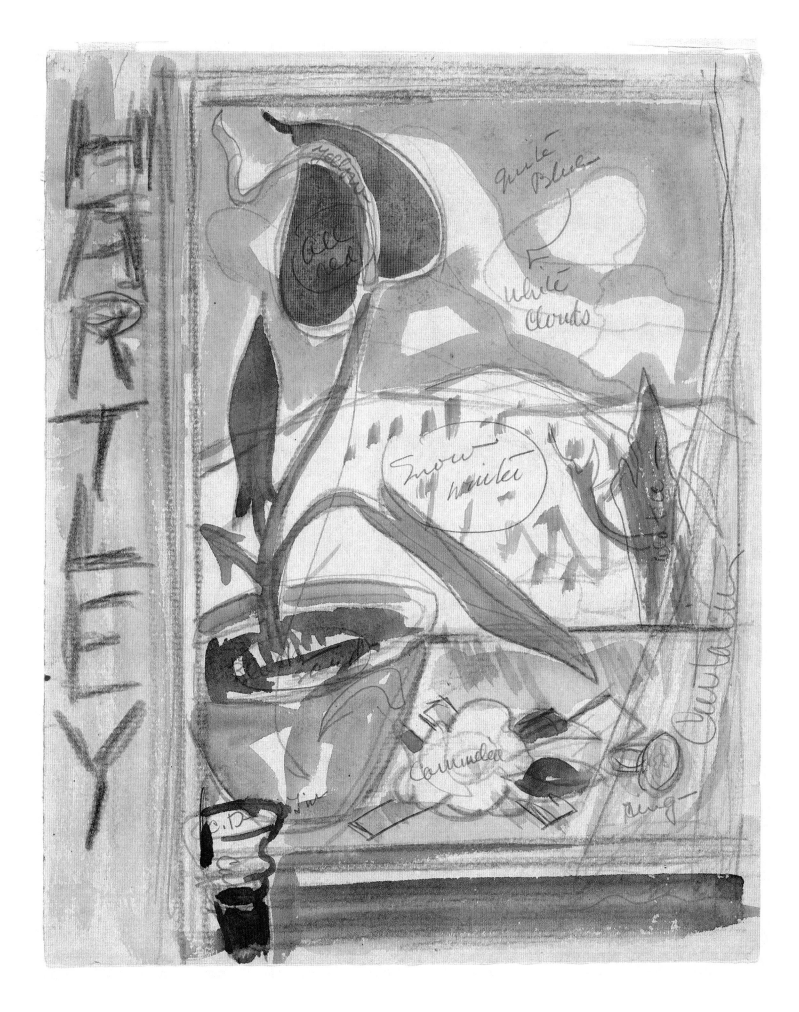

Plate 12
Self-Portrait

As my eyes took in the artist's daring statement of self—the defiant stance, the sober costume with its rakishly turned collar, the unyielding set of the chin, eyes ablaze from the shade of an outsized top hat—I experienced a shock of recognition: She's my kind of woman, I said to myself, not needing confirmation from the wall text (which offered none in any event).

—Tirza True Latimer, *Women Together/Women Apart: Portraits of Lesbians in Paris* (2004)

In this self-portrait, Romaine Brooks deploys a complex set of codes and pictorial conventions to assert her membership in the elite coterie of lesbians living in Paris between the world wars. Brooks's upper-class status and financial independence permitted her a rare freedom of expression. Her position on a balcony, the threshold between public and private space—her sleek masculinized attire coupled with her brightly rouged lips and thickly powdered face, the shadow that obscures (but does not mask) her eyes—all signify, in various ways, her self-conscious performance of a lesbian identity. As a wealthy woman, Brooks never had to sell her paintings to support her art, so she was freer than most artists to accurately portray the largely queer social universe she inhabited. Her paintings thus stand as one of the most nuanced documents we have of lesbian and gay life before the Second World War.

By Romaine Brooks
(1874–1970)
Oil on canvas, 117.5 × 68.3 cm (46^1/4 × 26^7/8 in.)
1923
Smithsonian American Art Museum, Washington, D.C.
Gift of the artist

Plate 13

Una, Lady Troubridge

English sculptor and writer Una, Lady Troubridge (1887–1963) was the longtime partner of the writer Marguerite Radclyffe Hall (1880–1943) who wrote *The Well of Loneliness* (1928), one of the first novels to overtly treat the subject of lesbian desire. Just as Hall adopted a man's nickname— John—the main character of *The Well of Loneliness* was a woman named Stephen. In postwar England, the Hall "circle" was notorious and *The Well of Loneliness* was the subject of a successful prosecution for obscenity. Troubridge had been married to Admiral Sir Ernest Thomas Troubridge, but the marriage ended after she met Hall in 1915. They lived openly together until Hall's death; Troubridge would later write a biography of her lover. Radclyffe Hall introduced Troubridge to artist Romaine Brooks, who painted this severe portrait in 1924. The crossover into the adoption of a man's tailoring, as well as the exotic touch of the monocle, all are rendered not just as mannish, but as coded acknowledgments of the subject's lesbianism. Cold and aloof, the fervently Catholic Troubridge sought and secured a papal audience, epitomizing the kind of contradictory postwar sexual mores that we have come to identify especially with Weimar Germany. The pet dachshunds, of whom she was a celebrated breeder, add yet another touch of erotic uncanniness.

96 / 97

By Romaine Brooks
(1874–1970)
Oil on canvas, 127.3 × 76.5 cm (50$^1/8$ × 30$^1/8$ in.)
1924
Smithsonian American Art Museum, Washington, D.C.
Gift of the artist

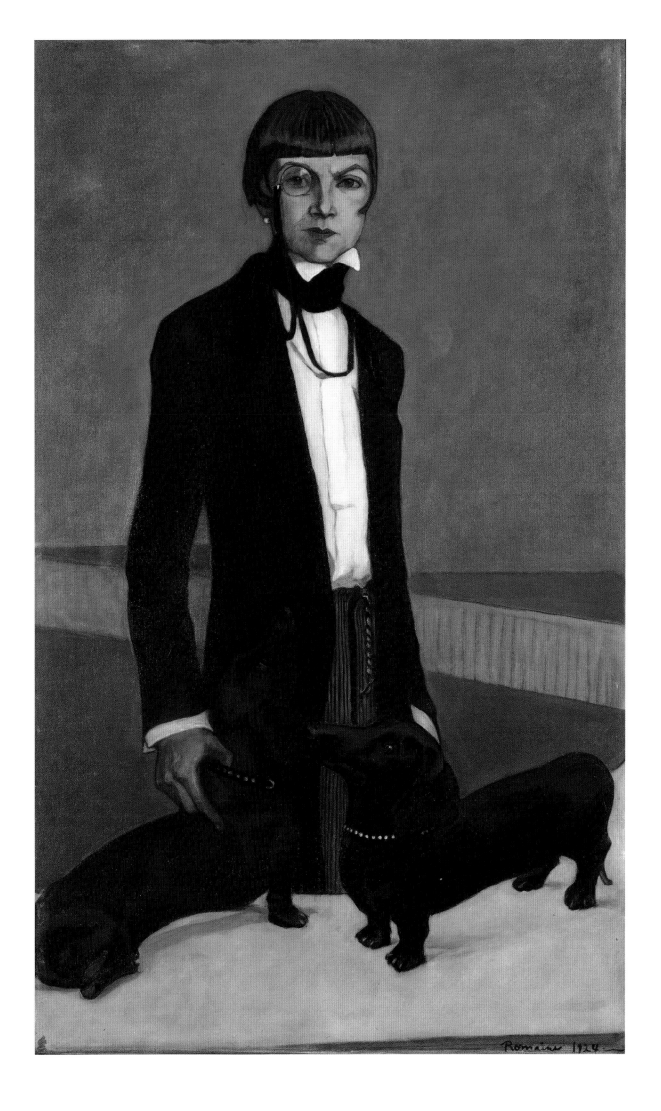

Plate 14
**Rrose Sélavy
(Marcel Duchamp)**

"Rrose Sélavy" was the artist Marcel Duchamp's (1887–1968) gender-bending alter ego, a drag character in which he posed as a woman with a full range of womanly accoutrements, such as perfume. Here Rrose/Marcel peers slyly out from under her/his hat, snug in her/his coat and fur collar. The character of Rrose was part of Duchamp's project to destabilize the spectator's expectations—what you saw was not what you got—as well as the very premises of art itself. Game-playing was in Duchamp's artistic DNA, as he cheerfully overturned established shibboleths of gender and sexual identity as well as artistic practice. In picturing himself as "Rrose," Duchamp was drawing on established drag conventions in an era when drag performances were very much in vogue. Moreover, by adopting a woman's persona, Duchamp destabilized gender conventions and suggested how easy it was to subvert the austerity and coldness—and implicitly the stunted sensual life—that were integral to the masculine and patriarchal roles. The clues were in the name. "Rrose" punned as "Eros," and "Sélavy" was trans-

formed into the French tagline "C'est la vie." All the words combined to mean "The erotic is life," an affirmation of the delights that accompanied sexual experimentation and the crossing of conventional boundaries. Duchamp's celebration of the life instinct, by adopting the guise of a woman, was part of a powerful postwar reaction by modernist artists to the culture that had engendered the mass slaughter of World War I. And it was this very decoupling of artwork and artistic identity that made him a model for generation of artists not eager to disclose their sexuality during the heyday of expressionism in the 1950s.

By Man Ray
(1890–1976)
Gelatin silver print, 22.1 × 17.6 cm (8 $^{11}/_{16}$ × 6 $^{15}/_{16}$ in.)
1923
The J. Paul Getty Museum, Los Angeles, California

Plate 15

**Portrait of Marcel
Duchamp**

From 1915 until 1935, Florine Stettheimer and her sisters hosted a salon for New York's cultural elite in their flamboyantly decorated Upper East Side apartment—replete with cellophane drapery, rococo furniture, and Florine's paintings of the guests who frequented their parties. The Stettheimers' salon was a space where sexuality remained fluid, ambiguous, and largely unspoken, yet abundantly clear. As Parker Tyler, Stettheimer's biographer, put it, "the very fact that certain lacunae existed in the visible social front made by the family inevitably told a great deal." Marcel Duchamp (1887–1968) joined the Stettheimers' milieu in 1917 and remained one of Florine's most important guests and ardent supporters. In this portrait, Stettheimer presents Duchamp as an androgynous, disembodied, light-emanating head. "Marcel in real life is pure fantasy," wrote Henry McBride, art critic and fellow member of the Stettheimers' circle. "If you were to study his paintings, and particularly his art constructions, and were then to try to conjure up his physical appearance, you could not fail to guess him, for he is his own best creation."

By Florine Stettheimer
(1871–1944)
Oil on canvas, 64.1 × 64.1 cm (25 1/4 × 25 1/4 in.)
1925
Michele and Donald D'Amour Museum of Fine Arts, Springfield, Massachusetts
Gift of the estate of Ettie and Florine Stettheimer

Plate 16

Djuna Barnes

Berenice Abbott's photograph captures the glitteringly dangerous appeal of Djuna Barnes, one of the instigators of 1920s modernism both as a writer and a personality. Brought up in a sexually extravagant and dysfunctional household (her father was a polygamist), Barnes's tempestuous life and her shape-shifting passage through postwar Europe and America made her an index of the era's sexual and artistic experimentation. In her first book of poems, *The Book of Repulsive Women* (1915), Barnes's description of lesbian sex was so explicit that she escaped prosecution for obscenity largely because straight society could not comprehend her audacity. After living in Greenwich Village, Barnes moved to Paris in 1921, the year in which *Ulysses* and *The Waste Land* were published, and in that epicenter of modernism she cut an alluring figure.

T. S. Eliot would write the foreword and publish her 1936 novel *Nightwood*, a thinly fictionalized experimental novel about Barnes's own romantic disappointment. Aside from *Nightwood*'s frank avowal of same-sex desire, Barnes's style commended itself to critics as an innovation in language comparable to those of Eliot and Gertrude Stein. Barnes's is an interesting case study in how an author's marginalization as an "other" leads to artistic and linguistic innovation to express one's distance from the society that one observes.

By Berenice Abbott
(1898–1991)
Gelatin silver print, 24 × 18.1 cm (9^7/$_{16}$ × 7^1/$_8$ in.)
1926
National Portrait Gallery, Smithsonian Institution, Washington, D.C.

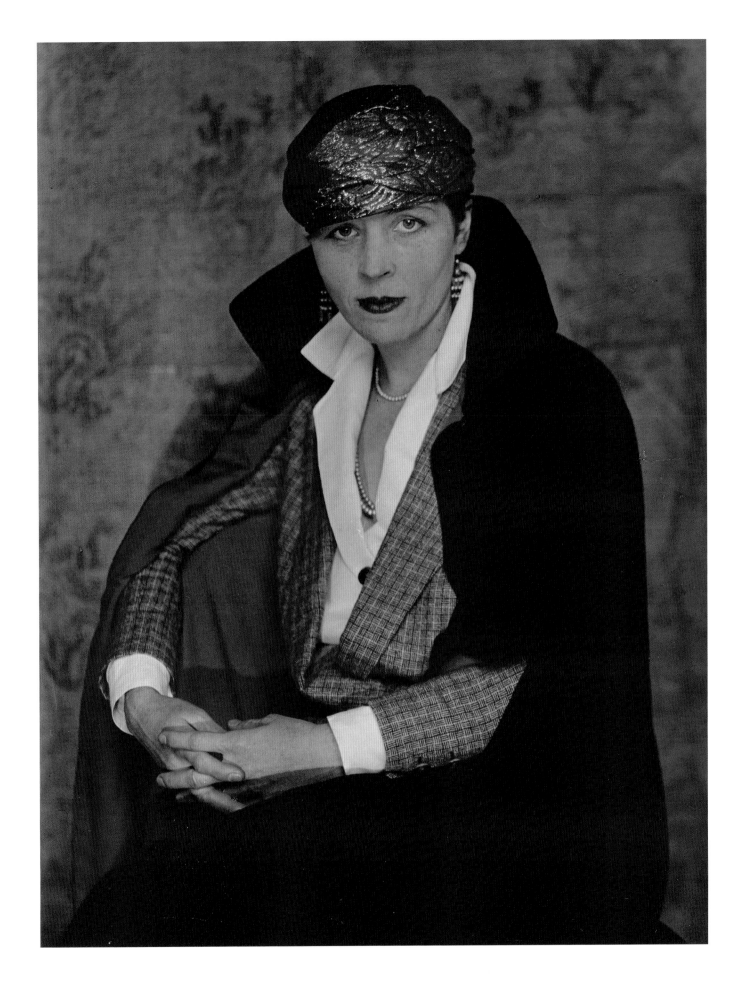

Plate 17
Janet Flanner

In 1922, Janet Flanner settled in Paris with her lover, Solita Solano. She would spend the next fifty years writing her "Letter from Paris," a column that appeared regularly in the *New Yorker*. Flanner and Solano soon became fixtures in the salon life of the city, their homosexuality providing a crucial entrée into the most fashionable literary coteries, which were then dominated by wealthy expatriate lesbians. In her column, Flanner used the decorously French and sexually ambiguous pseudonym "Genêt." "The trick is never to say 'I'," she once told a friend; "'I' is like fortissimo. It's too loud." Flanner used "Genêt" to quiet her private identity—an identity that was inextricably bound with her homosexuality. But "Genêt," like most masks, hid as much as it revealed. With her campy prose and focus on known gay and lesbian personalities, Flanner provided a coded glimpse of the Paris "in" crowd. In this poignant portrait by Berenice Abbott, Flanner wears two masks, which—like her pseudonym—both hide and reveal. The masks indicate multiple disguises, one private and one public. But placed on her top hat and coupled with her "mannish" attire, the masks provide a rich, and quite legibly homosexual, code. After all, neither mask actually hides her face or obscures her identity.

104/105

By Berenice Abbott
(1898–1991)
Gelatin silver print, 23 × 17.3 cm (9^1/16 × 6^{13}/16 in.)
1927
Prints and Photographs Division, Library of Congress, Washington, D.C.

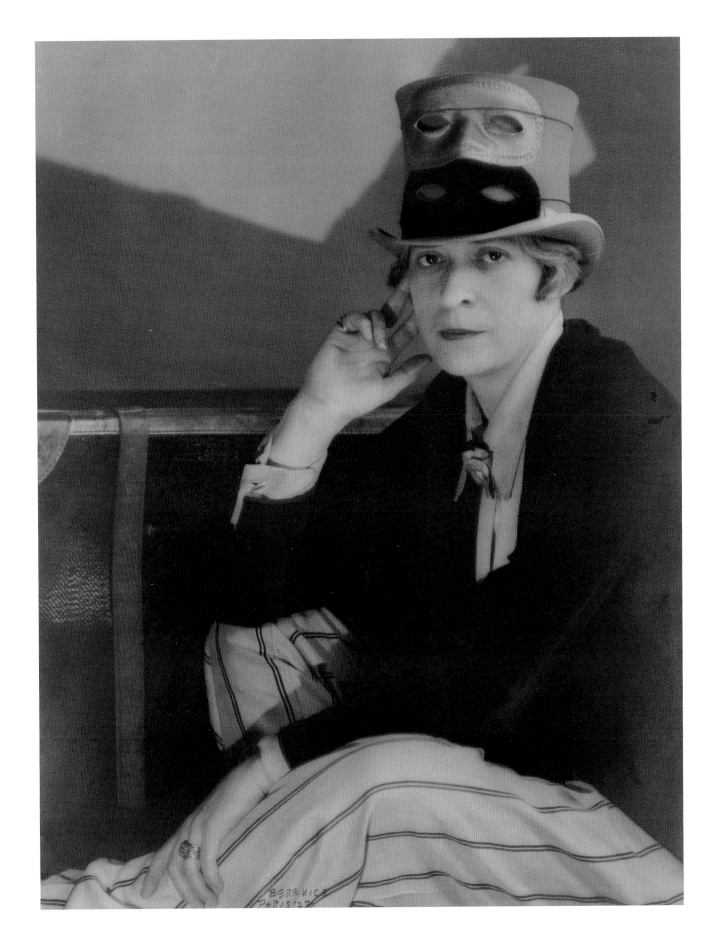

Plate 18
Betty Parsons

In 1927, when Betty Parsons sat for this portrait by Berenice Abbott, she was well known as a young and spirited member of Paris's elite expatriate lesbian society. When alimony from her two-year failed marriage began to run thin, Parsons returned to New York City. She quickly became entrenched in the New York art scene where, with keen insight, she began to champion the "big boys" of American art—Jackson Pollock, Mark Rothko, Clyfford Still, Barnett Newman, Hans Hofmann, and Ad Reinhardt—well before success claimed them. In 1946, she opened the Betty Parsons Gallery. Through the McCarthy-era 1950s, as Parsons transformed her public persona from feisty young Parisian lesbian to American matron of the then-burgeoning abstract expressionism, she retreated (publicly, at least) into the closet. Nonetheless, she continued to support women and openly lesbian and gay artists—spurring many of the initial so-called "giants" to leave her gallery when she refused to drop obscure artists to concentrate on selling their works. "She felt art should be democratic," says gallery director Jack Tilton, Parsons's former assistant. "The gallery was not just about stardom and making money. She wanted to show what she wanted to show."

By Berenice Abbott
(1898–1991)
Gelatin silver print, 29.2 × 23.5 cm (11^1/$_2$ × 9^1/$_4$ in.)
1927
National Museum of Women in the Arts,
Washington, D.C.
Gift of Wallace and Wilhelmina Holladay

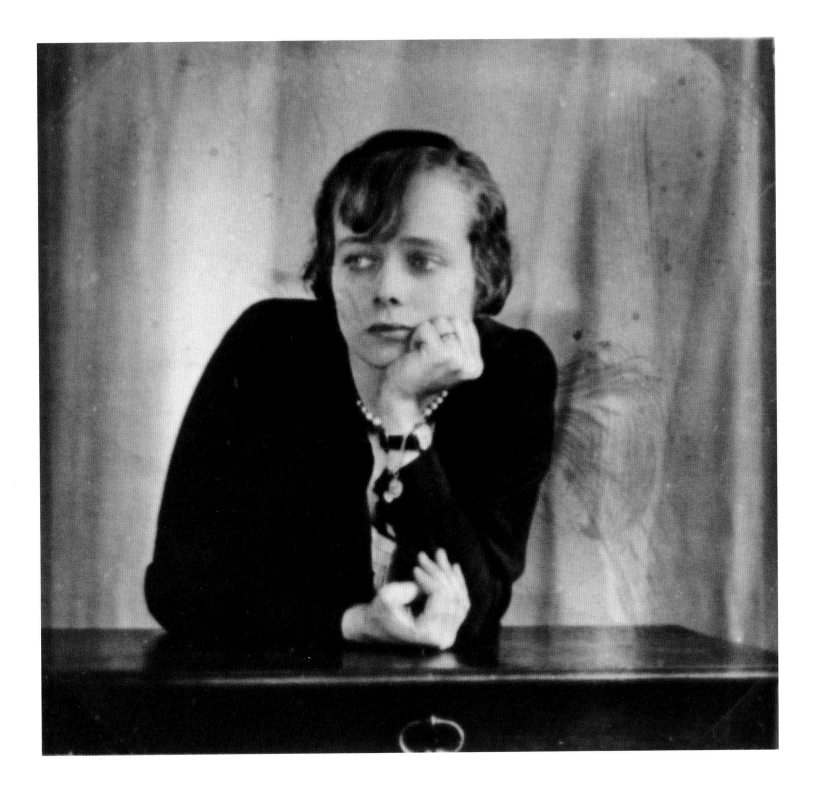

Plate 19

Lincoln Kirstein

During his adolescence, the future cultural impresario Lincoln Kirstein (1907–1996) drifted and showed little promise. Once he was finally admitted to Harvard, he sparked to life and exhibited the remarkable energy and engagement with people and culture that would mark his long and productive career. At college he founded and edited *Hound and Horn*, which, despite being an undergraduate magazine, assembled a remarkable stable of contributors, including Alfred Stieglitz and Berenice Abbott. He also published his fellow undergraduate Walker Evans's first essays on photography and assisted with several of Evans's photographic projects. Evans made a number of portraits of Kirstein, including this moody and romantic likeness. Kirstein always had an energetic romantic life, and he was highly attracted to Evans, but he lost interest as he discovered how difficult Evans's personality was. However, Kirstein always supported Evans's career despite finding him exasperating.

108/109

By Walker Evans
(1903–1975)
Gelatin silver print, 16.1 × 11.4 cm (6 $^5/_{16}$ × 4 $^1/_2$ in.)
1930
The Metropolitan Museum of Art, New York City; Ford Motor Company Collection
Gift of Ford Motor Company and John C. Waddell, 1987
(1987.1100.71)

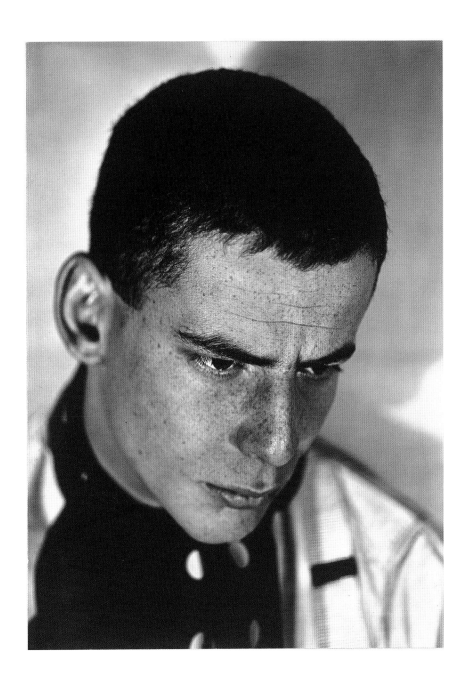

Plate 20

**Gertrude Stein and
Alice B. Toklas**

Gertrude Stein (1874–1946) and Alice B. Toklas (1877–1967) are probably the most famous gay or lesbian couple in modern history. The English society photographer Cecil Beaton pictured them here in an image of exotic domesticity. Stein was one of the first American expatriates, taking up residence in Paris in 1903 and soon after meeting Toklas, with whom she lived until her death. As a writer, Stein was one of the most demanding modernists, re-creating both the novel and English semantics in works such as *The Making of Americans* (1903–11) and the more traditionally grammatical *The Autobiography of Alice B. Toklas* (1933), which chronicled their circle in Paris. As much as a writer, though, Stein was a crucial American modernist because her Parisian salon was the site for the germination and transmission of modernist culture, both visual and verbal, during the first third of the twentieth century. She, with her brother Leo, amassed one of the great private art collections, cultivated artists like Picasso (who produced a remarkable portrait of the Buddha-like Stein), and brought word of the new art to emerging talents like Ernest Hemingway. Significantly, in his nasty, score-settling memoir, *A Moveable Feast* (1964), Hemingway acknowledges his debt to Stein and also writes that he broke with her after overhearing a sexual encounter between Stein and Toklas that disgusted him. Hemingway's censoriousness reveals much about his own insecurities while also indicating how a gay relationship, no matter how long established, was always liable to threat.

By Cecil Beaton
(1904–1980)
Gelatin silver print, 24.1 × 19.1 cm (9$^{1}/_{2}$ × 7$^{1}/_{2}$ in.)
1935
Cecil Beaton Archive at Sotheby's, London, England

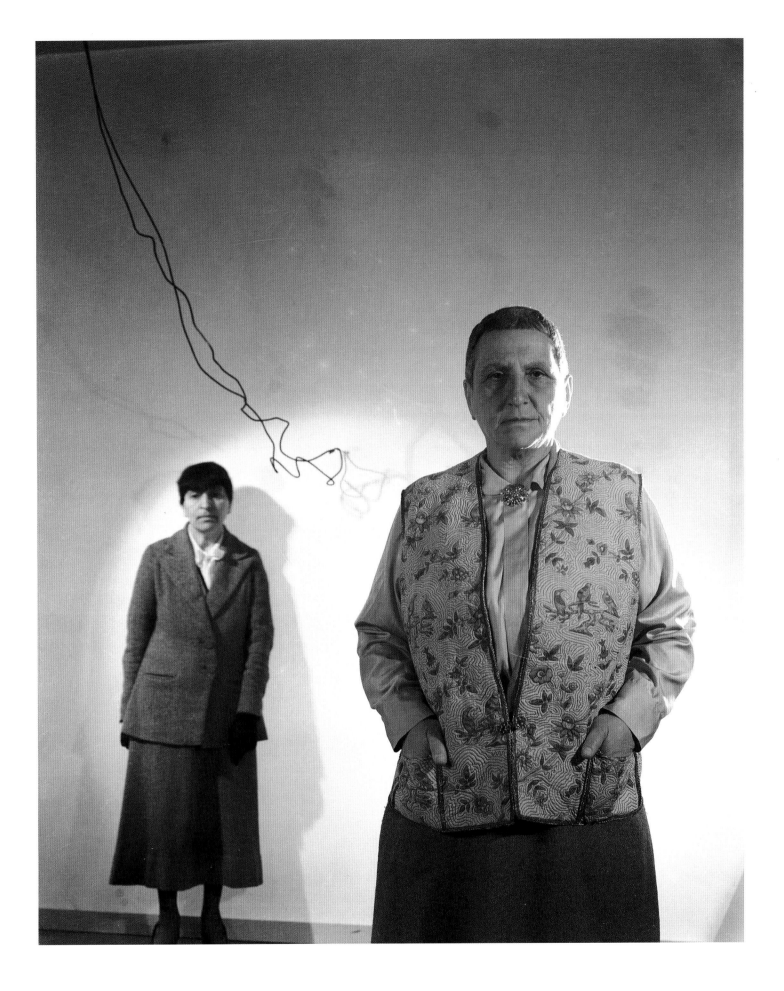

Plate 21

Arnold Comes of Age

The standard interpretation of twentieth-century America has the excesses of the "roaring" twenties followed by the retrenchment of the 1930s as the country hunkered down and turned inward as a consequence of the Great Depression. Artistically, the cosmopolitan modernism of the century's first three decades was replaced by a regionalist emphasis on the homely virtues of traditional America. Representation was back in vogue. Grant Wood, painter of the iconic *American Gothic*, had had a difficult time as a student in France, and he returned to Cedar Rapids in 1926 with a certain amount of relief. But it would be a mistake to see his working in an American vernacular as a simple retreat from modernism. Instead, he inflected traditional forms and subjects with a knowing take on art history and the complexity of social mores; he was a notable satirist, for instance, of American pieties, and his landscapes are so stylized that they become abstractions. In *Arnold Comes of Age*, the wistful youth set against the homoerotic scene in the background suggest the tension and difficulties faced by gay men who stayed behind in Middle America—or gay men, as was Wood, who returned to their native grounds after realizing they could not find a home in the big cities of America and Europe either.

By Grant Wood
(1892–1941)
Oil on board, 67.9 × 58.4 cm (26³/4 × 23 in.)
1930
Sheldon Museum of Art, University of Nebraska-Lincoln, NAA—Nebraska Art Association Collection

Plate 22
Prove It on Me Blues

Went out last night with a crowd of my friends
They must've been women, 'cause I don't like no men
It's true I wear a collar and tie, Make the wind blow
all the while
'Cause they say I do it, ain't nobody caught me, They
sure got to prove it on me

—"Ma" Rainey, *Prove It on Me Blues*

Legendary "Mother of the Blues" Gertrude "Ma"
Rainey (1886–1939) made no secret of her
proclivities for members of the same sex. In 1925,
just three years before she recorded "Prove It
on Me Blues," Rainey was arrested for hosting a
rowdy lesbian party. "She and a group of young
ladies had been drinking and were making so
much noise that a neighbor summoned the police,"
recalls friend and fellow musician Clyde Bern-
hardt. "Unfortunately for Ma and her girls, the law
arrived just as the impromptu party got intimate."
But she made over her arrest into both song and
an advertising campaign, suggesting the pro-
gressive attitudes around same-sex desire in the
African American community at the time.

Advertisement
Chicago Defender, September 22, 1928

Went out last night with a crowd of my friends
They must've been women, 'cause I don't like no men
It's true I wear a collar and tie, Make the wind blow
all the while
'Cause they say I do it, ain't nobody caught me, They
sure got to prove it on me

Plate 23
Langston Hughes

The Harlem Renaissance as it was—as opposed to how it was depicted—was inspired by a sense of racial and community pride that was fostered by such African American cultural figures as author and poet Langston Hughes (1902–1967). Born and raised in the Midwest, and from a broken home, Hughes was educated at Lincoln University (Pennsylvania) after leaving Columbia University, in part because of its racism. He lived in Harlem most of his life. Artistically, Hughes anticipated black separatism (even black nationalism) in historically grounded work that dealt with the desperate predicament of African Americans. Not simply despairing, his poetry insisted on the dignity and beauty of African Americans: "Beautiful, also, is the sun./Beautiful, also, are the souls of *my people*." Culturally, he countered the ideology of white supremacy and helped lay the groundwork for the postwar civil rights movement. Beset by the contradictions and difficulties of being a celebrated black artist and a cultural

radical in a segregated society, Hughes kept his homosexuality publicly hidden, although it traced through his poetry in coded and oblique messages of loneliness and fulfillment.

In this portrait by Carl Van Vechten, the white chronicler of black America, the contradictory impact of the dominant culture is fully revealed. Hughes's likeness is sympathetically displayed. Yet Van Vechten poses this urbane, cultured man against an African mask, evidence of the white inability to see African Americans outside of the paradigm of their "naturalness" as a counterpoise to the dominant culture's stiffness.

By Carl Van Vechten
(1874–1970)
Gelatin silver print, 14.1 × 21.4 cm (5 $^9/_{16}$ × 8 $^7/_{16}$ in.)
1932
National Portrait Gallery, Smithsonian Institution, Washington, D.C.
Gift of Prentiss Taylor

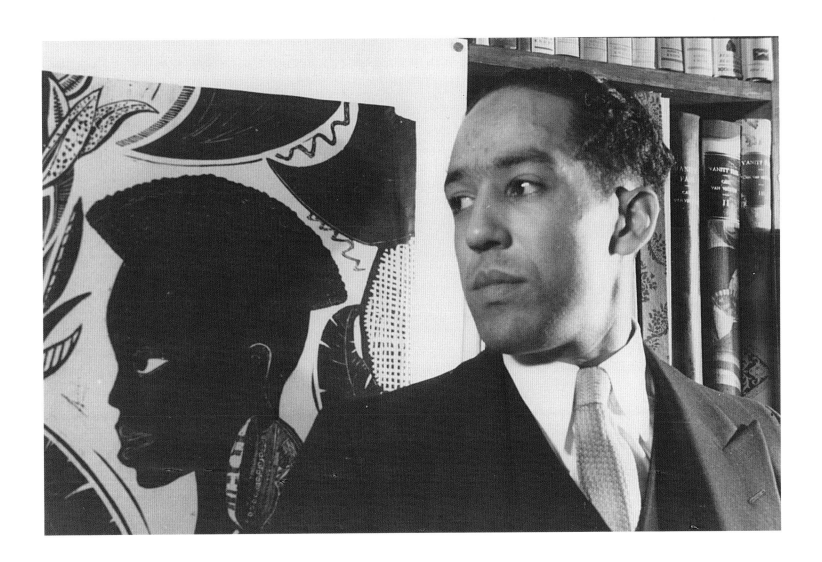

Plate 24
Carl Van Vechten

Critic, novelist, and photographer Carl Van Vechten (1880–1964) was one of the most important makers of American modernism and is best known for introducing white America to Harlem. As Harlem grew into the capital of black America, it became alluring to many whites, who saw it as the exotic counterpoint to the soulless, mundane, and bureaucratized life of the modern city. Attracted by jazz, nightclubs, and a demimonde that was tolerant of gays, whites went north of 125th Street in search of a raw, pulsating, and "authentic" experience. Van Vechten's delight in "earthy" or "primitive" black folkways drew the fire of intellectuals like W. E. B. Du Bois.

Romaine Brooks wickedly referenced this critique of Van Vechten as an exploiter by posing him whitely against a black background containing the sublimated images of young black men. For art-world habitués, the jab was doubled because it was known that the respectably married Van Vechten went up to Harlem to cruise and find subjects for his homoerotic photographs.

By Romaine Brooks
(1874–1970)
Oil on canvas, 116.8 × 96.5 cm (46 × 38 in.)
1936
Carl Van Vechten Papers, Yale Collection of American Literature, Beinecke Rare Book and Manuscript Library, Yale University, New Haven, Connecticut

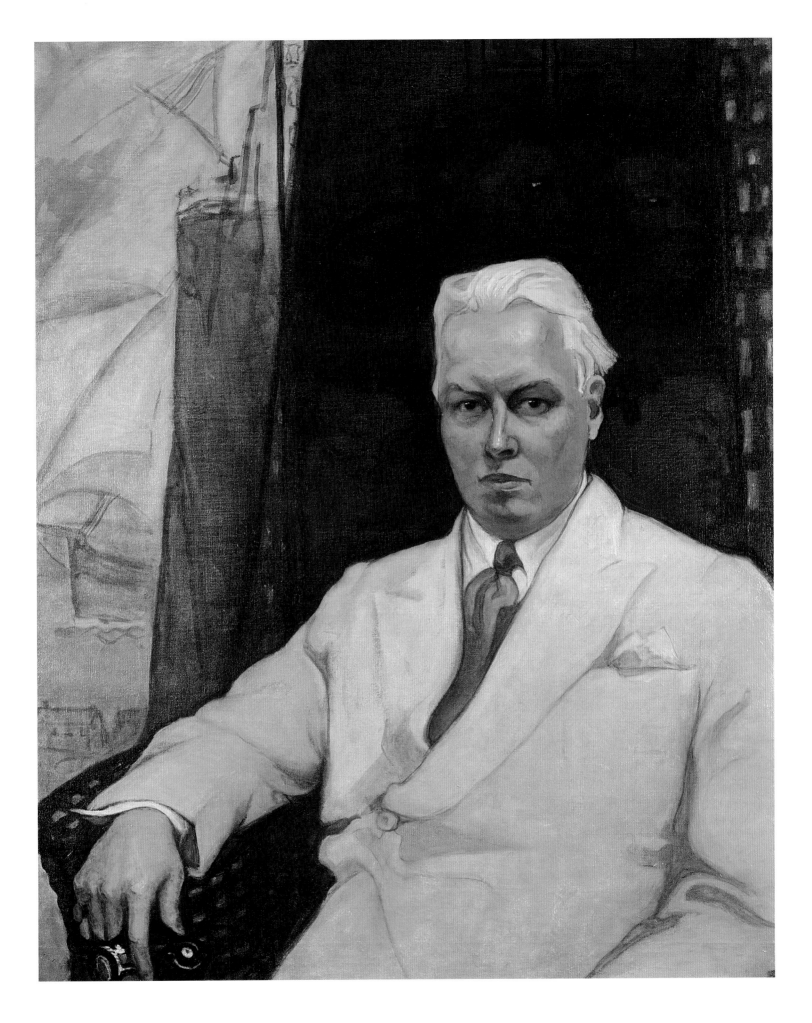

Plate 25
Bessie Smith

Carl Van Vechten's descriptions of black Americans were of the "romantic racist" variety, in which African Americans epitomized elemental, even "primitive," qualities absent in the falsity of modern society. Yet in his photographs, he recovered and preserved the dignity and humanity of people such as the great blues singer Bessie Smith (1894–1937). Born in Tennessee, Smith got her start in vaudeville reviews, sometimes playing a male impersonator, before developing a stand-alone career as a singer able to command nearly $2,000 a week. Smith always sang blues, not jazz, and her songs evoked the hard life and desperate consolations of the rural poor. Smith's career waned during the Depression and after vaudeville, although her remarkable voice was preserved in recordings made by music anthologist John Hammond. She died after a traffic accident when a segregated hospital refused her treatment.

By Carl Van Vechten
(1880–1964)
Gelatin silver print, 25.2 × 18.6 cm (9^{15}/$_{16}$ × 7^{5}/$_{16}$ in.)
1936 (printed 1983)
National Portrait Gallery, Smithsonian Institution, Washington, D.C.

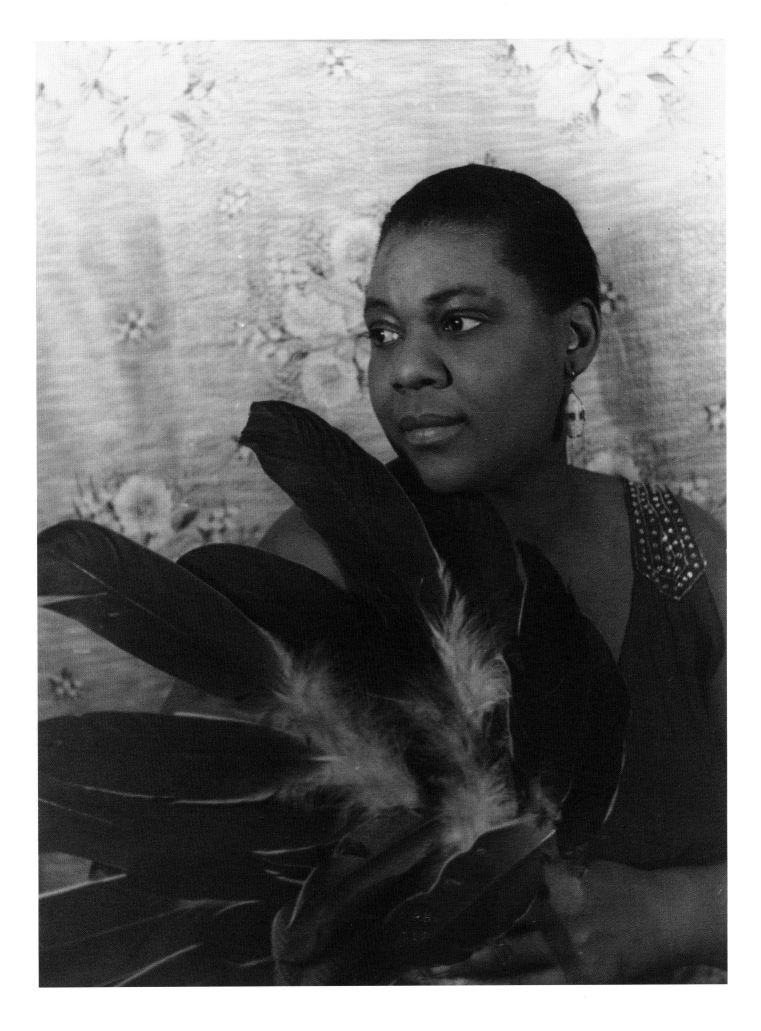

Plate 26

**Hugh Laing and
Antony Tudor**

This charming photograph of the noted chore-
ographer Antony Tudor with dancer Hugh Laing
exemplifies them as paragons of English taste
that has become popular in America as "preppy"
or "Ivy League." But it is also a carefully posed
document of their personal relationship. As
scholar and artist Deborah Bright points out,
Tudor was careful about how much he revealed
to the public about his personal life. This por-
trait of Tudor and Laing reveals that relationship
obliquely. The men sit close together so that
their two bodies overlap. Above all, there is Van
Vechten's careful positioning of their hands.
The two men are holding hands, but the actual
joining is masked by the fall of Laing's arm across
his knee. The perfect balance of Van Vechten's

composition derives from the necessity of know-
ing just how much could be shown or revealed
both for the sake of the subjects themselves and
for the audience as well. Society demanded that
proprieties had to be maintained, just as ties,
collars, and tweeds had to match, but within those
constraints the photographer and the subjects
participated in a dance in which revelation and
restraint pushed against each other to obtain
a satisfactory aesthetic outcome.

By Carl Van Vechten
(1880–1964)
Gelatin silver print, 24 × 18 cm (9 7/16 × 7 1/16 in.)
1940
Carl Van Vechten Papers, Yale Collection of American
Literature, Beinecke Rare Book and Manuscript Library,
Yale University, New Haven, Connecticut

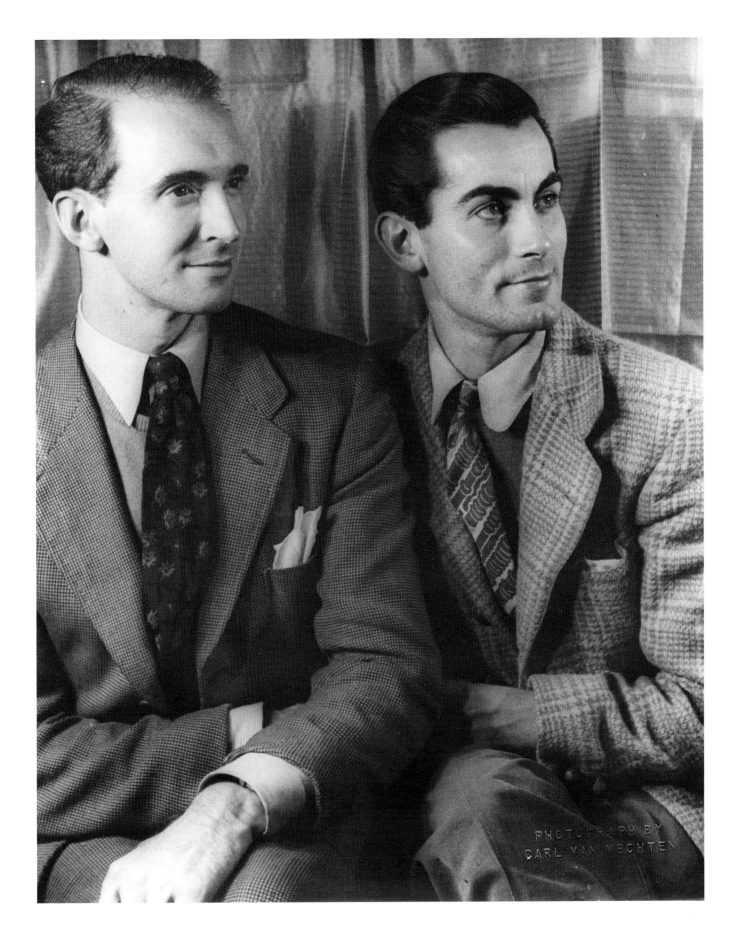

Plate 27

**Une Mise en Scène
de Charles Henri Ford**

Henri Cartier-Bresson captured this mischievous "portrait" of writer, artist, and filmmaker Charles Henri Ford (1913–2002) coming out of a Parisian *pissoir* (public urinal); the lasciviously juxtaposed tongue on the structure's wall is an advertisement for a popular brand of coffee. Ford was quite the literary *enfant terrible* and agent provocateur; in his teens he founded a magazine called *Blues: A Magazine of New Rhythms*. In postwar Paris he was a habitué of Gertrude Stein's circle and coauthored (with Parker Tyler) *The Young and the Damned* (1933), one of the earliest explicitly gay novels published in the United States. He returned to New York City in 1934, having already begun a relationship with the artist Pavel Tchelitchew that would last for both their lifetimes.

Cartier-Bresson took this photograph early in his career, just after he had moved from painting to photography and was busy taking impromptu, "man-in-the-street" photographs using a small, unseen camera. Although in a documentary mood, the Ford picture was posed to suggest Ford's flamboyant (and good-humored) homosexuality. The only hint of Cartier-Bresson's growing interest in surrealism is the use he makes of the advertisement's serpentine tongue.

124/125

By Henri Cartier-Bresson
(1908–2004)
Gelatin silver print, 18.1 × 25.1 cm (7^1/8 × 9^7/8 in.)
1935
Charles Cowles

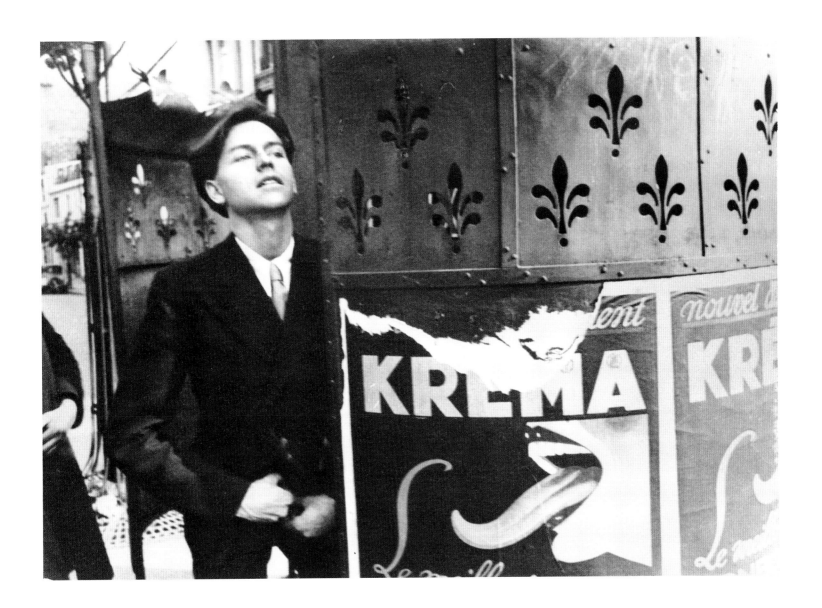

Plate 28

Margaret French, George Tooker, and Jared French, Nantucket

PaJaMa was a photographic partnership consisting of Paul Cadmus, Jared French, and Margaret French. The trio's artistic work as PaJaMa, taken from the first two letters of their first names, was founded on their intertwined personal relationships; the trio regularly summered together and made themselves the objects of photographic projects, notably in a stylized series of pictures taken on the beaches of Fire Island and Nantucket. Jared French and Cadmus had been lovers, and when French married Margaret Hoenig in 1937, the partners incorporated her into their preexisting relationship. It was Margaret's Leica camera that took the photographs. The PaJaMa ménage was free-floating, adding people—as friends, lovers, artistic collaborators, and combinations thereof—such as George Tooker and Lincoln Kirstein. The relationship created a protective space where the fluid boundaries of their personal relationships enabled the kind of artistic creativity and experimentation that its participants were working toward. The ethereal, near-surrealism of PaJaMa's beach scenes is echoed in the magic realist style of Cadmus's works of the same period.

126/127

By PaJaMa
Gelatin silver print, 12.7 × 17.5 cm (5 × 6 7/8 in.) sheet
c. 1946
D.C. Moore Gallery, New York City

Plate 29
What I Believe

Paul Cadmus's Manichean depiction of a world divided between light and darkness summed up not only what was at stake, but what was of value at the end of World War II. To the right are the forces of evil, shown both allegorically and historically, as in the figure of Hitler. This scene of human misery is notably heterosexual, while to the left are scenes of homoerotic love and creativity, which herald a return to Edenistic wholeness. In the new era of history that now dawned, personal self-fulfillment would finally be achieved after emerging from the violent world of the ideologues. Cadmus took his title and theme from E. M. Forster's 1938 essay, in which the English writer says, "Where do I start? With personal relationships. Here is something comparatively solid in a world full of violence and cruelty." Foster wrote in resistance to the war to come, while Cadmus depicted the world that he thought had been attained.

128/129

By Paul Cadmus
(1904–1999)
Egg tempera on pressed wood panel, 41.3 × 68.6 cm
(16¹/4 × 27 in.)
1947–48
McNay Art Museum, San Antonio, Texas
Gift of Robert L. B. Tobin

Eight Bells Folly: Memorial to Hart Crane (detail)
by Marsden Hartley
Reproduced in full as Plate 31.

Abstraction

In April 1932 the poet Hart Crane sailed back to the United States after a sojourn in Mexico during which Crane had alternated between periods of ecstatic creativity and deep despair over his writing and personal life. In Mexico, Crane had written a masterwork, "The Broken Tower," but overall his mood was fouled by feelings of blockage and sterility. Forebodingly, the ship on which he traveled was named *Orizaba*, after a Mexican volcano. During the sea passage home, Crane, for reasons that cannot ultimately be known, lost control of himself, drank heavily, and became belligerently hostile to his first and only heterosexual lover, Peggy Baird; the passengers and crew of the *Orizaba*; and most of all, to himself. After a punishing night, he described himself to Baird as "utterly disgraced," and according to eyewitnesses, at noon of April 27, he walked to the stern of the ship, neatly folded his coat on the railing, which he then climbed, and jumped, disappearing into the Gulf of Mexico. Crane's body was never recovered, and his family, disbelieving his suicide, memorialized him at the family gravesite in Ohio as "lost at sea."

In 1933, Crane's contemporary, the artist and poet Marsden Hartley (pl. 11), completed a painting about Crane's death called *Eight Bells Folly: Memorial to Hart Crane* (pl. 31). Hartley described the painting as "a marine fantasy" of Crane's drowning and went on to say that the picture had a "very mad look" to it. He described what he meant:

> There is a ship foundering—a sun, a moon, two
> triangles, clouds—a
> Shark pushing up out of the mad waters—and
> at the right corner—a
> bell with "8" on it—symbolizing 8 bells—or noon
> when he jumped off —

Crane had published two books, *White Buildings* and *The Bridge*, but Hartley may have eventually decided that including the number two would have minimized Crane's career. Although Hartley did not include the "two," he did paint three eight-pointed stars and a "33" on the ship's sail, added another "8" to one of the triangles, and put the number "9" on the belly of the up-rushing shark. The painting's "mad look" is not fully accounted for in Hartley's explanation of it, which is a hodgepodge of incomplete description that only hints at the painting's symbolic elements, scattering teasing clues and suggestions in a way that seems almost designed to keep the viewer focused on the painting's surface and to ignore its depths.

In his letters and private writings, Hartley (pl. 32) expresses enough hostility to Crane and Crane's taking of his own life to make one question why he undertook the *Memorial* at all. When Hartley first met Crane on the Riviera, the artist found the poet attractively interesting but too rambunctious and willful, especially when drinking and socializing, to be enjoyable or creative company. After the suicide Hartley made the point that Crane "belonged to the species opposite to me, mentally speaking—there being two kinds of people—one for whom something must 'act' constantly. . . the other is the type that does nothing about anything much, and life simply presents itself." Or, as Hartley put it more personally, Crane "couldn't help disturbing the peace of others. . . . They [i.e., people like Crane] want order and continuance but they seem impelled to destroy it in the wild disordered craving for the color of life." Hartley ascribed Crane's impulsive death to his infection by the feverish culture of Mexico. If Crane threw his life away, Hartley implies, he also wasted his talent. Misanthropic and judgmental, Hartley concludes his comments on *Eight Bells Folly* that "the story is told now and the sea has silenced all of it far too early—for Hart had not done his work."

Yet Hartley did paint *Eight Bells Folly*, and significantly, he painted it in a style of abstract portraiture that he had adopted when working in Germany before the United States entered World War I. In a remarkable series of images, Hartley reduced Berlin and its inhabitants, especially the German officer who was the subject of several of these canvases, to a series of abstract signs and symbols. For instance, *Portrait of a German Officer* (fig. 10) contained the colors of the German flag, the Iron Cross, regimental numbers and epaulettes, and the initials "K v. F." On the one hand, the officer himself was hidden behind the appurtenances of Germanic militarism; on the other, his identity was hinted at, but still concealed, in the initials. "K v. F" was the German flyer Karl von Freyburg, who was killed early in the war and had possibly been Hartley's lover. What Hartley accomplished in the Berlin and German officer paintings was a profound evocation of the mechanisms of modern society: the city and its people reduced to their functional parts, symbolized by the insignia they wore and the personas they displayed in the public square. Yet Hartley gestured to the deeper, emotional relationship that underlay and may have inspired his colorful yet austere canvases. The paradox of Hartley's Berlin paintings—which simultaneously urged the viewer to close scrutiny with their evocation of modernism's spectacle even as

they blocked inquiry beyond a certain point—made them similar in their effect to what Nietzsche had written about the theater:

The brightest clarity of the image did not suffice us, for this seemed to wish just as much to reveal something as to conceal it. Its revelation, being like a parable, seemed to summon us to tear the veil and to uncover the mysterious background.

In about 1917, after his Berlin period Hartley abandoned abstract portraiture as he continued his peripatetic search for an artistic style he could call his own. Yet when Crane died, fifteen years after the war had ended, Hartley returned to abstract portraiture to memorialize the dead gay poet. It seems likely, and thus significant, that he did so because Crane was also gay. While many elements of Hartley's portrait abstraction derived from the general conditions of modernism as he experienced them in the cosmopolitan, vibrant streets of Berlin, the primary impetus for his abstraction was his own homosexuality. Moreover, in Hartley's contrasting of his own character with Crane, one can see the genesis for the coolly distancing restraint of the Berlin pictures. Full of the hurly-burly of the city, passionate in their evocation of street life, they nonetheless are paintings that are discreet and chaste, precisely because that was the careful, undemonstrative character of Marsden Hartley. In his paean to Germany and militarism—Hartley rhapsodized about military parades—the artist nonetheless carefully included a coded marker to his own pre-dilection and passion. It was precisely because he felt he could not express these feelings publicly that he came to make the almost claustrophobic, jam-packed paintings that represented his Berlin: a Berlin of a passion that could not be openly ex-pressed—at least by the always-careful Marsden Hartley. So in *Eight Bells Folly*, the abstraction is all Hartley's, but the disorder is his attempt to order the passionate romanticism of Crane's verse, especially his great verse sequence, *The Bridge*. The disorders of Crane's life bulge against Hartley's desire for restraint, causing the painting to look destabilized in its weird agglomeration of signs and symbols: the shark, the eyes, and the looming triangular arches that represent the Brooklyn Bridge. Hartley implicitly plays off his own insistence on restraint and order against Crane's flamboyantly unrestrained behavior. It was a meeting of two styles of homosexuality: the cool versus the hot; the salon versus the subway restroom. If Hartley painted Crane in this way, it was because he had to: as the title of his memorial poem to Crane indicated, everything

else aside, Crane was Hartley's gay brother and as a gay man he could only—for Hartley—be represented abstractly.

The extent to which Hartley used abstract portraiture to simultaneously express and repress sexual desire was acute, and it helped him to create a totally unique and distinctive style of art, one that he could not maintain, possibly because the emotional stakes were too high. Through abstraction Hartley could negotiate all the societal taboos and inner restraints that militated him from approaching his subject directly.

For a brief period, Hartley showed the most wholehearted commitment to abstraction by any Americanist until Jackson Pollock. Other art-ists used abstraction more judiciously, dipping in and out of the genre as it suited their needs—artistic, cultural, and autobiographical—as their careers evolved.

Charles Demuth's artistic output proceeded on two tracks: a public one in which he displayed precisionist landscapes and cityscapes as well as symbolic portraits that distilled personalities down to signs and symbols; and a private one in which he painted genre scenes about social life in the city (pl. 10). Many of the latter were explicitly homoerotic, including scenes of gay bathhouses or nude sailors on the beach. As Jonathan Weinberg has argued, the bifurcation of Demuth's career between public abstraction and private realism illustrated the necessary division of his artistic career in a way that mirrored the need for discretion about his homosexuality. While Hartley's Berlin period saw him just paint abstrac-tions, Demuth's career proceeded on parallel tracks, with his investment in abstraction fueled by precisely what he could not express in his pictures for the general public. It is intriguing to note that Demuth did not produce realist paint-ings in his public career. Rather, his investment in abstraction added another level to the mask that protected him from unwonted public scrutiny. For instance, many of his Poster Portraits were of gay or lesbian subjects. His *Calla Lilies* was a symbolic representation of the popular drag performer Bert Savoy, who ended his act by throwing lilies into the crowd. Similarly, Gertrude Stein, Marsden Hartley, and other gay and lesbian subjects had their sexuality alluded to through aesthetic coding. In his portrait of Stein called *Love, Love, Love*, theatrical masks were the main motif, signifying the necessary bifurcation in the lives of gay people when being gay was a criminal offense.

Intriguingly, although Demuth's Poster Portraits hid their subjects in plain sight through careful abstract coding, he did show his genre scenes of the demimonde in public (see fig. 9),

allowing people thereby to draw whatever conclusions they might wish. It may have been that it was because these works were positioned as genre scenes—salacious and comic "takes" about sex in the city (pl. 10)—that Demuth could risk showing them. Lower down the scale of the artistic hierarchy, they titillated a sophisticated art audience that could at least flirt with the idea of gender bending and sex on the beach. What the genre scenes show is how capacious the "closet" really was—and is. It really was an alternative social universe, one that frequently overlapped with other areas of the public square.

While Demuth alternated between figurative and abstract work throughout his career, other artists proceeded from one vocabulary to another, usually becoming more abstract. Agnes Martin's career evolved toward abstraction as she found herself temperamentally and artistically unable to paint figuratively. Her flawed and uncomfortable nudes (pl. 36) did not meet her artistic ambitions and standards. She also thought they were too self-revelatory and emotionally open to public interpretation; at the end of her life, she tried to destroy all her figurative paintings for personal and artistic reasons. Martin moved from attempts at lush and sensual figure studies to intricately plotted, mazelike abstractions, most of which are monochromatic. The intricacy of their design suited her buttoned-down public personality.

Hartley (and Crane), Demuth, and Martin were all gay, and one can link their use of abstraction as an artistic way of figuring their gayness. A more complicated instance of the relationship between abstraction and gender and sexual ambiguity is that of Georgia O'Keeffe. In O'Keeffe's case, the evolution toward a particular phase of abstraction— the dry, sere, and prickly abstractions she derived from the desert Southwest—came from the problematic yet creative tensions she experienced in her personal and artistic relationship with Alfred Stieglitz. Stieglitz, a photographer and an artistic impresario, played a major role in molding and promoting O'Keeffe's career, both when they were single and after they married. As the arbiter of early-twentieth-century American modernism, Stieglitz used O'Keeffe both as subject and object as he laid down the parameters of his artistic aesthetic. Not only did he boost O'Keeffe's career in his gallery's exhibitions, he also made her the subject of lengthy photographic series in which O'Keefe appeared both clothed and nude. In many of the nude portraits, O'Keeffe's features were abstracted to specifically highlighted body parts: breasts, neck, hands, and so on; her face was omitted in these experiments in photographic abstraction.

For O'Keeffe, these photographic studies were problematic. Whatever their intrinsic formal elements as photographs, they also reduced her to component parts and detached both her body and her sexuality from her subjectivity. Fiercely assertive of her creativity and her self-hood, O'Keeffe began a series of projects in which she reacted against Stieglitz's photographs to reclaim her own artistic and personal autonomy. In a small oil painting, she painted her breasts in a conscious evocation of Stieglitz's photographs of them (fig. 13). But she skillfully portrayed them both as breasts and as studies in light and shadow that defamiliarize and desexualize them so that they become naturalized, like rocks on the beach. Moreover, the painting is roughly framed so that it looks like the reverse side of a painting. It is not signed so much as labeled, with O'Keeffe's name running vertically down the canvas's left side. The effect is that of a painting turned inside out so that O'Keeffe's revealing image of herself is restricted and kept hidden. Hiding in plain sight, O'Keeffe reclaims her body—and her autonomy—from Stieglitz's appropriation of it and her.

O'Keefe's small oil painting was created in a counterpoint with Stieglitz's photographs of her nude torso. The oil painting hides what Stieglitz sought, and the two artists remained locked in an encounter that did not promise a solution unless one side or the other gave in. O'Keeffe cut through this impasse in a dramatic rupture, by transferring her subject-matter to the desert Southwest. Her abstract portrayals of desert iconography do, of course, reference the culture, geography, and climate of the Southwest. But they are also portrayals of the female body that overturn the convention of female lubricity, fecundity, and receptivity in favor of an austere, formal aesthetic that acts as a prickly defense against invasion. The spikiness of the antlers that O'Keeffe deployed as a motif throughout her southwestern paintings (pl. 35) are a mark that says, "Don't tread on me."

Plate 30
Joseph Cornell

This profile portrait of the surrealist Joseph Cornell (1903–1972) was taken by the American photographer Lee Miller at the outset of both their careers in the early 1930s. While Miller had served a photographic apprenticeship with Man Ray in Paris, Cornell had spent ten years as a traveling salesman, a seemingly unpromising background for a modern artist. Yet Cornell steeped himself in art and literature, especially surrealism, and around 1932 he hit upon the idea of creating shadow boxes containing found objects, curiously juxtaposed. Thus he combined the display window of the department store with his own vision of the chance and contingency of daily life. The boxes provided an aesthetic analogue to Cornell's biographical attempt to manage and control the space of his own life. Miller's photograph, by incorporating a model of a toy boat, mimics the juxtapositions found in a Cornell box. But the boat also serves to suggest the ambiguities of Cornell's personality: the sails feminize his profile, and boats, of course, are always referred to as feminine. Artistically, the boat suggests how Cornell voyaged in his own mind—the ultimate, and ultimately unknowable, "Cornell box."

By Lee Miller
(1907–1977)
Gelatin silver print, 31 × 24 cm (12$^{3}/_{16}$ × 9$^{7}/_{16}$ in.)
1933
Lee Miller Archives, Chiddingly, East Sussex, England

Plate 31

**Eight Bells Folly:
Memorial to Hart Crane**

When Hart Crane, the great romantic modernist poet, committed suicide, Hartley memorialized him by reverting to the style in which he had painted Karl von Freyburg, who was probably his lover. Crane and Hartley had a difficult, testy, and distant relationship in which the always fastidious Hartley disparaged Crane's careless ebullience and love for cruising Manhattan's streets. Yet when Crane died, Hartley honored his fellow gay artist in a gesture that was unmistakable to those who knew of his love for von Freyburg. Packed into the superheated atmosphere of *Eight Bells Folly*—Hartley said it "had a mad look" to it—were references to Crane's age (thirty-three), his life,

his death by jumping off a ship, and above all his poetry. Over the entire painting looms a blood-tinged sun (Crane died at high noon, or "eight bells") and two arcs symbolizing the subject of Crane's great poem, "The Bridge" (1930). Put off by Crane, yet fascinated by him, Hartley signaled his ultimate connection to Crane by calling him, in a memorial poem, *Hermano*—or brother.

By Marsden Hartley
(1877–1943)
Oil on canvas, 77.8 × 100 cm (30 5/8 × 39 3/8 in.)
1933
Frederick R. Weisman Art Museum at the University of Minnesota, Minneapolis
Gift of Ione and Hudson D. Walker (1961.4)

Plate 32
Marsden Hartley

Marsden Hartley (1872–1943) died not long after this portrait was made, and the work is shot through with abstract themes of death and loss, both for the subject and the photographer, George Platt Lynes. Hartley sits slumped and exhausted, a condition exacerbated by his mourning the recent death of a young man to whom he was attracted in Maine. But Lynes alludes to Hartley's earlier loss of Karl von Frey-burg in World War I in the shadowy figure of the young man in uniform projected on the back wall. This memorial to lost youth was given a poignant double meaning since Lynes's assistant George Tichenor, to whom he was deeply and unsuccessfully attracted, had just been killed in action in World War II. Lynes posed an assistant—quite possibly Tichenor's brother Jonathan—in George's uniform as an abstract representation of the unspoken losses that shadowed both him and Hartley, and of countless other unnamed men across two world wars.

By George Platt Lynes
(1907–1955)
Gelatin silver print, 23.5 × 19.1 cm (9 1/4 × 7 1/2 in.)
1942
Bates College Museum of Art, Lewiston, Maine
Marsden Hartley Memorial Collection

Minor White's influential photographs helped create the next generation of American photographers after Alfred Stieglitz. His pictures' formal qualities were underlain with his theory of correspondences, an almost Baudelairean use of symbols and signs in which empirical representation evoked a mood or feeling. As his aesthetics were based on sublimation, White tried to keep his personal life out of his photography; many of his male nudes were only published after his death. Yet the correspondence between landscape and desire are shown in this pair of photographs that, although taken three years apart, uncannily echo each other. The delicacy of Tom Murphy's hands is reminiscent of a Balinese dancer, and the recessive, demure posture is a counterpose to the muscular presentation of his body that makes him ambivalently available. The stripped-down cypress branches against a spectacular ocean view reference the earlier work, creating an anthropomorphized landscape that uncannily recalls Murphy's body. The two photographs work together in a way that rhymes the natural world and the human, largely male, form to suggest their commonality, an implicit justification for their equal value as photographic subjects.

140/141

By Minor White
(1908–1976)
Murphy: Gelatin silver print, 11.7 × 9.2 cm (4 5/8 × 3 5/8 in.)
1948
Cypress Grove Trail: Gelatin silver print, 29.5 × 21.9 cm
(11 5/8 × 8 5/8 in.)
1951
The Minor White Archive, Princeton University Art
Museum, New Jersey
Bequest of Minor White

Plate 35
Goat's Horn with Red

Georgia O'Keeffe's lover, husband, and patron, Alfred Stieglitz, did an extensive photographic survey of his wife's nude body in 1918–19. In these photographs—close-ups of breasts (fig. 13), hands, feet, neck, and torso—Stieglitz fragmented her self while reconstituting it through the aggregating power of his lens and eye. To a later generation of critics, the O'Keeffe "portraits" look disturbingly like dismemberments, inflicted by the cutting male gaze. While O'Keeffe was willing to make her body available to Stieglitz's camera, much of her career reveals her disquiet at being turned into an object of someone else's scrutiny. She was famously prickly about attempts to interpret her work, especially attempts to anthropomorphize it. This prickliness was carried over into the paintings themselves. The plethora of horns and antlers in her Southwestern painting demonstrates her attempt to protect her own space, both pushing against the impositions of the viewer and protecting her artistic and personal vision on the canvas itself. O'Keeffe claims she simply was in the habit of gathering dried horns and antlers from the remains of antelope,

deer, and mountain goats; they were simply found objects that she turned into desert still lifes. But her repetitive use of these objects reveals a deeper theme in her art. The jagged and jutting antler spikes in *Summer Days* (fig. 14) erect an organic palisade, an artistic *cheval de fries*, against encroachment; it proclaims "don't tread on me." In the later, and more subtle, *Goat's Horn with Red*, the horn, seen from the side as opposed to head-on, wraps an enveloping, protective bulwark around the lake of blue in the middle. The blue does represent an ideal of the American pastoral, a life-giving sanctuary in the midst of a forbidding landscape. But, considered as the amniotic fluid and the womb, it is also a representation of womanhood, protected from the world of men.

By Georgia O'Keeffe
(1887–1986)
Pastel on paperboard, 70.7 × 80.4 cm (27⁷/₈ × 31¹¹/₁₆ in.)
1945
Hirshhorn Museum and Sculpture Garden, Smithsonian Institution, Washington, D.C.
Gift of Joseph H. Hirshhorn, 1972

Plate 36
Nude

As an artist, Agnes Martin evolved to abstraction after working through a figurative phase in which she discovered she was not interested in realism, either artistically or personally. She openly acknowledged that abstraction was a refuge for her: "We have a lot of really abstract emotions not caused by anything in this world." But the tumult of the world, including relationships, caused her to withdraw; she reputedly never read a newspaper for fifty years and was prone to falling into near-catatonic trance states when the world was too much for her. This nude, possibly a self-portrait or a lover, was one of her attempts to depict "real" life. It has a 1930s feel to it and reminds the viewer of Jackson Pollock's early realist/regionalist stage, before he too turned to abstraction as a way of expressing his inner life. In contrast to Pollock's flung paint, Martin specialized in tightly organized, near-minimalist grid paintings. To contemporary viewers, their subtly modulated, obviously hand-drawn lines seem to hold the artist's consciousness. Before she died, Martin attempted to reacquire and destroy all of her figurative works.

By Agnes Martin
(1912–2004)
Oil on canvas, 50.8 × 40.6 cm (20 × 16 in.)
1947
Peyton Wright Gallery, Santa Fe, New Mexico

Fig. 6—A Lamb for Pylaochos: Herko in New York '64:
Translation #16, (detail) by Jess (Burgess Collins)
Reproduced in full as Plate 55.

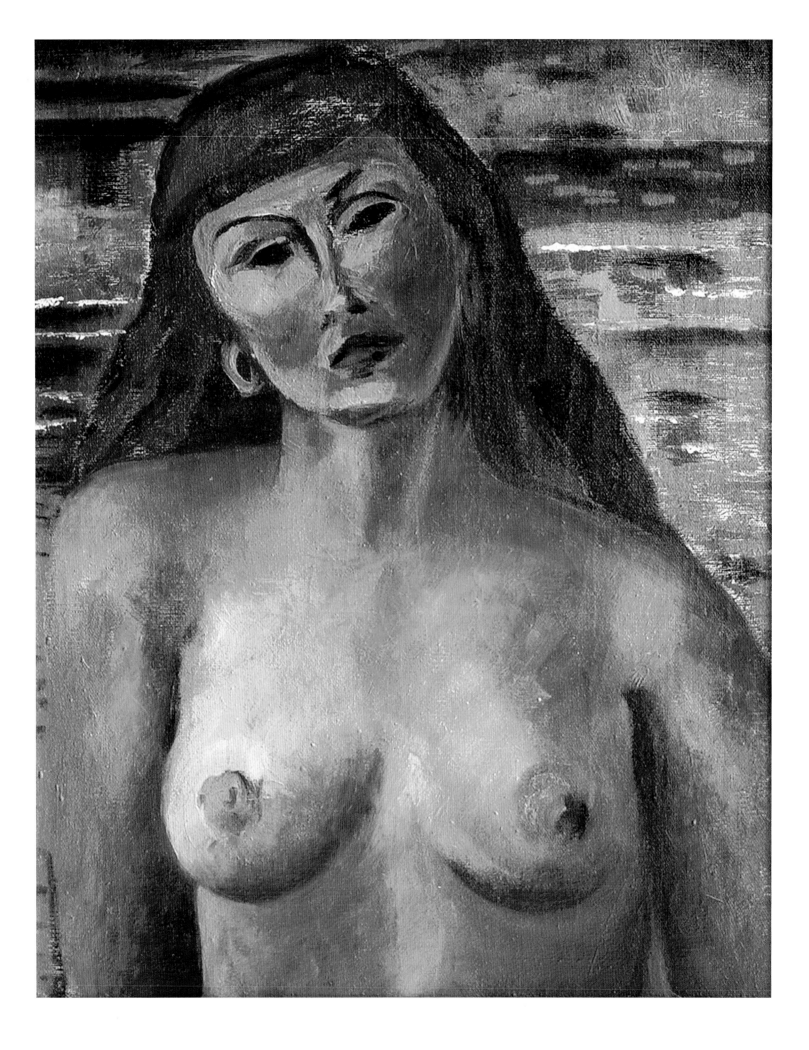

Postwar America: Accommodation and Resistance

Jasper Johns began as a poet and moved sideways into art in the early 1950s, in part under the influence of his companion, Robert Rauschenberg. Johns's first paintings consisted of series of representations of self-defined, self-contained "objects" such as letters or numbers, the American flag, and targets. The targets (fig. 15) are particularly interesting, both in and of themselves as well as for what they say about Johns's artistic project and the culture of the 1950s. While the target refers to a real thing, it is also a pure abstraction; the target is constantly shifting between determinate and the indeterminate worlds. This duality, as well as the other attributes associated with the target in both of its states, provides an entry point to the predicament of representing difference in the years after World War II.

Johns may have chosen to paint targets under the inspiration of Marcel Duchamp or from other Dadaists like Francis Picabia, who incorporated them into his work. Johns spoke of the targets as having the attribute of a Duchampian readymade. But this seems like an artistic fiction to provide the project with a pedigree that it actually doesn't have—and doesn't need. While Johns's targets can still bear the Dadaesque conceit that an artwork might be turned back to its original "objective" function—that is, you can shoot at them—the targets as John painted and constructed them are the antithesis of readymades. If a comparison, or starting point, is needed, Gustave Courbet's *Origin of the World* is more apposite.

The targets were modeled after the big, fat archery targets that are a familiar feature of American summer camps; pistol or rifle targets are more detailed and complicated. It is the archery target that has come to embody "targetness" to the public. Johns sometimes added additional design elements (including sculpture) around squares that framed the circular spiral of the target itself. He varied both the size of the overall painting and the targets. Johns painted the series thickly with encaustic colors varying from starkly contrasting primary colors to the near indivisibility of shades of shades of gray or white (pl. 53). The thickness of paint and the visible brushstrokes obviate the idea that these are actual targets; a pop-era target by someone like Andy Warhol or Tom Wesselmann would replicate the slick vinyl of an actual target and come closer to the claim of having the character of a readymade. Instead, the targets were Johns's remaking of the original Dada conceit to fit the particular exigencies of the 1950s.

A Duchampian resonance can be drawn between Johns's targets and his punning on Duchamp's alter-ego and artistic "subject" Rrose Selavy (pl. 14). Duchamp's phrase was *eros c'est la vie* in the original, but when applied to Johns and shifting from French to (partially) English the phrase becomes "arrows *c'est la vie*." And thus in Johns, the arrows of Eros find their mark in the target they desire.

Social circumstances always are pushing against the targets' aspiration toward pure form. For instance, their range of colors can be read geopolitically: in Johns's series, the Manichean opposition of primary colors, signifying the ideology of the Cold War, devolves into the murky gray and white contingencies of real life, where things were not quite as certain. More balefully, everyone had targets painted on their back in the postwar world of nuclear weapons and mutually assured destruction. Johns's targets also allude to the military's bomb-assessment charts that showed the widening bands of damage radiating out from a detonation at Ground Zero. In a decade when nuclear alarmism was both a rational government policy and a popular fear, the idea that there were no front lines, and that everyone was both a combatant and a potential victim, was pervasive and deep. This element of fear and paranoia became a fact of life in the decade in which Johns became an artist.

The targets have no sexuality at all, of course, and they imply nothing except their own receptivity. Yet read longitudinally, as any series allows regardless of chronology, the series becomes an allegory to the predicament of gays in a society, which, at best, tolerated them and, at worst, as we shall see, actively oppressed and tried to extirpate them. Many paintings in the series are muted, the rings disappearing beneath thick layers of paint (gray, white, or green) so that the identity as a target is hidden and nearly lost. Not only do these paintings recapitulate the dilemma, predicament, and tragedy of the closet, but they have a special salience when coupled with the idea of targeting in the 1950s. If everyone had a target on their back during the first decade of the "American Century," homosexuals were doubly targeted. The concomitant effect of the national security state's vigilance over Communists and spies in the government was a crackdown on gays as well. Eventually, during what became known as the "Lavender Scare," more homosexuals were dismissed from government service than Communists or Soviet spies. The persecution endured during the 1950s creates another level of symbolic meaning in Johns's targets through their allusion to the fate of St. Sebastian, who is commonly thought to have been martyred around 288 A.D. by being shot full of arrows. St. Sebastian actually survived the arrow attack,

only to be beaten to death for his beliefs at a later date. As Richard Ellmann rather loftily informs us in his biography of Oscar Wilde, Sebastian is the "favorite saint of homosexuals."

While the hunt for Communists had an initial rationale—there actually were Soviet spies in America, including a few in the federal government who had stolen atomic secrets—it quickly got out of control and became a civil liberties nightmare. Investigations into specific, legally defined criminal actions became a way of using governmental power to intimidate people for their ideas and beliefs. As the investigation metastasized (a development fueled in part by the tortured desires of its instigators, Joseph McCarthy, Roy Cohn (pl. 67), and J. Edgar Hoover), the focus shifted from what was provable to an assessment of one's potential for subversion: that one was a security "risk," not that one had actually done anything subversive.

Once the objective became discovering potential subversives, it was an easy jump to decide that certain people had become un-American and needed to be expunged. In a campaign that focused on who was or wasn't a real American, gay and lesbian citizens became irresistible targets. That some Soviet sympathizers were gay provided a dubious justification for expanding the witch hunt. So did the perennial rationale that gays were vulnerable to blackmail by a foreign power, and therefore had to be removed from sensitive positions of employment, or indeed from all such employment. (This canard avoids the obvious: if gay and lesbians were not criminalized there would be no basis for blackmail.) Yet it was the government itself that did the blackmailing, using the threat of exposure of one's sexual preference as a lever to force people to "name names."

The attack on gay Americans was so disproportionate that it has to be seen not as a reaction to an actual threat but as a type of heterosexual panic. The reasons for this panic are not hard to find. As with the American Civil War and Reconstruction, the end of World War II meant the continuation of the conflict by other means. Barely pausing for breath, the world segued from a hot war to the Cold War, in which the two hegemons confronted each other, each backed with a powerful arsenal of nuclear weapons. For the United States, the USSR's early acquisition of the atomic bomb (aided by the aforementioned Soviet spies) was an alarm bell that "the American Century," so confidently proclaimed by Henry Luce in his 1941 *Life* magazine article, would not be uncontested. The "loss" of China to a Communist government and a host of other geopolitical

developments only exacerbated concern about American mastery. Ideologically, politically, and culturally, America mobilized to push back. Many of these activities were legitimate expressions of national interest. But the bipolar world of actual diplomacy created an impulse to divide the world into light versus dark. In the defense of the American way of life, the place of gay and lesbian Americans became precarious. Moreover, an official rhetoric that bristled with aggressive hypermasculinity could only look with suspicion on the "sissies."

One of the more curious aspects of Cold War culture in America involves the way in which the most cutting-edge art became a weapon in the country's arsenal of democracy. The archetypical case was that of abstract expressionist Jackson Pollock, whose all-over painting made up of drips and jets of paint was viewed with only limited comprehension, and much hostility, by an American public that did not consider his work to be art. Yet in a complicated piece of cultural legerde main, the demands of America's Cold War politics "domesticated" Pollock by positioning him as a uniquely American talent whose prodigious masculinity was tamed and focused by his private life as a devoted husband and family man. If people didn't understand Pollock's painting, they could understand his story as an unlettered man from the West who poured out his authentic personal vision onto canvases that he bestrode like a hero. Yet like the skilled but basically peaceable gunfighter who is the hero of so many westerns, away from his work Pollock lived harmoniously, fulfilling his duties to his family. A determined public relations campaign showed Pollock painting, but also included pictures of him gardening and working around his farmhouse with his wife, Lee Krasner. It was all a myth, of course. But it was a myth that worked because of a cultural paradigm that insisted on and enforced normalcy. If even a wild man like Jackson Pollock could be domesticated to serve American interests, who could resist the pressure to conform?

The creation of a normative model for masculine behavior went far beyond the unique case of Jackson Pollock, of course. Cold War politics coupled with American prosperity meant that Americans, and especially American men, had to be resocialized as the country finally shook off the hardships and sacrifices of the Depression and the war years. In particular, as more Americans became middle class, they had to learn how to behave. Some of this inculcation was done by way of the large corporations and other public bodies that were dominating the economic and social landscape. *The Man in the Gray Flannel*

Suit, albeit a novel, was reality: corporations imposed a regimented dress and appearance code on their employees; IBM's "uniform" was especially well known. Previously in American history, there had never been a prohibition against long hair for men. Styles fluctuated of course, but in the 1950s American men retained their wartime crew cuts, adding a sense of military uniformity to civilian life. Long hair on men was viewed with suspicion, not least because it was now considered effeminate, in a way it never had been for J. E. B. Stuart or George Armstrong Custer.

The American man had to be domesticated, but not gelded, not least because the Cold War might turn hot at a moment's notice. As with Pollock, passion had to be disciplined and directed. In controlling the libido, added benefits could accrue, as Hugh Hefner's *Playboy* magazine demonstrated. Appearing in 1953, its founder's editorial purpose was to overthrow the stifling conformity of American Puritanism through its open, yet tasteful, avowal of carefully airbrushed hedonism. Posing as a rebel, Hefner never noticed that his magazine prospered precisely because the "Puritanism" he attacked was a straw man that nearly no one supported. Indeed, American Protestantism had always shown a remarkable ability to adapt to and justify worldly ways. (A standard feature of the magazine was and is the appearance in its pages of "hip" ministers.) Instead, *Playboy* signaled the shift from a culture of production to one of consumption. The magazine's nudes were advertised as "the girl next door," and the bulk of the magazine presented lifestyle features that guided the reader through the safer precincts of avant-garde culture. As the domestic market boomed, consumers could purchase style. *Playboy* became a reliable guide for young men to the different brands of stereos and blondes. What Hefner did was desexualize sex, not least by making it integral to American consumerism—a development that created the conditions that would lead to the Dionysian explosions of the 1960s. But in the 1950s, *Playboy* was a leading indicator in making the link between (hetero-) sexuality and the wider culture explicit.

Against the superheated rhetoric of the Cold War, a rhetoric in which the abstract expressionists were included regardless of their own say-so, artists evolved a series of strategies to resist or avoid the editorial tendencies of the time. Even evasion could prove to be a productive strategy: the young Andy Warhol realized that a direct evocation of his innermost feelings ("Boys Kissing") could not work in such an atmosphere and shifted sideways into art forms that took the society's commodity fetishism to absurdist heights. For other artists, such as Johns and Robert Rauschenberg, the reaction against abstract expressionism's extravagance owed something to the inevitable tides in which one style succeeds another; cool following hot, in this case.

The paradox of the culture of the 1950s is that while on the surface it was the most boring and conformist decade in American history, it spawned a whole series of countercultures, ranging from the New York School to Black Mountain to the Beats to Elvis to the Hell's Angels. Cold War consensus was asserted so vehemently precisely because its hegemony was continually under threat by those who didn't (or couldn't) buy into its rationale. Policy spokesmen and government mouthpieces like Henry Luce might want society to be infused with William James's "moral equivalent of war," but sizeable numbers of people didn't report for duty. Ironically, the artistic triumph of the consumer culture that developed in the 1950s would occur a decade later, with the arrival of pop art, a movement that made icons out of American name brands. But at the time, pockets of cultural resistance grew out of the like-mindedness and friendships between and among circles of people. A Venn diagram of the cultural scene would show many overlapping areas of collaboration and interaction. Differing from an earlier intellectual model centered on the salon as a place of refuge, these collaborations were functional relationships between practicing artists working their way through a problem. One thinks of Frank O'Hara working with Larry Rivers, for example. Indeed, think of Frank O'Hara working with everyone! Consciously or not, the model of the artist as the lone wolf—the agonized Prometheus—was being displaced by a more flexible, interactive style of creativity.

These associations, then, were not simply a matter of congenial temperaments. Rather they were a way of reimagining the body politic through the lives of the artists or writers themselves. These groupings created a network of resistance, both cultural and political, that set the stage for what would come next. In their practice, they give the lie to the idea that the 1950s was wholly an era of dogmatic conformity.

Plate 37
The Mouse's Tale

Like early witches, the homosexuals, far from seeking to undermine the popular superstition, have accepted and even anticipated the charge of demonism. Sensing the fear in society that is generated in ignorance of their nature, they have sought not understanding but to live in terms of that ignorance, to become witch doctors in the modern chaos.

—Robert Duncan, "The Homosexual in Society," August 1944

Made in the early 1950s, Jess's collage is perhaps the very first explicit visual articulation of homosexuality as constituting a minority *group* that exists in didactic opposition to the heterosexual majority, rather than simply as a "perversion" among certain individuals. Jess depicts the "heterosexual majority" as a group of sneering, mocking clowns that forms a noose as it issues a preemptive verdict against the homosexual minority— "I'll be judge, I'll be jury. . . . I'll try the whole cause, and condemn you to death." The minority body, internalizing this verdict, becomes monstrous— a jumble of splayed limbs and pinup-men who flex their muscles under the condemning eyes of mother and priest.

By Jess (Burgess Collins)
(1923–2004)
Collage: gelatin silver prints, magazine reproductions, and gouache on paper, 120.9 × 81.3 cm (47⅝ × 32 in.)
1951–54
San Francisco Museum of Modern Art, California
Gift of Frederic P. Snowden

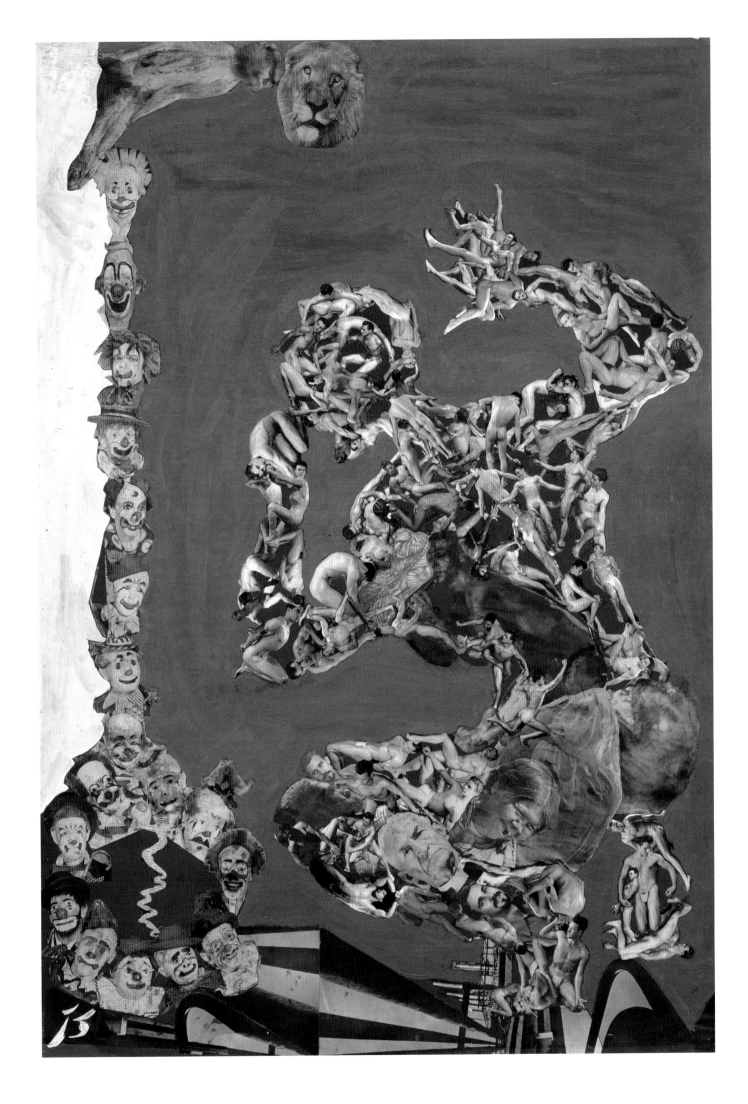

Plate 38
Ralph McWilliams

Dancer Ralph McWilliams (1926–1981) was a frequent subject for George Platt Lynes and other artists, such as Paul Cadmus. In this image of McWilliams, Lynes shows the ambiguity of the gay "gaze" and thereby the divided, dangerous position of gay men as they navigated social encounters. As George Chauncey has documented, gay men would meet by violating the no-eye-contact rule practiced by heterosexual men (who would, of course, look women directly in the eye as a preliminary expression of interest). Yet making this initial contact was always fraught with difficulty, ranging from simple embarrassment to actual danger if the signal was taken the wrong way. Hence Lynes hides McWilliams's gaze and face from us, and only reveals him by way of the mirror, in which the eye looks boldly and directly at the viewer. The mirror not only shows the way that gays have to live a double life, but its damaged surface imposes its scars on McWilliams's face, mirroring society's disdain for those it has cast out.

By George Platt Lynes
(1907–1955)
Gelatin silver print, 25.4 × 20.3 cm (10 × 8 in.) sheet
1953
David Leddick

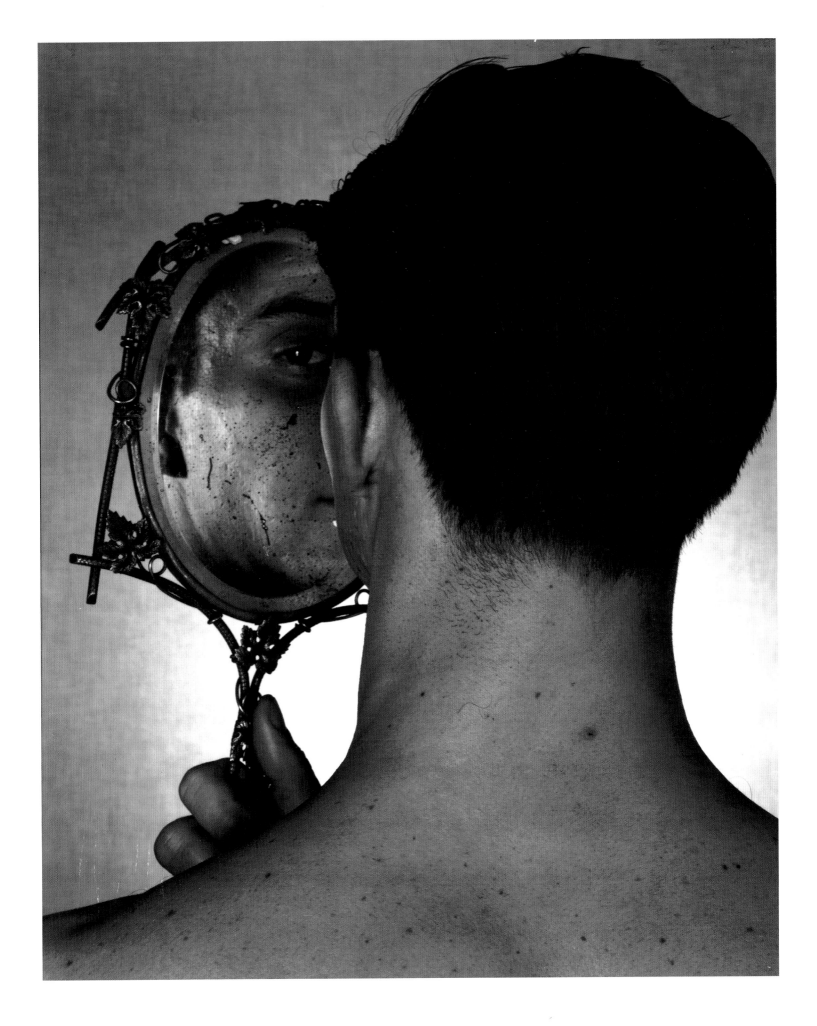

Plate 39

Allen Ginsberg

"I saw the best minds of my generation destroyed by madness, starving hysterical naked." With this, the first line of *Howl* (1955), Allen Ginsberg (1926–1997) launched the postwar counter-culture's revolt against the American consensus. Ginsberg sparked the self-styled Beat movement that took the double meaning of its name from a sense of exhaustion with postwar American triumphalism and a despairing commitment to beat back with a new cultural politics rooted in individual identity. *Howl* was also Ginsberg's coming out as a poet as he put aside all his self-consciousness and his unmediated voice poured out. His biographer wrote that with *Howl*, "Allen finally accepted his homosexuality and stopped trying to become 'straight'" in all meanings of the word. In this New York photograph, Ginsberg presents himself as a nice, buttoned-down Jewish boy, recently a student at Columbia, whose appearance gives no indication of the turmoil that would result in America's greatest long poem since Walt Whitman's *Leaves of Grass*.

154/155

By William S. Burroughs
(1914–1997)
Gelatin silver print, 28.6 × 43.8 cm (11^1/4 × 17^1/4 in.)
1953
National Portrait Gallery, Smithsonian Institution, Washington, D.C.

Myself seen by William Burroughs, new-bought Kodak Retina from Bowery hock-shop in his hand, our apartment roof Lower East Side between Avenues B and C, Tompkins Park Trees under new antennae, Kerouac, Corso and Alan Ansen visited, The Subterraneans record much of the scene, Burroughs & I worked editing manuscripts he'd sent me as letters from Mexico & South America, the neighborhood heavily Polish & Ukranian, some artists, junkies to medical students, rent only 1/4 of my $120 monthly wage as newspaper copyboy. Fall 1953.

Allen Ginsberg

Plate 40

O'Hara Nude with Boots

Frank O'Hara was totally unselfconscious about posing for artists, and he was portrayed in a panoply of styles (see also pls. 45 and 46). The most dramatic was this full-length nude by O'Hara's friend, sometime lover, and artistic collaborator, Larry Rivers. Heavily sexualized —O'Hara's hands-on-head pose mirrors Botticelli's heterosexualized *Primavera (Venus)*—Rivers bridges sacred myth and art-historical precedents with the profane in a dazzling mix of high and low culture. While referencing grand-manner painting by posing O'Hara out of doors, with one booted foot on a cinder block, Rivers also alluded

to O'Hara's poetical and personal celebration of cruising and sex in the city. The shifting meaning of Rivers's painting mirrors the poet's enjoyment of masks and masquerade, yet this overtly homoerotic work was an act of personal courage in the cultural climate of the 1950s, a climate in which the repression of homosexuals was as severe as that of political dissidents. As O'Hara liberatingly wrote, "It's wonderful to admire oneself/with complete candor."

156/157

By Larry Rivers
(1923–2002)
Oil on canvas, 246.4 × 134.6 cm (97 × 53 in.)
1954
Larry Rivers Foundation, Wainscott, New York

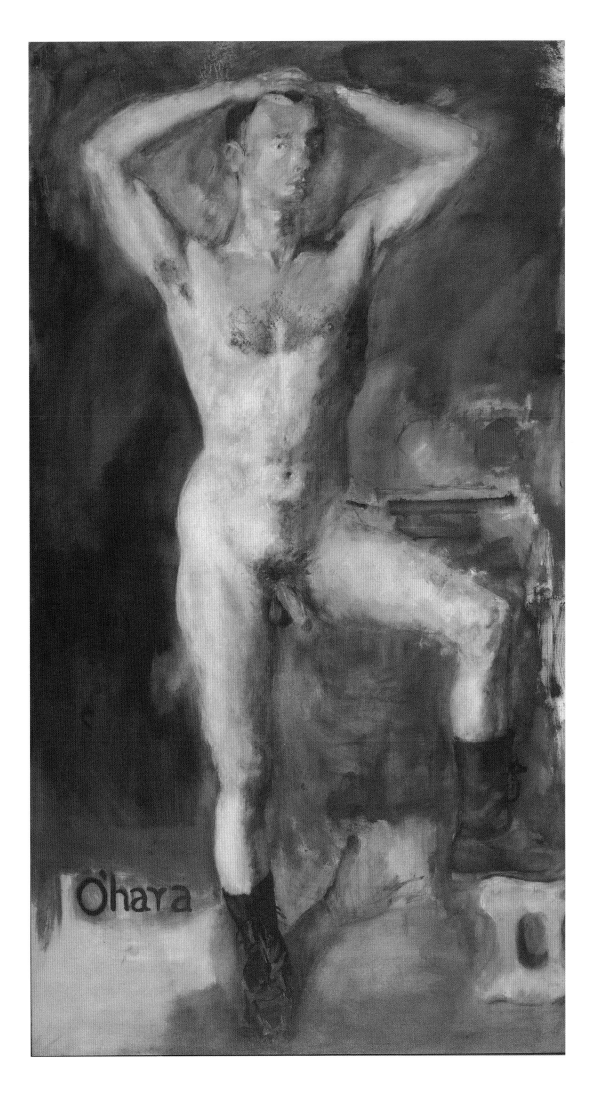

Plate 41
Truman Capote's Shoe

When Andy Warhol transitioned toward a form of abstraction that eventually became his signature pop style, he used his interest in the decorative arts and his work as a commercial artist to facilitate this shift. He had an interest in painting shoes that almost became a fetish. The shoe as a subject bridges Warhol's fascination with celebrity and his elevation of the quotidian into banal icons of modern consumerism. Warhol frequently painted shoes as simply highly elaborative decorative items of apparel, but for a 1957 issue of *Life* magazine he did a double-page spread in which he imagined shoes that could be worn by such celebrities as Elvis Presley, Julie Andrews, and Zsa Zsa Gabor. These shoes took off from a core understanding of their "owner's" character and were then embroidered in a way that became

camp. But since camp is always serious, the shoes became a signifier of the ambiguities of gender sexuality, and public identity. Warhol's shoe for Truman Capote (1924–1984) was in this vein, and it played off how Capote had made a splash with his first book, *Other Voices, Other Rooms* (1948), in part because the languidly sexual pose of the author in the jacket photograph caused a sensation. The young Warhol wrote fan letters to the equally young Capote and immortalized him with one of his iconic shoes. Warhol also produced a series of shoe illustrations that paid homage to great gay artists like Marcel Proust, signifying how the shoe could become an emblem of sexual difference.

By Andy Warhol
(1928–1987)
Gold leaf and ink on paper, 40.6 × 52.1 cm (16 × 20^1/$_2$ in.)
c. 1955
Edward De Luca

Truman Capote

andy Warhol

Plate 42
Oedipus (Elvis #1)

Art writer Grace Glueck once described Ray Johnson as "New York's most famous unknown artist." Beginning in the 1950s, Johnson's practice of cutting up pictures from magazines, embellishing them with doodles, and sending them, often through the mail, to his friends (many of whom were quickly becoming the art world's most influential players) secured his fame among the art-world cognoscenti as a consummate rebel outsider. Johnson responded to an art world infatuated with the hypermasculine purity of Jackson Pollock's monumental paint drips with small, hand-wrought collages that celebrated the homoerotic appeal of all-American pinup boys—a subversive gesture indeed. Here, Johnson turns Elvis into the tragic Greek figure of Oedipus, who gouged his eyes out after discovering that he killed his own father and married his mother. This classic monumentality is immediately undercut, however, by the image's frivolity—it is, after all, a decorated page torn from a magazine. Johnson here touts America's favorite heartthrob and sex icon as his own.

160/161

By Ray Johnson
(1927–1995)
Tempera and ink wash on magazine paper,
27.9 × 20.3 cm (11 × 8 in.)
1956–57
William S. Wilson

Plate 43
David Herbert

David Herbert began his career as the manager, first of Betty Parsons's highly influential gallery (1951–53) and then its successor, Sidney Janis Gallery (1953–59), and the chief purveyor of abstract expressionism. He subsequently opened his own gallery. Herbert discovered Ellsworth Kelly, who had previously exhibited only in France (where he had gone to study under the GI Bill) and introduced Kelly to Parsons, which helped him secure his first U.S. exhibition and launch his career. Here, Kelly returns the favor in a portrait that is notable for its casual intimacy as well as for its refusal of Kelly's celebrated "hard-edged" abstraction. A shirtless Herbert relaxes in an Adirondack chair, his hands placed, seemingly casually, on his lap.

Kelly's link with the Parsons Gallery through Herbert is significant in the cultural politics of the postwar art world. When the leading lions of the abstract expressionist movement insisted that Parsons drop other artists and concentrate on promoting their work, she declined. Her decision to retain her curatorial independence, often in favor of quieter, more geometric forms of abstraction, made her gallery a de facto haven for female as well as gay and lesbian artists.

162/163

By Ellsworth Kelly
(born 1923)
Pencil on paper, 62.9 × 49.5 cm (24^3/4 × 19^1/2 in.)
1957
Private collection

Plate 44

**Canto XIV (from XXXIV
Drawings from Dante's
Inferno, including KAR)**

In the early 1950s, Robert Rauschenberg's work juxtaposed his cool silences against the overheated gestures of action painting (or abstract expressionism); his most notorious work was the erasure of a Willem de Kooning drawing. Implicitly, the work juxtaposed a quiet anti-expressiveness against aggressive masculinity. More tragically, in the public sphere this aesthetic negotiation necessitated personal silence as a consequence of the political realities of a decade when homophobia increased and repression was tightened. But by the end of the

1950s, an aesthetic and political strategy of private resistance allowed a limited subjectivity to emerge, as in such coded works as this one of Rauschenberg's Dante series. Representing the circle of hell where "sodomites" are forced to run barefoot on hot sands, the artist inserts the outline of his own foot. By signaling his own outcast status, he appropriates the sign of his own oppression and makes it his own in a quiet rebellion.

By Robert Rauschenberg
(1925–2008)
Offset lithograph (one of thirty-four), 36.8 × 29.2 cm
(14^1/$_2$ × 11^1/$_2$ in.)
1959
The Museum of Contemporary Art, Los Angeles
Gift of Marcia Simon Weisman

Plate 45
Frank O'Hara

Frank O'Hara (1926–1966) is one of the most important poets of postwar America and was a leading figure in making American verse more confessional, intimate, and personal. He rejected abstraction and theoretical posturing for a direct and immediate style, and his subjects were generated from his day-to-day encounters with people and places. (He was a curator at the Museum of Modern Art and wrote poems every day during his lunch hour.) His relaxed, humorous, and offhand style does not mean that he did not take his art or his subjects seriously. Rather, his tendency toward indirection was influenced by camp as a necessary defensive bulwark for a gay man.

O'Hara also had a deep well of privacy, which kept much of his life hidden from even his closest friends. While not conventionally handsome, O'Hara was extremely charismatic and attractive, to the point that probably more portraits were painted of him than any other American writer. This picture by the American realist Alice Neel captures O'Hara's distinctive profile. She described it as "a romantic falconlike profile with a bunch of lilacs."

By Alice Neel
(1900–1984)
Oil on canvas, 85.7 × 40.6 cm (33 3/4 × 16 in.)
1960
National Portrait Gallery, Smithsonian Institution, Washington, D.C.
Gift of Hartley S. Neel

Plate 46

**In Memory of My Feelings—
Frank O'Hara**

As a bridge to pop art, Frank O'Hara took the spontaneity of abstract expressionism ("action painting") and lightened the mood by more directly engaging with the contingencies of daily life. In his "I do this, I do that" aesthetic, he skated on the surface of daily life, processing his impressions in verse that he produced rapidly, on the spot. Oxymoronically, O'Hara's surfaces were always deep. His poem "In Memory of My Feelings" was an elegy to a lost love that in its mourning shows the way to transcendence— and art. When Jasper Johns took the poem as a subject for a painting, he may have been thinking of his recently ended relationship with Robert Rauschenberg. But visually he carries through O'Hara's great theme of multiplicities: "My quietness has a number of naked selves." The logo "DEAD MAN," sublimated at the painting's bottom edge, represents an absolute nullity: "I have

lost what is always and everywhere/present, the scene of my selves, the occasion of these ruses." However, the painting (or poem) builds on these absences to overcome them. Hinged in the middle, the painting suggests an altarpiece. But it is also something that you can close and open to reveal or conceal what you want. Finally, the hinge suggests that you can take the piece with you: carrying your selves and memories, using the spoon and fork for sustenance, journeying out of the past under the imperative to create art from the wreckage.

168/169

By Jasper Johns
(born 1930)
Oil on canvas with objects, 102.2 × 152.4 × 7.3 cm
(40^1/4 × 60 × 2^7/8 in.)
1961
Museum of Contemporary Art, Chicago
Partial gift of Apollo Plastics Corporation, courtesy of
Stefan T. Edlis and H. Gael Neeson

Plate 47

**We Two Boys
Together Clinging**

Despite the continued illegality of homosexuality in England (it was not decriminalized until 1967), David Hockney directly presented his homosexuality as integral to his art. While his paintings from the early 1960s did use coded references—to pop stars he had a crush on, lovers, and other gay references—the overriding avowal of male desire made these codes appear instead as a commentary on England's proscriptions. Hockney's emotional and intellectual debt to the "Calamus" poems of Walt Whitman undercut any idea of concealment. And Hockney openly stated his intent to propogandize "for something that hadn't been propagandized: homosexuality. I felt it should be done." *We Two Boys Together Clinging* is from Whitman's poem of that name, which celebrates two tramping boys roistering "North and South excursions making/Power enjoying, elbows stretching, fingers clutching. . . . No law less than ourselves owning." This projection of the gay body to claim and occupy public space is reflected in the bulky figures that Hockney uses to represent the two boys. Once he moved to California in 1964, he stopped using this kind of crude depiction of the figure, and he became a cool, sensual realist, painting as if he was liberated by the life he found on the West Coast.

170/171

By David Hockney
(born 1937)
Oil on board, 121.9 × 152.4 cm (48 × 60 in.)
1961
Arts Council Collection, Southbank Centre,
London, England

Plate 48
Troy Diptych

172/173

Andy Warhol is known for his deadpan transformation of ordinary commodities—soup cans, Coke bottles—into art: a double commentary on commodity production and art as commodity. His portraits have a similar aim: to chart the creation and exploitation of celebrity and the subsequent translation of lives into commodities. Yet Warhol cut against the banality of celebrity biography by making portraits when the subject made evident the ambiguities and strain of his or her previously hidden private life. So his *Diptych* of the actor Troy Donahue (1936–2001) shows the marketing and rise of the hunky beach boy and teen idol; the replication of the fan-club photo shows how his image saturated the culture for a time. But the picture also divides along the lines that this emblem of wholesome American innocence was in fact widely known to be deeply in thrall to drugs and alcohol. The diptych exists because the fault line in Donahue's life runs across the otherwise smooth surface of his carefully constructed and artificial public image.

By Andy Warhol
(1928–1987)
Silkscreen ink on synthetic polymer paint and graphite on linen, 205.7 × 281.3 cm (81 × 110 3/4 in.) overall
1962
Museum of Contemporary Art, Chicago
Gift of Mrs. Robert B. Mayer

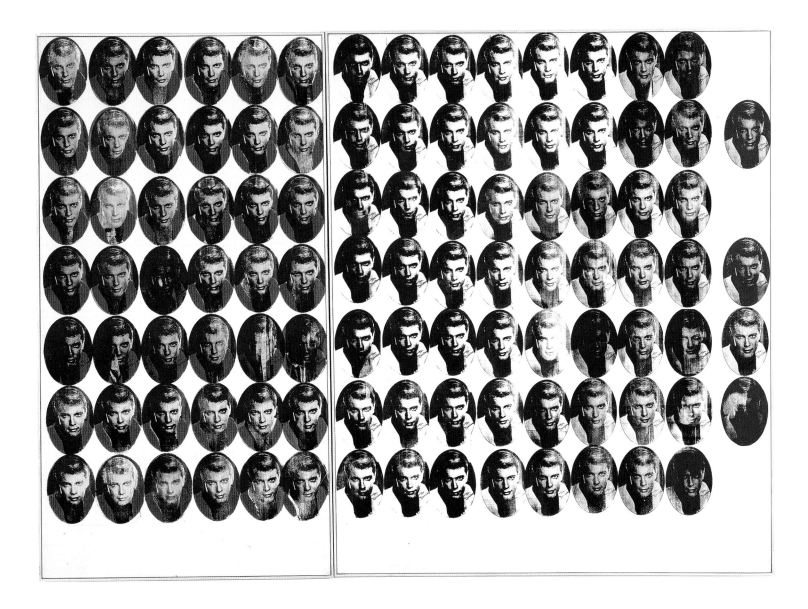

Plate 49

Le Ruban Denoue:
Hommage à
Reynaldo Hahn

Paul Cadmus often counterpoised explicitly homoerotic imagery to allegorical work that may or may not have an erotic, sexual, or gendered subtext. Sometimes, he pursued both lines at once, as in his *Hommage à Reynaldo Hahn*. The musician Reynaldo Hahn (1874–1974) was a child prodigy both as a performer (piano) and composer; he wrote his first songs when he was eight. He adapted many of his songs from the poetry of Victor Hugo and Paul Verlaine and was a composer of exquisite love songs that embodied the neo-romanticism of belle-époque France. Women were desperately attracted to Hahn, and he reciprocated only to the extent of taking his admirers as his muses. In 1894 he met and fell in love with Marcel Proust, who used Hahn as a character in an 1895 autobiographical novel that he wrote before beginning his masterpiece, *A la Recherche du Temps Perdu* (1909–21). In Cadmus's flamboyantly romantic and eroticized *homage*, Hahn is visited and seduced by Pan, who lies in languor on the steps, while a sprite kisses Hahn, unknotting the ribbon ("*la ruban denoue*") of music that unfurls like notes into the air.

By Paul Cadmus
(1904–1999)
Egg tempera on gessoed Masonite, 53.3 × 91.4 cm
(21 × 36 in.)
1963
Columbus Museum of Art, Ohio
Museum purchase, Derby Fund, from the Philip J. and Suzanne Schiller Collection of American Social Commentary Art, 1930–1970 (2005.012.013)

Plate 50
David Roper

Since the publication of his groundbreaking photo essay *Tulsa* (1971), Larry Clark's fixation on outlaw teenagers has always been controversial. His photographic subjects, most often shot in documentary-style black and white, are generally doing troubling, dangerous, and illegal things. These include harrowing displays of masculine aggression, drug-taking, sex, sexual violence, and hustling in Times Square. Clark has consistently articulated a strong sense of identification with alienated youth and was deeply invested in depicting adolescents and their touching revelations of insecurity beneath their bravado. Clark's often explicitly eroticized images have confounded an art world long accustomed to closeted artists who flee the slightest imputation of homoeroticism. While maintaining a traditional American fascination with the outlaw, Clark's

work is also a revealing instance of the inadequacy of our ascription of sexuality to an artist based on the work. While the work is doubtless homoerotic—adhering to a fascination with the ephebic youth going back millennia—it doesn't necessarily follow that the artist is gay, for Clark asserts that he is not. The fact that the current culture cannot conceptualize homoeroticism otherwise is testament to the inadequacy of both the gay/straight binary and to a social system that frames the homoerotic as necessarily homosexual. In the meantime, Clark documents and expresses our continual fascination and attraction to the outcast, the rebel, and the outlaw.

176/177

By Larry Clark
(born 1943)
Gelatin silver print, 35.6 × 27.9 cm (14 × 11 in.)
1963 (printed before 1980)
National Gallery of Canada, Ottawa
Gift of Benjamin Greenberg, Ottawa, 1982

Plate 51

James Baldwin

Beauford Delaney came to New York City in 1929 from Tennessee by way of Boston—where he attended art school—and was immediately enthralled by the city and all its terrors. Heir to the Ashcan School of social realists, Delaney produced a series of works that recast the realities of the Great Depression through modernist abstraction. Private by nature, he led a highly compartmentalized life, which he divided among his African American friends in Harlem, his white gay acquaintances in Greenwich Village (where he lived), and the modernist art circles revolving around Alfred Stieglitz. Delaney was of, but not in, all these communities; he felt the weight of his isolation in each of them. Living off of ill-paying jobs—he was a janitor and bellhop—and failing to sell many paintings despite positive reviews, he immigrated to Paris in 1953. In this he followed the path of many expatriate blacks, who found America repressive. He also left America just as abstract expressionism triumphed, an artistic movement with which he had no sympathy, either personally or intellectually. Yet Paris would not be a home to him either, and after 1961 he suffered increasingly from mental problems and alcoholism. A figurative painter in the age of abstraction, he left many brilliant likenesses, including this one of the novelist James Baldwin (1924–1987), who described Delaney as his "spiritual father." Baldwin, although much more honored and materially successful than Delaney, also negotiated the intersection of race and sexuality in his fiction and in his life.

By Beauford Delaney
(1901–1979)
Pastel on paper, 64.8 × 49.8 cm (25 1/2 × 19 5/8 in.)
1963
National Portrait Gallery, Smithsonian Institution, Washington, D.C.

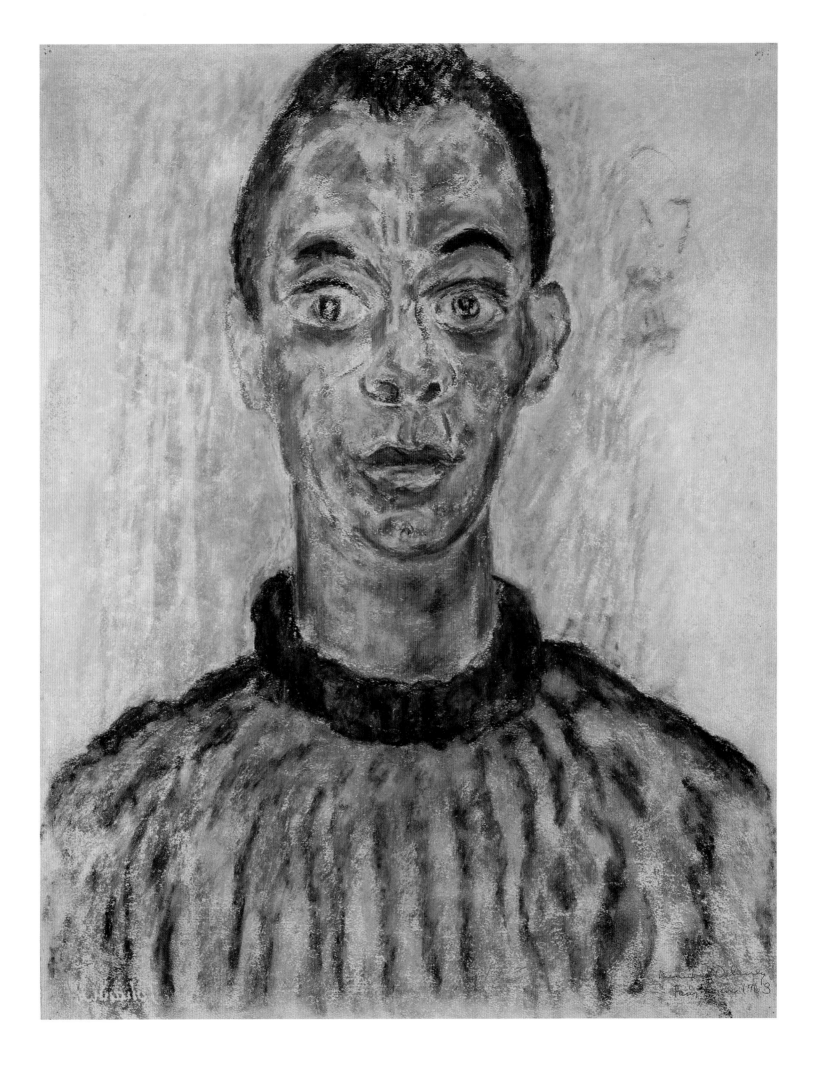

Poets (Clothed)
Poets (Naked)

In 1965, the artist Wynn Chamberlain, then a realist painter, had an exhibition of nude portraits of New York's major cultural figures. His double-panel portrait of the poets Frank O'Hara, Joe Brainard, Joe LeSueur, and Frank Lima, showing them both clothed and naked, served as a witty commentary on the separation between public and private. It also suggested that beneath the bland surface of white-bread conformity—the clothed poets are posed like a team of corporate salesmen in their white shirts—beat romantic, anarchic hearts. The nakedness of the poets also confirmed the emergence, out of the conformity of the 1950s, of a more engaged and personal style of poetry, one that valued personal revelation over formal structure. Finally, the portrait is simply funny: it is a *trompe l'oeil* painting that tricks no one; the poets hide themselves in plain sight. This overt ironic humor was something new to American art after the fervid heat of the abstract expressionists.

By Wynn Chamberlain
(born 1927)
Oil on canvas; two panels, each 168.9 × 115.6 cm
(66 1/2 × 45 1/2 in.)
1964
Earl McGrath

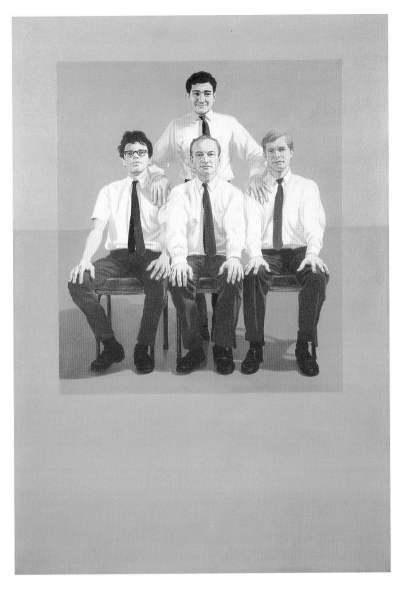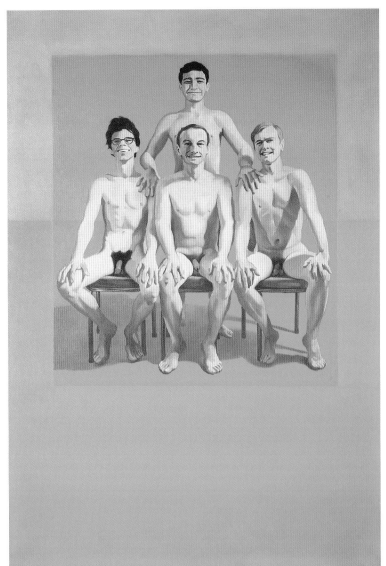

Plate 53
Souvenir

Having painted objects—targets, numbers, letters, and so on—during his formative years as an artist, Jasper Johns began to expand the range and scope of his subject matter during the 1960s. He evinced a particular interest in portraiture, even self-portraiture. Nonetheless, just as his paintings of objects masked or coded their meanings, so Johns approached portraiture gingerly, deflecting attention from the ostensible subject to other aspects of the painting and the process of painting. There was an element of demystification involved, as when Johns wrote that "a picture ought to be looked at the same way you look at a radiator." With that analogy, Johns indicates that he is interested in how art functions and in the processes of art-making. As throughout his work, the *Souvenir* series incorporates readymade items, specifically flashlights and rear-view mirrors from cars—items that assist one to see. In the series, the actual portrait of Johns is always

a cheap, tourist artifact, a Japanese-made plate that has a photographic head shot of the artist; a readymade, it is also infinitely reproducible and hence almost valueless. The angle of the rear-view mirror reflects light onto the medallion; the flashlight is clipped to the frame; and the blue-black encaustic is layered on: it's all about indirection and resistance. Around Johns's dead-pan photograph on the "souvenir," he substitutes the words blue, red, and yellow for the colors themselves: more indirection. *Souvenir* creates a machine for self-portraiture that is inevitably frustrated: a souvenir is never the thing itself.

By Jasper Johns
(born 1930)
Encaustic on canvas with objects, 73 × 53.3 cm
(28 3/4 × 21 in.)
1964
Collection of the artist; on long-term loan to the
San Francisco Museum of Modern Art

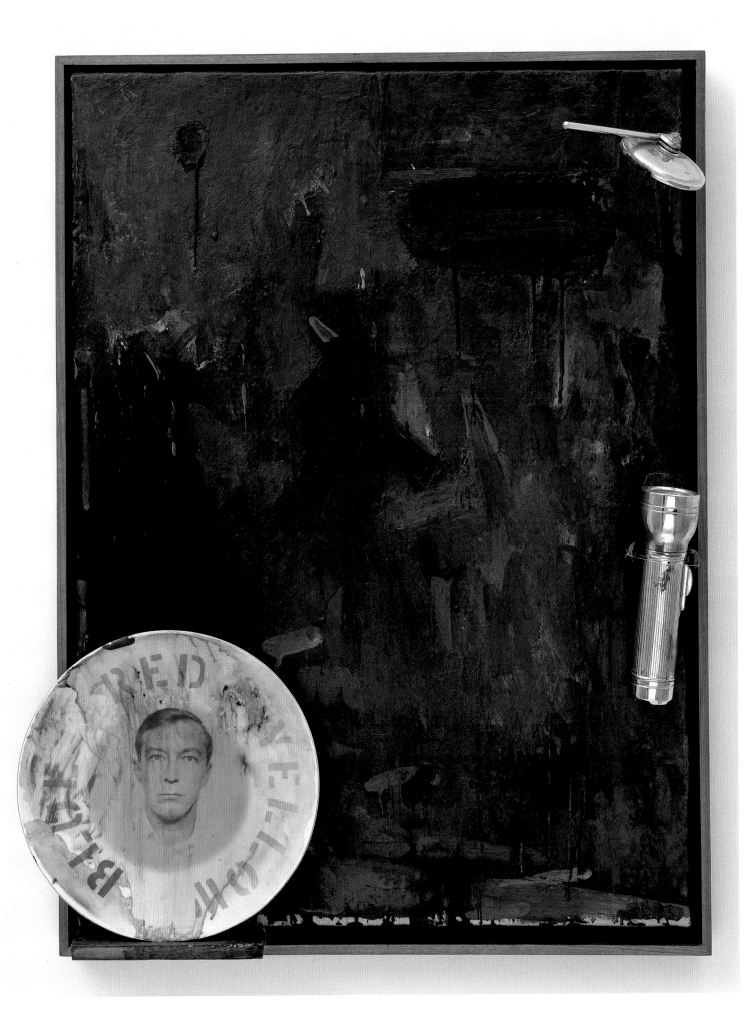

Plate 54
Untitled

This rare Rauschenberg self-portrait was subsequently used as a poster announcing the artist's major exhibition at the Dwan Gallery in Los Angeles in 1965. In the typical style of a Rauschenberg combine, it deploys a combination of photographs, typography, solvent transfer drawing, collage, and private symbols to create a self-portrait that is both legible to the general public and meaningful to Rauschenberg's circle of friends and intimates. Here, the monogrammed, reversed letter R announces the artist and subject's name, and is accompanied by such obvious attributes as the pencil used in making transfer drawings (along with a photograph of a man's hand so rendered); a photograph of Rasuchenberg's face; the serrated edge of notebook paper; and the points of scissors used to cut out collage. More generally, Rauschenberg satisfies his taste for sexual play with a distinctly

phallic photograph of a paint tube. He also includes swatches of the colors yellow, red, and blue, which he first used in one of the earliest combines that he made after he fell in love with Jasper Johns. (Johns often used the same colors as a sign of connection, as in his *Souvenir* series of paintings and prints.) Finally, Rauschenberg includes two ears, suggesting his famed openness and receptivity to his environment as well as his ability to artistically assimilate and use everything that crossed his path. In *Untitled,* art and artist combine to create not just a likeness but a philosophical statement by Rauschenberg.

184/185

By Robert Rauschenberg
(1925–2008)
Solvent transfer, graphite, ink, chalk, and collage on paper, 20.3 × 22.9 cm (8 × 9 in.)
1965
Barbara Bertozzi Castelli

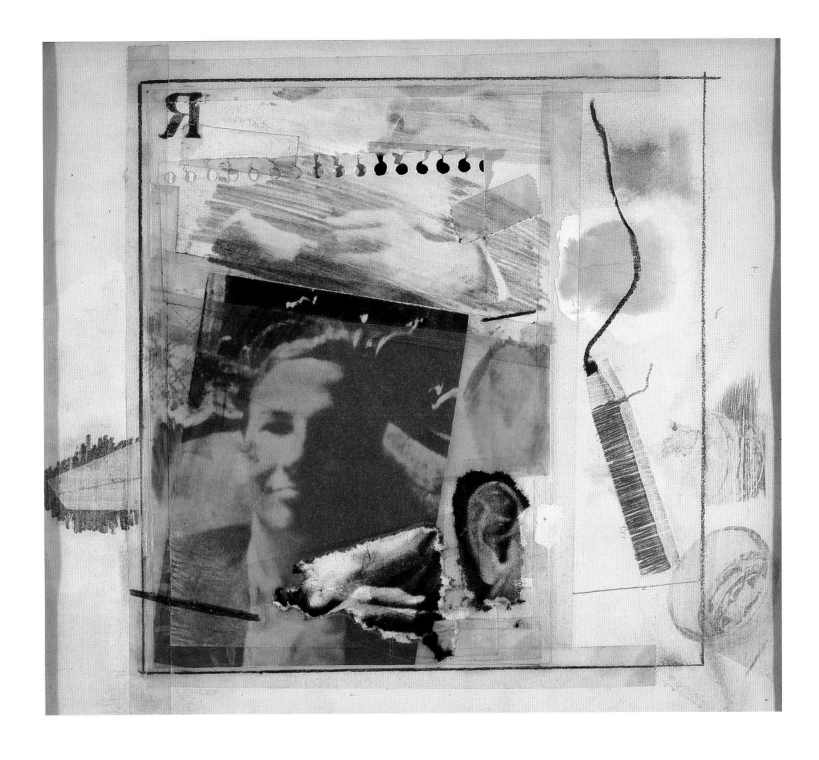

Plate 55

Fig. 6—A Lamb for Pylaochos: Herko in New York '64: Translation #16

One reason for the success of pop art was the deadpan way in which it captured the world and reduced everything to the banality of a supermarket's commodities. When Warhol made his series of prints of spectacular (and gory) car crashes, he leached them of all sensation, including the fear of death. As an aesthetic strategy, Warhol caught the way that the repetitions of modern life flattened everything into meaninglessness. But for individual cases, this deadpan attitude proved insufficient. When the dancer Freddie Herko (1936–1964), a gay habitué of the Warhol Factory scene and a dancer and choreographer, killed himself, he did so with a final performance: dancing naked and strung out on drugs, across the floor of a friend's apartment and out the window. Warhol, when told of the suicide performance, notoriously replied that he wished he had been there to film it. In contrast to Warhol's cynicism, Jess (aka Burgess Collins) made this memorial portrait of Herko two years

after his death. Jess states his intentions in making this memorial by titling it *A Lamb for Pylaochos*. Pylaochos is the guardian of the entrance to the underworld or Hades, who in Dionysian rituals had to be propitiated with the sacrifice of a lamb. While Herko carries a lamb over his shoulders, Jess makes it clear that Herko himself is the sacrificial lamb, not just memorializing Herko but offering a political rebuke to the culture—and art—of the 1960s. In contrast to Warhol's glib frigidity, Jess built on the conventions of pop to transcend their superficiality. He used found images, including Herko's likeness, as source materials and then built up a thick, painterly impasto that gave his terrible subject a dignity it shared with its classical title.

By Jess (Burgess Collins)
(1923–2004)
Oil on canvas mounted on wood, 60 × 50.8 cm
(24 × 20 in.)
1966
Byron R. Meyer

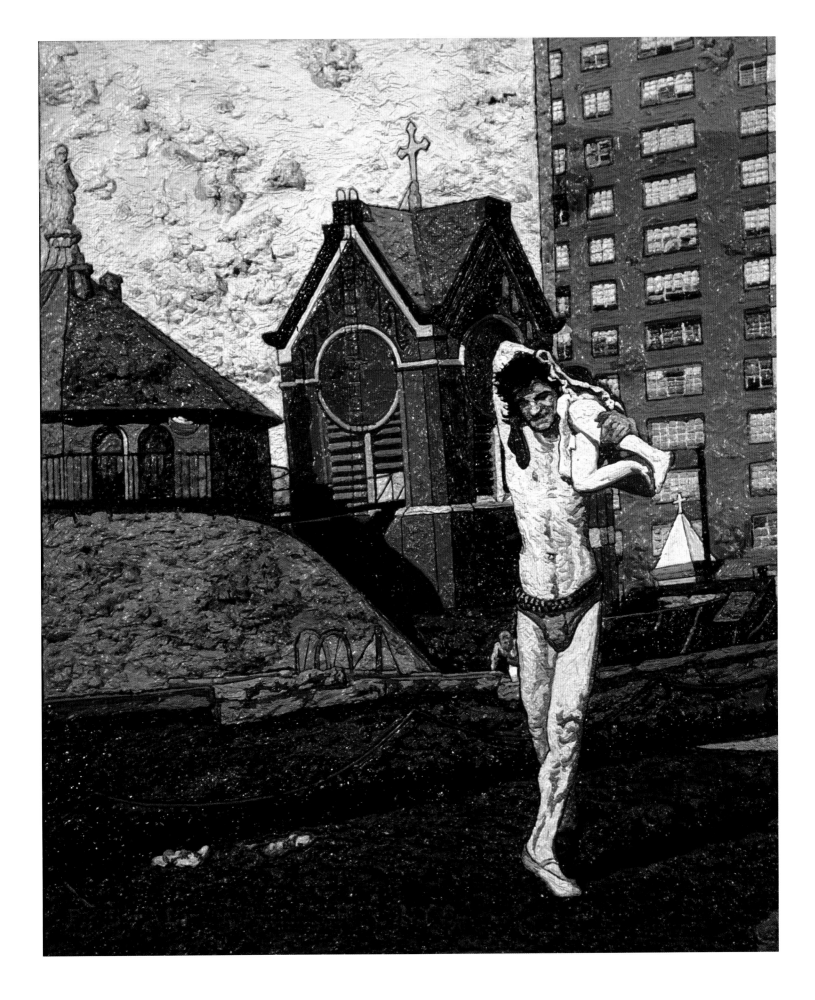

Unfinished Painting (detail) by Keith Haring
Reproduced in full as Plate 71.

Stonewall and More Modern Identities

Most place names only become historically resonant after the fact, when whatever happened there becomes associated with and symbolic of a larger cultural or societal change. It is uncanny, then, that the Stonewall Inn on Christopher Street in Greenwich Village should have become the site, and the occasion for, the first overt, public, and indeed violent resistance by gay citizens to their marginalization and oppression. A spontaneous act of resistance, the decision to stand against the police galvanized the embryonic gay civil rights movement and immediately transformed its tactics and long-term goals. Conversely, the radicalization of gay politics that followed Stonewall led to a self-assertiveness that cracked the community's own reticence and intentions; older political groups like the Mattachine Society, which was formed in the 1950s, were now seen as timid. Finally, the causes and consequences of the Stonewall riots were set into the history of public politics in the 1960s, as the social and political issues that had been kept tamped down during the Eisenhower years erupted. The words that Langston Hughes (pl. 23) wrote about African Americans would be applicable to the history of many people in the 1960s: "What happens to a dream deferred? Does it dry up like a raisin in the sun?. . . Or does it explode?"

The Stonewall riots, which started on June 28, 1969, were a spontaneous uprising that metamorphized from a minor disturbance into a political touchstone. Comparisons with the other liberation movements of the 1960s are inevitable, and Stonewall is frequently likened to Rosa Parks's heroic refusal in December 1955 to move to the "colored" section of a Birmingham, Alabama, bus. But Parks's refusal to abide by the laws and customs of the segregated South was actually a premeditated act. Local civil rights leaders had been looking for an occasion to challenge the public accommodation laws, and Parks's action was preplanned to create a provocation.

Absolutely nothing was premeditated about the Stonewall riots. The Stonewall Inn was a rather seedy bar in the middle of Greenwich Village, which had long been a center of gay life in America. Even though the Village was safer than many locales, it still endured antigay activity, especially vice raids and other periodic attempts to "clean up" the city. Such a campaign was underway in the summer of 1969 as Mayor John Lindsay's administration, under political pressure from the right, sought to improve city services and control the streets. The Stonewall Inn had been pegged by the local precinct as a trouble spot because its clientele tended to be marginal

and down-market as well as prone to rowdiness that often spilled into the street. The police raid was business-as-usual—a routine dance where the police would assert their authority with a few arrests or citations, after which the bar would quickly reopen. Police payoffs were a common means to live and let live. Yet that evening, against all precedent, the crowd at the Stonewall began to resist. The incident quickly grew in size and scope, becoming more violent and exuberantly resistant: a chorus line of drag queens did a high kick routine in the faces of the police who were cordoning off the site. As the crowd grew, so did the chanting and low levels of violent resistance. The riot escalated, lasting three days as the authorities struggled and failed to contain it. Finally, it burned itself out, in part because the police brought in armored vehicles and the tactical squad to quell the disturbance. But in its three days, the Stonewall riots created the conditions for what followed: a spontaneous civic outbreak that became the basis for a sea change in the politics of the LGBTQ community.

Why did that particular police action result in active resistance? It has been suggested that the recent death of Judy Garland, who had passed away a week earlier, on June 22, was a contributing factor that incited a crowd mourning for its lost icon. This is hardly a serious cause, but as a trigger, it has a certain campy plausibility. Regardless, the decision to push back was a spontaneous reaction to years of frustration at the petty indignities and serious penalties suffered by gay citizens. Above all, the people involved at Stonewall had a new model of physical resistance derived from the tumultuous politics of the 1960s. The recent history of the civil rights and antiwar movements provided a context that could be adapted for gay civil rights. Moreover, the radical and violent political climate of the late 1960s made the physical response at Stonewall not only possible but inevitable. Coming a year after the tumultuous events of 1968—especially the marches on the Pentagon and the violent demonstrations at both political conventions— the Stonewall riots had an existing template to adopt. Unlike the other mass political or civil rights movements, which had a long history and had evolved toward a more confrontational, even violent, strategy with the authorities, Stonewall was a prepolitical riot. That is, Stonewall was the starting point for the coalescence of a new political voice based on the assertion of gay identity and culture as a positive force. As such, the landscape of gay politics was transformed. The small, isolated, and disparate attempts at organization around issues of gay civil rights,

such as the Mattachine Society, were immediately superseded by a new political dynamic. Quiet lobbying on incremental issues, with the goal of attaining toleration for the presence of gays, was replaced by a confrontational insistence on equality. It's hard not to be sympathetic with and even feel sorry for the Mattachine Society, which had led a series of genteel actions called "sip-ins" to force New York bars like the Ritz to tolerate a gay presence. Suddenly, out of the blue, a chorus line of motley drag queens kicked down the door.

Not unlike the civil rights movement, which was fracturing along demographic lines between the old guard (the NAACP) and an increasingly radicalized younger generation (the Black Panthers), Stonewall was the flash point for a generational divide that subsequently affected the politics of the emerging gay liberation movement. First, the group that initially kicked off the riot consisted of outcasts who had nothing to lose. The riot drew in participants who were disproportionately young, Latino, and black and, most important, gender outlaws such as drag queens and hustlers, not a small number of whom worked the piers for a living. They were, to adapt Frantz Fanon's phrase, "the wretched of the earth," and sociologically not unlike the disaffected blacks among whom the Panthers found their recruits. Yet however spontaneous the riots were, they was not simply an orgiastic expression of anarchic rebellion. They had still occurred within a political context in which the loosely organized coalitions of the New Left sought a unified program of political action on a broad front. Hence, many of the individuals who promoted the riot, stoked its fires, and kept it going for three days were veterans of the student movement, members of the Students for a Democratic Society (SDS), and veterans of the movement's experience during the "days of rage" in 1968. So Stonewall evidenced a familiar pattern of many revolutionary moments: it was both spontaneous and managed.

Once the riot had burned itself out, in part because of a massive police response, the question inherent in all such moments became salient: what next? Could the cathartic politics of the event be transformed into a lasting and effective political program?

Immediately afterward, a further split was in evidence as the meaning of Stonewall was contested by various factions and groups seeking to navigate the new landscape of gay politics. To wit, was Stonewall simply about gay liberation, or was it part of a broader coalition that sought to give "power to the people," to use the slogan of the day. As the SDS presence indicates, radical offshoots

emerged that followed the model of the students' revolution: antiwar and also embracing a general program of people's liberation. Alliances were sought with other radical groups, including the Black Panthers, although the Panthers' hyper-masculinity and misogyny made the long-term prospects of such a coalition extremely dubious. Conversely, the old guard did not sit still even as the smoke cleared on Christopher Street. The more conservative, largely white, gay men of New York split off and abandoned the Gay Liberation Front (GLF), the immediate post-Stonewall organization, in favor of the Gay Activist Alliance, (GAA), which only addressed specifically gay issues. Their very names specified their differing political goals and suggested their tactical differences as well, differences that would be drawn more clearly in subsequent years.

The schism in the gay movement differed from other radical politics in that the two contending groups represented very different conceptualizations of sexuality itself. For many in the GLF, the goal was to liberate sexuality from any barriers of identity, not promoting gayness per se but rather a polymorphous sexuality that knew no labels of boundaries. In contrast, for those who adhered to the GAA, Stonewall signaled the advent of identity politics as the fulcrum with which to shift the social paradigm. It argued for the claims of an essential gay identity, an identity that had to be forcefully asserted but that neither needed nor wanted to make common cause with other civil rights groups. With the disappearance in the early 1970s of the dream of a transcendental, broad-based radicalism, the GAA was the default victor. The irony of it all was that GAA could not have started the revolution that was Stonewall, but got to finish it.

The burgeoning gay liberation movement that followed Stonewall was a volatile combination of traditional-interest group politics targeting objective and de jure issues along with a transcendental program of consciousness-raising based on identity politics. (A similar pattern occurred in the women's liberation movement of the 1960s.) In particular, the movement was simultaneously outward- and inward-looking. For gay activists, Stonewall was a breakthrough because it signaled that gays did not need to passively or silently accept the treatment that was meted out to them. Allen Ginsberg (pl. 39), who lived on Christopher Street and visited the site after the riot, deplored the violence at Stonewall but he hit on the sea change it occasioned when he said: "Gay power! Isn't it great? It's about time we did something to assert ourselves. You know, the guys there were so beautiful—they've lost that wounded look that fags all had ten years ago."

The idea that violence could be self-actualizing
was a controversial part of the ideology of the
New Left in the 1960s, deriving on the work of
Frantz Fanon and other third-world writers caught
in the struggle against colonialism. An espe-
cially controversial offshoot of this work was that
victims had acquiesced in their own victimhood
by internalizing the attitude of their oppressors,
hence Ginsberg's comment about the wounded
look that had been lost. Whatever the merits
of a complicated psychological argument, Stone-
wall, and the onset of gay politics, generated
a visibly gay presence in the political sphere.

Plate 56

Homosexual Wedding

In a gesture that now seems almost impossibly prescient, in 1968 artist and performer Yayoi Kusama staged the "first Homosexual Wedding ever to be performed in the United States"— as she put it in a press release for the event. That Kusama's *Homosexual Wedding* took place one year *before* the Stonewall Riots inaugurated the "modern gay liberation movement" attests to the presence in New York City of an earlier queer ethos that powerfully imagined the blurring of a gay/straight dichotomy. "The purpose of this marriage is to bring out into the open what has

hitherto been concealed," Kusama wrote in the press release. "Love can now be free, but to make it completely free, it must be liberated from all sexual frustrations imposed by society. Homosexuality is a normal physical and psychological reaction, neither to be extolled or decried. It is the normal reaction of many people to homosexuality that makes homosexuality abnormal."

192/193

By Yayoi Kusama
(born 1929)
Photographs from happening
1968
Yayoi Kusama Studio, Japan

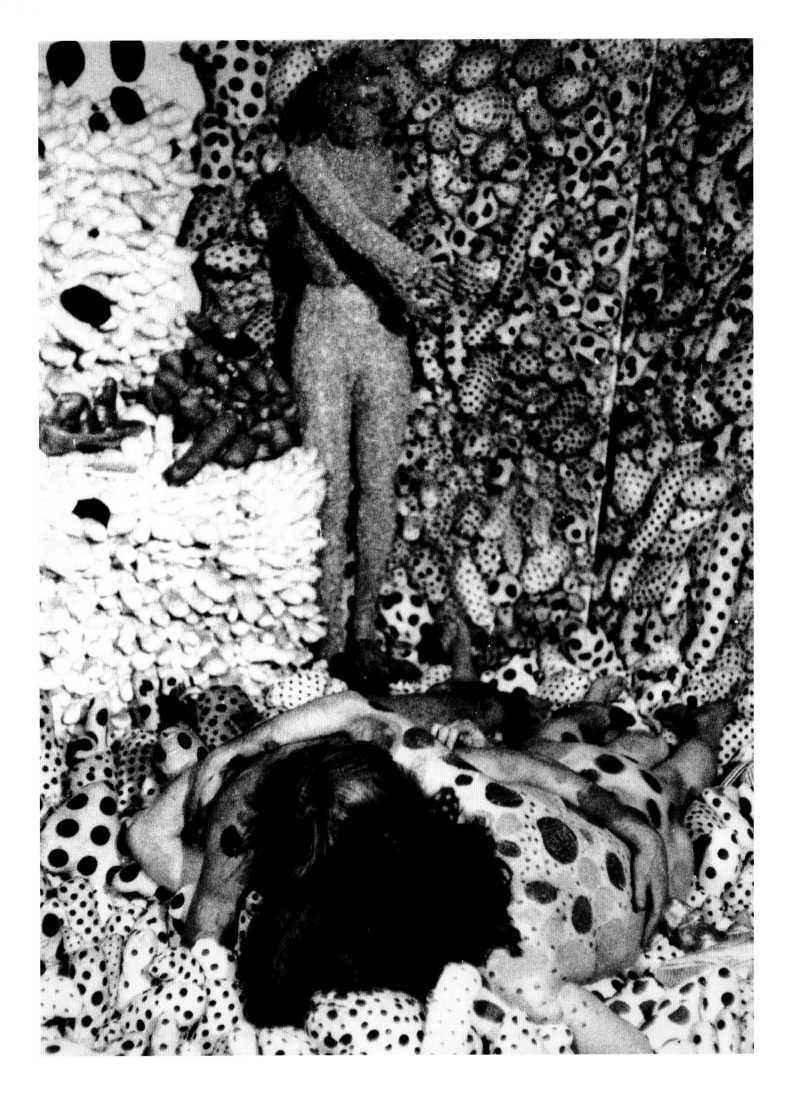

Plate 57
Chance Meeting

"There's an art to cruising and it has a lot of do with timing and with the eyes," wrote Charles Silverstein and Edmund White in *The Joy of Gay Sex* (1977), the seminal post-liberation guide to gay life. "Take eyes first. You're walking down the street and you pass a man going in the opposite direction. Your eyes lock but you both keep on moving. After a few paces you glance back and see that the man has stopped and is facing a store window but looking in your direction. . . .

After these preliminaries you may extend your hand, introduce yourself, ask him his name and suggest you have a drink together." In *Chance Meeting*, Duane Michals stages this interplay of glances, but also visually suggests the wider perils and possibilities of life in the modern city. Will this "chance meeting" result in a mugging or a date? Will the men have a drink together, or will they continue walking through the alleyway in opposite directions?

194/195

Duane Michals
(born 1932)
Gelatin silver prints (six sheets), each 12.7 × 17.8 cm
(5 × 7 in.)
1970
Pace/MacGill Gallery, New York City

CHANCE MEETING

Plate 58
AutoPolaroids

"Are you a very moral person?" Lucas Samaras
asked himself in one of his famous "Auto-Interviews"
from 1971. "Outwardly yes," he responded. "In-
wardly I get glimpses of the cannibal, the selfish
autocrat, the destroyer of things, the suicide."
"Of what value is art?" he continued. "It protects
my adult existence." "How?" "I can be pretty
abnormal without having to isolatedly receive
society's contempt or punishments. My separation
is institutionalized." "Do you like to be called
an artist?" "Sometimes I like it, sometimes I don't.
I like antagonism and temporary anonymity."
After graduating from Rutgers University in the
late 1950s, which was at the time a veritable hot-
bed of artistic innovation and experimentation,
Samaras moved to New York City, where he cast
himself in the role of eccentric, reclusive artist—
master of unusual media and visionary provoca-
teur. In this series of photographs, at once silly
and disquieting, Samaras interrogates himself in
front of the camera. Using various wigs, props,
and stage makeup, he plays with codes of drag
and femininity in experimenting with the con-
tours of his own visage by pushing it to different
and ever-shifting extremes.

196/197

By Lucas Samaras
(born 1936)
Gelatin silver transfer prints (eighteen sheets),
each 9.5 × 7.3 cm (3 3/4 × 2 7/8 in.)
1970–71
The Art Institute of Chicago, Illinois
Gift of Robert and Gayle Greenhill

Plate 59
Roommate with Teacup, Boston

Nan Goldin was twenty years old when she took this photograph of her roommate, who performed regularly at The Other Side, a drag bar in Boston. In her soon-to-become signature style, Goldin here captures her roommate behind the scenes—presenting a slice of "real life" tinged, as it is, with a sense of not belonging and impending tragedy. "It wasn't, 'Oh, I'm gonna get involved with drag queens, 'cause they'll be good photographic subjects'—it was a much deeper connection," Goldin explains. "You know, the beauty, the transcendence of male-female classi-fication, the humor, and the courage." Goldin's

public photographs of her private life (she often held slide shows at local bars and eventually at major museums) muddle distinctions between private and public, male and female, "real life" and performance. Is this photograph of Goldin's friend at home, for example, any more "real" than her performances on stage?

By Nan Goldin
(born 1953)
Gelatin silver print, 50.5 × 40.3 cm (19 7/8 × 15 7/8 in.)
1973
Solomon R. Guggenheim Museum, New York City
Purchased with funds contributed by the Photography Committee and with funds contributed by the International Director's Council and Executive Committee Members, 2002

Plate 60

Untitled

In this now-infamous advertisement for his 1974 show at the Sonnabend Gallery, minimalist sculptor and avant-garde performer Robert Morris flexes his muscles for the camera while sporting a Nazi army helmet, sunglasses, chains, a spiked collar, and a full beard. In a parody that both reifies and unhinges dominant codes of masculinity, Morris's playful S&M garb indicates working-class machismo and at the same time gestures toward urban gay subcultures that have laid claim to such hypermasculine attributes—as in Robert Mapplethorpe's double portrait (pl. 64). However, Morris's edgy universal appeal and the ease with which this image can be (and has been) commodified serve perhaps to undermine its subversive potential. In a 1994 interview Morris said, "As for memorable images, one I consider a total failure and mistake, the 1974 poster of myself with chains and a Nazi helmet, seems destined for a Guggenheim T-shirt."

By Robert Morris
(born 1931)
Offset lithograph on paper, 93.3 × 60.3 cm
(36 3/4 × 23 7/8 in.)
1974
Sonnabend Gallery, New York City

Plate 61
Self-Portrait

The photographer Robert Mapplethorpe was part of New York City's downtown scene in the late 1960s and was best known initially as the art rocker Patti Smith's lover and artistic collaborator. Mapplethorpe came out around the time of the Stonewall Riots (1969), but he and Smith remained close. In 1971 Mapplethorpe began taking pictures with a Polaroid camera, and this self-portrait from 1975 has the instant, offbeat edginess that Mapplethorpe initially liked in photography: a kind of faux-documentary technique that was loose and didn't take itself too seriously. Over time, Mapplethorpe became more interested in an almost pristine formalism in both his portraits and other photographs, moving away from the spontaneity encouraged by the Polaroid. Even his overtly sexual pictures—such as those of the sadomasochistic subculture— have a gravity that is some distance from this exuberant self-portrait made in the year that his career took off.

202/203

By Robert Mapplethorpe
(1946–1989)
Polaroid print, 40.6 × 50.8 cm (16 × 20 in.)
1975
Robert Mapplethorpe Foundation, New York City

Plate 62
Susan Sontag

Depending on your proclivity, the first thing you noticed about Susan Sontag (1933–2004) was her intelligence—or her striking good looks. A prodigy, Sontag graduated from the University of Chicago as a teenager; studied at Harvard, Oxford, and the Sorbonne; and published *Against Interpretation* (1966) with a glamorous photograph of herself on the dust jacket. Sontag made abstruse European political and cultural theory sexy, and in the fraught political climate of the 1960s she became the avatar of the intellectual as hipster. Wide-ranging and eclectic, given to aphorism, she published *On Photography* (1977), an important reconsideration of the epistemology of the photographic image, and two studies of illness as metaphor. She also was a writer of fiction: her *New Yorker* short story "The Way We Live Now" was an elegy for life under AIDS, and Sontag won a National Book Award for her novel *The Volcano Lover* (1992), a coolly limned examination of rationalism and desire. Sontag courted controversy with her opposition to American

power, and her nuanced assessment of the 9/11 attacks brought a wave of opprobrium down on her. Sontag had an early marriage to the sociologist Philip Reiff, but was primarily attracted to women. She did not publicly address her lesbianism, but that kind of personal revelation was antithetical to her postmodern analytical tendency. In her later years, Sontag had a committed relationship with the photographer Annie Leibovitz. Leibovitz documented Sontag's fight against cancer, and the pictures of Sontag on her deathbed make a tragic counterpoint to this early portrait of Sontag: the one that established her as an intellectual gamine; the dreamy intellectual as the object of (bisexual) desire.

By Peter Hujar
(1937–1987)
Gelatin silver print, 37.1 × 37.6 cm (14 5/8 × 14 13/16 in.)
1975
National Portrait Gallery, Smithsonian Institution, Washington, D.C.

Plate 63 a–d
Arthur Rimbaud in New York

Under Brooklyn Bridge

In New York subway

As Duchamp

At West Side Pier with Graffiti

Composed of twenty-five photographs of friends wearing a cutout paper mask of the French symbolist poet Arthur Rimbaud, David Wojnarowicz's *Rimbaud Series* compresses historical time and activity by fusing Rimbaud's biography with Wojnarowicz's own. Wojnarowicz's identification with Rimbaud—a disruptive genius-poet who wandered the streets of Europe and North Africa, wrote about his homosexuality, and advocated for a systematic "deranging of all senses"—seems natural. The series tracks the locations of Wojnarowicz's life: his days as a teenaged hustler in Midtown, sex and drugs on the abandoned Hudson River piers, walks along the boardwalk at Coney Island. By using Rimbaud as his surrogate,

Wojnarowicz created an autobiography that is at once objective and intimate. "I have always loved my anonymity, and therein lies a contradiction because I also find comfort in seeing representations of my private experiences in the public environment," Wojnarowicz wrote. "They need not be representations of my experiences—they can be the experiences of and by others that merely come close to my own or else disrupt the generic representations that have come to be the norm in the various medias outside my door."

By David Wojnarowicz
(1954–1992)
Gelatin silver prints (four), each 20.3 × 25.4 cm
(8 × 10 in.)
1978–79 (printed 2004)
Estate of David Wojnarowicz and PPOW Gallery, New York City

Plate 64
**Brian Ridley and
Lyle Heeter**

In this playful inversion of the classic family photo-
graph, leather-clad Brian Ridley sits in an ornate
wingback chair, chained and shackled to his domi-
nant, horsewhip-wielding partner, Lyle Heeter.
Far from submissive, Ridley's wide-legged stance,
erect posture, and direct address to the camera
indicate that he willingly acts out his chosen sado-
masochistic role. The machismo of the couple's
leather gear is undercut by the flamboyance
of their living room—replete with an Oriental rug,
pewter vases, sculpted lamp and clock, and grass
cloth wall covering. This complicated interplay

of hypermasculine and homosexual attributes,
of perversion and domesticity, undoes any
interpretive move that might confine Ridley and
Heeter in or as their sadomasochistic roles. That
this homosexual S&M ritual takes place in the
context of the couple's "normal" life (which also
includes antique collecting), powerfully destabi-
lizes received notions of what it means to be
a "normal" or "domestic" couple.

208/209

By Robert Mapplethorpe
(1946–1989)
Gelatin silver print, 40.6 × 50.8 cm (16 × 20 in.) sheet
1979
Robert Mapplethorpe Foundation, New York City

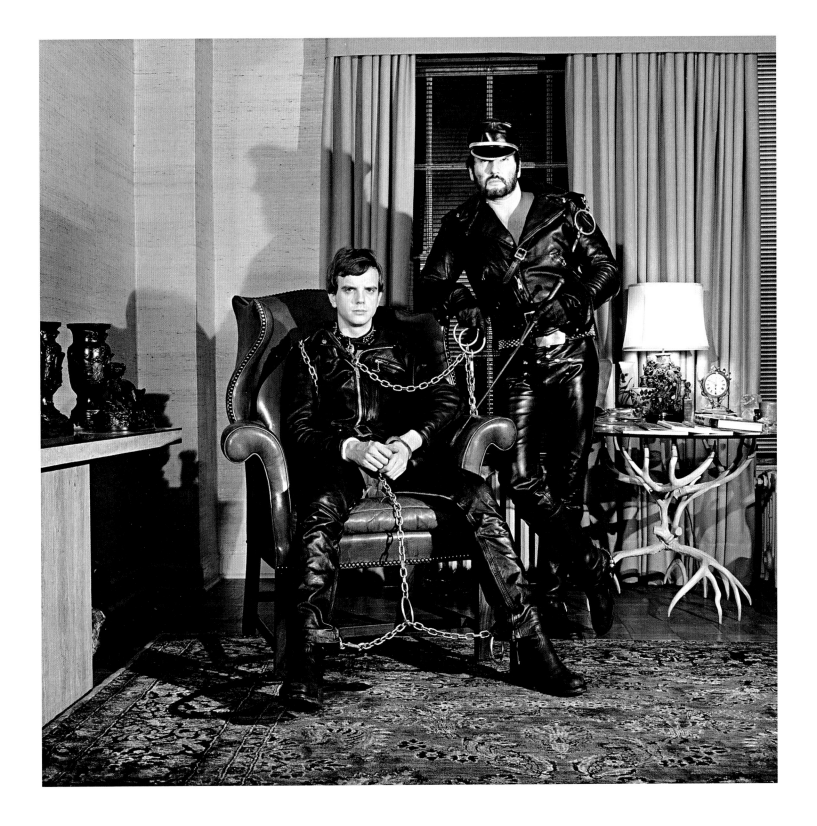

Plate 65
The Clearing

Andrew Wyeth is one of America's most beloved artists. His depictions of a bucolic rural America excite a communal nostalgia for mythic times past, where hardworking neighbors coexist peacefully without the trappings of modern capital and technology. For this very reason, critics often deride his work as saccharine and dismiss it as kitsch. *The Clearing*, along with many other paintings that Wyeth first made public in the mid-1980s, complicates his easy categorization as either an American folk hero or an overtly sentimental provincial painter. Here, Wyeth's young neighbor Eric Standard arises from the wheat field much like Botticelli's Venus emerging from

her shell. His prominent tan line adds a peculiar specificity to what is otherwise a completely idealized and improbable depiction. By emphasizing his flowing blond hair, androgynous facial features, and prominently displayed genitals, Wyeth imbues his subject with an undeniably homo-erotic, as well as heterosexual, appeal.

"I have to have a personal contact with my models," Andrew Wyeth once said. "I don't mean a sexual love, I mean real love. . . . I have to become enamored, smitten."

210/211

By Andrew Wyeth
(1917–2009)
Tempera on composite board, 58.4 × 51.4 cm
(23 × 20¼ in.)
1979
Betsy James Wyeth

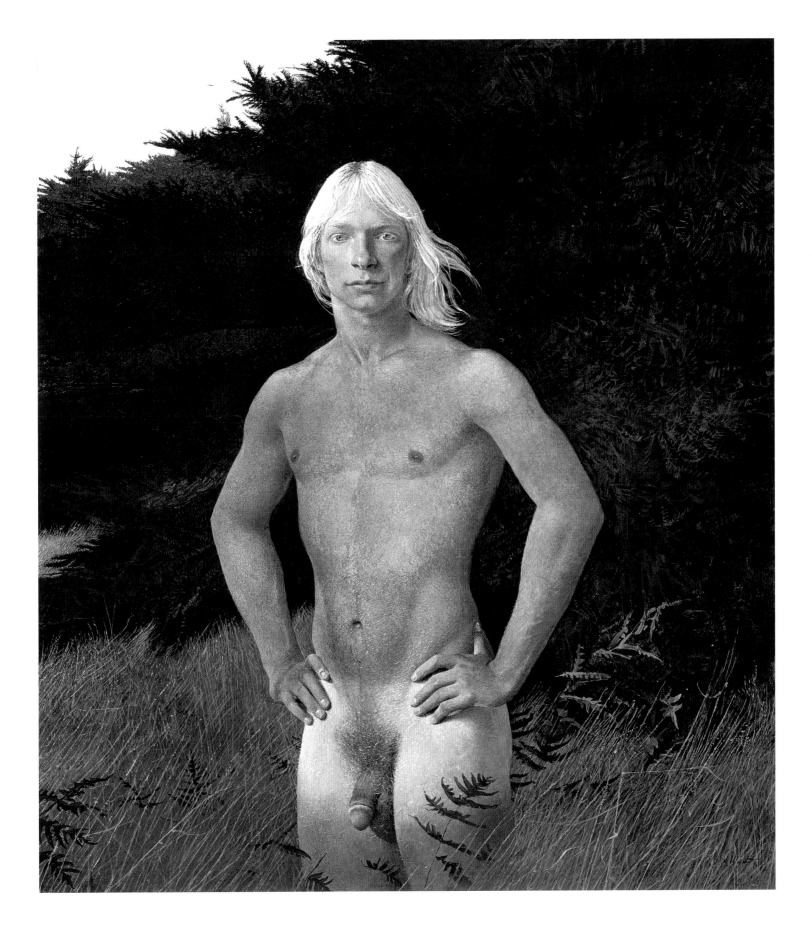

Plate 66
Lisa Lyon

Robert Mapplethorpe met Lisa Lyon in 1980, a year after she won the first World Women's Bodybuilding Championship. After abandoning competitive bodybuilding, she entered into a collaboration with the artist that spanned several years and culminated in Mapplethorpe's portfolio *Lady: Lisa Lyon* (1983). Lyon's chameleon-like ability to inhabit a multiplicity of guises—a Playboy pinup, a muscular bodybuilder, a leather-clad dominatrix, and a sophisticated fashionista, among others—attests to the constructed nature of beauty and the mutability of desire across different groups and subcultures. In this photograph, Mapplethorpe's attention to Lyon's muscularity, particularly evident in her outstretched arm, shows Lyon's body as a peculiar type of physique desirable within the small subculture of bodybuilding, where standards for female beauty were, for many, uncomfortably "masculine." Yet Mapplethorpe's sophisticated play of light, shadow, and contour imbues this photograph with formal logic and beauty that transcends normative standards of beauty by destabilizing our expectations about the female form.

By Robert Mapplethorpe
(1946–1989)
Gelatin silver print, 40.6 × 50.8 cm (16 × 20 in.)
1980
Robert Mapplethorpe Foundation, New York City

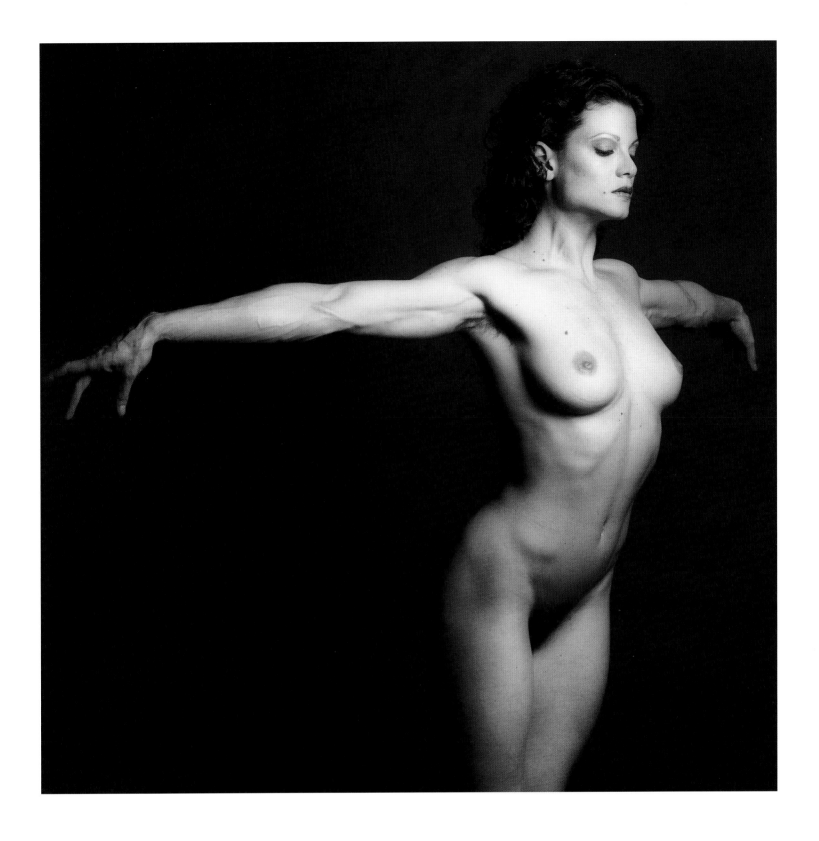

Plate 67

Roy Cohn

Robert Mapplethorpe created polished and flattering society portraits as well as his notorious explorations of male sexuality. Among his portraits, the jarring exception to his glossy images was this likeness of lawyer Roy Cohn (1927–1986). Mapplethorpe's uncanny and frightening image precisely captures Cohn as the dark, malevolent presence who haunted and shadowed American culture, starting with his days as Joseph McCarthy's lead lawyer during the Red Scare. Despite—or perhaps, because of—his homosexuality, Cohn took a near-sadistic relish in using their sexuality against those he investigated. Cohn was a key figure in intertwining the Red Scare with the Lavender Scare against homosexuals in the government.

Mapplethorpe's portrait is a death's-head vision of Cohn as a disembodied, hooded presence who balefully surveils us still. It is telling that Mapplethorpe portrayed him without even the suggestion of a body. But the portrait is also a death mask beneath whose hard, repellant surface lived a man who doubtless did not care about his own tragic contradictions. Cohn died of AIDS in 1986.

By Robert Mapplethorpe
(1946–1989)
Gelatin silver print, 40.6 × 50.8 cm (16 × 20 in.)
1981
Robert Mapplethorpe Foundation, New York City

Plate 68
**Ethyl Eichelberger
in a Fashion Pose**

Peter Hujar photographed the drag queens and gay men and lesbian women who populated his world with the sensitivity of a lover rather than the probing curiosity of a voyeur. Nowhere is this more evident than in his photographs of Ethyl Eichelberger (1945–1990)—a drag queen who graced the 1980s East Village performance scene with her campy improvisational plays about the lives of great women. Here, Hujar photographs Eichelberger seated on a wooden chair against the back wall of his apartment. Eichelberger appears at ease inside of Hujar's domestic space, even as she remains "on"—performing her adopted gender in full drag with over-the-top theatrical gestures. Seven years after this photograph was taken, on August 12, 1990, Eichel-berger committed suicide after reacting badly to the only AIDS medication available at the time. As Hujar's friend and fellow photographer Nan Goldin has eloquently stated, "Peter Hujar's work also functions on another level than was intended: His photographs become the most honest, haunting, and sustaining record of our vanishing tribe."

By Peter Hujar
(1937–1987)
Gelatin silver print, 37 × 38 cm (14 $^5/_8$ × 14 $^3/_4$ in.)
1981
Peter Hujar Archive, courtesy Matthew Marks Gallery, New York City

Plate 69

**Yantra #41,
Yantras of Womanlove**

For lesbian artists working in the 1980s, sexual difference tended to be trumped by gender difference. In the late 1970s and early 1980s, some lesbian separtist creeds even held that lesbianism was primarily a an ideological identification premised on the decentering of patriarchal imperatives. In contrast, the lesbian body is defiantly erotic in Corrine's work. In her *Yantras of Womanlove* series, she arranges prints of women engaged in sexual activates into *mandalas*, thereby equating sex with spirituality. By heavily manipulating the images, Corinne minimizes

the possibility that they will be usurped by a voyeuristic "male gaze." The *Yantras* also reference the position of lesbians out in public—they are present yet hidden—threatening societal norms, yet in need of protection themselves.

218/219

By Tee Corinne
(1943–2006)
Gelatin silver prints joined with tape, 18.7 × 23.5 cm
(7 3/8 × 9 1/4 in.) sheet
1982
Private collection

Plate 70
Self-Portrait

Robert Mapplethorpe died of AIDS in 1989, and this self-portrait seems to pose him as the figure of death itself, replete with a death's-head cane with which to strike down victims. The somber, dark contrast with the youthful innocence and sexual playfulness of the 1975 self-portrait (pl. 61) could not be more marked. Memorial, *memento mori*, and warning: the self-portrait reads as all of these. Yet Mapplethorpe is playful and rebellious to the last. Knowing how AIDS victims were demonized—not least because the homoeroticism that Mapplethorpe celebrated in his work and life was taken as the cause of the "gay plague"—Mapplethorpe poses as death to defy his critics. Here, he says, I will take on everything you accuse me of and turn it back to you in a work of art. Formally, the picture evinces the gravity with which Mapplethorpe made portraits. Tonally it takes on his flirtation—in life and art—with the dark side: Mapplethorpe as devil, a legend that has only grown since his death. The picture, which is more than a little camp, is a last, knowing wink from an artist who was defiant to the end.

By Robert Mapplethorpe
(1946–1989)
Gelatin silver print, 61 × 50.8 cm (24 × 20 in.) sheet
1988
Robert Mapplethorpe Foundation, New York City

Plate 71
Unfinished Painting

In the midst of the AIDS crisis, the English poet Thom Gunn said he never thought there was a "'gay community' . . . until the thing was vanishing." In 1990, 18,447 people died of HIV/AIDS. On February 16 of that year, at age thirty-one, the artist Keith Haring joined those who passed away. Haring had vaulted to public prominence as a graffiti artist whose comical and enigmatic cartoons started appearing randomly in New York City's subway system and led him to mainstream fame in the art world. The sketchy, skittering nature of his drawing is worked into this painting—note the typical Haring humanoid in the design at top left—but the structure of the unfinished work gives a formal weight to the painting at odds with his usual cheerful ephemerality. The hanging strings of the unfinished painting are not only heartbreaking but suggest that it will never be finished, a carpet that is entirely unraveling. One hears in it the poet Philip Larkin's words about death, "The good not used, the love not given, time/Torn off unused."

222/223

By Keith Haring
(1958–1990)
Acrylic on canvas, 100 × 100 cm (39 3/8 × 39 3/8 in.)
1989
Katia Perlstein

Plate 72

"Untitled" (Portrait of Ross in L.A.)

Although a minimalist, Felix Gonzalez-Torres also had a whimsical side that showed the influences of pop art on his installations. In this "portrait" of his deceased partner, Ross Laycock, Gonzalez-Torres created a spill of candies that weighed 175 pounds, Ross's weight when he was healthy. The viewer is invited to take away a candy until gradually the spill diminishes and disappears; it is then replenished, and the cycle of life, death, and rebirth continues. With the colorfully wrapped candies, Gonzalez-Torres gestures at camp or kitsch and the use of common commodities by artists like Claes Oldenburg. While Gonzalez-Torres wanted the viewer/participant to partake of the sweetness of his own relationship with Ross, the candy spill also works on a powerful emotional and symbolic level as an act of communion, a partaking of the body with deep resonance in Gonzalez-Torres's own Catholicism. Moreover—and more darkly—another message that accompanies the steadily diminishing pile of cheerfully wrapped candies is that society itself is abetting the continued martyrdom of those who suffered from AIDS. In the moment that the candy delightfully dissolves in the viewer's mouth, the participant also receives a shock of recognition at his or her complicity in Ross's demise.

224/225

By Felix Gonzalez-Torres
(1957–1996)
Candies individually wrapped in multicolored cellophane, endless supply; overall dimensions vary with installation; ideal weight 175 pounds
1991
The Art Institute of Chicago, Illinois
On extended loan from the Donna and Howard Stone Collection

Plate 73
Untitled (face in dirt)

We started digging with our hands. He took off his jean jacket, his sweatshirt, and then he lay down in the hole. Then I took the camera, stood above him with his body between my legs. . . . I realized he was giving me what he wouldn't be able to give me later: he had made me a witness to his death. He created this image because he knew he couldn't hold his promise and keep me next to him while he was dying. And it was our last collaboration.

—Marion Scemama

David Wojnarowicz created this image with his good friend and long-time collaborator Marion Scemama only months before he would die of AIDS-related complications. "When I was told that I'd contracted this virus it didn't take me long to realize that I'd contracted a diseased society, as well," Wojnarowicz once said. Here, on the brink of a premature death, Wojnarowicz is at once disappearing peacefully into the American landscape and being violently suffocated by it.

By David Wojnarowicz
(1954–1992)
Gelatin silver print, 50.5 × 60.3 cm (19^7/$_8$ × 23^3/$_4$ in.)
1990
Rita Krauss

Plate 74

Felix, June 5, 1994

I made this photograph of Felix a few hours after his death. He is arranged to receive visitors, and his favorite objects are gathered about him: his television remote control, his tape-recorder, and his cigarettes. Felix suffered from extreme wasting, and at the time of his death his eyes could not be closed: there was not enough flesh left on the bone. Felix and Jorge and I lived and worked together from 1969 until 1994. This communal life ended when Jorge died of AIDS on February 3, 1994. Felix followed shortly after, on June 5, 1994. . . . During that time we became one organism, one group mind, one nervous system; one set of habits, mannerisms and preferences. We presented ourselves as a "group" called General Idea and we pictured ourselves in doctored photographs as the ultimate artwork of our own design: we transformed our borrowed bodies into props, significations manipulated to create an image, a reality. We chose to inhabit the world of mass media and advertising. We made of ourselves the artists we wanted to be.

Dear Felix, by the act of exhibiting this image I declare that we are no longer of one mind, one body. I return you to General Idea's world of mass media, there to function without me.

—AA Bronson

By AA Bronson
(born 1946)
Lacquer on vinyl, 213.4 × 426.7 cm (84 × 168 in.)
1994
National Gallery of Canada, Ottawa

Camouflage Self-Portrait (Red) (detail)
by Andy Warhol
Reproduced in full as Plate 83.

Postmodernism

Hide/Seek has two conclusions, or more precisely, it has a coda that can only hazard a guess at the future. The problem is the appearance of the monstrous HIV/AIDS epidemic in the early 1980s. Its metastasizing and ravaging of the gay population and other communities destroys the progressive narrative that would have transpired had the epidemic never occurred. Without AIDS, the arc of *Hide/Seek* would have been straightforward: the insistence of a binary definition of sexuality with the codification (indeed criminalization) of homosexuality led to decades in which gay and lesbian artists developed strategies (hiding and seeking, as it were) to work creatively and even to survive. These strategies changed and evolved in each successive epoch of the dominant American culture, and artistic practice was modified according to the ongoing relationship between artist and the materials at hand. This narrative, omitting AIDS, has a happy ending. The general tendency of postwar American society to accelerate the expansion of civil rights, most dominantly the movement by African Americans to gain full civic and social equality, became generalized to include women and other groups, including gays and lesbians. The Stonewall Riots of 1969 and the growth of the modern Gay Liberation movement marked a sea change in the community as simple legal tolerance was coupled with a demand for wider cultural acceptance. The artistic consequences of this liberation were only beginning to be explored when the community and the nation was blindsided by the AIDS epidemic.

Speaking personally, we as curators could not end this exhibition with the triumph of Stonewall, completing a progressive narrative as if we did not know what came next. Yet we are still hamstrung by the age of AIDS, one in which the liberation promised by 1969 has only been imperfectly realized or actually retrogressed. Although the art world is small and comparatively unimportant, it has always, as this exhibition has demonstrated, provided an index to the state of the community and of the nation. In lieu of a conclusion, since a conclusion is denied us by events, it might be possible to tease out the meaning of the current predicament with a discussion of postmodernism—a peculiarly elusive category whose very slipperiness reflects our groping attempts at defining the society in which we live now.

Postmodernism is an exasperating term. Its very name does not define the thing itself but is indeterminate, referring only to what came before; it's a bit like calling capitalism "postfeudalism." But the fact that it cannot be defined precisely captures its essence: it means and has meant different things to different people at different conceptual levels. Today we speak about our postmodern age—a culture with no originals or models. In our postmodern culture, everything seems to be culled from somewhere else in a dizzying cycle that causes us to lose track of what imitates what. Real life seems to mimic movies that imitate other movies that are adaptations of books that are based on real-life events that imitate other texts. In 1967 Roland Barthes famously declared the author dead—which is to say that he transformed the "author" into a compiler of quotations and thus freed "text" from the thoughts, feelings, experiences, and sentiments of its "author." With this slightly hyperbolic conclusion, the age of heroic individualism was dead.

Postmodernism literally means "after" modernism, and when we're talking about the history of art, this means something specific. Modernism designates the period from roughly 1880 to roughly 1950. It is congruent with the period of high capitalism, after industrialization and the consolidation of the nation-state in the West. Before modernism, painters represented the world as it appeared to them—painting was analogous to a mirror or a window to the world. With modernism, as part of the division of labor and the decoupling of art and culture from general life, painting the conditions of representation became central, so that art became its own subject and its formal qualities given primacy. As the art critic Clement Greenberg interprets, painting no longer receded into the canvas to mimic the world but became even more flat. Manet's forms got increasingly flat; Cézanne's trees and mountains became increasingly square; Monet's brushstrokes became increasingly apparent; and Van Gogh's portraits and cafés became increasingly stylized and impastoed. Brushstrokes declared themselves as brushstrokes, and canvases declared themselves as flat supports. In his 1969 essay "Modernist Painting," Greenberg summed up: "The essence of Modernism lies in the use of the characteristic methods of a discipline to criticize the discipline itself, not in order to subvert it, but in order to entrench it more firmly in its area of competence." In Greenberg's schema, painting has always been engaged in an inevitable march toward stripping itself of external elements—narrative, figuration, three-dimensionality—and becoming a pure exploration of the properties unique to painting: flatness and color.

For Greenberg, Jackson Pollock's monumental drip canvases in the late 1940s were the apogee of modernism, the point to which painting had been moving since the Renaissance. Pollock

therefore became Greenberg's quintessentially American modernist hero. "What [Pollock] invents," Greenberg wrote in 1947, "has perhaps, in its very abstractness and absence of assignable definition, a more reverberating meaning. He is American and rougher, more brutal, but also completer. . . . Pollock points a way beyond the easel, beyond the mobile, framed picture, to the mural." *Rougher*, *more brutal*, *American*—with these adjectives we see that Greenberg's celebration of "pure" painting is tantamount to a celebration of masculine virility and the genius of the artist who created the painting.

What could come after this moment of fulfillment? Since life and history went on even after Pollock's decline and early death in 1956, what comes next? This is why postmodernism is defined against what came before. Postmodernism entails a self-conscious rejection of modernism itself; a severing of the presumed equivalency between artist and artwork, so that the artwork became, in Barthes's words, a "tissue of quotations." But what type of artist would want to sever the equivalency between *him*self and *his* artwork—who would want to decline the heroic role of the Promethean artist? The answer, of course, is artists on the margin—women artists; artists of color; gay artists—in short, artists who have something to lose rather than gain by presenting their art and the heroic extension of their identity. This is particularly true for queer artists, who *literally* had something to lose by disclosing too much. Queer artists had a vested interest in creating cryptic and detached artworks that were able to address multiple audiences at the same time.

Robert Rauschenberg is a case in point. His story has already been touched on in the section on the 1950s, and it is instructive here as well. At the same time that Jackson Pollock was creating his monumental drip paintings, twenty-five-year-old Robert Rauschenberg was creating paintings of a very different kind. In 1951, he made a collage titled *Should Love Come First?* only to "destroy" it shortly thereafter by completely overpainting it with one of his celebrated Black Paintings. Which begs the question, why?

The first and perhaps most obvious answer is that he had something he wanted to hide—and in fact, he did. As Jonathan Katz has noted, *Should Love Come First?* was profoundly autobiographical. In June of 1950, Rauschenberg married an art school classmate, Susan Weil. The following February, he had an affair with fellow art student Cy Twombly at the Art Students League in New York. In August of 1951, Twombly and Rauschenberg departed together for Black Mountain College in North Carolina. When Rauschenberg's wife and infant son arrived a month later, Weil quickly decided to leave her husband; they divorced the following year. Twombly and Rauschenberg's relationship became an open secret on Black Mountain College's campus. *Should Love Come First?* references these tumultuous changes in Rauschenberg's emotional life, and the painting's title signals the fraught weighing of love against paternal responsibility. It prominently features references to same-sex love, including footprints for a male-male waltz and the number 8—a visualization of the conjunction of identical forms, seemingly another oblique pictorialization of the attraction of same to same. By overpainting *Should Love Come First?* Rauschenberg depicted the road not taken. Unlike Rauschenberg's later combines, the two-dimensional collage materials that Rauschenberg selects quickly lose their identity and history outside the picture plane and come to function more or less exclusively pictorially. In this sense, *Should Love Come First?* is much more of a traditional collage than the combines Rauschenberg would subsequently pioneer. Rauschenberg's preoccupation was in moving his art away from normative expressions of artistic intent and toward an investment in camouflaging or masking the artist as the provider of meaning.

More cheerfully, pop artists like Warhol or Claes Oldenburg took the ordinary objects of experience and daily life and re-created them as artworks. Artists mined the popular culture and the detritus of daily life to create images. Moreover, they unabashedly culled material from elsewhere, including the art and culture of past times. Postmodern buildings referenced Sheraton or Chippendale chests-of-drawers, for instance. Philosopher Arthur Danto cites his favorite example of this creative rummaging in Kevin Roche's 1992 addition to the Jewish Museum in New York. Roche created an exact duplicate of the old Gilded Age building on Fifth Avenue. "It was," Danto writes, "an architectural solution that had to have pleased the most conservative and nostalgic trustee, as well as the most avant-garde and contemporary one, but of course for quite different reasons." This ability to address multiple audiences at the same time through the use of the common culture is a hallmark of postmodernism.

There things might have rested, with an infinite recycling of imagery. And in the case of gay and lesbian audiences, heady with the personal and artistic freedoms entailed with the Gay Liberation movement going public, the existing practice might have been enhanced with sharpened, affirmative projections of gay history

and experience. Some of this did occur, most notoriously with Robert Mapplethorpe's notorious Black Portfolio, which depicted homoerotic sexuality in graphic display. What the confluence of these two tendencies—postmodernism and contemporary gay-identity politics—would have resulted in artistically was tragically halted by AIDS, which first appeared in the late 1970s.

With the onset of the AIDS epidemic in the early 1980s, Barthes's metaphorical "death" of the author became a horrifying reality as artists literally began to die in staggering numbers. Postmodern "detachment" became painfully inadequate, and there was an inspiring reworking of aesthetics for political and human purposes, a feature that had been lost in the chilly and ironic sensibility that had governed American art since Pop. Minimalism and conceptual art was no longer sufficient. English poet Thom Gunn never thought there was a "'gay community,' until the thing was vanishing." Keith Haring's lovely *Unfinished Painting* (1989) (pl. 72) is a case in point about how art could reknit a community under threat. On the one hand, his carpet or fabric appears to be unraveling as his trademark cartoon abstractions of humans that make up the carpet's patter devolve into their constituent strands of cloth/paint. It is clear that a sense of mortality was on Haring's mind: he died of AIDS within a year. Leaving the figure unfinished is a poignant memento of a life struck down prematurely. Yet if the painting is unfinished, there is no reason why it cannot metaphorically be completed by the artists who came after Haring.

That Haring's carpet could become a found object—a remnant of the plague years—and that it could itself be recycled into art indicated the artistic resistance that occurred once the full magnitude of the epidemic became apparent. This was postmodernism at its best, as it indicated a way forward that transformed the very insecurities and contingencies of the present moment into acts of resistance. The career of Felix Gonzalez-Torres, himself dead of AIDS in 1996, illustrates how he used the disease to defeat the disease. "I want to be like a virus that belongs to the institution" he said, "an imposter, an infiltrator, I will always replicate myself together with those institutions." Artists like Gonzalez-Torres returned politics to art while retaining the techniques of art for art's sake. As he wrote in 1988, "It is a fact people are discriminated against for being HIV positive." He responded by infusing the public sphere with personal statements of love and loss—billboards, curtains, infinitely replenishable stacks of paper, and candy-spills (pl. 72) all created a communion between viewer and

art in a way that re-created postmodernist art with a traditional humanist sensibility.

In recent years, since the consolidation of the gay and lesbian movement after the worst years of the AIDS crisis, a different kind of postmodernism has emerged, one that was built on the resistances of the generation of 1982 to 1990—one that imagines a gay and lesbian utopia. *Hide/Seek* concludes with queer portraiture's renewed questioning of the binary relation between gay and straight, harking back to the utopian polymorphous character of the exhibition's founding moments in the careers of Whitman and Eakins.

Cass Bird's poignantly portrayed young woman wears a hat that says *I Look Just Like My Daddy* (pl. 96), and she does, in part because she is wearing typically young men's clothes and her hair is tucked in the hat. The ambiguity of her gender, even though she is in plain sight, is an indication that categories are never as fixed or as strictly divided as they seem. Similarly, Jack Pierson plays with the themes of identity in his self-portrait series (cats. 97 and 98), each of which portrays a different young man who is *not* Jack Pierson. They are not self-portraits except insofar as they turn the tables on the viewer, asking viewers to consider what *they* are when confronted with this exposition on the fluidity and malleability of identity. "Pierson here asks, "How can I represent myself?" And, like Frank O'Hara (pl. 46) fifty years earlier, he concludes that he has not one but "several likenesses, like stars and years, like numerals." But how is it possible, at the dawn of the twenty-first century, with identity politics firmly entrenched, to have not one, but many selves? Pierson's self-portraits superficially constitute a typology of gay male desirability, reified by the media and ingrained in our consciousnesses—young, beautiful, Calvin Klein models and Adam-like Abercrombie & Fitch youths. But Pierson's images ask: Is it possible to represent myself as distinct from the readymade images that represent me? The tentative, hesitant, necessarily incomplete work that is being performed *right now* is perhaps a harbinger that as a culture we are emerging out of the long, postmodernist cycle where society cannabalizes itself. It is perhaps possible that having survived into the new century, despite the long trail of tragedies that preceded, and having worked through the old as creatively as its limits allowed, we can now clear away the wreckage to return to Walt Whitman's original quest for an art and culture that combines rather than divides us—even from ourselves.

Plate 75

**New York, New York
(from the Expeditionary
Series of Self-Portraits
1979–1989)**

"Spy" is a now an outdated nineteenth-century slang term for a homosexual. The term was an epithet—not least because spying was considered odious in Victorian society—and it suggested the homosexual as an alien, hostile presence who was certainly not to be trusted and was perhaps even a traitor. But purged of moralism, the term is actually useful to describe the double lives of gay people as they existed in society but not entirely of it. Hidden or detached, they could observe the normative society without being invested or implicated in it, putting them in a free-floating position from which they could observe and comment upon what "straight" (i.e., normative) society could not. The necessary marginality of the observer was a classic modernist theme, highlighted, for instance, by the French poet Baudelaire in his essays on art and the city. Baudelaire's character of the *flaneur* maintained an icy detachment from which to comment on the bourgeois world that surrounded him, and from which he recoiled. But for gay men, marginality was imposed upon them by a society that disdained and officially proscribed them.

Yet since they lacked the visible signs of that exclusion (indeed, they crossed all the usual lines of race, gender, ethnicity) they were able to turn proscription to their advantage by operating under cover, like spies. When Ralph Ellison described African Americans as "invisible," he meant that whites didn't see blacks. For gays, straights couldn't see them. Paradoxically, oppression created the possibility of aesthetic freedom, one exploited by the New York School of poets and others. Tseng Kwong Chi's photograph series, in which he posed himself before famous attractions, is a deadpan and self-reflexively mocking take on this theme of the gay man as the walker in the city . . . and spy.

234/235

By Tseng Kwong Chi
(1950–1990)
Gelatin silver print, 91.4 × 91.4 cm (36 × 36 in.)
1979
Muna Tseng Dance Projects, Inc., New York City

Plate 76

**Altered Image:
Warhol in Drag**

"I'm fascinated by boys who spend their lives try-ing to be complete girls, because they have to work so hard," Warhol wrote in *The Philosophy of Andy Warhol*. "It's hard work to look like the complete opposite of what nature made you and then to be an imitation woman of what was only a fantasy woman in the first place." Warhol collaborated with a makeup artist and his young assistant, Christopher Makos, to create this now-ubiquitous portrait of himself in drag. The doubling of eyebrows (painted-on, sculpted "feminine" eyebrows above caked-over, bushy "masculine" eyebrows) and the coupling of wig and heavy makeup with a crisp white shirt and

tie reveal not so much a "real man" behind a female mask but recall Marlene Dietrich's fashion statements of the 1930s. Here is a man dressed as a woman playing with male signifiers—in other words, we have imitation piled upon imitations with no real core or source. Warhol, who indeed always wore a wig, famously remarked: "If you want to know all about Andy Warhol, just look at the surface of my paintings and films and me, and there I am. There's nothing behind it."

By Christopher Makos
(born 1948)
Gelatin silver print, 50.8 × 40.6 cm (20 × 16 in.)
1981
Collection of the artist

Plate 77
Altered Image I

A woman dressed as a man dressed as a woman—
multiplying drag upon drag, Deborah Kass
here poses as Andy Warhol posing as a Marlene
Dietrich-like muse in the now-famous photo-
graph by Christopher Makos (pl. 76). Part of her
larger *Warhol Project*, Kass substituted Warhol's
*Marilyn*s, *Jackie*s, and *Elvise*s with her own pan-
theon of Jewish superstars—Barbra Streisand,
Sandy Koufax, and here, herself. "Andy was a hero
since my teenage years," Kass has said. "It was
the familiarity of his images. Everybody knows his
work." Navigating the double bind of being a
gay female artist, Kass positions herself as both

heir to Warhol's queer camp and critical of his
complacency in the art world's patriarchical
sexism. She infuses Warhol's interchangeable
representations with her own Jewish-lesbian
content—Streisand-worship and pleasure in
cross-dressing. Ultimately, quoting poet Adrienne
Rich, Kass says, "This is the oppressor's language
yet I need it to talk to you."

238/239

By Deborah Kass
(born 1952)
Gelatin silver print, 50.8 × 40.6 cm (20 × 16 in.)
1994
Private collection

Plate 78
David Wojnarowicz

Artist David Wojnarowicz (1954–1992) arrived in New York's East Village in 1978, after a childhood filled with abuse and later years hustling in Times Square and hitchhiking around the United States and Europe. Soon after settling in New York, Wojnarowicz met photographer Peter Hujar, who was to become a surrogate father, brother, artistic mentor, and briefly his lover. This photograph, one of many that Hujar took of Wojnarowicz, captures a moment of profound melancholy and seems to foreshadow Wojnarowicz's sadness and rage as Hujar began to die from AIDS only a few years later. "I mean just the essence of death," Wojnarowicz wrote just moments after Hujar died in 1987, "the whole taboo structure in this culture the mystery of it the fears and joys of it the flight it contains this body of my friend on the bed this body of my brother my father my emotional link to the world this body I don't know this pure and cutting air just all the thoughts and sensations this death this even produces in bystanders contains more spirituality than any words we can manufacture."

By Peter Hujar
(1937–1987)
Gelatin silver print, 35.6 × 35.6 cm (14 × 14 in.) sheet
1981
The Museum of Modern Art, New York City
The Fellows of the Photography Fund

Plate 79
Fascination

Mark Morrisroe's portrait of his fellow artist and one-time partner Jack Pierson (born 1960) plays their relationship off against the allegory provided by the cat and the canary. Morrisroe's life was tempestuous, fraught with drug addiction and an attraction to the demimonde that positioned him as an outlaw artist whose transgressions were as creative as they were self-destructive. The cat-canary relationship suggests an element of cruelty and hurt that are intrinsic, even vital, to the call-and-response dynamic that can be necessary for a relationship. The bird is attractive and elusive, the cat cruel and domineering. The essentials of a relation's volatility are played out against the axis of Pierson's arm and body. Yet Pierson, lying in bed, also acts as the protector, keeping the bird safe from the predators who seek to harm it simply because of its beauty and allure. So the photograph moves in layers from cruelty to a transcendent kindness in which the (homosexual) body becomes the site in which the beauty of society is both preserved and passed on. The artist Anthony Goicolea made a comment that being gay was especially hard because unlike other minorities, each generation had to create its own history for itself, lacking the generational continuity that was available to, say, African Americans or women. What Morrisroe suggests here is that that act of self-creation could be achieved through art.

By Mark Morrisroe
(1959–1989)
C-print, 50 × 40 cm (19^{11}/16 × 15^{3}/4 in.)
1982
Marc Wolf

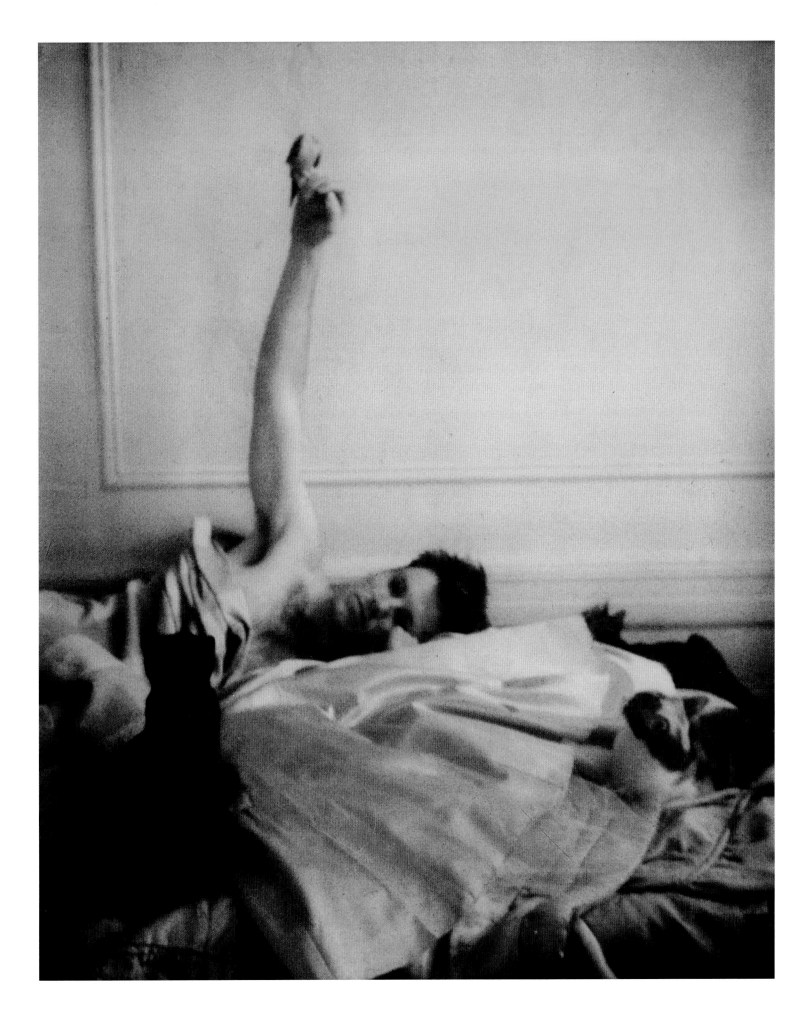

Plate 80
Ventriloquist

In the 1950s, Jasper Johns started his career by painting objects like flags, targets, and numerals. He was little in the public eye during this period, and his own reclusiveness was mirrored in the cool, detached quietness of the art itself, art that seemed to make no claim on public attention in its reliance on things as they are. Johns's quietude, both artistic and personal, was a reaction against the superheated, even bombastic, claims to attention of the abstract expressionists who preceded him, as well as his partner Robert Rauschenberg. While abstract expressionists like Jackson Pollock and Willem de Kooning posed as swaggering exemplars of American heterosexuality—a pose adopted in part to "sell" avant-garde art to a distrustful public—Johns embraced a quieter, more reflective presence, both in his art and personal life. As Johns moved both artistically and personally into the public sphere, his work began to engage issues of self-fashioning and presentation. He was particularly interested in hidden meanings and masking, an issue he explored in such paintings as *Tennyson* (fig. 17), which memorialized the poet laureate even as

it recognized the tensions in his private life. In *Ventriloquist,* Johns turns this scrutiny on himself, picturing his interrogation of his own career as he highlights how he used flags and other "found" objects in the painting. Through the painting he also speaks of his own interests as a collector of pottery and other artifacts that we associate with still-life painting. He depicts a copy of a Barnett Newman painting and adds his own reference to Newman's famous "zip" with a lavender line as the painting's right border. One wonders if this marks his recognition of the Lavender Scare of the 1950s, when homosexuals were pursued by the government, and artists like Johns himself had to speak like ventriloquists through other mouths.

By Jasper Johns
(born 1930)
Encaustic on canvas, 190.5 × 127 cm (75 × 50 in.)
1983
The Museum of Fine Arts, Houston, Texas
Museum purchase with funds provided by the Agnes Cullen Arnold Endowment Fund

Plate 81
Bill T. Jones

In 1994, the African American dancer and choreo-grapher Bill T. Jones (born 1952) debuted "Still/Here," a major artistic intervention to confront and transfigure the AIDS/HIV epidemic through a work of public culture. The reaction from political conservatives and artistic traditionalists was immediate, vehement, and censorious. While one might expect conservatives to be antipathetic to a ballet about AIDS by a gay African American dancer, the reaction from the liberal intelligentsia and art establishment was unexpected and dis-heartening. America's leading dance critic, Arlene Croce, refused even to see the ballet, calling it "victim art," and hence inherently unartistic and unworthy. This exclusion—the refusal to see, even if to condemn—marked more than the simple quarantining of the gay presence in American life, a quarantine that was proposed during the AIDS epidemic. It marked, by an otherwise sensitive and intelligent critic, the refusal to consider gays as part of the cultural body politic; that many

dancers and members of the arts community were gay only redoubled the bitter irony of the attack on Jones's work. Yet as Jones's very title indicated, this presence could be vilified but not denied. His insistence on making himself visible is echoed in Tseng Kwong Chi's collaboration with the graffiti artist Keith Haring. Haring painted on Jones's body, making him simultaneously a performer and a canvas that was its own work of art. More than a painting of the body, painting on the body fused art and likeness in the way that Jones's dance productions—in which the instrument of the body is the cultural pro-duction—would aspire to in "Still/Here." Chi's photograph, created in the year that the AIDS virus was identified, was a harbinger of the resis-tance to come.

246/247

By Tseng Kwong Chi
(1950–1990)
photography
By Keith Haring
(1958–1990)
body painting
Gelatin silver print, 50.8 × 40.6 cm (20 × 16 in.) sheet
1983
Muna Tseng Dance Projects, Inc., New York City

Plate 82

**Self-Portrait
(with broken finger)**

Son of a drug addict mother, Mark Morrisroe was shot by an angry "john" while working as a teen-aged hustler. He carried the bullet in his chest for the remainder of his short life and used X-ray pictures of the wound in some of his art. Part of the Boston punk and art scene, Morrisroe took up photography when he was given a Polaroid camera, and his portraits of the scene have the same disquieting documentary quality as his contemporary, Nan Goldin. But Morrisroe eschewed Goldin's sense of exhausted, yet glamorous, decadence, as well as her sentiment-ality, for a gritty, confrontational "street" aesthetic that was raw and unblinking. Morrisroe experi-mented with a wide array of techniques for manip-ulating and altering both his photographs and films. Yet, as in this *Self-Portrait*, he always comes back to the wounds that had been inflicted on him and on his contemporaries. The sense of the wound, as something imposed yet to be overcome, is a steady presence in American arts and culture, going back to Ahab in *Moby-Dick*. Here Morrisroe poses himself, bandaged, like a wounded prizefighter or gladiator, hunkered down against life's battering but still almost eager for the next blow. After Morrisroe was diag-nosed with HIV in 1986, he spent the last years of his life recording the disease's progress through his body, even down to his last days in the hospital.

By Mark Morrisroe
(1959–1989)
C-print, 50.8 × 40.6 cm (20 × 16 in.) sheet
1984
Romain Soulez Larivière Collection

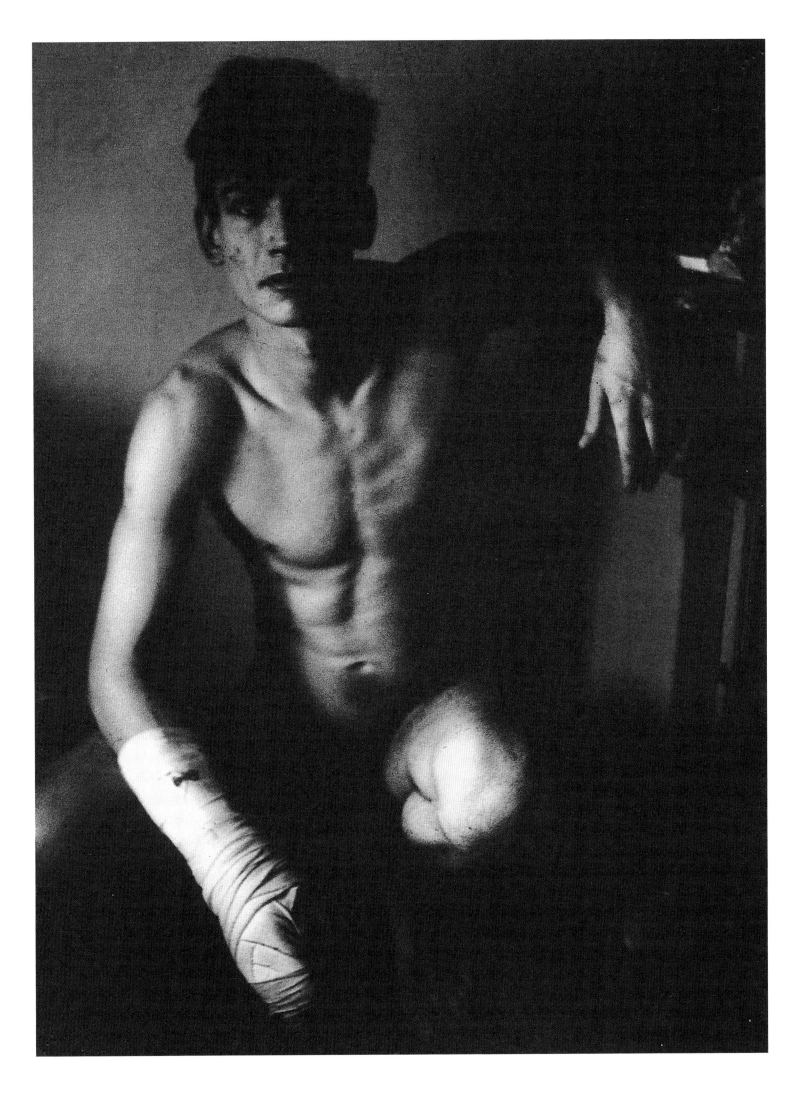

Plate 83

Camouflage Self-Portrait (Red)

Andy Warhol was famous for much longer than the fifteen minutes that he famously prophesized for everyone. Indeed, Warhol became so famous for being famous that his art tended to take second place to his personality. Warhol's was a peculiar kind of fame: against the thrusting aggressiveness of postindustrial commercialism and its celebrity culture, he posed himself as a blank. Always present yet always absent, his pale features, deadpan expression, gnomic utterances, and famous wig created a brand whose ubiquity repelled inquiry or connection, let alone intimacy. In his series of *Camouflage Self-Portraits*, Warhol riffed on the idea that portraits are a mask. He hides in plain sight, not camouflaged at all, instantly recognizable yet ultimately hidden behind the facade of his own making.

250/251

By Andy Warhol
(1928–1987)
Synthetic polymer paint and silkscreen on canvas,
204.5 × 193 cm (80$^1/_2$ × 76 in.)
1986
Philadelphia Museum of Art, Pennsylvania
Acquired with funds contributed by the Committee on Twentieth-Century Art and as a partial gift of the Andy Warhol Foundation for the Visual Arts, Inc., 1993

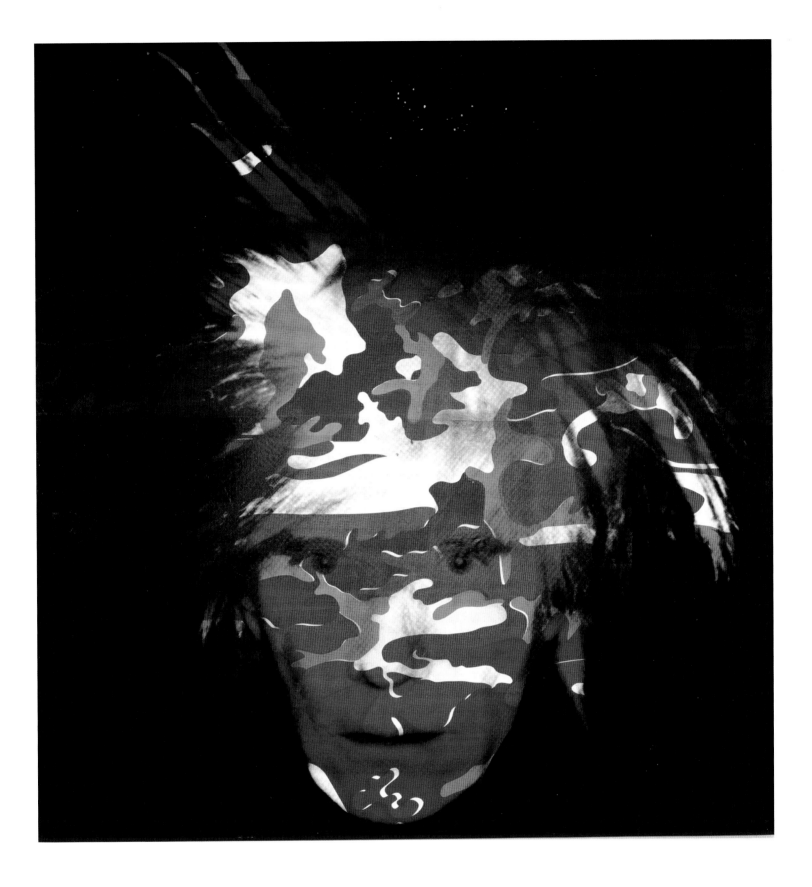

Plate 84

Film still from *Dream Girls*

The impulse for a lesbian photomonteur (menteur) to paste (not suture, please) her constructed butch-girl self-image into conventional narrative stills from old Hollywood movies requires no elaborate explanations.

—Deborah Bright

In her *Dream Girls* photography series, Deborah Bright "lesbianized" the classic Hollywood story of love, lust, seduction, and deception. By pasting pictures of herself into otherwise clichéd stills from old films, Bright makes literal both her childhood fantasies of becoming a glamorous movie star and her desire to see lesbians represented in mainstream American popular culture. In this image, from Spencer Tracy and Katharine Hepburn's 1949 comedy *Adam's Rib*, Bright inserts herself as the disgruntled chauffeur of the lawyer couple who share a smooch after their courtroom tussle as legal adversaries. Hepburn was always a lesbian icon because of her pantsuit, wisecracking, and employment in predominately masculine jobs; in *Sylvia Scarlett* she cross-dressed as a man to dramatic and sexually powerful effect. The perfect partnership with Tracy, both in the movies and in their real-life love affair, was one of equals; the title *Adam's Rib* is ironic since Amanda Bonner, Hepburn's character, is by no means subservient to her husband, Adam. Here, Bright, unable to bear such happiness and seeing herself in the role of Tracy, turns away from the couple and waits for the traffic jam to clear. In, but not of, the scene, Bright's character cannot enjoy the connection enjoyed by Tracy and Hepburn, yet the questions of sexual difference raised by the film's title as well as Hepburn's ambiguous allure captured precisely the ambiguity and multiplicity that Bright desired in her photographic reconstructions.

By Deborah Bright
(born 1950)
Archival inkjet print, 23.2 × 30 cm (9 1/8 × 11 13/16 in.)
1990
Collection of the artist

Plate 85 a–d

Being and Having (Papa Bear, Chief, Jake, and Chicken)

During the last twenty years, Catherine Opie has produced a complex body of photographic work— from portraits of queer subcultures to sprawling urban landscapes—that constitutes a frank and unapologetic exploration into the formation of communal, sexual, and cultural identities in America. "I am an American photographer," Opie said in a 2008 interview. "I have represented this country and this culture. And I'm glad that there is a queer, out, dyke artist that's being called an American photographer." *Being and Having*, one of Opie's earliest series, boldly questions the naturalness of gender by asserting the presence of a subculture in which identity does not fall neatly into the categories male/female. Here, Opie's subjects flaunt the artifice of their gender identities; the fakery of their facial hair becomes obvious as the camera's raking light reveals drips of glue and netting. "They don't want to be men or to pass as men all the time," Opie says about her subjects, who were friends of hers from the lesbian community. "They just want to borrow male fantasies and play with them."

By Catherine Opie
(born 1961)
Chromogenic prints (four), each 43.2 × 55.9 cm
(17 × 22 in.)
1991
Gregory R. Miller

Plate 86
Charles Devouring Himself

The advent of AIDS gave birth to a host of diver-gent reactions—it was bemoaned as an all-pervasive death sentence, mourned as harbinger of the death of family and loved ones, and hailed as just punishment for a "sinful lifestyle." Feared and lamented, AIDS became a tool to scapegoat an entire "gay community" as vectors of conta-gion. With forceful irreverence, however, Jerome Caja denies us all of these scripted responses, thrusting us instead into an uncomfortable state of *not knowing* how to react. Jerome mixed his friend Charles's ashes with nail polish to create this image of Charles ingesting his own body. (Charles committed suicide once his life with AIDS became unbearable and recovery was beyond hope.) One can hardly imagine a more gruesome inversion of Goya's famous painting of Saturn devouring his son. This searing condemnation of America's willingness to devour its sons during the AIDS crisis is immediately undercut by Jerome's campy frivolity and cartoonish vulgarity.

256/257

By Jerome Caja
(1958–1995)
Ash and nail polish on platter, 21.6 cm
(8$^1/_2$ in.) diameter
1991
Scott England

Plate 87

**Misty and Jimmy
Paulette in a Taxi,
New York City**

Partygoers or war-zone refugees? The thousand-yard stares on the faces of two of Nan Goldin's favorite subjects in a photograph taken in a cab after a hard night out begs the question. In 1883, when John Singer Sargent famously painted Madame X's dress strap slipping down her shoulder, he suggested a nakedness that fractured Gilded Age propriety. Here, Goldin references Sargent, but by showing both of Jimmy Paulette's straps down, she creates a *fin de siècle* symbol of exhaustion and desperation rather than erotic promise: s/he's come undone. The photograph's immediate sense of glamour is belied when you look closely at the rips and tears in the clothing and faces of the girls, whose eyes look like holes poked in the black snow of their mascara. Goldin gives her subjects a weight and dignity that keeps the picture from either Wegee-like voyeurism or moralistic posturing. Instead, as part of her artistic project documenting the decade after AIDS, Goldin suggests that we are all in the front seat with her, trapped in a cab ride to nowhere.

By Nan Goldin
(born 1953)
Cibachrome print, 76.2 × 101.6 cm (30 × 40 in.) framed
1991
Courtesy of the artist and Matthew Marks Gallery,
New York City

Plate 88

**Untitled
(newspaper stacks)**

Robert Gober matured as an artist in New York of the 1980s, a decade of rampant consumption turned upside down by the trauma of AIDS and a sputtering economy. Amid a generation of artists who eschewed the handmade in favor of the anonymous "readymade," Gober distinguished himself by meticulously constructing his objects by hand—sinks, beds, cribs, and here, news-papers. With a touch of wry humor, Gober tanta-lizes viewers with faux-newspapers that they cannot pick up to read. Under a headline that reads "Vatican Condones Discrimination Against Homosexuals" with the subheadline "Concern that gay rights threaten marriage," Gober stands, in full wedding drag, in the guise of a Saks Fifth Avenue advertisement. Upon close inspection, the newspaper's text reveals Gober's profound political, social, and sexual outrage.

By Robert Gober
(born 1954)
Five sculptures, each a photolithograph on archival Mohawk Superfine paper and twine with supporting bundles, overall dimensions approximately 76.2 × 116.2 × 81.3 cm (30 × 45^3/4 × 32^1/2 in.)
1992
Chara Schreyer

Plate 89
Untitled, from Runaways

To create *Runaways*, a series of ten prints that mimic the appearance of nineteenth-century posters seeking fugitive slaves, artist Glenn Ligon solicited descriptions from ten of his friends, asking each of them to write a missing persons report about him. The results are rife with contradictions, generating a disjunctive portrait of the artist that necessarily keeps him fugitive. For example, one poster proclaims "Glenn. He is black," while another proclaims, "He has medium-dark skin," and yet another describes him as "slightly orange." *Runaways* plays into Ligon's ongoing preoccupation with the slipperiness of identity (as male/female, black/white, gay/straight, etc.). If identity is based, at least in part, on how others perceive us, *Runaways* underscores how even the self is in large measure a shifting construction of others.

By Glenn Ligon
(born 1960)
Max Protetch Gallery, New York (publisher); Burnet Edition, New York (printer)
One from a portfolio of ten lithographs, 40.6 × 30.5 cm (16 × 12 in.) sheet; composition (irregular), 31.9 × 22.7 cm (12^9/$_{16}$ × 8^{15}/$_{16}$ in.)
1993
The Museum of Modern Art, New York City
The Ralph E. Shikes Fund, 1993

RAN AWAY, Glenn, a black male, 5'8", very short hair cut, nearly completely shaved, stocky build, 155-165 lbs., medium complexion (not "light skinned," not "dark skinned," slightly orange). Wearing faded blue jeans, short sleeve button-down 50's style shirt, nice glasses (small, oval shaped), no socks. Very articulate, seemingly well-educated, does not look at you straight in the eye when talking to you. He's socially very adept, yet, paradoxically, he's somewhat of a loner.

17/45 '93

Plate 90

Brotherhood, Crossroads, Etcetera (center panel)

Lyle Ashton Harris created the triptych *Brotherhood, Crossroads, Etcetera* in collaboration with his brother, Thomas Allen Harris. Drawing from their political and cultural heritage as well as their personal histories, the Harris brothers weave a complex visual allegory that invokes ancient African cosmologies, Judeo-Christian myths, and taboo public and private desires. In this provocative center image, the brothers exchange a passionate kiss as Thomas presses a gun into Lyle's chest—conjuring the original biblical story of Cain's treachery toward his brother, Abel. The red, black, and green velvet background references Marcus Garvey's UNIA (Universal Negro Improvement Association) tricolor flag: red standing for blood, green for the wealth of the land, and black for the African race. "As black queer cultural producers, we are celebrating the liberatory potential of this black nationalist icon by expanding the notion of who may lay claim to it," Lyle explains. The image transgresses many dualisms we use to structure society: male versus female, black versus white, "brotherly love" versus homosexual desire. And it raises provocative questions surrounding themes of domestic abuse between lovers, perceived violence among black men, and the dangers that come from engaging in an "illicit" love—whether it be from disease, homophobia, or a lethal combination of the two.

264/265

By Lyle Ashton Harris
(born 1965)
C-print, 50.8 × 40.6 cm (20 × 16 in.)
1994
Collection of the artist, courtesy CRG Gallery, New York City

Plate 91

Interim Couple (1164)

"I hope to create floating, fragile objects that evoke ghosts and spirits of a rapidly disappearing segment of the population," Bill Jacobson wrote about his *Interim Portrait* series. Here, two men—identified only by the number 1164—embrace as they dematerialize into a diaphanous gray background. Covered by a fog that completely obscures their identities, these men come to stand in for the thousands who were villanized, neglected, and silenced during the early years of the AIDS crisis. An evocative sentimental response to a horrific epidemic that touched every corner of the gay community, this photograph references the "fading away" of the physical body through disease and bears witness to the potential for love and commitment between gay men.

By Bill Jacobson
(born 1955)
Gelatin silver print, 20.3 × 25.4 (8 × 10 in.)
1994
Courtesy of the artist and Julie Saul Gallery, New York City

Plate 92
Nature Self-Portrait No. 4

Laura Aguilar describes herself as a mostly self-taught photographer. Based outside of Los Angeles in the San Gabriel Valley, Aguilar is third-generation Mexican American on her father's side and Irish American on her mother's side. She identifies openly as a lesbian. In this self-portrait, Aguilar presents her body so that it appears naturalized as a part of the surrounding landscape. A witty twist on the classical tradition of the reclining female nude, Aguilar here positions herself so that the puddle in front of her appears to be a lake and her body becomes a mountain that rises above it. Rather than highlighting her obesity, Chicana ethnicity, or lesbianism—all of which make her an ostensible "outsider" in United States society—Aguilar emphasizes her unity with nature. This fits with her larger goal of using photography to expose certain universalities underlying socially imposed categories. She writes: "My artistic goal is to create photographic images that compassionately render the human experience, revealed through the lives of individuals in the lesbian/gay and/or persons of color communities."

268/269

By Laura Aguilar
(born 1959)
Gelatin silver print, 40.6 × 50.8 cm. (16 × 20 in.)
1996
Courtesy of the artist and Susanne Vielmetter,
Los Angeles Projects, Culver City, California

Plate 93

**Ellen DeGeneres,
Kauai, Hawaii**

Despite its reputation for progressive politics, Hollywood has been surprisingly skittish when it comes to publicly acknowledging sexual difference. Thus it was a landmark event in April 1997 when the sitcom star and talk-show host Ellen DeGeneres (born 1958) told *Time* magazine, "Yep I'm Gay." DeGeneres went on to say that she was ambivalent about coming out, feeling that there should be a zone of privacy allowable to public figures and celebrities. But she also felt that not openly acknowledging her lesbianism meant that she lacked control over her own life and career. Coming out, she said afterward, has been the most freeing experience "because people

can't hurt me anymore." Annie Leibovitz took this photograph in 1998; its carnival of visual signs evidences the element of ambiguity with which DeGeneres presented herself in public and on her television shows. Notice the aggressive "Playboy-esque" presentation of the breasts vis-à-vis the exposed boxer shorts. The mime-like mask both reveals and hides, but the most startling thing about the picture is the tough-guy cigarette!

By Annie Leibovitz
(born 1949)
Gelatin silver print, 50.8 × 40.6 cm (20 × 16 in.)
1997
Collection of the artist

Plate 94
Whet

The contemporary artist Anthony Goicolea has spent the beginnings of his career up to age thirty creating a large series of photographs that provide a carefully fabricated glimpse into the world of an all-boys prep school. His photographs, a form of pseudo-documentary that stands in stark opposition to the work of Larry Clark (pl. 50)—even though both are fascinated with adolescent rebellion—offers an exaggerated portrayal of the rebelliousness, bullying, acting-out, and sexual experimentation that goes on at an age when discretion is at the mercy of hormones. But everything in Goicolea's photographs is not as it first appears—all of the "boys" that inhabit his world are, in fact, photographs of the artist himself. "I use myself to explore themes of narcissism and vanity," Goicolea says. "Not as a bad sort of self-absorbed quality, but more as an idea of nostalgia and loss." Goicolea's incessant narcissism—his desire to (re-)create his youth by inserting version after version of himself into an imagined past—results in a nightmarish world of missed connections and malicious intentions in which the artist is simultaneously a participant and observer in his own carefully posed fictions. In *Whet* (the title is a pun: the boys are wet and their appetites are always whetted), the picture obliquely quotes the self-destructive myth that bedevils Goicolea—that of Narcissus.

By Anthony Goicolea
(born 1971)
Photograph mounted on Sintra board, 58.4 × 127 cm
(23 × 50 3/4) mount
1999
Stephane Janssen

Plate 95
Mirror

"All of the physical characteristics of the Negro which had caused me, in America, a very different and almost forgotten pain were nothing less than miraculous—or infernal—in the eyes of the village people. . . . In all of this, in which it must be conceded there was the charm of genuine wonder and in which there were certainly no element of intentional unkindness, there was yet no suggestion that I was human: I was."

—James Baldwin, "Stranger in the Village" (1955)

Glenn Ligon has made several paintings that excerpt texts by James Baldwin exploring the writer's alienation from the world and his own resistance to his self-alienation. In *Mirror*, Baldwin's careful calibrations, which the artist inscribed as the first layer on his canvas, are effaced by the building up of an unbroken surface of black paint coarsened with coal dust, through which language is broken, fragmented, and dimly perceived. As this painting suggests, Ligon is interested in looking at and embodying signal episodes in African American history, appropriating the struggles of such iconic figures as Baldwin in order to explore his own ambivalent relationship to the depiction of black bodies within the Western aesthetic tradition. That Baldwin was not only black but also gay leads to a double effacement, as we visually impose upon him the overwhelming "fact" of his blackness. The title (*Mirror*) is significant: in making us complicit in Baldwin's disappearance, the painting portrays us, not its ostensible subject.

274/275

By Glenn Ligon
(born 1960)
Coal dust, printing ink, oil stick, glue, acrylic paint, and gesso on canvas, 208.3 × 139.7 cm (82 × 55 in.)
2002
Private collection

Plate 96
I Look Just Like My Daddy

Through her photographs, Cass Bird asserts the positive existence of people who subvert and push the perceived boundaries of gender specification. She thereby suggests a world that is polymorphous, indeterminate, and androgynous. In this photograph, taken on a rooftop in Brooklyn, Bird's friend Macaulay stares out from under a cap emblazoned with the words "I Look Just Like My Daddy." Macaulay's gender—powerfully self-determined against societal assumptions of what it means to be male or female—is ambiguous. Her cap's proclamation is likewise ambiguous—perhaps it is true, perhaps it is an ironic statement of an expectation that will never be realized. Bird's sensitivity toward lives that both resist and intersect with accepted notions of gender and family informs her entire photographic practice. Raised in Los Angeles, Bird graduated from Smith College in 1999 and currently lives and works in New York City.

276/277

By Cass Bird
(born 1975)
C-41 print, 76.2 × 101.6 cm (30 × 40 in.) sheet
2003
Collection of the artist

Self-Portrait #3
Self-Portrait #28

My quietness has a man in it, he is transparent
and he carries me quietly, like a gondola, through
the streets.
He has several likenesses, like stars and years, like
numerals.
My quietness has a number of naked selves.

—Frank O'Hara, "In Memory of My Feelings" (1956)

Self-Portrait #3 and *Self-Portrait #28*—both by
Jack Pierson—neither one is a self-portrait, or are
they? Pierson here asks, "How can I represent
myself?" And, like Frank O'Hara fifty years earlier,
he concludes that he has not one but "several
likenesses, like stars and years, like numerals."
But how is it possible, at the dawn of the twenty-
first century, with identity politics firmly
entrenched, to have not one but many selves?
Pierson's self-portraits (of which, you see two)
constitute a typology of gay-male desirability,
reified by the media and ingrained into our
consciousness, but Pierson asks if we must be
consigned to and accept the masks and roles
assigned to us. How is it possible, in other words,
to create a distinctive self-portrait?

278/279

By Jack Pierson
(born 1960)
#3: pigment print, 137.2 × 111.8 cm (54 × 44 in.)
2003
James R. Hedges IV, courtesy Cheim & Read,
New York City
#28: pigment print, 135.9 × 109.2 cm
(53 1/2 × 43 in.) sheet
2005
Courtesy of the artist and Cheim & Read, New York City

Acknowledgments

Hide/Seek: Difference and Desire in American Portraiture had its origins in historian David C. Ward's 2006 exhibition at the National Portrait Gallery, "Walt Whitman, a kosmos." That exhibition contained a portrait of Whitman and his lover Peter Doyle, taken by an unidentified photographer in the year the two had met, 1865. In the exhibition label, Ward wrote that after encountering each other on a Washington omnibus, Whitman and Doyle "remained companions and lovers for the next eight years." Not having any background in gender studies, queer studies, or the history of sexuality, Ward thought nothing further about a label that simply, to his mind, stated the facts about Whitman's (and Doyle's) life. He was therefore surprised when at a symposium on Whitman, Jonathan D. Katz, the founding professor of gay and lesbian studies at Yale University and now director of the Visual Studies doctoral program at SUNY—Buffalo, introduced himself and said that this was the first time that the relationship between Whitman and Doyle—one grounded in a shared gay identity—had ever been explicitly stated in a major museum exhibition. At the same time, the *New York Times* was pleased to note that the National Portrait Gallery was paying attention to difficult issue of race, gender, and sexuality.

From Katz and Ward's initial meeting, a conversation developed about several issues of importance to the study of American culture and art, including the refusal of society to acknowledge the role of gay and lesbian artists. Katz had long proposed such an exhibition and was delighted to find a willing partner at the National Portrait Gallery. With motivations ranging from a misplaced gentility to outright repression, the story of modern American art was being incompletely told because of the refusal to deal with the question of homosexual identity. Not only was credit not given where it was due, but the censorship distorted the history of American modernism by excluding a major reason why gay and lesbian artists created the art that they did. Moreover, much of these artists' work cannot be adequately understood unless their sexual identity is taken into account; scholars who had no difficulty linking Jackson Pollock's drip paintings to his aggressive heterosexuality elided the question when it came to Marsden Hartley's abstractions and their relationship to his homosexuality. In but not of American society, gay and lesbian portraitists occupied a position of marginality that allowed them to make innovative and vital cultural statements about American society and its people.

From a discussion of these and other topics, Ward and Katz implemented the exhibition that is presented here: a survey of American portraiture beginning in the late nineteenth century—when the very concept of the "homosexual" was categorized—through the years of opprobrium, in which an excluded (and frequently despised) subgroup evolved strategies to survive; to the period of Gay Liberation in and around the Stonewall riots (1969) and the aesthetic/cultural changes that followed; and finally to the confrontation of the AIDS epidemic and its aftermath in the 1980s.

Katz asked Ward when they met, "Did you get in trouble when you wrote that label on Whitman and Doyle?" That Ward did not was due in large measure to Marc Pachter, then director of the National Portrait Gallery. As Ward and Katz's ideas evolved into an exhibition proposal, Pachter was immediately supportive of their work, grasping its potential for the National Portrait Gallery as a necessary expression of the museum's emphasis on individual rights in American history. Marc's support has been followed by that of his successor, Martin Sullivan, who similarly saw any obstacles in the way of the exhibition as simply obstacles that would be overcome. In the interim, when Marty took a medical leave of absence, acting Director Brandon Fortune held the fort.

As ideas began to coalesce into the physical reality that is a museum exhibition, staff at the National Portrait Gallery provided essential work. Our thanks go out especially to Beverly Cox, director of exhibitions and collections management, and Nello Marconi, former chief of design and production, for their perseverance in the face of sometimes-daunting problems of implementation and design. We also thank Tibor Waldner, who has become chief upon Nello's retirement. In the exhibitions office, Kristin Smith did extraordinary work to create object and illustration lists, arrange loans, and secure illustrations with an efficiency that neither of the co-authors can ever hope to match. Director of Development Sherri Weil and Deputy Director of Development Charlotte Gaither Morgan provided logistical support and planning for the fundraising that *Hide/Seek* required. Thanks also to Louise Dawson and Julia Zirinsky for their help in fundraising and rolling out *Hide/Seek*. Dru Dowdy, NPG's head of publications, did as much as the authors to bring this catalog into being through her supervision of both the manuscript and the logistical relationship with Smithsonian Books. Other staff at the NPG need acknowledgement here as well: Deb Sisum, webmaster, for her usual faultless ability to turn code into elegance; Rebecca Kasemeyer, director of education, and her staff for

coordinating and helping to plan public events and educational programming for *Hide/Seek*; and Bethany Bentley, public affairs officer, who was our critical interface with the public and also helped coordinate information about the exhibition within the Smithsonian. Finally, thanks to everyone at NPG who supported our project as we moved forward. Any exhibition is only as good as the museum that presents it, and we hope that the quality of *Hide/Seek* matches the quality of NPG's employees.

Finally, our personal and professional thanks go out to the many donors who stepped forward to contribute money, time, and effort to support this exhibition; the donors are listed in the front matter. But we would be remiss in not singling out Donald Capoccia and his partner Tommie Pegues, who made an early and decisive contribution to get our work off the ground. Thereafter, the Calamus Foundation was a generous contributor, providing both an exceedingly generous amount of its own money as well as setting up a challenge grant that reaped more support for *Hide/Seek*. Finally, special mention should go to the Warhol Foundation for its major grant in support of the exhibition.

Both authors would like to thank Jennifer Sichel, who is at the beginning of her own career, for her exemplary work as a research assistant; thanks also to Patrick Mansfield for his early work compiling the object package. With regard to personal acknowledgements, David C. Ward would like to thank his brother Chris and his sister-in-law Pam Cook Ward for their support and for a place to stay in Manhattan; thanks also to Andrew Ward. Jonathan D. Katz would like to thank his husband, Andre Dombrowski, for his editorial assistance and just because; special thanks also to his brother, Jeremy. Thanks also to Jeff Soref, Jim Marcus, Michael Taylor, Amelia Jones, Rick Brettel, Susan Fort, Bruce Robertson, Charles Leslie, George E. Jordan, and Michel G. Delhaise.

For Further Reading

Adams, Henry. *Eakins Revealed: The Secret Life of an American Artist*. Oxford, England: Oxford University Press, 2005.

____. "The Identity of Winslow Homer's 'Mystery Woman.'" *The Burlington Magazine* 132, no. 1045 (April 1990): 244–52.

____. "Mortal Themes: Winslow Homer." *Art in America* 71, no. 2 (February 1983): 113–26.

Avena, Thomas, Adam Klein, and William Lyon Strong. *Jerome: After the Pageant*. San Francisco: Bastard Books, 1996.

Benderson, Bruce, and James Bidgood. *James Bidgood*. Cologne, Germany: Taschen, 1999.

Benita, Eisler. *O'Keeffe and Stieglitz: An American Romance*. New York: Doubleday, 1991.

Berger, Martin A. *Man Made: Thomas Eakins and the Construction of Gilded Age Manhood*. Berkeley: University of California Press, 2000.

Bergman, David. *Camp Grounds: Style and Homosexuality*. Amherst: University of Massachusetts Press, 1993.

Blessing, Jennifer, and Judith Halberstam. *Rrose Is a Rrose Is a Rrose: Gender Performance in Photography*. New York: Guggenheim Museum, 1997.

Boffin, Tessa, and Jean Fraser. *Stolen Glances: Lesbians Take Photographs*. London: Pandora Press, 1991.

Bolger, Doreen, and Sarah Cash, eds. *Thomas Eakins and the Swimming Picture*. Fort Worth: Amon Carter Museum, 1996.

Bolton, Richard. *The Contest of Meaning: Critical Histories of Photography*. Cambridge, Mass.: MIT Press, 1989.

Brennan, Marcia. *Painting Gender, Constructing Theory: The Alfred Stieglitz Circle and American Formalist Aesthetics*. Cambridge, Mass.: MIT Press, 2002.

Bright, Deborah. *The Passionate Camera: Photography and Bodies of Desire*. London: Routledge, 1998.

Bruhm, Steven. *Reflecting Narcissus: A Queer Aesthetic*. Minneapolis: University of Minnesota Press, 2001.

Butt, Gavin. *Between You and Me: Queer Disclosures in the New York Art World, 1948–1963*. Durham, N.C.: Duke University Press, 2005.

Cadmus, Paul, Margaret French, and Jared French. *Collaboration: The Photographs of Paul Cadmus, Margaret French, and Jared French*. Santa Fe: Twelvetrees Press, 1992.

Capozzola, Christopher. "The Man Who Illuminated the Gilded Age?" *American Quarterly* 52, no. 3 (September 2000): 514–32.

Carr, C. *On Edge: Performance at the End of the Twentieth Century*. Middletown, Conn.: Wesleyan University Press; Hanover: University Press of New England, 1993.

Cassidy, Donna M. *Marsden Hartley: Race, Religion, Nation*. Durham, N.H.: University Press of New England, 2005.

Chadwick, Whitney, and Tirza True Latimer. *The Modern Woman Revisited: Paris Between the Wars*. New Brunswick, N.J.: Rutgers University Press, 2003.

Chadwick, Whitney, with an essay by Joe Lucchesi. *Amazons in the Drawing Room: The Art of Romaine Brooks*. Berkeley: University of California Press, 2000.

Chadwick, Whitney, and Isabelle De Courtivron, eds. "The Art of Code: Jasper Johns and Robert Rauschenberg." *Significant Others: Creativity & Intimate Partnership*. New York: Thames and Hudson, 1993.

Chauncey, George. *Gay New York: Gender, Urban Culture, and the Makings of the Gay Male World, 1890–1940*. New York: Basic Books, 2003.

Cleto, Fabio, ed. *Camp: Queer Aesthetics and the Performing Subject: A Reader*. Triangulations. Ann Arbor: University of Michigan Press, 1999.

Cooper, Emanuel. *The Sexual Perspective: Homosexuality and Art in the Last 100 Years in the West*. London: Routledge & Kegan Paul, 1986.

Corinne, Tee. *Cunt Coloring Book: Drawings*. San Francisco: Last Gasp, 1988.

Crimp, Douglas. *Melancholia and Moralism: Essays on AIDS and Queer Politics*. Cambridge, Mass.: MIT Press, 2002.

Crimp, Douglas, and Leo Bersani. *AIDS: Cultural Analysis, Cultural Activism*. Cambridge, Mass.: MIT Press, 1988.

Crimp, Douglas, and Louise Lawler. *On the Museum's Ruins*. Cambridge, Mass.: MIT Press, 1993.

Crump, James. *Suffering the Ideal: F. Holland Day, British Decadence and American Philhellenism*. Ann Arbor: UMI Dissertation Services, 1999.

Crump, James, and George Platt Lynes. *George Platt Lynes: Photographs from the Kinsey Institute*. Boston: Little, Brown, 1993.

Davis, Whitney. "'Homosexualism,' Gay and Lesbian Studies, Queer Theory in Art History." In *The Subjects of Art History*, edited by Mark A. Cheetham, Michael Ann Holly, and Keith Moxey. Cambridge New Art History and Criticism. Cambridge, Eng.: Cambridge University Press, 1999.

____. *Gay and Lesbian Studies in Art History*. New York: Haworth Press, 1994.

____. "Erotic Revision in Thomas Eakins's Narratives of Male Nudity." *Art History* 13, no. 3 (September 1994): 301–41.

D'Emilio, John. *Sexual Politics, Sexual Communities: The Making of a Homosexual Minority in the United States, 1940–1970*. Chicago: University of Chicago Press, 1983.

De Salvo, Donna M., Paul Schimmel, Russell Ferguson, and David Deitcher. *Hand-painted Pop: American Art in Transition, 1955–62*. Los Angeles: Museum of Contemporary Art, 1992.

Dillon, Diane. "Looking and Difference in the Abstract Portraits of Charles Demuth and Duncan Grant." *Yale Journal of Criticism* 11, no. 1 (Spring 1998): 39–51.

Doyle, Jennifer. "Sex, Scandal, and Thomas Eakins's The Gross Clinic." *Representations* 68 (Autumn 1999): 1–33.

Doyle, Jennifer, Jonathan Flatley, and José Esteban Muñoz. *Pop Out: Queer Warhol*. Series Q. Durham, N.C.: Duke University Press, 1996.

Drutt, Matthew, and Robert Gober. *Robert Gober: The Meat Wagon*. Houston, Tex.: Menil Foundation, 2006.

Duberman, Martin B. *Stonewall*. New York: Dutton, 1993.

Duchamp, Marcel, John Cage, and Moira Roth. *Difference/Indifference: Musings on Postmodernism*. New York: Gordon and Breach, 1998.

Elger, Dietmar, and Felix Gonzalez-Torres. *Felix Gonzalez-Torres*. Ostfildern-Ruit, Germany: Cantz Verlag, 1997.

Ellenzweig, Allen. *The Homoerotic Photograph: Male Images from Durieu/Delacroix to Mapplethorpe*. New York: Columbia University Press, 1992.

English, Darby. *How to See a Work of Art in Total Darkness*. Cambridge, Mass.: MIT Press, 2007.

Erkkila, Betsy, and Jay Grossman. *Breaking Bounds: Whitman and American Cultural Studies*. New York: Oxford University Press, 1996.

Falckenberg, Harald, Peter Weibel, and Paul Thek. *Paul Thek: Artist's Artist*. Karlsruhe, Germany: ZKM/Center for Art and Media, 2008.

Fairbrother, Trevor J. *John Singer Sargent: The Sensualist*. Seattle: Seattle Art Museum, 2000.

Fanning, Patricia J. *New Perspectives on F. Holland Day: Selected Presentations from the Fred Holland Day in Context Symposium Held at Stonehill College, North Easton, Massachusetts, April 19, 1997*. North Easton, Mass.: Stonehill College, 1998.

Ferguson, Russell, and Frank O'Hara. *In Memory of My Feelings: Frank O'Hara and American Art*. Los Angeles: Museum of Contemporary Art, 1999.

Fried, Michael. *Realism, Writing, Disfiguration: On Thomas Eakins and Stephen Crane*. Chicago: University of Chicago Press, 1987.

Fritscher, Jack. *Mapplethorpe: Assault with a Deadly Camera: A Pop Culture Memoir, an Outlaw Reminiscence*. Mamaroneck, N.Y.: Hastings House, 1994.

Fuss, Diana. *Inside/Out: Lesbian Theories, Gay Theories*. New York: Routledge, 1991.

Gober, Robert, Richard Flood, Gary Garrels, and Ann Temkin. *Robert Gober: Sculpture + Drawing*. Minneapolis: Walker Art Center, 1999.

Goldin, Nan, Jonathan Weinberg, and Joyce Henri Robinson. *Fantastic Tales: The Photography of Nan Goldin*. University Park: Palmer Museum of Art, in association with Pennsylvania State University Press, 2005.

Griffin, Randall C. "Thomas Eakins' Construction of the Male Body, or 'Men Get to Know Each Other Across the Space of Time.'" *Oxford Art Journal* 18, no. 2 (1995): 70–80.

Hammond, Harmony. *Lesbian Art in America: A Contemporary History*. New York: Rizzoli, 2000.

Harris, Melissa, ed. *David Wojnarowicz: Brush Fires in the Social Landscape*. New York: Aperture, 1994.

Hart, Lynda. *Between the Body and the Flesh: Performing Sadomasochism*. New York: Columbia University Press, 1998.

____. *Fatal Women: Lesbian Sexuality and the Mark of Aggression*. Princeton, N.J.: Princeton University Press, 1994.

Hatt, Michael. "The Male Body in Another Frame: Thomas Eakins' The Swimming Hole as a Homoerotic Image." *Journal of Philosophy and the Visual Arts* 4 (1993): 8–21.

Horne, Peter, and Reina Lewis. *Outlooks: Lesbian and Gay Sexualities and Visual Cultures*. London: Routledge, 1996.

Hughes, Holly. *Clit Notes: A Sapphic Sampler*. New York: Grove Press, 1996.

Hughes, Holly, and David Román. *O Solo Homo: The New Queer Performance*. New York: Grove Press, 1998.

Hujar, Peter, Urs Stahel, Hripsimé Visser, and Max Kozloff. *Peter Hujar: A Retrospective*. Zurich, Switzerland: Scalo, 1994.

Hujar, Peter, and Stephen Koch. *Peter Hujar Photographs, 1956–1958*. New York: Matthew Marks Gallery, 2009.

Imesch, Kornelia, and Hans-Jörg Heusser, eds. "The Silent Camp: Queer Resistance and the Rise of Pop Art." In *Visions of a Future: Art and Art History in Changing Context*, 147–58. Zurich: Swiss Institute for Art Research, 2004.

Jay, Karla, and Allen Young. *Out of the Closets: Voices of Gay Liberation*. New York: Douglas Book Corp., 1972.

Jess, and Robert Edward Duncan. *Paste ups*. San Francisco: San Francisco Museum of Art, 1968.

Johns, Elizabeth. *Winslow Homer: The Nature of Observation*. Berkeley: University of California Press, 2002.

Jones, Amelia, ed. "'The Senators Were Revolted': Homophobia and the Culture Wars." In *A Companion to Contemporary Art Since 1945*, 231–48. Oxford: Blackwell Publishing, 2006.

Jones, Amelia, and Andrew Stephenson, eds. *Performing the Body/Performing the Text*. London: Routledge, 1999.

Jussim, Estelle. *Slave to Beauty: The Eccentric Life and Controversial Career of F. Holland Day, Photographer, Publisher, Aesthete*. Boston: D. R. Godine, 1981.

Kaiser, Charles. *The Gay Metropolis: 1940–1996*. Boston: Houghton Mifflin, 1997.

Kardon, Janet, Robert Mapplethorpe, David Joselit, and Kay Larson. *Robert Mapplethorpe: The Perfect Moment*. Philadelphia: Institute of Contemporary Art, University of Pennsylvania, 1989.

Katz, Jonathan. "'Committing the Perfect Crime': Sexuality, Assemblage and the Postmodern Turn in American Art." *Art Journal* 67, no. 1 (Spring 2008).

____. "John Cage's Queer Silence or How to Avoid Making Matters Worse." *GLQ*, 5, no. 2 (April 1999): 231–52. Reprinted in David Bernstein, ed., *Writings Through John Cage's Music, Poetry and Art*. Chicago: University of Chicago Press, 2001

____. *Andy Warhol*. New York: Rizzoli, 1993.

Kirstein, Lincoln, and Paul Cadmus. *Paul Cadmus*. New

York: Imago Imprint, 1984.

Klusacek, Allan, and Ken Morrison. *A Leap in the Dark: AIDS, Art, and Contemporary Cultures*. Montreal: Véhicule Press, 1992.

Kornbluth, Jesse. *Pre-Pop Warhol*. New York: Panache Press at Random House, 1988.

Lambert-Beatty, Carrie. *Being Watched: Yvonne Rainer and the 1960s*. Cambridge, Mass.: MIT Press, 2008.

Latimer, Tirza True. *Women Together/Women Apart: Portraits of Lesbian Paris*. New Brunswick, N.J.: Rutgers University Press, 2005.

Leddick, David, and Pavel Tchelitchew. *The Homoerotic Art of Pavel Tchelitchew, 1929–1939*. North Pomfret, Vt.: Elysium Press, 1999.

Leibovitz, Annie. *A Photographer's Life, 1990–2005*. New York: Random House, 2006.

Ligon, Glenn, Darby English, and Stephen Andrews. *Glenn Ligon: Some Changes*. Toronto: Power Plant, 2005.

Mariani, Paul. *The Broken Tower: A Life of Hart Crane*. New York: W.W. Norton., 1999.

McDonnell, Patricia. *Dictated by Life: Marsden Hartley's German Paintings and Robert Indiana's Hartley Elegies*. Minneapolis: Frederick R. Weisman Art Museum, University of Minnesota; distributed by D.A.P./Distributed Art Publishers, 1995.

Meyer, Richard. *Outlaw Representation: Censorship and Homosexuality in Twentieth-Century American Art*. New York: Oxford University Press, 2002.

———. "Gran Fury and the Graphics of AIDS Activism." In *But Is It Art? The Spirit of Art as Activism,* ed. Nina Felshin. Seattle: Bay Press, 1995.

Michals, Duane, and Marco Livingstone. *The Essential Duane Michals*. Boston: Little, Brown, 1997.

Moon, Michael. *A Small Boy and Others: Imitation and Initiation in American Culture from Henry James to Andy Warhol*. Series Q. Durham, N.C.: Duke University Press, 1998.

Morrisroe, Mark. *Mark Morrisroe*. Santa Fe: Twin Palms Publishers, 1999.

Muñoz, José Esteban. *Disidentifications: Queers of Color and the Performance of Politics*. Vol. 1. Cultural Studies of the Americas. Minneapolis: University of Minnesota Press, 1999.

Neiland, Justus. *Feeling Modern: The Eccentricities of Public Life*. Champagne, Ill.: University of Illinois Press, 2008.

Newton, Esther. *Mother Camp: Female Impersonators in America*. Chicago: University of Chicago Press, 1979.

Opie, Catherine, Nat Trotman, and Russell Ferguson. *Catherine Opie: American Photographer*. New York: Guggenheim Museum, 2008.

Owens, Craig. "Outlaws: Gay Men in Feminism." In *Men in Feminism,* ed. Alice Jardine and Paul Smith. New York: Routledge, 1989.

Owens, Craig, and Scott Stewart Bryson. *Beyond Recognition: Representation, Power, and Culture*. Berkeley: University of California Press, 1992.

"Passive Resistance: On the Critical and Commercial Success of Queer Artists in Cold War American Art." *L'image*, Paris, no. 3 (December 1996): 119–42.

Pierson, Jack, Rachael Thomas, Maeve Butler, and Lucia Pietroiusti. *Jack Pierson*. Dublin: Irish Museum of Modern Art/Áras Nua-Ealaíne Na H-Éireann, 2008.

Prather, Marla, and Donald B. Kuspit. *Unrepentant Ego: The Self-Portraits of Lucas Samaras*. New York: Whitney Museum of American Art, 2003.

Reed, Christopher. *Art and Homosexuality: A History of Ideas*. New York: Oxford University Press, forthcoming 2011.

———. "The Artist and the Other: The Work of Winslow Homer." *Yale University Art Bulletin* 40 (Spring 1989): 69–79.

Roberts, Pam F. *Holland Day*. Amsterdam: Van Gogh Museum; Zwolle: Waanders Publishers, 2000.

Román, David. *Acts of Intervention: Performance, Gay Culture, and AIDS*. Unnatural Acts. Bloomington: Indiana University Press, 1998.

Saslow, James M. *Pictures and Passions: A History of Homosexuality in the Visual Arts*. New York: Viking, 1999.

Schimmel, Paul, and Hal Foster. *Robert Gober*. Los Angeles: Museum of Contemporary Art, 1997.

Sedgwick, Eve Kosofsky. *Epistemology of the Closet*. Berkeley: University of California Press, 1990.

Siegel, Marc. "Documentary That Dare Not Speak Its Name: Jack Smith's Flaming Creatures." In *Between the Sheets, in the Streets: Queer, Lesbian, Gay Documentary,* ed. Chris Holmund and Cynthia Fuchs. Minneapolis: University of Minnesota Press, 1997.

Smalls, James. *The Homoerotic Photography of Carl Van Vechten: Public Face, Private Thoughts*. Philadelphia: Temple University Press, 2006.

———. *Homosexuality in Art*. New York: Parkstone Press, 2003.

Smith, Anna Deavere. *Lyle Ashton Harris*. New York: Gregory R. Miller & Co. in collaboration with CRG Gallery, 2002.

Smyth, Cherry. *Damn Fine Art by New Lesbian Artists*. London: Cassell, 1996.

Squiers, Carol, ed. *The Critical Image: Essays on Contemporary Photography*. Seattle: Bay Press, 1990.

Suárez, Juan Antonio. *Bike Boys, Drag Queens and Superstars: Avant-Garde, Mass Culture, and Gay Identities in the 1960s Underground Cinema*. Bloomington: Indiana University Press, 1996.

Sussman, Elisabeth, Nan Goldin, David Armstrong, and Hans Werner Holzwarth. *Nan Goldin: I'll Be Your Mirror*. New York: Whitney Museum of American Art, 1996.

Sussman, Elisabeth, Keith Haring, and David Frankel. *Keith Haring*. New York: Whitney Museum of American Art, 1997.

Syme, Alison. *A Touch of Blossom: John Singer Sargent and the Queer Flora of Fin-de-Siècle Art*. University Park: Pennsylvania State University Press, 2010.

Tyler, Parker. *Florine Stettheimer: A Life in Art*. New York: Farrar, Straus and Company, 1963.

Wagner, Anne M. *Three Artists (Three Women): Modernism and the Art of Hesse, Krasner, and O'Keeffe*. Berkeley: University of California Press, 1996.

Warner, Michael. *Fear of a Queer Planet: Queer Politics and Social Theory*. Minneapolis: University of Minnesota Press, 1993.

Watney, Simon. *Policing Desire: Pornography, AIDS, and the Media*. Minneapolis: University of Minnesota Press, 1987.

Waugh, Thomas. *Hard to Imagine: Gay Male Eroticism in Photography and Film from Their Beginnings to Stonewall*. New York: Columbia, 1996.

Weinberg, Jonathan. *Ambition and Love in Modern American Art*. New Haven: Yale University Press, 2001.

____. *Speaking for Vice: Homosexuality in the Art of Charles Demuth, Marsden Hartley, and the First American Avant-Garde*. New Haven: Yale University Press, 1993.

____. "'Some Unknown Thing': The Illustrations of Charles Demuth." *Arts Magazine* 61 (December 1986): 14–21.

Whiting, Cecil. "Decorating with Stettheimer and the Boys." *American Art* 14, no. 1 (Spring 2000) 25–49.

Wojnarowicz, David, and Barry Blinderman. *David Wojnarowicz, Tongues of Flame*. Normal, Ill.: University Galleries of Illinois State University, 1992.

Wojnarowicz, David, Dan Cameron, and Amy Scholder. *Fever: The Art of David Wojnarowicz*. New York: Rizzoli, 1998.

Image Credits

Index

Note: Page numbers in bold type indicate illustrations.

Colophon

The typefaces used in *Hide/Seek: Difference and Desire in American Portraiture* are Knockout and Locator. Knockout, released in 2000 by Jonathan Hoefler and Tobias Frere-Jones, is rooted in American gothic woodtypes of the late nineteenth century. Locator, designed by Eric Olson and released in 2003, originated as a proposal for the *Typeface: Twin Cities* project, and projects a contemporary, accessible appearance. The fonts were selected to represent both the American subjects and artists in the National Portrait Gallery's collections and the time span covered by this book.

Hide/Seek: Difference and Desire in American Portraiture's layout is completed in Adobe Indesign CS2 by Studio A, Alexandria, Virginia.